THE BERLIN SECESSION

THE BERLIN SECESSION

Modernism and Its Enemies
in Imperial Germany

PETER PARET

THE BELKNAP PRESS OF
HARVARD UNIVERSITY PRESS
Cambridge, Massachusetts, and London, England
1980

Library of Congress Cataloging in Publication Data

Paret, Peter.
 The Berlin Secession.

 Bibliography: p.
 Includes index.
 1. Berliner Secession. 2. Modernism (Art) – Germany.
3. Politics in art – Germany. 4. Germany – History –
William II, 1888 – 1918. 5. Politics and culture – Germany.
I. Title.
N6868.5.B3P37 709'.431'55 80-15117
ISBN 0-674-06773-8

To

Aimée and Monty

CONTENTS

ILLUSTRATIONS

The present location of *Skaters* by Anton von Werner is not known. Lovis Corinth's pen-and-ink drawing, *Two Nudes,* was first published in the catalogue of the 1901 summer exhibition of the Berlin Secession. The remaining works are in the author's collection. The ornaments on the part title pages are Thomas Theodor Heine's drawing, based on his poster for the Berlin Secession, showing the genius of art kissing a bear — the heraldic symbol of Berlin — and crowning him with a laurel wreath, and Max Slevogt's panther design for the colophon of the Paul Cassirer Press.

THE BERLIN SECESSION

INTRODUCTION

In the 1890s one of the recurring conflicts between the traditional and the modern that punctuate the history of art erupted in Germany. Among the new groups formed by artists who wanted to free themselves from the constraints of the academy and the annual salon, the Berlin Secession soon stood out as the most combative and the most cosmopolitan in its values, to the point of being condemned as un-German by its numerous critics. For a decade and a half it constituted a major cultural force in Germany, eroding the parochialism and conformity from which German sculpture and especially painting had suffered for generations, and exposing Germans to the full spectrum of native and foreign avant-garde art. It became the institutional center of German impressionism, but remained sufficiently flexible to help pave the way for expressionism, many of whose leading figures exhibited under the secession's auspices in the early stages of their careers. The group's importance, however, transcends its role in the development of German art. The secession and the battles it fought with the emperor and his allies in the bureaucracy, the established art organizations, and among a public largely intolerant of experimentation, also proved to be a revealing phenomenon in the political history of the later Wilhelmine empire.

Only a few of the artists who founded the secession, or who subsequently joined it, were seriously concerned with politics, and their work rarely refers to themes of social or political change. But the fine arts in Prussia were dependent on the government and on the emperor's favor in so many ways that even membership in an association devoted to the exhibition and sale of apolitical art could become politicized. The antagonism felt toward the avant-garde by those who dispensed state patronage and controlled the most important exhibitions in the country turned the founding of the secession itself into a political act. The group's efforts to achieve equity for its members in such matters as access to exhibitions, prizes, and pur-

1

chases by the state inevitably led to conflicts, in which the ideologi-
cal element of opposition to the state was always present, if only
because the other side tended to see the issue in that light.

While it pressed the government for a more evenhanded treat-
ment of the arts, the secession clashed with other forces — popu-
list, extreme conservative, and anti-Semitic factions in German so-
ciety, which agitated for the expulsion of what they took to be alien
cultural influences, in favor of a homegrown art that some enthu-
siasts believed would regenerate the nation. The secession as
the agent of a dangerously cosmopolitan modernism became a sta-
ple in the demonology of the radical right, which converted the sim-
ple distinction between innovative and traditional art into a con-
frontation of corrosive and healthy ideologies.

At the time, the Berlin Secession's conflicts with the art patriots
and the prophets of Germanism, on one front, and the emperor and
the Prussian and imperial bureaucracies, on the other, more often
than not ended in the political sphere. Three generations later the
rise and decline of the secession seems also to illustrate some gener-
al features of German public life before the First World War: the
reckless politicizing of what could have been nonpolitical issues, for
instance, or the unnecessary driving into opposition of groups that
might otherwise have strengthened the status quo — an intolerance
that eventually damaged its own cause. From the vantage point of
our own day, certain episodes in the secession's history appear para-
digmatic of the course of Wilhelmine Germany as a whole.

If I am right in thinking that the secession deserves attention not
only for its activities as an association of painters and sculptors but
also for the political facets and implications of its existence, it may
seem strange that not more has been written about it. The seces-
sion's place in the development of modern art in Germany is, of
course, well known, but a detailed history of the group, even seen
solely as an art organization, does not yet exist.[1] Until recently, one
reason for this neglect has been the relative dearth of sources. Im-
portant documents on the secession and on the government's policy
toward the group have become available to scholars only in the past
few years; the same is true of the private papers of its most deter-
mined opponent among German artists, the director of the Royal
Institute for the Fine Arts in Berlin, Anton von Werner.

Another reason for the neglect has to do with the kind of art the
secession primarily stood for. The German variety of impressionism

1. See "A Note on Sources."

never achieved the level of originality that was necessary to make a lasting impact on international taste. Its best works were good by any standard, but the new elements they had to offer to the non-German world could easily be overlooked or misunderstood as awkward variations on a familiar theme. Two members of the secession who touched the edge of expressionism, Lovis Corinth and Ernst Barlach, have gained reputations that go beyond the limits of Central Europe, but interest in their work seldom extends to the organization that played an important role in their professional lives — perhaps because they impress many later observers as atypical of the group. From this point of view, the Berlin Secession was unfortunate in being founded nearly a decade before expressionism burst on the Western world and made modern German art into a force that critics and the public could not ignore. For good reason, much more has been written about such expressionist associations as the Brücke than about the secession. Yet as a political institution the secession outdid the later group by far, and even on aesthetic grounds the intense preoccupation with the Brücke painters at the expense of their secessionist contemporaries is not invariably justified.[2]

It is not the purpose of this book to analyze in detail the work, politics, and economic conditions of the secession's more than two hundred members and associate members. Nor do I intend to discuss all of the more significant aesthetic, institutional, social, and political elements of German art with which the secession came into contact, even though many of them have not yet received adequate treatment in the literature. The history of Wilhelmine culture, of which the history of the Berlin Secession is only a small segment, remains to be written.[3] Instead, I want to outline the specific situation of the fine arts in Berlin and Germany that gave rise to the secession, and then turn to the major episodes in its existence, each of which seems to me also to illuminate more general cultural and political aspects of Wilhelmine Germany. I shall say something about the dynamics and developments over time that

2. In an interesting illustration of the power of fashion over fact, the great 1978 exhibition in the Centre national Georges Pompidou, "Paris-Berlin: 1900 – 1933," contained almost no references to the Berlin Secession, although the secession was the most important institutional link between the fine arts in Germany and France during the first decade of the century, and even though it was constantly praised or attacked in Germany for its role in introducing French art and ideas on art to the German people.

3. Of the recent work in this area, I find Peter Gay's essays, collected under the title *Freud, Jews and Other Germans* (New York, 1978) particularly suggestive.

link these episodes, but I have not shied away from risking an un-
evenness of treatment in order to concentrate on those issues and
incidents that I regard as particularly significant.

It will not escape the reader that the painters and sculptors dis-
cussed in the following pages interest me not only as propagandists
and cultural politicians, but also as artists, and it may be that I value
the work of some of them more highly than would many art histori-
ans and critics today. Yet to deny my likes and dislikes in those not
very numerous passages that address the work of art itself, rather
than efforts to create a public for it or critical and public reactions to
it, would be pointless as well as dull. One further potentially subjec-
tive element in the book should be mentioned: one of the leaders of
the secession, the art dealer and publisher Paul Cassirer, was my
maternal grandfather. He died before I was two years old, and I have
not felt it difficult to remain objective, though it is not for me to
judge whether the relationship has affected my interpretation to an
inadmissible degree. Personal involvement may, of course, not only
create problems for the historian, but also bring advantages. When I
was a boy in the early 1930s, the secession had long ceased to exist;
many of its most creative members were still at work, however,
even in advanced old age—Max Liebermann, for instance, who was
born in 1847 and sold his first painting the year after the German
empire was founded. To visit these men in their studios, or to watch
them hang an exhibition, could give even a child a strong sense of
their cultural values and personal style, a combination of qualities
and attitudes that was becoming rare and outdated, and that now
belongs to the more remote past.

The history of the Berlin Secession is part of the history of Ger-
many's encounter with modernism, the revolution throughout
Europe that, in Peter Gay's words, "transformed culture in all its
branches . . . [and] compelled Western civilization to alter its
angle of vision, and to adopt a new aesthetic sensibility, a new
philosophical style, a new mode of understanding social life and
human nature."[4] The degree of political engagement felt by those
who carried the revolution forward differed from country to coun-
try; among Germans at the turn of the century it was still minimal.
But political and social reactions to modernism reached unusual
intensity in Germany. Before the war, German critics of modernism
sought more consistently and with greater success than those in
other countries to transform the work of art into an ideological

4. Introduction, ibid., pp. 21–22.

force. Populists and anti-Semites pushed the old German fantasy of the apolitical thinker and artist to the opposite extreme by asserting that all art, whatever its subject or style, was ideological and demanded a political response. The insecurity and defensiveness of the country's political elites, from the emperor on, left them susceptible to this message, even while they still rejected some of its more radical characteristics as exaggerated or distasteful. Not only the artists of the secession, but also the reactions to them, and the implications of the reactions for German history, form the subject of this study.

Environment and Origins

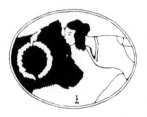

1

STATE AND ART IN IMPERIAL BERLIN

At the beginning of William II's reign, two organizations held commanding positions in the world of Berlin painters, sculptors, and architects: the Royal Academy of Arts and a private association of artists, the Verein Berliner Künstler. The links between them were close, and success tended to bring membership in both groups. Nevertheless, their interests differed in some respects, and for years the association had been dissatisfied with the greater authority of the academy in such matters as managing the city's annual art exhibitions. By the late 1880s the association pressed for a change in the relationship. Conceivably it might have chosen to emphasize its character as an unofficial body, increase its independence from government agencies, and assert itself more forcefully as the representative of the private artist. But admiration for the state as well as the economic importance of government patronage in the form of fellowships, commissions, and teaching appointments pushed the Verein Berliner Künstler in the opposite direction. It sought to strengthen its influence by allying itself more closely with the state. The significance of this move is not lessened by the fact that at the time no member regarded the decline of the association's autonomy as an issue worth raising in public.

The academy was founded in 1696 by Elector Frederick III, on the model of the academies of Paris and Rome, to foster and reward distinguished achievements in the arts in Brandenburg. After 1833 it was divided into a section for music and a section for the fine arts; a section for literature was added only under the Weimar Republic.[1] Candidates for membership were nominated by the gov-

1. The history of the section for the fine arts is treated in the official work, anonymously edited by Hans Müller, *Zur Jubelfeier 1696–1896* (Berlin, 1896). In the same year one of its members, the director of the Prussian museums, Wilhelm Bode, published very critical comments on the section's past and present activities, "Die Berliner Akademie," *Pan*, 2, no. 1 (1896), pp. 45–48. The academy's budget, comparable to that of a small university, is discussed by Wilhelm Wygodzinski, "Die Kunst

ernment or by the academicians themselves, and elected for life by the members of the relevant section, who also elected a senate and a chairman. A few senior officials, such as the directors of the state museums, were members ex officio, and honorary members included princes and princesses of the ruling house. The senators of the two sections met jointly to determine issues of common concern under a president who was elected by the entire membership.

In the nineteenth century, after functional ministries had developed in Prussia, the academy was subordinated to the Ministry of Ecclesiastical Affairs, Education, and Medicine—the Kultusministerium for short—which was responsible for state activities in the arts.[2] The Kultusminister approved the academy's budget and policies; he also submitted the results of academy elections, along with his recommendation to confirm or reject them, to the emperor, who as king of Prussia retained ultimate and by no means purely formal authority over the affairs of the academy.[3] In the 1890s the approximately fifty regular members of the section for the fine arts were men whose work, it was generally felt, was the best in their field that Prussia was capable of. Among their predecessors were such magnificent architects and sculptors as Karl Friedrich Schinkel and Gottfried von Schadow, and since the 1860s they included such a robust talent as Adolph von Menzel; but in Prussia, as elsewhere, the academy welcomed mainly artists whose work expressed traditional aesthetic concepts in terms readily acceptable to the present.

The academy was one of the instruments through which the state fulfilled what it regarded to be its cultural obligations to society. Election to its ranks was an important sign of official recognition

im preussischen Etat," *Kunst für Alle*, 19 (1903–1904), pp. 281–285. Interesting details on personalities and administration are mentioned in the memoirs of its politically most powerful member during the Wilhelmine period, Anton von Werner, *Erlebnisse und Eindrücke, 1870–1890* (Berlin, 1913).

2. The ministry was organized into three divisions, art being dealt with by a special section within the division on education. In 1907 this section was expanded into a fourth division on "Arts and Sciences."

3. An example of the Crown's role: in 1876, when Theodor Fontane—not yet established as the great novelist—was nominated as permanent secretary of the academy, a post carrying with it membership in the senate, William I suggested that he be offered a trial appointment to make certain he was suited for his duties. The emperor was persuaded not to insist on this condition, but his skepticism proved correct when, a few months later, Fontane found the bureaucratic politics of his position intolerable and resigned. The documents of the episode were published by a later archivist of the academy, Walther Huder, *Theodor Fontane und die preussische Akademie der Künste* (Berlin, 1971).

of artistic achievement, and might be a preliminary to the still greater distinction of being awarded the "peace class" of the order Pour le mérite, one of whose chapters was incorporated in the Academy of Arts, the other in the Academy of Sciences.[4] In return the academy defined the aesthetic standards of society, and helped to implement them. As experts on prize juries, fellowship committees, and on the permanent National Commission for the Arts, the Landeskunstkommission, its members advised government departments on the expenditure of tax monies for museum purchases, on the design and construction of monuments and public buildings, and on numerous other matters where public affairs and the arts joined.

The didactic role of the academy and its links with the bureaucracy were further strengthened by the association of teaching institutions with its two sections: the Royal Institute of Music with the section for music and the Royal Institute for the Fine Arts — the Königliche akademische Hochschule für die bildenden Künste — with the section for the fine arts. Like all German educators, the directors and instructors of these institutes were civil servants, appointed and paid by the state. The senior faculty, who had been promoted to the rank of professor and placed at the head of "master studios," were also members of the academy, while the president of the academy and the chairmen of its two sections were always on the faculty of the institutes.[5] Academy and institutes remained separate, and many academicians were demonstratively independent spirits; but under the circumstances collaboration could not but be close. The free artist, whose merit had been recognized by election to the academy, and the faculty and large student body of the Insti-

4. The academy had the right to propose three candidates for each vacancy, with the emperor making the final selection. Like his grandfather, William II refused to delegate this responsibility; on the contrary, he regarded appointments to the academy and awards of the order Pour le mérite as an opportunity to educate the German public's taste in art. In 1908, for instance, he rejected the three candidates for a foreign vacancy of the order, among them Anders Zorn and Albert Besnard, after studying reproductions of their works. When the names of three new candidates were submitted, he chose John Singer Sargent, who had been ranked third. Zorn was nominated again in 1909 and yet again in 1912, but to no avail. Archiv der Akademie der Künste, Friedensklasse des Ordens *Pour le mérite*, Abt. 3, Nr. 7, unpaginated, reports of 19 June and 17 July 1908, 25 January 1909.

5. The "master studio" or "master class" gave a small number of advanced students the opportunity of working in relative independence under a senior instructor. Nikolaus Pevsner calls the arrangement a German innovation that was adopted in the second half of the nineteenth century by some foreign academies, but not by the Royal Academy in England. *Academies of Art, Past and Present* (New York, 1973), pp. 218–221.

tute for the Fine Arts together developed and maintained artistic excellence and assured its dissemination throughout the country.[6] A different view was also possible. In 1893, Alfred Lichtwark, the director of the Hamburg Kunsthalle, reported to the trustees of his museum on his visit to the annual Berlin salon. The intense August heat, he wrote, may have lessened his tolerance of a jury that had accepted such a very large number of works. Nevertheless, he felt compelled to ask:

By what right do apprentices and bunglers show their wares at government expense in this costly exhibition hall? If the exhibition were a private enterprise and space had to be rented . . . the value of the space would surpass the value of the overwhelming majority of paintings. But does arithmetic come to a halt when it is a matter of public funds? And have journeymen painters the right to expect the state to create a market for them?

I realize how enormously difficult it would be to bring about any changes in the system, nor would I be able to suggest changes so long as we have academies and an art proletariat that is officially recognized by the state because the state created it. Academy and exhibition form the vicious circle in which our artists rotate like beasts grazing on a parched field.

I don't want to disgust you with a comprehensive report of the exhibition. It seems to me more pitiful than ever. Berlin is ruled by a brutal variant of academic art, whose colors are more vulgar than reality, and whose portraits more commonplace than their models.[7]

Lichtwark's Prussian *Kunstproletariat*, constantly replenished by the graduating classes of the Institute for the Fine Arts, consisted of two groups: artists who eked out an existence as private teachers or commercial artists, or who worked for an entrepreneur who sold pictures by the yard; and those who had achieved somewhat greater success, and who might even join one of the private associations of painters and sculptors, of which the largest and most influential in Prussia was the Verein Berliner Künstler.

6. In the spring of 1875 the institute had 77 pupils, a number that increased rapidly after Anton von Werner was appointed director. Twelve years later, when the figure stood at 350, the Kultusminister — against Werner's opposition — fixed the maximum enrollment at 250. Werner, *Erlebnisse und Eindrücke*, pp. 363, 442, 519. Additional information on the institute is contained in its privately printed annual reports, several of which are in the Stanford Collection of German, Austrian, and Swiss Culture [hereafter cited as Stanford Coll. GASC], Cassirer Collection V, Miscellaneous Papers.

7. Alfred Lichtwark, "Briefe an die Kommission für die Verwaltung der Kunsthalle," *Kunst und Künstler*, 21 (1922 – 1923), pp. 48 – 49. This and all other translations are the author's. A longtime member of the organizing committee of the exhibition was frank in declaring that its purpose was to "enable the mass of artists to pursue their profession." Heinrich Deiters, *Geschichte der Allgemeinen Deutschen Kunstgenossenschaft* (Düsseldorf, [1906]), p. 8.

The Verein began in 1841 as a social and professional association of Berlin artists.[8] After a general union of German and Austrian artists – the Allgemeine Deutsche Kunstgenossenschaft – had been formed in 1856, nearly all members of the Berlin group also joined the local chapter of the Kunstgenossenschaft.[9] In 1867 the Verein was given a royal charter, meaning that royal and ministerial consent was now needed for such matters as the revision of by-laws and the acceptance of legacies. To help defray expenses of shows and publications during the decades that followed, the Verein occasionally received subventions from the government or the private purse of the Crown. At the beginning of William II's reign the association had 18 honorary members, among them such luminaries of the state as Moltke, and 584 regular and associate members.[10] In the early years of the empire, the *Gründerjahre* when Berlin expanded from an administrative and military center into an industrial city, the Verein still served mainly social functions. Members met on Tuesdays and Saturdays in their clubrooms in the Kommandantenstrasse to play cards or attend lectures and concerts. Their biennial dinners and costume balls became an established part of the Berlin season.

In 1884 one such banquet, "by means of whose beauteous splendour, Berlin's artists brought art to the capital," in the words of the *Berliner Tageblatt,* included a series of *tableaux vivants,* in one of which the sixteen-year-old Richard Strauss represented the female figure of "Peace" confronting "War." Two years later, in conjunction with the annual summer exhibition, the Verein gave its most magnificent party. Thirteen hundred costumed members and guests celebrated the recent excavation of Pergamon with a triumphal procession, sacrifices to Zeus, and a Greco-Roman fair; the organizing committee had even provided a Charon who transported curious visitors across the Styx. To the amusement of such prominent members of the association as the historical painter Anton von Werner, the *Pergamonfest* was subsequently attacked as immoral by

8. Some documents on the history of the Verein are contained in the Zentrales Staatsarchiv [hereafter cited as ZstA] Merseburg, Kultusministerium, Rep. 76 Ve, Sekt. 4, Abt. IV, Teil IV, Nr. 2, I.

9. A legal distinction was maintained between the Verein and the local chapter of the Kunstgenossenschaft, but in practice they became nearly identical. Deiters, *Geschichte der Kunstgenossenschaft,* p. 38. Not only social and professional but also political concerns led to the founding of the Kunstgenossenschaft. Its charter declared that "although Germany is politically divided, at least the German artists in their [new] association will try so far as possible to represent German unity."

10. *Verein Berliner Künstler: Mitglieder Verzeichnis, Februar 1889* (Berlin, 1889); Werner, *Erlebnisse und Eindrücke,* p. 593.

socially conscious churchmen, among them the leader of the anti-Semitic Christian Social party, Adolf Stoecker. Werner, on the contrary, regarded it as an innocent attempt to revive "the aesthetically alluring past" and to foster beauty in the industrial age.[11]

In 1887, Werner, already director of the Institute for the Fine Arts, was elected chairman of the Verein as well as of the Kunstgenossenschaft, positions he was to hold repeatedly during the next two decades.[12] The unusual scope of his leadership, embracing both the official and the private camp, and the backing he received from the imperial family enabled Werner in effect to reorganize the Berlin art world. He strengthened the financial resources of the Verein by modernizing its exhibition and sales program, and began negotiations that led, a decade later, to the construction of a new and imposing home for the Verein in the Bellevuestrasse, near the Brandenburg Gate, among ministries and embassies. With its professional stature increased, the association pressed more persuasively for stronger representation on official commissions and juries. This could come about only at the expense of the academy, but Werner recognized that its traditional position as an agency of absolutist government was no longer tenable in an age of growing middle-class strength, political parties, and an energetic daily press. Unless the academy shared some of its authority, artists would increasingly oppose it. Change was further stimulated by the new emperor, William II, who ordered the government to examine its relationship with organized art. Other German states were asked about their policies on art education and the support of artists; in light of their reports, Prussian policies were revised.

At first William II seems to have wished to give the Verein a dominant role in the annual Berlin salon, held in the state exhibition hall in the Lehrterstrasse, the main showcase of art in the country, an event on which many lesser-known painters and sculptors depended for sales, commissions, and publicity. In 1891 the Verein organized a commercially successful international art show, demonstrating its ability to manage large enterprises; but a scandal over the showing of Edvard Munch's paintings in 1892 indicated the danger of granting a private organization too much power.[13] Werner also argued that the academy's voice should continue to be strong.[14]

11. Werner, *Erlebnisse und Eindrücke,* pp. 108–110, 411–412, 466–467.
12. Ibid., pp. 477–479.
13. Adolf Rosenberg, *A. von Werner* (Bielefeld and Leipzig, 1895), pp. 109–110. The scandal over the Munch exhibition is discussed in chapter 2.
14. Werner to William II, 6 November 1891, ZStA Merseburg, Königliches Geheimes Civil-Cabinett, Rep. 2.2.1, Nr. 20564, pp. 100–101.

Largely as a result of his mediation among the emperor, the Kultus-minister, and his own colleagues in the academy and the Verein, a compromise was reached in 1892. The association became an equal partner in the management of the annual salon and gained greater access to government commissions and juries; at the same time, it was brought under closer control by the government, to which it was also indebted for increased financial support. Werner had succeeded in fusing the elite of the academy and the foot soldiers and even proletarians among Berlin artists into a common front.

The forces this front might have to resist were not yet clearly defined, although the Munch episode and occasional appearances of works of French impressionists in German galleries suggested that assaults on traditional standards might be expected. Equally disquieting, art organizations throughout the country were showing signs of dissension, caused perhaps as much by personal and institutional rivalries as by aesthetic issues, but adding to the sense that change was imminent. To this atmosphere of uncertainty, Werner opposed a program, which he tried to implement in Berlin, of cooperation among the artists themselves and among artists, society, and the state, in the service of an aesthetic based on a clean realism that inspired or amused, did not eschew narrative or didactic elements, but never shocked. It was an important attribute of his cultural policies that he combined the expertise and loyalties of a senior Prussian bureaucrat with sympathy for the mass of artists and for their economic and professional concerns, which he himself had shared in his youth.

Werner was born in 1843 in Frankfurt on the Oder. One of his ancestors had been ennobled in the 1720s, but after some generations the family's position declined. His grandfather, a retired lieutenant, earned his living as a subaltern tax official; his father was a carpenter; he himself was apprenticed to a housepainter. When Werner was sixteen he won a fellowship at the Institute for the Fine Arts in Berlin, which he attended for three years before moving to Baden to complete his studies at the academy in Karlsruhe. He was able to gain the patronage of the grand duke, which led to portrait commissions at German headquarters during the Franco-Prussian War and brought him to the attention of William I, his son the crown prince, Moltke, and Bismarck, who later said that if Werner had not been an artist he could have been a success at the Foreign Office.

Even after Werner established himself in Berlin, where he soon became the court's favorite painter of scenes from recent Prussian and German history, he did not shed the moderate, liberal attitudes

he had acquired in Karlsruhe before 1870, when it was still the capital of an independent constitutional state. He moved easily in court and official circles and was almost an intimate of Crown Prince Frederick and his wife, whose eldest son, the future William II, he instructed in drawing and painting. But Werner valued the educated middle classes, as he valued the cultural diversity of Germany and the particularist roots of the empire. In his home he brought together members of the military and bureaucratic elites with artists, scientists, newspaper proprietors such as Rudolf Mosse, and businessmen.[15] He regarded art as a profession as much as a calling, akin to academic scholarship in the humanities or sciences, of use and value to society, and in turn deserving of its support.

Werner's interest was not with the great talents but with the mass of painters and sculptors, whose condition he tried to improve by the wider distribution of prizes, scholarships, and commissions, and by such measures as the development of insurance and pension programs for the members of the Allgemeine Deutsche Kunstgenossenschaft. As chairman of the national association and of the Verein Berliner Künstler, he was demonstratively antielitist. He believed in the rule of the majority, whose sound judgment—like that of the German people as a whole—might, he thought, occasionally be swayed in matters of art, but would always reassert itself. The Institute for the Fine Arts, by contrast, he guided with a firm hand. He was an excellent administrator and propagandist, and he took the institute's pedagogic mission seriously, teaching classes in life drawing and composition himself. In common with heads of academies everywhere, he disclaimed the power to teach men to be artists; all the institute could do was to instruct its students in such technical elements of their craft as perspective, anatomical accuracy, the scientific preparation of canvas and paints—elements without which the kind of art he believed in was not possible, and whose absence he regarded as the fatal flaw of impressionism and of other modern movements.

Werner's annual graduation addresses became famous for their

15. The sculptor Fritz Klimsch, one of the founders of the Berlin Secession, was a frequent guest in Werner's house as a young man; he recalls one of these dinners, after which Werner, an excellent cellist, played chamber music with the violinist Waldemar Meyer and Richard Strauss at the piano. At the end of a Strauss trio, he told the composer in his customary challenging manner that he would do better to stick to Beethoven and other classics than to write such very odd music, a comment "to which Strauss responded merely with a derisive grin." Fritz Klimsch, *Erinnerungen und Gedanken eines Bildhauers* (Stollhamm and Berlin, 1952), p. 37.

outspoken attacks on modern art and for their equally blunt criticism of the students themselves. "Year by year," he told the assembled student body in 1895, "but recently more than ever before, I find that your technique in composition and studies is so awkward that even you cannot possibly gain any pleasure from your drawings and paintings."[16] He was not unappreciative of such extracurricular events as dances, concerts, or excursions, which fostered a sense of community among the students, but he would not tolerate attempts to exploit the institute for purposes that had nothing to do with the study of art. When some students circulated an anti-Semitic petition, he called faculty and students together, forbade further distribution of such materials, and threatened any student who disobeyed with instant dismissal.[17] His dislike of Stoecker's anti-Semitic "Berlin Movement," which he called disgusting and cruel and against which he protected Jewish professors on the faculty, was part and parcel of the liberalism in which he had grown up, but which by the 1890s had become somewhat old-fashioned. That his attitude was genuine is borne out by the fact that even when he became one of the leaders in the fight against German impressionism, Werner— unlike some of his followers—never resorted to anti-Semitism to vilify artists whose works he disliked and feared.

Werner's imperiousness was barely restrained by his official position, which afforded its holder more autonomy than most senior bureaucrats possessed. His relations with the Kultusminister were analogous to those of a strong-minded, influential department chairman with his dean in an American university. When Werner was first offered the directorship of the Institute for the Fine Arts in 1875, he underlined his independence by insisting on a five-year term instead of the customary lifetime appointment. As a successful painter and illustrator he did not need to rely on a career in government. Neither that demand nor his automatic reappointment every five years prevented him from claiming, at a later crisis, that he had been badly treated, or from asking for an increased budget and higher faculty salaries in compensation.[18] Werner did not hesitate to

16. Rosenberg, *A. von Werner*, pp. 121–122. Werner published a collection of his speeches under the title *Ansprachen und Reden an die Studierenden der kgl. akadem. Hochschule f. d. bild. Künste zu Berlin* (Berlin, 1896). Several of his adresses from later years are in the Stanford Coll. GASC, Cassirer Collection V, Miscellaneous Papers.

17. Werner, *Erlebnisse und Eindrücke*, pp. 270–271, 577–578.

18. See Werner's long letter of complaint to the Kultusminister Konrad von Studt of 20 August 1904, and Studt's letter of 29 August 1904 to the minister of finance, whose department had to approve additions to the institute's budget, ZStA Merse-

make use of his connections with emperor or minister to get his way even on minor issues, and his combative personality and intolerance in professional matters eventually cost him much of his effectiveness. But in his prime his political abilities were considerable. Simply to be on good terms with three such different men as William I, Frederick III, and William II called for great sensitivity and self-control. Werner's memoirs hint that he felt closest to Frederick III and his English wife, whose cultural style suited him best and under whose rule he expected a flowering of German art. But when the emperor died after the briefest of reigns, Werner experienced no great difficulty in accommodating himself to his son, whose most influential artistic advisor he became and remained for years.

Werner was not as bad an artist as he is usually said to have been. He was energetic and facile, his portraits achieved a high degree of verisimilitude, and his more successful group compositions, *The Coronation of Frederick I*, for instance, or the smaller of his two versions of *The Proclamation of the German Empire*, are filled with an attractive sense of theater. It needed only a finer use of color to turn these and similar works into impressive examples of Victorian historical painting. But Werner's intelligence and imagination rarely probed beneath the surface. His paintings possessed the accuracy but not the vigor of photographs. The men and women on his canvases lack life, and the themes that most attracted him are aesthetically unrewarding. *William I Receiving Napoleon's Emissary*, *The Congress of Berlin of 1878*, *William II Congratulating Moltke on His 90th Birthday*, or in a less official mode, his interpretation of a Prussian NCO singing Schubert songs in a requisitioned French drawing room or the crown prince and his staff paying homage to a dead French general, whose little dog barks at the men in strange uniforms — no depiction of such scenes, however carefully arranged and detailed, can evoke more than a feeble response in today's viewer. Significantly, Werner's technique and manner of composition scarcely changed between his late twenties, when he achieved his first successes, and old age. His best works by far were some early paintings of German middle-class life and later oil or watercolor studies of heads and single figures; these sketches caught an impression or quick movement, which in the final painting would inevitably be transformed into statuesque emptiness, fixed in the

burg, Kultusministerium, Rep. 76 Ve, Sekt. 17, Abt. IV, Teil IV, Nr. 21, XIV, unpaginated. The incident ended with the institute receiving more funds and Werner a lifetime appointment.

smooth, translucent finish that was considered a major feature of good academic art. Although he would never have understood the fact, Werner's entire achievement refuted the credo with which he concluded one of his graduation addresses: "Do not let the well-known statement 'Many are called, few are chosen' cause you to forget the other principle: 'Industry is the better part of genius.' "[19]

Even those members of the public who enjoyed the vein of genteel and patriotic realism in which Werner worked, knew him to be less significant as a painter than as an administrator, representative of the arts in government, and cultural politician. In lectures and articles addressed to them, he tried to demythologize art and its practitioners. His conviction that artists were a responsible force with which the state and the educated classes of society could work to achieve common goals lay behind his reorganization of the relationship between art and government in Berlin, and it characterized the new system. In 1889, the Kultusminister invited the Verein to nominate three candidates for membership of the Landeskunstkommission, from whom he would choose one. In the same year the academy agreed to give the Verein five places on the organizing committee of the annual Berlin art exhibition, and three on the committee in charge of hanging the paintings — a step toward the final settlement, reached in 1892, under which membership on all exhibition committees was divided equally between the academy and the association, as were the profits from the sale of artworks. At the same time, the scope of the salon was enlarged, in the words of the Cabinet Order defining the new arrangements, to embrace all artists in Prussia; consequently the second center of organized art activity in Prussia, Düsseldorf, was also granted "adequate representation."[20]

19. Werner, *Erlebnisse und Eindrücke*, p. 384. Werner regarded the speech, given on 7 July 1883, as an important statement of his views on art and on the institute's mission, and he included the full text in his memoirs. Twenty years later he defined the basic attributes of the artist as "industry and a sense of duty." Perhaps the best summary evaluation of Werner by a modern historian is Golo Mann's, in his *Deutsche Geschichte des neunzehnten und zwanzigsten Jahrhunderts* (Frankfurt, 1960), p. 455: "The representative artists and writers, supported by the state, were content with their own achievements. Emanuel Geibel and Paul Heyse, Felix Dahn and Viktor von Scheffel, Karl von Piloty or Anton von Werner — all still produced some decent paintings, some gorgeous and even beautiful poems and novels. But they were epigones, working in a belated classicism, a false Renaissance manner, not in a new, original style suited to the changing times."

20. Cabinet Order of 19 November 1891; Report of the Kultusminister to the chief of the Civil Cabinet, 14 November 1892 (on the history of the negotiations); *Satzungen für die grossen Berliner Kunstausstellungen*, statutes to apply from 1893 on, ZStA Merseburg, Königliches Geheimes Civil-Cabinett, Rep. 2.2.1., Nr. 20564, pp. 108–115, 163–170. Under the new regulations, the exhibition's executive commit-

The state made available at no cost the new exhibition hall in the Lehrterstrasse, which could hold several thousand paintings and sculptures, and the salon was further supported by subventions from the state and the municipality. In return, the regulations and programs of the salon were subject to government approval. In November 1892 the new Kultusminister, Robert Bosse, wrote William II that the plans being developed in accordance with Werner's suggestions placed the salon on a new and more independent footing, although the academy retained a strong say in its conduct He continued: "Still, the royal government will not be able to divest itself of all influence and supervision. If the state provides the grounds and buildings that make the exhibition possible at all, then the state has the obligation, first, to see to it that these advantages do not favor a particular group or movement but benefit the entire community of Prussian artists . . . and second, that the exhibition really provides what its visitors have a right to expect: a survey of the entire Prussian—and, if possible, German—production of the present day."[21] To the issue of government support of the arts Bosse applied the classic concept of the bureaucrat's duty to remain above the clash of opposing views and, within the limits set by overriding state interest, ensure equitable treatment for all. William II had a different opinion of his obligations to German art and German society.

As king of Prussia, he possessed—if he chose to exercise it—a decisive role in the conduct of the Berlin salon: indirectly, through his power to appoint the Kultusminister and to pass on nominations to the academy, and through his patronage and financial support of the Verein; directly, through his personal donation of the prizes that were annually awarded in his name and with his approval. Each winter preceding the salon, the organizing committee petitioned the emperor to donate the necessary medals. In an imperial rescript, its wording unchanged from year to year, William II would

tee consisted of one or two government commissioners and six representatives each of the academy and the Verein; Düsseldorf could, if it wished, appoint up to three members. The interests of officially recognized groups of artists in other Prussian cities were safeguarded by an additional one to three members. Draft regulations for a corporation to run the exhibition, contained in Anton von Werner's papers, *Satzungen [der] Landes-Kunst-Ausstellungs-Gemeinschaft* [1892], specify a slightly different geographic distribution of members. Even after the reform, the academy enjoyed disproportionate representation since its total membership was much smaller than that of the Verein.

21. Bosse to William II, 15 November 1892, ZStA Merseburg, Königliches Geheimes Civil-Cabinett, Rep. 2.2.1., Nr. 20564, pp. 102–107.

respond by declaring his "willingness to award three large and six small gold medals for art to those artists who in this year's great Berlin art exhibition will particularly distinguish themselves," adding that he would "look forward to the [jury's] recommendations when the time comes."[22]

The jury, in short, was an advisory body, whose votes required ministerial and imperial confirmation. Almost always its judgments were approved, but the possibility of control and rejection was taken seriously, which did not mean that artists whose work displeased the emperor were necessarily denied a prize. In 1897, for instance, the Kultusminister forwarded the jury's recommendation that a large gold medal be awarded to Max Liebermann, the most prominent of the German impressionists, and the emperor approved the prize without comment.[23] The following year, however, when the jury, of which Liebermann was now a member, proposed a small gold medal for Käthe Kollwitz, the minister commented adversely in his report to the emperor:

The suggested prize for the etcher Käthe Kollwitz gives me cause for concern. This artist has exhibited a cycle of rather small etchings and lithographs, which she has entitled "Revolt of the Weavers." They depict the misery of the weavers and of their families, . . . their uprising, an assault on an iron gate and the tearing up of the pavement, finally an interior with some corpses of workers—a series of images that appears to have been inspired by Gerhard Hauptmann's drama "The Weavers." The technical competence of her work, as well as its forceful, energetic expressiveness may seem to justify the decision of the jury from a purely artistic standpoint. But in view of the subject of the work, and of its naturalistic execution, entirely lacking in mitigating or conciliatory elements, I do not believe I can recommend it for explicit recognition by the state.[24]

Bosse requested the emperor to authorize deletion of Kollwitz's name from the list of prizewinners, although he warned that this step would cause disagreeable comments in the press. In

22. See, for instance, the request of the executive committee, 16 December 1896, and the emperor's response in the form of an *Allerhöchsten Erlass*, 3 February 1897, ZStA Merseburg, Kultusministerium, Rep. 76 Ve, Sekt. 1, Abt. IV, Teil IV, Nr. 9, III, pp. 25–26, 31–32. The award of a large gold medal conveyed not only prestige but significant economic and professional advantages. The holder became a member of the exhibition jury, and his own works were "jury-free"—that is, he could exhibit a certain number of works without first submitting them to the jury. Members of the academy were automatically "jury-free."

23. Bosse to William II, 23 May 1897, and the emperor's agreement, ZStA Merseburg, Königliches Geheimes Civil-Cabinett, Rep. 2.2.1, Nr. 20564, pp. 200–202.

24. Bosse to William II, 12 June 1898, ibid., pp. 206–207.

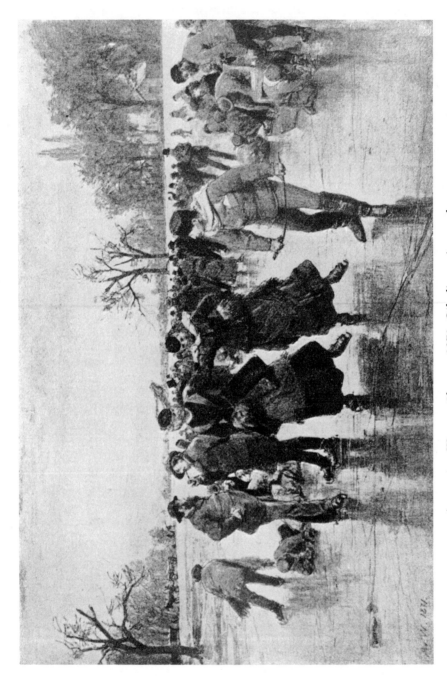

Anton von Werner. *Skaters*. 1871. Oil, dimensions unknown.

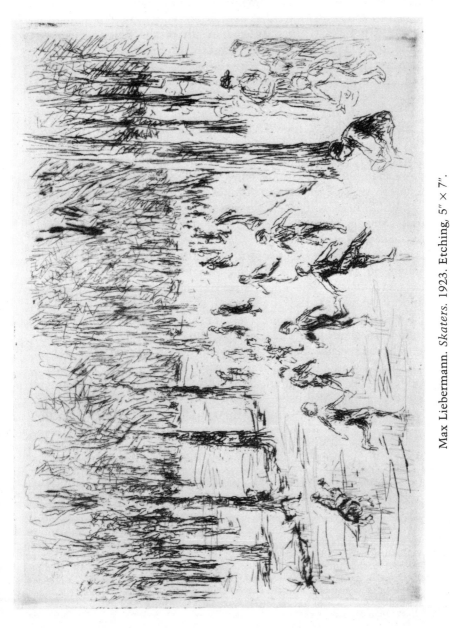

Max Liebermann. *Skaters.* 1923. Etching, 5″ × 7″.

consequence William II denied the jury's recommendation. Soon afterwards, Liebermann's support helped Kollwitz's cycle to win a medal in the annual Dresden exhibition, where the Prussian king's writ did not run—a not unusual result of the Reich's federative structure, which still afforded possibilities of escape from Prussian dominance.[25]

It has been suggested that William II's interest in art, as in so many other matters, was feigned rather than real, and that the views on aesthetics expressed in his speeches and policies were borrowed from Anton von Werner.[26] No doubt the emperor enjoyed playing the connoisseur, patron, and gifted amateur artist—roles in which his competence was not remarkable. But his official papers, even more than his overt actions, show that he was far from being indifferent to art. He had categorical likes and dislikes, and he felt strongly that German art needed his leadership if it was to fulfill what he took to be its mission. Spasmodically, he immersed himself deeply in the details of artistic affairs. The files of the Imperial Civil Cabinet indicate that he kept informed on the openings and closings of shows, on the number of visitors, on sales figures, on the results of competitions for state and municipal projects. Proposals for official honors, even for the lower grades of the Order of the Red Eagle or the *Kronen Orden*, evoked his careful attention. The more important business of the academy, the Institute for the Fine Arts, and the museums routinely came to his desk.[27]

Especially in the early years of his reign, the emperor liked to visit his favorite painters and sculptors, surprising Anton von Werner in his Wannsee villa or inspecting the latest works of Max Koner or Walter Schott in their studios.[28] With Schott, a sculp-

25. The supposition expressed by, for instance, Annemarie Lange in *Das Wilhelminische Berlin* (East Berlin, 1976), p. 514, that Käthe Kollwitz was denied the medal because she was a woman is inaccurate. Several women exhibitors received prizes in the 1890s, some of them the large gold medal.

26. For example, in his excellent survey *Die Berliner Secession* (Berlin, 1972), pp. 22–23, Rudolf Pfefferkorn asserts, in my view incorrectly, that "William II had no real relationship to art" and adduces the absence of references to art and artists in the emperor's memoirs as an indication of his true attitude.[Note that titles in German cited in this book follow the spelling—*Secession* or *Sezession*—of the original.]

27. Obviously William II could not read every one of the tens of thousands of papers that reached the Civil Cabinet every year, but marginal notations prove that he either saw or heard reports on numerous documents dealing with the arts. It may be assumed that decisions in this field made by officials of the Civil Cabinet usually reflected the emperor's views. See also Rudolf von Valentini, *Kaiser und Kabinettschef* (Oldenburg, 1931), pp. 49, 55.

28. Werner, *Erlebnisse und Eindrücke*, p. 545; Max Jordan, *Koner* (Bielefeld and Leipzig, 1901), p. 38; Walter Schott, *Ein Künstlerleben und gesellschaftliche Erinne-*

tor who specialized in nymphs of an astonishing eroticism, he remained on good terms even after his abdication. But it was not only the emperor who by virtue of his position and personal inclination involved himself in various aspects of art; often artists themselves took the initiative, approaching him with projects, requests for financial help, appeals against adverse jury decisions.[29] When the Verein Berliner Künstler collected funds for its new home, it felt free to solicit his support, which the Kultusminister suggested should take the form of 5,000 marks from the privy purse, a sum the emperor doubled.[30] "Art can prosper only under the monarchy and the protection of princes," he still believed in the 1920s. "Without their supportive hand it must atrophy."[31]

William II's personal tastes reinforced his opinions on the function of art in German society. He believed in narrowly defined, absolute aesthetic truths. In his most important statement on the subject, his address celebrating the completion of the double row of monuments, lining the Siegesallee, he compared art to nature, which exists

according to eternal laws that the creator himself observes, and which can never be transgressed or broken without threatening the development of the universe. It is the same with art. Before the magnificent remnants of classical antiquity we are overcome with the same emotion; here, too, an eternal, unchanging law is dominant: the law of beauty and harmony, the law of aesthetics. This law was expressed by the ancients in such a surprising and overwhelming manner, with such perfection, that despite all our modern feelings and knowledge we are proud when a particularly fine achievement is praised with the words: "That is nearly as good as the art of 1900 years ago."[32]

rungen aus kaiserlicher Zeit (Dresden, 1930), passim. Max Koner's paintings and sketches of the young emperor were regarded at the time as the best of their kind. After Koner portrayed a left-wing politician, William II never again sat for him.

29. For instance, on 3 May 1897 the "animal and genre painter" Franz Ulrich petitioned the emperor to reverse the jury's rejection of a painting and two comical sketches of cats, which he had entered in the annual Berlin exhibition. It was denied, as were all such requests. ZStA Merseburg, Kultusministerium, Rep. 76 Ve, Sekt. 1, Abt. IV, Teil IV, Nr. 9, III, pp. 78–81.

30. Cabinet Order, 24 November 1897, ZStA Merseburg, Königliches Geheimes Civil-Cabinett, Rep. 2.2.1, Nr. 20002, Bd. 1, p. 46.

31. Schott, _Ein Künstlerleben_, p. 142.

32. Speech of 18 December 1901, in _Die Reden Kaiser Wilhelms II._, ed. Johannes Penzler (Leipzig, [1907]), III, p. 60. The theme that classical art constitutes an eternally valid but unattainable model returns in other speeches, such as those of 25 January and 2 November 1902.

The deep, almost hopeless conservatism of this statement is note-worthy. Equally striking is its misunderstanding of the classical achievement. What could the emperor have seen in Greek and Roman statues that enabled him to suggest an affinity between them and the row of marble puppets, depicting his ancestors back to the Second Crusade, which now defaced the Tiergarten? Probably it was the element of idealized realism in classical sculpture that impressed him; it was this same element around which he developed his views on the didactic and ideological functions of art. The glorification of the Hohenzollern, to which art could contribute, seemed to him an essential part of modern German nationalism, even if his dynasty and state were elevated at the expense of other German patriots and territories. The Siegesallee, with its idealized portraits of rulers and of their soldiers and administrators, is an obvious example of this attitude; another is the so-called National Monument, an equestrian statue of William I, honoring German unification under Prussian leadership, which was financed by the Reich but which William II appropriated as his own project.[33] It was under his influence that the monument became an apotheosis not of the nation but of his grandfather.

According to the emperor's views, art that was in any sense politically relevant — above all monuments, historical paintings, and the design and decoration of public buildings — must convey a message of unquestioning loyalty, of pride, power, and assertive self-confidence. German artists became proficient in working in this spirit, which has no equal in earlier Prussian history, although, as Thomas Nipperdey has recently pointed out, the monuments of the later years of the empire increasingly reveal a sense of insecurity beneath the bombast, a resigned Nibelungen acceptance of the external and inner worlds as full of enemies.[34] But William II recognized that even art that was not directly political could have political implications. "Art should contribute to the education of the people," he declared in his speech on the Siegesallee.

Even the lower classes, after their toil and hard work, should be lifted up and inspired by ideal forces. We Germans have permanently acquired these great ideals, while other peoples have more or less lost them. Only the Germans remain, and are above all others called upon to guard these great ideals, to nurture and perpetuate them, and it is part of these ideals to en-

33. Thomas Nipperdey, "Nationalidee und Nationaldenkmal in Deutschland im 19. Jahrhundert," in *Gesellschaft, Kultur, Theorie* (Göttingen, 1976), p. 142.
 34. Ibid., pp. 163–170.

able the working and toiling classes, too, to become inspired by the beautiful, and to help them liberate themselves from the constraints of their ordinary thoughts and attitudes.

But when art, as often happens today, shows us only misery, and shows it to us even uglier than misery is anyway, then art commits a sin against the German people. The supreme task of our cultural effort is to foster our ideals. If we are and want to remain a model for other nations, our entire people must share in this effort, and if culture is to fulfill its task completely it must reach down to the lowest levels of the population. That can be done only if art holds out its hand to raise the people up, instead of descending into the gutter.[35]

That was said in 1901, soon after the founding of the Berlin Secession had institutionalized and intensified the conflict between academic and modern art in Germany. But William II held the same beliefs ten years earlier. They expressed a narrow, dull conception of art, shot through with political and social concerns, suspicious of diversity. In paintings and sculptures for the home as well as in art that decorated public buildings, streets, and squares, he sought images of cohesion that would reassure Germans and impress their foreign neighbors and rivals. The emperor may have valued the combative and dynastic strains in art more than did most of his subjects, and he did not share every enthusiasm of the state-approving middle class. He appears, for example, to have remained fairly indifferent to the art of Arnold Böcklin, whose fantastic and symbolic canvases on such themes as *War* or *Vita somnium breve* became enormously popular in the 1890s. But his liking for uncomplicated renderings of realistically detailed landscapes, idealized nudes, and evocative historical scenes reflected the taste of large groups of the middle and upper classes in German society, and at the same time bestowed a kind of sacral approval on it.

Actually the emperor's taste showed a remarkable dichotomy. He saw nothing questionable in works that treated his person and the lives of his ancestors with an excess of pomp and byzantine devotion that even monarchists found absurd. But he also had an instinct for art that appealed to the ordinary man. Not only for political reasons, but from aesthetic convictions as well, William II took art for the masses seriously. One of the interesting facets of the coming conflict with the Berlin Secession would be that the new movement

35. *Die Reden Kaiser Wilhems II.,* III. pp. 61–62. The emperor did not actually use the term *gutter art,* which was derived from this passage and became a well-known, derogatory label for modern German art.

self-consciously represented a small elite of artists and connois-
seurs, while the emperor showed an unflagging awareness of popular
taste and a sense of obligation to it. This concern paralleled Anton
von Werner's championing of the values and abilities of the good
craftsman, the journeyman painter. A political paradox resulted.
William II and the Prussian art bureaucracy upheld not only the
aesthetic concerns of the dynasty, as he interpreted them, but also
the taste and values of the majority; the artists of the secession, to
whom individual excellence meant everything and even the gradual
improvement of popular taste had only a low priority, immediately
attracted support from the left, although this support always re-
mained somewhat equivocal.

On several occasions William II was to engage himself deeply in
the conflict. He never broached the limits of his constitutional au-
thority, which, as has been seen, afforded him considerable scope in
artistic affairs in Prussia. But his frank partisanship on the side of
academic art exposed him to criticism and proved to be politically
reckless. He was undoubtedly sincere; it might be said that he could
not help, or control, himself; but his favoritism led to unnecessary
rigidity in policy and helped introduce into art ideological antago-
nisms that, in the end, weakened rather than strengthened German
society and the imperial system.

2

GERMAN SECESSIONS AND THE ELEVEN

I

In the spring of 1892, 106 painters and sculptors resigned from the Munich chapter of the Allgemeine Deutsche Kunstgenossenschaft to form a new association, the Verein bildender Künstler Münchens, or Munich Secession. The secession, in turn, soon split into further segments, other separatist movements followed in Düsseldorf, Weimar, Dresden, and Karlsruhe, and by 1895 the art organizations in every major German cultural center except Berlin had divided into two or more groups. In 1897 the Vienna Secession was founded. A wave of protest against the parochialism of German art, against officially approved tradition and the academies, seemed to sweep Central Europe. But the aesthetic motives that were present to a greater or lesser extent in each movement were accompanied and sometimes overshadowed by other concerns. Problems created by the greatly expanded membership of the art associations, and by changing patterns of patronage and exhibitions, lent impetus to the secessions; far from reacting against conditions unique to Germany, they formed part of a European phenomenon.

The market for contemporary painting and sculpture had changed in the course of the nineteenth century. The state continued to be of primary importance as a buyer and a source of projects and commissions, but these functions had been systematized and were carried out more bureaucratically than under the *ancien régime;* the significance of the individual princely or noble patron was diminishing, although by no means at an end. At the same time the middle classes were buying more art. By the 1890s the fine arts had joined literature and music as essential components of higher education. Possibly these shifts encouraged a trend away from monumental paintings to smaller canvases; it is certain that they affected the system of exhibitions. The relatively small shows, held every few years and usually sponsored by the local academy, which in the early years of the century acquainted the inhabitants of the larger European towns with the work of contemporary artists, became

29

annual events and grew considerably in size. Beginning in 1830 the Paris salon was held nearly every year. In 1840 it exhibited 1,900 works out of 4,300 submitted; the salon of 1848, opened some weeks after the Republic had been proclaimed, contained as many as 5,180 items.[1] In other countries the growth and regularization of exhibitions followed the pattern set by Paris. Except for the revolutionary year of 1848, the academies continued to dominate organizing committees and juries; thus the annual salons took their place in the array of art sponsored and supervised by agencies of the government, together with state schools, such as the French École des Beaux-Arts or the Prussian königliche akademische Hochschule, travel grants and fellowships, commissions and purchases.

The imposition of official standards was always resisted by some artists, but even the majority, who had no quarrel with academic doctrine, could feel dissatisfaction with the academies' control over the processes of selecting works for the salon. Their resentment led, on the one hand, to efforts to make the juries more representative of the great mass of artists and, on the other, to additional exhibitions, organized either by the artists themselves, joining together in temporary or more permanent groups, or by one of the increasing number of art dealers. The appearance of "international" or "world" expositions from the middle of the century on also loosened the academies' hold on what could and what could not be shown. Because these international fairs tried to reflect the variety of work being done in industry, science, and the fine and applied arts, some crossing of academic boundaries was almost unavoidable. Organizations that grasped the opportunity, as the Verein Berliner Künstler did in 1891, became powers in their own right, with which the academy had to negotiate. The buildings that were erected for the vastly expanded exhibitions, often on the model of the Crystal Palace in London, themselves became a factor in the development and economics of art. Alfred Lichtwark even suggested that the Munich art market would never have achieved its dominant position in Central Europe in the second half of the nineteenth century, had the city not been the first in Germany to possess large, permanent exhibition halls. He was referring to two structures funded by the Crown, which in this way helped the transition from one type of patronage to another: the Kunstausstellungsgebäude, built in 1845, and the Glaspalast, which opened in 1854, thirty-two years before the

1. Jean Bouret, *The Barbizon School* (London, 1973), pp. 115, 138.

Prussian state built the Lehrterstrasse exhibition hall in Berlin.[2]
The economic importance of the annual shows is indicated by the
Munich international art exhibition of 1888, which registered sales
of 1,070,000 marks, half of the total being spent on works by Ger-
man painters and sculptors.[3]

The expansion of the official exhibition system responded to the
needs of artists as well as to the great increase in their numbers, but
by the 1870s it was no longer a satisfactory solution. To art institu-
tions in Germany, as elsewhere, the growth of the population posed
problems that were as intractable as the recurring conflicts between
conventional artists and those who, with more or less justification,
tried to go their own way. Leaders of the academies and of the Kunst-
genossenschaft agreed that the sheer number of people who had
to display their work in order to make a living rendered the annual
salon nearly unmanageable. Not surprisingly, the Kunstgenos-
senschaft placed the blame on its old rivals, the academies, whose
"mass education in the arts" it saw as the source of the mounting
professional and social misery to which the modern artist was sub-
ject.[4] The Kunstgenossenschaft would have preferred its local chap-
ters to limit membership and function as guilds; instead they were
compelled to take on many of the characteristics of trade unions in a
free economy, which could not afford to be too exclusive.

The pressure to show the product of every reasonably competent
local member, together with the works of invited guests from other
chapters and countries, forced the juries of the annual salons to
make use of all available space. In France as well as in Germany,
paintings were hung in rows up to the ceiling, like stamps in an al-

2. Alfred Lichtwark, "Aus München," *Pan*, 2, no. 3 (1896), p. 254.

3. Heinrich Deiters, *Geschichte der Allgemeinen Deutschen Kunstgenos-
senschaft* (Düsseldorf, [1906]), p. 37. The international art exhibition held in Berlin
three years later had sales of nearly 920,000 marks.

4. Ibid., p. 43. The problem was already in evidence at the beginning of the century
when such an artist as the German neoclassicist Eberhard von Wächter refused a pro-
fessorship at the Stuttgart Academy because he believed it was training more artists
than society could, or would, support. The subsequent development has been out-
lined by Nikolaus Pevsner: "The governments supported academic artists; and this
made academies grow in reputation and in numbers of students. This caused an ever-
increasing over-supply of academically trained artists relying on success with a bour-
geois class of indistinct taste. If they went in for the official style, they hoped for pub-
lic commissions; if they preferred genre, or landscape, or still life, they counted on
selling through exhibitions of some *Kunstverein* or a similar institution . . . A prole-
tariat of artists, including lots of mediocre men and some of the best, is typical of the
nineteenth century." *Academies of Art, Past and Present* (New York, 1973), pp.
222–223.

bum, the smallest frequently invisible at the top. It was a poor way of presenting works of art, at once repetitive and confusing, and could give only doubtful pleasure to visitors. "Have you been to the annual salon yet?" went a Munich joke. "Good heavens, no. I saw it last year." A new category of painting developed, *das gute Ausstellungsbild*—a work that by virtue of its startling theme or treatment would not be overlooked on the crowded walls. In the many proposals for reform put forward in the 1870s and 1880s, calls for the exclusion of "sensational" paintings, often labeled as the products of "innovators" or splinter groups, alternated with demands that outsiders no longer be invited, so that more space would be available to inoffensive local artists. Considerations of taste and common sense were overwhelmed by the struggle for existence.

Artists who did not belong to the compact majority, either because they had achieved success or because they pursued an independent line, were equally dissatisfied with the salon. They, too, objected to overcrowding and demanded more severe juries; but their solution was to reduce the size of the exhibitions and to exclude the conventional and bad work that submerged their own, proposals the Kunstgenossenschaft could not accept. After the probably inevitable split had occurred in Munich, sympathizers of both sides agreed on the underlying cause: the conflict between the interests of the majority and those of a self-defined elite, which came to a head in the annual salon. Two decades later Heinrich Deiters, the historian of the Kunstgenossenschaft, concluded that despite all personal rivalries and other disagreements, the Munich Secession "was created by issues related to the exhibitions, and . . . it was these same considerations that lay at the root of subsequent splits in other chapters, where the ambition of the individual artist made him forget that in any association that is not organized on authoritarian principles, the majority must decide."[5]

The Munich Secession was formed in protest against the mass market of the salon; it did not champion any particular direction or style, nor was it a reaction against academic art as such. Even more than Berlin, Munich was a major center of academic art; it was also the host of some of the best German painters of the

5. Deiters, *Geschichte der Kunstgenossenschaft*, p. 38. See also the interpretation by a supporter of the Munich Secession, which is identical to Deiters's except for its approval of the secession's elitism: Benno Becker, "Die Sezession," *Pan*, 2, no. 3 (1896), pp. 243, 245; Hermann Eichfeld, "Münchner Malerei," *Süddeutsche Monatshefte*, 2 (1904), pp. 1022–27; and Adolf Paulus, "Zwanzig Jahre Münchner Secession 1893–1913, *Kunst für Alle*, 38 (1912–1913), pp. 326–327.

second half of the century. Leibl, with whom Courbet felt a strong affinity, Trübner, and the "German-Roman" painters Feuerbach and Marées were more than respectable talents, and their influence is evident in the new movement, as is the influence of the academy. The diversity of the secession is suggested by two members of its executive committee, the painters Fritz von Uhde and Albert von Keller, both of whom in later years were to serve as its president.

Uhde was the son and grandson of senior officials, a great-uncle had been Prussian minister of justice, and Uhde himself served as an officer in the Saxon horse guards for ten years. He was among the first *plein-air* painters in Germany. For much of his working life he was occupied with the problem of interpreting the Gospel in contemporary terms. He showed Mary as a poor peasant girl, leaning against a fence in the snow, waiting for Joseph; or Jesus, sitting down to eat with a lower-middle-class family. Peter Selz is probably right in thinking that Uhde's "religious paintings were neither conventional enough to gain the support of churches nor of any consequence as artistic statements."[6] But Uhde's insistence on grasping the unadorned fact in his religious works was a force that carried his treatment of psychologically less problematic themes to a more satisfying conclusion. Large canvases of a group of drummers practicing in a far corner in the parade ground, of a nursery in which children, toys, and furniture are unceremoniously spread before the viewer, studies of common people at work or of the artist's daughter watching her dog eat, combine an urge for realism with impressionist techniques into substantial statements on the appearance and spirit of everyday life.

Keller, on the other hand, was entirely derivative in technique, interpretation, and subject matter. His colorful yet tame portraits of fashionable ladies, sham rococo genre pieces, and nudes in Roman villas sold for good prices; but he became best known for his symbolist or spiritualist works, most of which mixed eroticism and the macabre: nubile witches at the stake, the wake of a young nun, and several versions of Jesus raising a woman from the dead. Keller ended his career as a society painter in great demand, his reputation authenticated by a Bavarian knighthood; but the genuine if limited promise of his earlier years had atrophied.

6. Peter Selz, *German Expressionist Painting* (Berkeley and Los Angeles, 1974, p. 36. See also Fritz von Ostini, *Uhde* (Bielefeld and Leipzig), 1911, pp. 8, 25–29. The most devastating criticism of Uhde's "new type of 'modern' Christ" is Rainer Maria Rilke's 1897 article "Uhde's Christus," reprinted in *Sämtliche Werke* (Frankfurt am Main, 1965), V, pp. 351–357.

Keller had no lasting impact on the artists of his generation, since he merely repeated more explicitly and in more vivid colors what hundreds had painted before him, while Uhde's influence was considerable for a time. But few members of the secession followed Uhde more than a step or two out of the drawing rooms and romantic villages of academic painting into an exploration of the modern world. What distinguished most of them from the main body of Munich artists was not so much originality as greater technical competence and aesthetic intelligence. On the whole they remained embedded in the conventional; as a group, however, they showed some willingness to experiment, and at least they tolerated different approaches. It was in its exhibition policies, soon to be adopted by other German secessions, that the group differed most significantly from the salon. No style or theme was excluded. Foreign artists continued to be welcomed; their presence demonstrated the existence of an international elite of which the Munich Secession felt itself a part. The juries were more rigorous; far fewer works were shown than in the salon, and those that were selected appeared in an environment of dignified simplicity, uncrowded, with the paintings hung on one or at most two levels. People commented on the risk the secession ran by exhibiting relatively few works but charging the substantial admission of one mark; the public was accustomed to pay the same amount or less for a much more extensive spectacle.

The first show was nonetheless a critical and commercial success. It aroused interest throughout Germany, so that in the following years the secession could send traveling exhibits of its members' works to Vienna, Berlin, and other German cities. When Albert von Keller led William II through the exhibit in Berlin, the emperor criticized one of the few timidly impressionist canvases included for not displaying clear, unambiguous outlines. Keller explained that if one stepped to the far side of the room, the seeming confusion would dissolve into order and beauty. The emperor would not agree: "Who has such large rooms that he can look at paintings from enormous distances? And is it really right that a painting should become worthwhile only at ten paces?"[7] Nevertheless he found much to his liking, and visited the secession's exhibitions again in following years. Not long after its inception, the movement was well established. Its members benefited economically from having become masters in their own house, and the Bavarian government, which at first had tried to prevent the breakup of the Munich chapter of the

7. Hans Rosenhagen, *Albert von Keller* (Bielefeld and Leipzig, 1912), pp. 113–114.

Kunstgenossenschaft, came to accept the new group as a permanent element in the cultural life of the country, with a claim on financial support from the state and on a share of seats on government boards and committees dealing with the arts.

The Munich Secession, which indirectly helped bring about the far more significant split that occurred in Berlin five years later, cannot be regarded as an archetype of European secessions. Each of these movements developed in its own way, in an environment peculiar to itself, and during its life each acquired unique aesthetic, social, and political characteristics. As I have tried to suggest in outlining events in Munich, however, the new movements also had much in common. It will be useful to expand briefly on these similarities and also to note certain variations in the overall pattern before turning to the Berlin Secession.

Secessions are social and institutional processes, sometimes caused by aesthetic considerations, and always accompanied and affected by them. In the nineteenth century they were basically incidents in the struggle over the control of major exhibitions, which had come to assume a crucial role in the life of the European artist. Even when the salons accepted innovative works, the abler artists, whether avant-garde or traditional in outlook, preferred to put some distance between themselves and the mass of their colleagues. Splinter groups, whether called Société anonyme cooperative des artistes, Salon du Champ de Mars, or Münchner, Wiener, or Berliner Secession, banded together to create their own forums and launch their own publications; in these ways they educated the public, stimulated demand for their works, and changed the attitude and policies of the art establishment, which throughout the Continent was either an arm of the state bureaucracy or closely associated with it. Often secession members not only exhibited as a group, but also worked together and shared specific aesthetic sympathies. The secession that coalesced around a definite program was not a universal phenomenon, however, and where unanimity did exist it rarely lasted for long.

At the time and subsequently, the conflict between secession and salon was usually defined as a struggle between young and old, of the creative talent against the academic style and the constraints of state patronage. Where issues of style were a major factor, which was not the case in Munich, new and traditional concepts were indeed in opposition; but it may be worth noting that even in such cases the generational difference was not always prominent. Uhde was in his middle forties when the Munich Secession was founded;

Max Liebermann was fifty-one when he became the first president of the Berlin Secession, only four years younger than his great academic adversary, Anton von Werner. On the other hand, many young people were associated with the salons and academies. It scarcely needs to be added that in their politics, members of secessions — even the most innovative — were not always or even usually on the left. Opposition to the academy and to other measures by which the state attempted to guide the arts might be allied with reformist or even revolutionary views, or lead to them; yet for every Daumier or Courbet there was a Théodore Rousseau or a Cézanne — or a Millet, whose *Stonebreakers* Proudhon called the first socialist painting, and whose *Thresher* and *Gleaners* were attacked as communist propaganda, but who was far from seeing himself as a fighter in the class struggle.

Nor were the innovators necessarily better painters and sculptors than the academicians. Inevitably, organizations of artists are comprised mainly of mediocrities. Of the more than a hundred men and women who formed the Munich Secession, the names of fewer than half a dozen have survived in even the most comprehensive histories. If we look at the group rather than at the individual, the secessionist process may be described as the attempt to replace one kind of mediocrity with another in public esteem and the art market, with a few genuine talents rising above this general movement — experimenting, teaching, influencing, but primarily, of course, always concentrating on their own work. Finally, it is striking how often the independents returned to the official fold, which had been somewhat changed by their impact. Indeed, the Munich Secession never wanted to leave the Allgemeine Deutsche Kunstgenossenschaft in the first place, and it was offered government help as soon as it proved its viability, an offer the members were glad to accept. The Vienna Secession, too, enjoyed official support almost from the start, support that the Berlin Secession was forced to do without for the first twelve years of its existence.

In their relations with the state, as in their environment and in their aesthetic characteristics, the Vienna and Berlin secessions, the two avant-garde movements at the turn of the century that were to have the greatest impact on German art, proved to be remarkably dissimilar. The Austrian court and government might not have welcomed changes in art that claimed to be revolutionary, but they rarely treated them as political threats. In Berlin, in contrast, the secession faced a hierarchy of official powers that was often openly hostile; it breathed an atmosphere in which aesthetic differences

turned almost as a matter of course into political and even ideological confrontations. The antagonism the Berlin movement encountered affected it as an institution; but, as will be seen, opposition did not influence the character of the group's work, which never became politicized. In an official environment that was less favorable to innovation and experiment than the Viennese, the Berlin Secession nevertheless retained a striking diversity. The relative stylistic unity found in the Vienna Secession, the significance that one particular style—*Jugendstil*, or *art nouveau*—had for much of its work, was lacking in Berlin. So was the Viennese concern for the improvement of design in everyday life—in public buildings, posters, furniture. The leaders of the Berlin Secession, and with few exceptions the entire membership, were preoccupied with individual excellence. The missionary and didactic strain of the Viennese, their search not only for artistic quality but also for social relevance that would encompass the entire community of artists and nonartists, was limited in Berlin almost entirely to efforts to acquaint the educated public with what was best in domestic and foreign art. The work of the outstanding figures of the Berlin Secession was influenced less by decorative elements and was more realistic than that of the Viennese, but in their views of art and of the artist in society they tended to remain more elitist.

II

The settlement that Anton von Werner had negotiated between the academy and the Verein Berliner Künstler in the early 1890s prevented a conflict that might have damaged both institutions. Sharing the jury duties and management of the annual salon did not alleviate the problem of overcrowding; indeed, the Verein felt compelled at this time to reassert the needs and rights of the mass of Berlin artists. But a secession similar to Munich's still appeared unlikely, if only because the necessary leadership had not yet emerged. Two events in 1892 nevertheless indicated the possibility of a rupture, which might be particularly difficult to mend because the differences involved were aesthetic rather than institutional. In February, during the same weeks when the Munich Secession was being organized, eleven painters announced the formation of a group that would exhibit separately, although its members were not resigning from the Verein Berliner Künstler and—with one exception—would continue to submit works to the annual salon. A few months later, partly as a result of a recommendation sent by Fritz

von Uhde from Munich, the Verein decided to devote one of its regular fall shows of artists from other German states or foreign countries to the Norwegian painter Edvard Munch, whose work was practically unknown in Germany. The Munch exhibition opened in November, and the resulting scandal nearly wrecked the Verein.

The Eleven—the Gruppe der Elf—originated in the dissatisfaction with the salon felt by several Berlin artists who had achieved a measure of local recognition. They decided to combine into "an informal association for the purpose of exhibiting" and, because they did not trust their own reputations to carry the venture, invited two established painters, Franz Skarbina and Max Liebermann, to join them.[8] Their interests varied, but each was experimenting with new approaches, and in the Berlin of the early 1890s, they stood out as representatives of the modern in art. Although their first show in the Schulte Gallery, ordinarily a conservative private firm, received mixed reviews in the press, the publicity drew visitors, and enough paintings were sold to continue the arrangement with Schulte in the following years. It became fashionable to visit the group shows of the Eleven, which were unlike the salon in that they were small, consisting of a few works by each member and occasionally by a guest, and held in spacious, discreetly furnished rooms. By 1896 a sympathetic commentator could write that the Eleven had "helped the cause of modern art more than anything else that has been done to introduce modernity to Berlin—no small achievement, considering the lazy and stupid trust in the conventional that resists anything new, young, and forceful. In the five years they have exhibited, a strong party has formed to support the modern direction."[9] By then the group had lost much of its élan, and in 1897 it disbanded.

Several members of the Eleven lacked ability or staying power. One, the landscape painter Konrad Müller-Kurzwelly, soon resigned; his place was taken by Max Klinger, then at the threshold of his astonishing popularity. Klinger's naturalistic, excessively theatrical paintings and sculptures—for example, his monumental statue of Beethoven facing an eagle, for which the Vienna Secession designed a special exhibition hall—are recognized today as questionable dead ends in the search for the *Gesamtkunstwerk*. But Klinger was also a gifted draftsman and etcher, and an interesting theorist, from

8. A facsimile of the handwritten programmatic statement of the Eleven is published in Lovis Corinth, *Das Leben Walter Leistikows* (Berlin, 1910), p. 37.

9. Richard Graul, "Die XI," *Pan*, 2, no. 1 (1896), p. 50.

whose ideas such artists as Käthe Kollwitz were able to profit. Of the other members of the group, Fritz Stahl, subsequently better known as a writer on art, George Mosson, and Ludwig von Hofmann were pleasing minor talents, all of whom were to be associated with the secession. Two members, Hugo Vogel and Franz Skarbina, taught at the Institute for the Fine Arts. Skarbina, by far the abler of the two, began with conventional but vigorous renditions of soldiers and Berlin street scenes. Under the influence of the early French impressionists, he developed into a sophisticated interpreter of the movement and color of the modern city. During the 1890s he was an outspoken champion of modern art and, together with his colleague Vogel, lost his professorship as a result of the Munch affair. He was one of the founders of the Berlin Secession; after a time, however, he resigned, and in his last years returned to anecdotal genrepainting that made a mockery of his earlier interests and promise. A critic close to the secession wrote after his death that Skarbina's work "meant little in the development of painting in general, but quite a bit for the cultural history and topographic record of the emerging metropolis Berlin."[10]

The only members of the Eleven whose talents have stood the test of time were Walter Leistikow and Max Liebermann. Leistikow, the youngest of the group, was born in 1865, the son of a West Prussian merchant. In 1883 he enrolled in the Berlin Institute for the Fine Arts, then already under the direction of Anton von Werner, but was dismissed after a semester for inadequate ability. "It is interesting," his friend and biographer Lovis Corinth writes, that Leistikow's "academic derailment ran like a red thread through his entire life. This absolutely honest artist, whom titles and decorations could not impress, repeatedly sought contact with the academy, in the hope of receiving academic honors that would demonstrate how incompetent his instructors had been when they found him wanting. This was the reason for his delight at being appointed Royal Prussian Professor, and this, too, the reason for his pain at never becoming a member of the academy that had once rejected him. His literary feud with Anton von Werner can probably be traced to the same source. To the end of his life he regarded Werner as a mighty and cunning Antichrist, who—in the words of the chorale—'on earth does have no equal'."[11]

After the setback at the academy Leistikow continued his studies

10. Julius Elias, untitled obituary, *Kunst und Künstler,* 9 (1910–1911), p. 110.
11. Corinth, *Das Leben Leistikows,* pp. 12–13.

at private schools and developed into a proficient and, eventually, highly original painter. For some years he spent part of his time designing carpets, wallpaper, and furniture, decorative work in which Norse motifs combined with elements of *art nouveau*. A few of his paintings also show the influence of this style, which he gradually left behind. From the middle of the 1890s on, his landscapes—he painted no other subjects—were in demand among collectors and museums; after years of frugality, he wrote to Corinth, he now "waded in money." When a cultural weekly asked its readers to vote for their favorite painter, Leistikow won second place after Adolph von Menzel, who in advanced old age had become something of a folk hero in Prussia.

Success did not, however, alter Leistikow's conviction that serious art could flourish in Berlin only if the academy and the Verein changed their policies. The Eleven were more to him than a personal forum. He saw the group as a means of influencing the established institutions toward greater tolerance of even those directions in art they could not understand, directions that might otherwise be stifled, as the Munch affair was to prove. As his attacks on Werner during this episode demonstrate, Leistikow could be a harsh opponent; his ability to express himself in fluent, imaginative prose, a talent he shared with a remarkable number of artists of his generation, deserted him in anger and he became shrill and offensive. But Leistikow's unwillingness to compromise on major issues was usually tempered by personal kindness and sympathy for the feelings of others, which may explain the many friends he retained in the conservative camp. Had it not been for his popularity and political acumen, the secession might never have come into being or weathered its early difficulties. He died of cancer in 1908, during the period of the group's greatest success.

In part, perhaps, because of his early death and his relatively small output, Leistikow never became known outside Germany, and even there did not leave a lasting impression beyond Berlin and Prussia. Even if he had lived and continued to develop, however, it is unlikely that his work would have aroused much interest elsewhere in Europe. Like every other German artist who can be broadly categorized as a realist or as an impressionist, Leistikow seemed to have little to offer to the international public. He and his peers were still limited by the parochialism that characterized German art in the second half of the nineteenth century—and also by the parochialism of other European societies. Leistikow's lack of appeal for the French or English public did not in itself make him inferior to his con-

Walter Leistikow. *A Country House*. ca. 1899. Etching. 6¼″ × 8¾″.

temporary Corinth, or to the next generation of the Brücke and other
expressionists, whose work was greeted as significantly innovative
in Western Europe. Nor can he be dismissed as a German who paint-
ed well enough in a familiar, by now generally accepted European
idiom, but one that was not sufficiently different from French im-
pressionism, for example, to be of interest anywhere beyond his
own environment. On the contrary, the mature Leistikow painted
unlike anyone else. His position in this regard bears some similarity
to that of an earlier and greater landscape painter, Caspar David
Friedrich, whose reputation was unquestioned in Germany genera-
tions before the world at large discovered him. The uniqueness and
magnificence of Friedrich's achievement did not save it from being
passed over for decades by societies that saw and felt differently.

Friedrich's mysticism and sense of the tragic are lacking in Leisti-
kow, whose paintings are more prosaic, less glowing, and whose
themes are more limited. But despite their narrow range they are
rarely repetitive. The best are marked by an unusual blending of
realistic detail and large geometric shapes: the single branch and
tree becoming part of a forest wedge that stands between similarly
differentiated and yet cohesive planes of sky and meadow. The
scene is reduced to the greatest degree of simplicity short of distor-
tion, creating an effect of timeless, impersonal calm. No one, it
seems, could find such paintings difficult to comprehend; their real-
istic elements, although on the verge of abstraction, remain suffi-
ciently evident to the unsophisticated viewer. For Berlin society
Leistikow became the painter who, better than any other, caught
the somber quality of the pines, lakes, and fields of Brandenburg.
Nevertheless, when William II was shown a Leistikow painting of a
sunset above the black-green pines of the Grunewald, the great for-
est at the edge of Berlin, he angrily denied that it bore the slightest
resemblance to a real forest. "I know the Grunewald," he declared,
"and, besides, I am a hunter."[12]

Like Leistikow, Max Liebermann never rose above regional signif-
icance. But his talent was more expansive, and in the course of a
very long life—he died in 1935 at the age of eighty-seven—he con-
fronted and mastered a sequence of problems. Aspects of his work,
such as the series of self-portraits extending from the 1890s to the
year before his death or the pastels he painted in his fifties and six-
ties, in which beaches, gardens, and animals dissolve into move-
ment and color, are notable achievements of twentieth-century art.

12. Ibid., p. 52.

Liebermann descended from a wealthy Jewish family of cotton manufacturers, who had settled in Berlin in the 1820s and used modern production methods to break the British hold over the German cotton market. According to a famous anecdote, his grandfather, on being presented to Frederick William III, introduced himself in Yiddish-inflected German: "Majesty, we are those who have driven the English from the Continent." One of his sons was ennobled; two others, of whom one was Max Liebermann's father, carried on the business. Liebermann's mother belong to a family of jewelers who had migrated from Vienna to Berlin in the seventeenth century. One of her uncles was elected mayor of Hamburg after converting to Christianity; Walther Rathenau, chairman of the Allgemeine Elektrizitäts-Gesellschaft and German foreign minister after the collapse of the empire, was her nephew. Liebermann was proud of his heritage, although he resented the slights and disadvantages to which it exposed him. To an acquaintance foolish enough to remark that there would be no anti-Semitism if all Jews were like him, he replied: "No, if all *gentiles* were like me there would be no anti-Semitism. For the rest, I am glad that my face makes it obvious that I am a Jew. I don't need to spell it out to anyone."[13] But he considered himself to be German, and indeed Prussian, in education, work habits, and manner of life. His parents, while retaining their religious faith, had become assimilated into Berlin society and culture, and it was only in the last years of his life, after Hitler had taken power, that their son declared assimilation to have been merely a beautiful dream.[14]

Liebermann studied painting in Berlin and Weimar. In 1871, at the age of twenty-four, he first attracted attention with a large canvas of a group of elderly women in a dark room, plucking geese. Although the figures were too obviously posed and the contrast between the white birds and the dim farmhouse interior was very studied, the painting conveyed a sense of sober reality. It attempted neither to romanticize the poor nor to engage in social commentary. The aesthetic confusion of the time, which led many people to seek the beauty of a painting in the story it told, is revealed by a hostile critic, who wrote that Liebermann's picture, in which "the most repulsive

13. Berthold Nothmann, "Meine Lebenserinnerungen," typescript (1936), p. 49. A copy of these memoirs is in the archives of the Leo Baeck Institute, New York.

14. Liebermann to Carl Sachs, 28 February 1934, in Max Liebermann, *Siebzig Briefe*, ed. Franz Landsberger (Berlin, 1937), p. 86. This small, beautifully designed book, published for Jewish readers by the Jüdischer Verlag is a product of the Jewish communal system that the National Socialists tolerated for a time in the 1930s.

ugliness reigns in naked loathsomeness [*worin die abschreckendste Hässlichkeit in unverhülltester Abscheulichkeit thront*], is executed with virtuosity, but technique cannot make up for the complete lack of aesthetic values, which are not even represented by a slight touch of humor."[15] As a student, Liebermann had already gone far toward achieving the psychological and social objectivity that was to mark his mature work. For the next two decades he painted many scenes from the world of common people — shoemakers and farmers, women canning food or mending nets, inhabitants of orphanages and old people's homes — without editorializing; he retained this detachment when he became more interested in middle-class and upper-class motifs: couples in parks and restaurants, polo and tennis players, horsemen on the beach. What fascinated him was the physical surface, and how light and shade affected it: what people looked like, not what they might stand for. The critic Karl Scheffler, who followed Liebermann's career for half a century and knew him well, said of him: "He was not a man with the gift of empathy"[16] That was only partly true, because Liebermann's choice of treatment and themes expressed more than visual predilections; objectivity might even be conducive to sympathy. But essentially he was an intense, vigorous observer, who despised the anecdotal and the least trace of pathos.

After some years in Paris, where his harsh naturalism had the attractiveness of the unaccustomed, Liebermann moved to Munich. He visited Holland almost annually until the First World War; there he expanded his range of urban and rural motifs and was able to study the work of Frans Hals, an artist with whom he felt a particularly close affinity. In 1879 he completed a painting that brought the experiences he was gaining in Holland to bear on other significant psychological and aesthetic elements in his life; *Jesus in the Temple* was one of the few works in his large output whose overt theme was not taken from the contemporary world. The young Jesus is shown talking to the scribes in an interior adapted from the Portuguese Synagogue in Amsterdam; the figures are still posed and executed in realistic detail, but their facial expressions and gestures give the whole an extraordinary sense of movement. The painting created a sensation when it was exhibited in the Munich salon. Leibl, Uhde, and other artists were impressed by its originality and bravura, but most critics condemned it; Adolf Stoecker joined the attack from

15. Quoted in Erich Hancke, *Max Liebermann* (Berlin, 1914), p. 55.
16. Karl Scheffler, *Max Liebermann*, 3rd ed. rev. (1953), p. 12.

Berlin by accusing Liebermann of perversion and sacrilege. In its session of 15 January 1880, the Bavarian Diet held a debate on the work, in the course of which it was called blasphemous and "a stench in the nostrils of decent people"; the local chapter of the Kunstgenossenschaft, which was responsible for the exhibition, was threatened with the loss of its government subsidy.[17]

At the time, before Uhde began to paint religious canvases, the unidealized treatment of an episode in the life of Christ was still unusual and disturbing. It was pointed out that the figure of Jesus did not even have a halo. But many people were outraged by something else. In *Jesus in the Temple*, Liebermann treats objectively phenomena that in the Germany of the day were usually regarded as repellent or embarrassing. He shows the scribes reacting with grimaces and other signs of open emotion to the twelve-year-old, who — far from being the usual pure figure — is, in the words of a critic, "the ugliest, most impertinent Jewish boy imaginable"; a boy, furthermore, who emphasizes his arguments with intense "Oriental" motions of his hands. The very features and gesticulations that had long been part of the anti-Semitic arsenal were here presented as entirely valid. Instead of the denial and defensiveness that Germans had come to expect from Jews, Liebermann's painting showed Jews, including the young Jesus, as very different from Germans, but for all that not inferior. It was a shocking message, and Liebermann himself seemed surprised at the violence of the reaction. When the salon closed he withdrew the painting from the market; instead he traded it for a painting by Uhde, from whose estate the Hamburg Kunsthalle bought it thirty years later for the substantial sum of 60,000 marks.

By the time Liebermann returned to Berlin to live in 1884, he had become one of the best-known of the younger German painters. Critics accused him of being an apostle of ugliness, but it was difficult to deny his technical competence; his work was praised by such acknowledged masters as Leibl and Menzel, and the honors he was gaining in foreign exhibitions could not be ignored. If, as might be expected, he grew more conventional in maturity, there was no rea-

17. Hancke's discussion of the work and its effect includes minutes of the debate; see *Max Liebermann*, pp. 131–142. The reaction shocked or frightened some of the very people who might have been expected to welcome the painting. Liebermann later wrote with some exaggeration that for fifteen years after he first exhibited *Jesus in the Temple*, Jews would not buy his paintings. Liebermann to Lichtwark, 5 June 1911, in *Künstlerbriefe aus dem neunzehnten Jahrhundert*, ed. Else Cassirer (Berlin, 1919), pp. 407–408.

son why he should not become one of the leading figures of the Berlin art world. Werner was glad to sponsor his membership in the Verein Berliner Künstler, and in the salon of 1888 he was awarded the small gold medal. For two reasons, however, the process of acceptance came to a halt: Liebermann became involved, largely by accident, in a minor incident affecting Germany's foreign relations, and he continued to experiment in his painting.

In 1889 France held an international exposition to mark the centennial of the outbreak of the French Revolution.[18] Several European governments refused to participate officially but supported privately sponsored exhibitions, and it was assumed in Paris that Germany, too, would send an unofficial delegation. When nothing was done on the German side, the French minister of fine arts, Antonin Proust, turned to Liebermann, who formed a small committee, invited artists and collectors to send works, and financed the enterprise with funds that had been raised with the silent approval of the Prussian Kultusministerium. At this point the chauvinistic weekly *La France* printed an attack on Germany's presence at the exposition, while *Le Figaro* condemned the German government in milder terms for its unwillingness to take part officially. German newspapers responded in kind, some castigating Liebermann for lack of patriotism, while Bismarck, irritated by the rudeness of the French press, tried to induce artists who held official positions to withdraw their works—efforts that were only partly successful.[19] The German show was well received. Liebermann and Uhde were awarded *Medailles d'Honneur* and elected to the new Société Nationale des Beaux-Arts. Liebermann was also given the *Légion d'Honneur*, a decoration that the Prussian government, in an excess of pettiness, would not permit him to accept. When at

18. Hancke, *Max Liebermann*, pp. 262–267.

19. When an official explained to Adolph von Menzel, the most eminent and honored of Berlin painters, that it would not be appropriate for him to participate in the centennial celebration of the French Revolution, Menzel replied that he did not need the government to teach him correct behavior, and left his paintings in Paris. Max Liebermann, "Menzel," *Die Phantasie in der Malerei* (Frankfurt am Main, 1978), p. 144. Menzel also declared in a Berlin newspaper that German artists owed much to French art, and that he saw no reason to apply political considerations to art exhibitions. In his memoirs, Anton von Werner wrote that the German exhibition included a statue by Reinhold Begas, the doyen of academic sculpture in Prussia, and continued: "Soon an official inquiry arrived—evidently on higher orders—demanding whether the work in question was being exhibited by the 'Head of an Academic Master Studio' R. Begas . . . Prince Bismarck had his eyes everywhere, and was not to be trifled with in such matters" (p. 566). It turned out that the statue had been sent not by the artist but by its owner, who had no official connections.

an official dinner he drank to "la grandeur de l'art et la confrater-
nité artistique," which the *Kreuzzeitung*, the organ of extreme
Prussian conservatism, mistranslated as "to art and the fraternal
collaboration of all nations," further attacks ensued.[20]

At the very time that circumstances drove Liebermann to oppose
his government, and as he was refurbishing his unpopularity among
xenophobes, his painting took a disturbing turn. Over several years
his brushwork had become broader; he was relying more on the spat-
ula, and his former careful rendering of detail was giving way to
suggestion. In his interiors and in the many studies of Dutch street
scenes, roofs, and facades he was painting during this period, verti-
cals and horizontals became approximate; windows lost their pre-
cise angularity. At the same time he began to use brighter colors,
which he applied more heavily, without concern for achieving an
even surface. He became preoccupied with the problem of sunlight,
especially the effect of the sun penetrating foliage. By degrees he left
naturalism behind—a style that, despite the shocking honesty it
assumed in his hands, was still generally understood—and was mov-
ing closer to the French impressionists, although he continued even
in his oils to emphasize line and other characteristics of graphic art
far more than they did. "He created a north-German impression-
ism," Karl Scheffler was to write, "but later on when we looked
more closely at his work we saw that actually it was not impression-
ism at all."[21]

Before he had gone far in the new direction, Liebermann painted
several works that carried his particular kind of naturalism to its
apotheosis. One of these paintings, *Woman with Goats*, was award-
ed the large gold medal when it was shown in the Munich salon of
1891 and was bought by the state collection—signs of official appro-
bation that had an effect on public opinion, even in Berlin, although
the work was by no means universally admired. The painting is fair-
ly large, 50 by 67 inches, and shows an old woman from the rear,
walking over barren dunes, pulling a goat while a second trots beside
her. The colors are subdued, almost monotonous—green, brown,
gray, the goats black with white markings; composition and draw-
ing are very firm. In places the paint is laid on heavily, so that on the
horizon, for instance, gray-white bands of sky spill over the dunes—
the antithesis of the smooth, "finished" surface beloved by the acad-
emy. Although woman and animals are in motion, and in their

20. Hancke, *Max Liebermann*, p. 266.
21. Scheffler, *Max Liebermann*, p. 10.

movements convey something of the sparse routine of their lives, the overall effect is of calm monumentality. The woman, who seems almost molded in paint, bears a similarity to statues of Rodin, but without their drama and vulgarity. Nevertheless, despite its great qualities, the painting suffers from the inherent weaknesses of naturalism, from which it could not be fully liberated even by Liebermann's determination to simplify the elements of composition and color to their essentials. To his contemporaries, who had learned to couch their aesthetic sensations in the grammar and vocabulary of naturalism, another aspect was more troubling: the relationship between the subject of the work and the means employed. The artist's refusal to idealize the work-worn woman was as disturbing to some viewers as his serious, unpatronizing treatment of animals and a peasant was to others.

Liebermann's artistic independence did not exclude a strong vein of ambition. Although he scoffed at art juries, which, he said, were like cattle traders in the way they reached their decisions, medals and official and semiofficial appointments were important to him. They helped define the position in German society he regarded as his due. He gave particular weight to this consideration in his native city, where he expected to live as a member of the established upper middle class, into which he had been born as the son and grandson of prominent citizens who had been decorated and given other honors by their government. In an autobiographical essay, he wrote that in habits and outlook he was the perfect bourgeois: "I eat, drink, sleep, take walks, and work with the regularity of a town clock. I live in my parents' house, where I spent my childhood, and would find it difficult to live anywhere else." His political and social views, he wrote in the same essay, were those of the generation of 1848: "Although unfortunately I have often experienced the opposite, I continue to assume that—in the words of the Constitution—every citizen is equal before the law."[22] He was a liberal whose views were shaped by the early stage of the industrial age; he believed not in absolute equality, but in equal protection and equal opportunity, as well as in an elite based on ability, education, and achievement.

For such a man it was particularly galling to see the government showing preference to artists who were his inferiors—making Anton von Werner a member of the academy before his thirtieth birthday, for example, while Liebermann was still excluded in his middle

22. Quoted in *Das Liebermann-Buch,* ed. Hans Ostwald (Berlin, 1930), pp. 34–36.

forties. He knew that being a Jew as well as an unconventional paint-
er meant laboring under a double burden; but rather than reject offi-
cial approval as irrelevant, he continued to demand it on his own
terms. That other artists were beginning to look to him for leader-
ship, a development he welcomed, reinforced his personal ambi-
tions for appointments and honors. He wanted to reconcile the state
with modern art and to gain for the new directions, as well as for
himself, an appropriate place in its academies, commissions, and
museums. When Leistikow and his friends invited him to join the
group they were forming, Liebermann was delighted at the oppor-
tunity to bring a measure of organizational cohesion to modern art
and improve its stature in Berlin; in the words of Corinth, he be-
came "the secret leader of the anarchic Eleven."[23]

To the opening show of the Eleven, Liebermann contributed his
Woman with Goats and, for the first time in his career, three por-
traits, a genre he was beginning to explore seriously. Among the
portraits was his first official commission, a painting of the Lord
Mayor of Hamburg, which so displeased the subject that he hid it
behind a cloth during his term of office. Critical opinion on the
show was divided; *Woman with Goats*, in particular, was con-
demned for its monumental treatment of a low theme. Other com-
ments were favorable. Franz Servaes, a widely read critic sympathet-
ic to the modern cause, even wrote that beside Liebermann the
rest of the group faded into insignificance: "It is difficult to stop
once one has started talking of Liebermann. The longer I remain in
the exhibition the more I find that it is being overwhelmed by his
absolutely truthful paintings, so that in the end Liebermann's work
seems to be the only thing that we see."[24] It seemed possible that
the Eleven, boosted by Liebermann's growing reputation, were
launched on a course that would make modern art more acceptable
in Berlin while avoiding the institutional conflicts taking place in
other German cities. The chances for a peaceful evolution were
ruined, however, by the fight over the Munch exhibition, which
proved that the traditionalists and the organizations they con-
trolled would refuse to make even minor concessions to the new
forces.

23. Corinth, *Das Leben Leistikows*, p. 32.
24. Quoted in Hancke, *Max Liebermann*, p. 314. See also Hans Schliepmann, "Die
Ausstellung der XI," *Neue Deutsche Rundschau*, 3, no. 1 (1892), p. 519; who charac-
terized the show as "a fountain of youth in the fine arts"; and such less favorable re-
views as Adolf Rosenberg, "Die Ausstellung des Vereins der Elf in Berlin," *Kunst für
Alle*, 3 (1892 – 1893), pp. 359 – 360; and the notice in the conservative *Kreuzzeitung*, 4
April 1892.

In September 1892 the exhibition committee of the Verein Berliner Künstler invited Edvard Munch to give a one-man show in the Rotunda, the *salle d'honneur*, in the association's headquarters. Munch, then twenty-nine, had already painted some important pictures, among them *Three Girls on a Bridge, Jealousy*, the first version of *The Kiss*, and the full-length portrait of his sister. In Berlin he was little more than a name; but one member of the committee, the Norwegian painter Adelsten Normann, knew his work; reports of his shows in Oslo had appeared in the German press; and Uhde's recommendation did the rest. At the beginning of November Munch arrived in Berlin with fifty-five paintings and etchings, which he hung himself. Only then did the Verein realize what kind of exhibition it was sponsoring. According to Leistikow's sarcastic account, staid and conservative members were outraged by Munch's paintings. "That is supposed to be art!" he has them exclaim. "Oh misery, misery! Why, it's entirely different from the way we paint. It is new, foreign, disgusting, common! Get rid of the paintings, throw them out!"[25] Conservative members petitioned Werner, the association's president, to close the show; when it was discovered that the bylaws prohibited such action by the president alone, a second petition was circulated that called for a general meeting to discuss a vote of censure of the exhibition committee. On Saturday, 12 November, approximately 250 members met in special session. It was Werner, Leistikow writes, who first moved the debate from a consideration of the propriety of the committee's invitation to the possibility of closing the exhibition. "He alone that evening raised the question: 'Should the exhibition be closed, or should it not be closed?' " Newspaper reports state that the motion was made, instead, by the marine painter Hans Eschke, a longtime friend of Werner. Eschke, who had been Leistikow's teacher after the debacle at the academy and had encouraged him to pursue his own ideas, found Munch incompetent and incomprehensible. He proposed that the show be closed at once and that the committee that had issued the invitation be replaced.[26] Some of Eschke's fellow members who shared his dislike of Munch's work nevertheless opposed the motion on the grounds that, once invited, a guest could not be expelled. One speaker declared that "the issue was not so

25. "Die Affaire Munch," published by Leistikow under the pseudonym Walter Selber — that is, Walter Himself — in *Freie Bühne*, 3 (1892), p. 1297.

26. *Vossische Zeitung*, 14 November 1892. On Eschke, see Corinth, *Das Leben Leistikows*, pp. 12–16; Anton von Werner, *Erlebnisse und Eindrücke, 1870–1890* (Berlin, 1913), pp. 61, 64.

much the person and special case of the painter Munch as whether all directions in art were assured full freedom in the Verein, which would no longer be true if Eschke's motion carried." Another speaker, August von Heyden, who, far from belonging to the avant-garde, taught at the Institute for the Fine Arts and glorified Teutonic mythology in enormous frescoes, warned the meeting not to push matters to extremes because a "total rupture" of the Verein might result. Nevertheless, a slim majority of 120 to 103 or 105 — the reports vary — voted to close the exhibition and replace the majority of the exhibition committee.[27] "In great excitement" about seventy members left the hall in protest; at a rump meeting they decided to form a "free association of artists" without resigning from the Verein.

This "secession," as Berlin newspapers called it, lasted only a short time. Leadership and organization could have been provided by the Eleven; but their program of sponsoring small shows of a few artists' works would have been destroyed by the size of the new group, whose members were in any case too heterogeneous to suit Liebermann and his associates. Its most useful function, Leistikow advised, was to work in the Verein and persuade the members to change their attitudes. For the moment it was not possible to do more: "If we wish to raise the standards of art in Berlin we must show good paintings and sculptures; in other words, we must organize good exhibitions, which cannot be done without money. But only the Verein, not the secession, has the necessary funds."[28] After a few weeks nothing more was heard of the new group; nevertheless, it did not disband without striking one blow. On 21 November, forty-eight artists, among them Liebermann, Skarbina, Vogel, and Heyden, published the following declaration in the *Vossische Zeitung:*

The undersigned belong to the minority of 103 members of the Verein Berliner Künstler who in the special meeting of 12 November voted *against* the motion that called for the immediate closure of the Munch exhibition. Our vote was guided by the consideration that Herr Munch, invited to show his work by a committee that had been freely elected by the members of the Verein Berliner Künstler, must be regarded as having been invited by the Verein itself. For that reason, and without wishing to take any position

27. It is possible that members who did not attend the meeting were given the opportunity to record their votes after the fact. At least Curt Glaser, in *Edvard Munch* (Berlin, 1922), p. 18, gives the total as 200 in favor of the closing and 130 opposed, while newspaper reports of the meeting contain the lower, and closer, figures.
28. *Freie Bühne*, 3 (1892), pp. 1299–1300.

whatever regarding the aesthetics expressed in Munch's paintings, we condemn the closure of the exhibition as a measure that contravenes common decency. We wish to assert this in public, and as emphatically as we can.[29]

This statement drew a satisfyingly clear line between ideological politics and the practices of polite society, but it also gave Werner a new opportunity to assert his conception of art against the dissidents. On 21 November he sent the Kultusminister a report on the Munch affair, in which he referred to the declaration in the *Vossische Zeitung* and its charge that Munch's opponents had acted contrary to accepted standards. Werner added: "As several members of the faculty of the institute as well as its director—whose position in this matter is surely beyond doubt—are among the accused, I believe the question arises: Should official cognizance be taken of this public act by one segment of the faculty against its director and another segment of the faculty, and should it be approved or disapproved?" The behavior of Skarbina, Vogel, and others appeared to him to be destructive of comradeship and cooperation among the faculty; consequently, he directed the minister's attention to it.[30] During the same days he let it be known in the Verein that he had reported to William II on the "differences existing among Berlin artists." This action, in turn, caused Heyden to write the Kultusminister that "Herr von Werner's statements do not quite touch the core of the matter" and insulted a minority of Berlin artists, "which has now grown almost into a repressed majority." Heyden asked for an audience with the emperor to tell him the full story, a request that was denied.[31]

The immediate result of the protest was that Heyden, Skarbina, and Vogel were compelled to resign their appointments as professors at the Institute for the Fine Arts.[32] Werner, profiting from his alliance with the emperor and the bureaucracy, on the one hand, and his strong bonds of empathy with the mass of Berlin artists, on the

29. *Vossische Zeitung*, 21 November 1892.

30. Werner to Robert Bosse, 21 November 1892, ZStA Merseburg, Königliches Geheimes Civil-Cabinett, Rep. 2.2.1, Nr. 20002, Bd. 1, p. 146. In an untitled record of important events of the year 1892, Werner briefly discussed the Munch affair and wrote, "I did nothing until Vogel's insulting letter against me appeared." ZStA Merseburg, Rep. 92, Nachlass Anton von Werner, VId, p. 116 verso.

31. Heyden to Bosse, ? November 1892, ZStA Merseburg, Königliches Geheimes Civil-Cabinett, Rep. 2.2.1, Nr. 20002, Bd. 1, pp. 143–144.

32. Wilhelm Doede, *Die Berliner Secession* (Berlin, 1977), p. 56, n. 19, states that the three resigned in protest, but Werner's letter to the Kultusminister and his record for the year 1892 strongly suggest that they were given little choice.

other, had reaffirmed the sovereignty of tradition, at least over the official art world.

For Leistikow the most significant aspect of the episode was its demonstration of the power generated by the mobilized majority. The incompetents, who in his opinion formed the majority of artists in Berlin, had triumphed because no one could withstand them in the aggregate, although individually each was insignificant. Borrowing consciously or unconsciously from Goethe in his analysis of the situation that had been created by the defeat over the Munch show, he used the term *cipher* as the pejorative definition of the force that would have to be overcome in the future:

For ciphers the socialist principle is an admirable defensive and offensive weapon. That is why it plays such an important role in clubs and associations. The herd dominates every group of this kind; very few people have the strength to go their own way. After what has happened, everyone will know how useful socialism is for the Verein Berliner Künstler. To be sure, the word *socialism* has been heard there before; but those who used it were the ciphers, and they directed it against the few young, strong individualists, who had confidence in their own powers. That use was always a lie, of course, a reversal of the true meaning of socialism. The word is, in any case, out of place in this context; but if one wants to use it at all one would have to say that it is precisely the traditionalists, who think of themselves as upholding conservative values and who rebelled in blind rage against the Munch exhibition, that represent the socialist principle in the Verein Berliner Künstler. It was solely due to the principles of equality and fraternity that the ciphers could overpower the artists.[33]

Leistikow was not yet prepared to renounce the elitist program of the Eleven. But five years later, when he helped found the Berlin Secession, he had come to feel that even talented artists could not always manage without the backing of numbers. The secession was to acknowledge the principles of equality and fraternity as much as the Verein; but Leistikow argued successfully for a strong executive. By instituting a leadership that was elected but that controlled policy with a firm hand, he tried to reconcile the standards of the few with the interests of the far greater number, who lacked true talent but were superior in intention and ability to the art proletariat in Werner's camp; they were thus appropriate members of a movement that fought for the right of individual expression.

Corinth, writing nearly twenty years after the Munch affair, thought that all parties had gained from it: "The ciphers, or An-

33. *Freie Bühne*, 3 (1892), p. 1299.

cients, won a Pyrrhic victory by getting rid of what bothered them, and muddling along for a while longer; the Moderns reinforced their hatred of reaction, and placed themselves in a good light as martyrs in the cause of art; and the object of all the fuss, Edvard Munch, won the greatest victory. Overnight he became the most famous man in Germany; his show immediately moved to Munich, and from there to other German cities, and since that time he has sold most of his work to German collectors."[34]

The academy and the Verein did not noticeably liberalize their policies during the next few years, and, since the new "free association" failed to survive, conservatives retained a firm hold on art in Berlin.[35] Nevertheless, receptivity to modern painting and sculpture showed signs of increasing, helped by the growing appeal of innovation in drama and literature. Modernism was still stronger in literature than in the fine arts, and its public appeal broader and deeper; the comparison a critic drew between the emergence of the Eleven and the new avant-garde literary journal *Die Freie Bühne* also applies to the condition of the two fields in general: "A certain relationship did, indeed, exist between the *Freie Bühne* and this organization of artists [the Eleven]. Both planted the banner of a new age in the wasteland. But in its realm the actions of the *Freie Bühne* were far more decisive, sweeping, successful than the art battle waged with more subdued means by the Eleven."[36]

On the whole, too, writers and artists were concerned with different issues; Käthe Kollwitz and a few others who dealt with social themes in an accusing or satirical manner were the exceptions among avant-garde artists rather than the rule. Still, movement in one area affected tastes in another. In 1895 the young art historian and critic Julius Meier-Graefe, together with the poet Richard Dehmel and other writers and artists, founded a new magazine, *Pan*, whose avant-garde content and luxurious design and printing not only expressed the belief of its sponsors in the "exclusive character

34. Corinth, *Das Leben Leistikows*, pp. 48–50. Before Munch left Berlin, the Eleven arranged a show of his rejected works in a private gallery.

35. Relations between the two organizations continued to be disturbed by the dissatisfaction of many artists with the privileges of the academy. In 1895, for instance, the Kultusminister was petitioned unsuccessfully to abolish the jury in the annual salon, or at least to grant all members of the Berlin Verein the same exemption from the jury that members of the academy enjoyed; characteristically, the justification they gave was that it was the obligation of the state to provide space for every artist who demonstrated honest effort.

36. Julius Elias, "Leistikow," *Kunst für Alle*, 18 (1902–1903), p. 346.

of art" but also served to make the artists whose works were repro-
duced and discussed acceptable to society.[37] Another, more technical
journal, *Das Atelier*, edited by Hans Rosenhagen, repeatedly at-
tacked Anton von Werner's repressive influence on art conditions in
the capital.

The country's economic recovery, beginning in the middle of
the decade, stimulated art sales, and the members of the Eleven
found a growing market for their works. In 1896 Hugo von Tschudi
was appointed director of the National Gallery and quickly revealed
himself as an outspoken and effective partisan of modern art, un-
deterred by the increasing hostility of Werner and the emperor.[38]
In the same year, Uhde was elected to the academy, and the Prussian
government granted Liebermann permission to accept the *Légion
d'Honneur*, which he had been awarded for the second time. Lieber-
mann's reputation, which was spreading from artists and collectors
to the general public, was itself a force for change in Berlin. Since
1892 he had refused to exhibit in the annual salon. The absence of
the man whom everyone but official Berlin now acknowledged to
be one of the foremost German painters became something of an
embarrassment. In the aftermath of the salon of 1896, widely con-
demned as one of the dullest in years, an exhibition committee of
more moderate outlook was formed. Its members made it a point to
appease Liebermann. He was offered an entire room in the next
year's salon, as well as the freedom from jury approval ordinarily
granted only to winners of the large gold medal. The thirty paintings
and pastels and thirty-one graphics that he showed were the sen-
sations of the 2,172 works of art displayed in the salon of 1897.[39]
Liebermann finally won the large gold medal, which he also received
in Dresden that year, was elected to the academy, and was awarded
the title of professor. His models and servants, he had written
a few years earlier, already addressed him as "Professor" because it

37. Untitled introduction, *Pan*, 1, no. 1 (1895), inside cover. The journal, which
counted William II and other German princes among its subscribers, reached a circu-
lation of 837 copies and was discontinued after five years.

38. The conflict with William II broke into the open after Tschudi condemned
academic and patriotic art in a speech to the Royal Academy of Arts on the occasion
of the emperor's birthday. The address, "Kunst und Publikum," is reprinted in Hugo
von Tschudi, *Gesammelte Schriften zur neueren Kunst*, ed. E. Schwedeler-Meyer
(Munich, 1912). Despite the emperor's dissatisfaction, Tschudi retained his position
until 1908, when he overstepped his budgetary authority to purchase paintings for the
museum (see chapter 5).

39. *Katalog: Grosse Berliner Kunst-Ausstellung* (Berlin, 1897).

was inconceivable in Berlin for a respectable artist not to have an academic title.[40]

It was suggested that the marks of recognition received by Liebermann, Uhde, and others were given partly in the hope of separating the avant-garde from its natural leadership; nevertheless, it seemed that Leistikow's counsel to work to change the art establishment from within was bearing fruit. The following spring proved the skeptics right. Leistikow submitted a large landscape to the salon of 1898 — it was the same sunset over the Grunewald that aroused the emperor's anger some years later — and the jury rejected it. The affront of having a painting turned down that could not conceivably be inferior to the thousand that were accepted drove Leistikow to take the step that in 1892 he had thought could not succeed. He told his friends that the time had come to leave the Verein. Liebermann agreed that the jury's prejudice could well be the issue needed to crystallize opinion, but he thought it might still be possible for the modern movement to achieve autonomy and recognition within the existing institutional framework. To a painter living outside Berlin he wrote in early May: "The weather has turned foul, and what has long been in the air is now apparently solidifying into fact: the Berlin Secession. The immediate cause is the jury, which admittedly has gone about its work in an especially one-sided manner [this year]." As the price for remaining in the Verein, he continued, he and his associates were demanding their own rooms and jury in the annual salon.[41] Meeting that demand would have given the dissidents everything they wanted, without the burden of having to organize and finance entirely separate exhibitions. The benefits that would accrue to the establishment were less apparent. Talks aimed at preventing a complete break nevertheless got under way between Liebermann's group and representatives of the Verein and the academy, and continued for months. But whether officially independent or merely independent in fact, by the summer of 1898 the Berlin Secession had become a reality.

40. Liebermann to his former teacher Karl Steffeck, undated, in *Das Liebermann-Buch*, p. 158.

41. Liebermann to an unnamed "Dear Colleague," 7 May 1898, Bodenheimer Collection, Leo Baeck Institute, New York.

The Berlin Secession

3

THE BEGINNINGS OF THE SECESSION

I

The secession came into existence in a series of meetings in May 1898, with 2 May usually regarded as the founding day. The new group consisted of some sixty-five men and women; unlike the Verein, the secession accepted women as regular members.[1] The first general meeting entrusted the conduct of the group's affairs to a president and an executive committee, who were bound by a constitution that defined membership qualifications and members' rights and that could be amended only by a three-fourths majority. Nevertheless, the power of the committee went very far; it did not hesitate, for instance, to reject applications for membership unilaterally.[2] Max Liebermann was elected president and Walter Leistikow first secretary. The other members of the executive committee were the painters Ludwig Dettmann, Otto Engel, Oscar Frenzel, and Curt Herrmann, and the sculptor Fritz Klimsch. Dettmann resigned from the secession early in 1900 because his colleagues regarded it as a betrayal of the movement that he broke the pledge, given by

1. The number of members scarcely changed for the first three years, a few early resignations being balanced by newcomers. On 31 January 1899, for instance, the sculptor Fritz Heinemann announced his resignation; see the entry for that date in "Protokoll Buch der Vorstand Sitzungen der 'Berliner Sezession.'" This volume of minutes of the executive committee, kept primarily by Otto Engel, covers the period from 18 January to 25 March 1899. A microfilm copy is in Stanford Coll. GASC, Cassirer Collection VI, Berlin Secession. Later minutes of the executive committee have disappeared.

In March 1899 the secession had 68 members; "Protokoll Buch," 16 March 1899. The printed list of members for 1900 contains three honorary and 65 regular members, among them four women. The following year two honorary members (Wilhelm Leibl and Arnold Böcklin) had died, but they were replaced by two others. The total number of regular members had declined to 62, but a new category, "corresponding members," included 96 names. The departure of 16 members between 1901 and 1902 did not interrupt the slow growth of the secession from this time on; in 1904 the printed roster lists 6 honorary members, 72 regular members, and 74 corresponding members. By 1909 these figures had changed to 5 honorary members, 97 regular members, and 119 corresponding members.

2. "Protokoll Buch," 26 January 1899.

59

every member, not to enter his work in the annual salon. His place on the committee was taken by Franz Skarbina, who had joined the secession more in disgust at Anton von Werner's behavior than for artistic reasons. Frenzel and Engel, the second secretary who kept the minutes, represented the conservative faction of the leadership. Together with fourteen others, they resigned from the secession after three years; Engel subsequently played an important role in the Verein and served as chairman of the salon of 1908.[3]

Of the two remaining members of the committee, Herrmann was then breaking out of the conventional if colorful realism in which he had been working for twenty years, coming under the influence of van Gogh and beginning to paint pointillist landscapes and still lifes. He was among the first German neo-impressionists, without ever achieving a manner distinctly his own. Klimsch, born in 1870, was already well known. He is most interesting for the psychological expressiveness that marks some of his sculptures. His *Salome* of 1902, for instance, interprets a favorite theme of the period in terms of an intense polarity of innocence and depravity, youth and age, health and depression. His design for the monument of the scientist and liberal politician Rudolf Virchow was rejected unseen by William II, on the basis of unfavorable reports; after Klimsch refused to change his design and the emperor was shown the sketches, he reversed himself.[4] Klimsch, who lived until 1960, was to do some of his best work in the Weimar era, although by then he seemed old-fashioned and unenterprising in comparison with Ernst Barlach, Wilhelm Lehmbruck, and other secession sculptors.

The driving force on the executive committee and of the secession as a whole was Leistikow, the group's "creator and most active member."[5] Liebermann liked and trusted the younger man, and allowed himself to be influenced by him, although the two could disagree. Leistikow invested far more emotional energy in the secession than Liebermann did; its success meant more to him, at least in the early phases of the group's history, and he hated Werner, whom Lie-

3. Julius Elias, "Der Berliner Glaspalast," *Kunst und Künstler*, 5 (1906–1907), p. 451; "Die Grosse Berliner Kunstausstellung 1910," ibid., 8 (1909–1910), pp. 565, 568.

4. Fritz Klimsch, *Erinnerungen und Gedanken eines Bildhauers* (Stollhamm and Berlin, 1952), pp. 72–76.

5. Liebermann's description in his unsigned preface to the catalogue of the tenth annual exhibition of the secession, the first held after Leistikow's death, *Secession 1909* (Berlin, 1909), p. 11. A friend of Leistikow, the critic Julius Elias, wrote about his role in founding the secession: "As propagandist he was great (drawing even Max Liebermann to his radical heart), as organizer even greater." "Leistikow," *Kunst für Alle*, 18 (1902–1903), p. 349.

bermann was able to treat with ironic patience. Leistikow's position in the negotiations between the secession and the art establishment is not clearly documented, but there are indications that, unlike Liebermann, he welcomed an open, complete break.

Both sides had used the talks held with the Verein since the secession was founded to gain time. A resolution of the conflict could not be postponed indefinitely, however, because arrangements needed to be made for the coming salon, scheduled to open in May 1899. As in every year since the relations between the academy and the Verein were reformed in 1892, a joint committee was appointed in November to organize and manage the next year's exhibition—the Geschäftsführende Kommission der Grossen Berliner Kunstausstellung, or Ausstellungskommission for short. The group consisted of a government representative, or Regierungskommissar (Erich Müller, head of the subsection on the fine arts in the Kultusministerium, who reported directly to the minister); several delegates from the Düsseldorf chapter of the Allgemeine Deutsche Kunstgenossenschaft; and six members each of the Verein and the academy.[6] The committee was chaired by the portrait painter Max Koner, a professor at the Institute for the Fine Arts, who had fallen out of favor at court, less for his style, which was that of a Prussian John Singer Sargent, than for his independent attitude.[7] Koner, like Müller, was eager to heal the breach among Berlin artists.[8] Together with several conservatives, Liebermann was elected by the academy to serve on the committee—a choice not as surprising as it might appear.[9] The

6. Müller was replaced in 1903, probably at the instigation of Anton von Werner. The incident is discussed in chapter 4. In "Über den deutschen Künstlerbund und die Tage von Weimar," *Kunst für Alle,* 9 (1903–1904), pp. 201–202, Leistikow describes Müller as "an unusually farsighted, objective man, who had come to realize that Uhde is not necessarily an anarchist because he paints the poor, that Liebermann is not an honorary member of the Social Democratic party because he sees the life of workers and peasants with an artist's eye, and that those who labor to depict nature on the basis of their own observations instead of the flat principles of state academies should not necessarily be called gutter artists." On Müller, see also Reinhard Lüdicke, *Die Preussischen Kultusminister und ihre Beamten* (Stuttgart and Berlin, 1918), p. 18; and the memoirs of his successor in the ministry, Friedrich Schmidt-Ott, *Erlebtes und Erstrebtes, 1860–1950* (Wiesbaden, 1952).

7. See chapter 1.

8. Koner was reelected chairman of the salon the following year. In his speech of 5 May 1900, opening the exhibition, he once more appealed for a reconciliation between the different factions. Max Jordan, *Koner* (Bielefeld and Leipzig, 1901), p. 3. Koner died suddenly in July 1900, shortly before his forty-sixth birthday.

9. Reports of the Ausstellungskommission and of the president of the Royal Academy of Arts to Kultusminister Robert Bosse, 11 November and 8 December 1898; ZStA Merseburg, Kultusministerium, Rep. 76 Ve, Sekt. 1, Abt. IV, Teil IV, Nr. 9, III, pp. 184–185, 200.

secessionist movement he led was still little more than a paper organization, whose continued existence was far from assured. At the same time, many of Liebermann's fellow academicians saw no reason to minimize his importance, which his recent successes in official exhibitions as well as his election to the presidency of the secession made evident enough. Liebermann's seat on the Ausstellungskommission enabled him to raise the central issue of secessionist access to the salon directly with the body that held ultimate authority, subject to ministerial approval, over the exhibition.

On 20 November Liebermann and the executive committee of the secession submitted a note to the Ausstellungskommission, asking that the secession be allowed to exhibit as a group in the salon of 1899, in its own "good" rooms, with its own jury, and with its own committee in charge of hanging. The note added that the "members of the [secession] group have mutually pledged themselves not to send works to the salon if their request is refused." A second memorandum dated the same day pointed to the special privileges granted to the Düsseldorf chapter; these, it claimed with some exaggeration, set a precedent for the secession's demands.[10]

The committee considered the request, now amended to ask specifically for eight rooms, a few weeks later. In the discussion it was pointed out that the secession wanted a disproportionate amount of space for its small membership, as well as autonomy; neither request could be granted. In response Liebermann reduced his demands to the conditions under which the Düsseldorf chapter exhibited: a preliminary jury made up of its own members, which submitted recommendations to the general jury; separate rooms; and a separate hanging commission. The compromise passed by a vote of 9 to 6, with Müller, the government representative, voting in favor, on two conditions: the rooms assigned to the new group would not be labeled *Sezessions Säle*, and the general hanging commission would supervise them to assure the exhibition's uniform character; these proposals were accepted unanimously. Müller reported to his minister that Liebermann had shown a readiness to meet the opposition half way, and he recommended approval of the compromise. He thought the management of the previous salon was open to some criticism; Liebermann had acted reasonably, and the members of the secession were "undoubtedly qualified to exhibit in the salon"— were *zweifellos ausstellungsfähig*.[11]

10. Ibid., p. 208.
11. Müller to Bosse, 12 December 1898, ibid., pp. 201–204.

Even a regular jury with limited authority would have been distasteful to Leistikow, and no doubt to other members of the secession as well; but the compromise never went into effect because Anton von Werner rejected it. To recognize a separatist art movement officially seemed to him pernicious; recognition was even less defensible if the secession's ranks included the most outspoken opponents of the academic style. In open letters published in the Prussian newspapers, Werner declared that the secession's proposal constituted an injustice to the majority of Berlin artists, one that the emperor would never tolerate. On what grounds, he asked, could the government, the academy, and the Verein justify preferential treatment of a minority? The case of the Düsseldorf chapter was not analogous. For a geographically separate group to have the privilege of preliminary selection was only reasonable; but the secession was merely a faction within the local Berlin chapter, which nevertheless demanded special rights. The advantages a few prominent artists might gain from showing their works in separate exhibitions under their own control could not justify splitting the unity of Prussian artists. However, those who joined the new group had no business remaining members of the Verein or of the academy. Werner repeatedly inquired into the motives behind the split. He denied that the Verein or the salon had discriminated against painters who tended toward impressionism, and pointed to Liebermann's medals and other distinctions as proof of the state's readiness to honor good work of whatever style. His letter did not deal clearly or honestly with the aesthetic issue, at least in part because he genuinely believed in the excellence of academic realism. But Werner was on firm ground in arguing that not every member of the secession was innately superior to other artists, and his adherence to the democratic or — as Leistikow would have said — socialist principle of absolute equality among the members of art organizations gave his reasoning even greater public appeal.[12]

Werner's statements, which mirrored his actions during months of negotiations and lobbying, made it obvious that he would accept only total surrender. He certainly recognized the advantage of keeping the secession within the fold and of preserving the institutional unity of Berlin artists, which he himself had laboured to bring about. But his aesthetic and political convictions compelled him to resist concessions to the new group, and with the emperor's support he

12. See, for instance, *Der Reichsbote*, 10 December 1898; *Berliner Tageblatt*, 16 January 1899. See also the later report by Julius Elias, "Chronik," *Kunst und Künstler*, 6 (1907–1908), p. 174.

overrode the wish of the Kultusministerium to reach an accommo-
dation. As a result, the members of the secession resigned from the
Verein in a body. Some years later, on the occasion of the founding
of a national union of modernist artists, the Deutsche Künstler-
bund, Leistikow wrote that "if we go to the heart of the matter, the
Berlin Secession . . . and today the Deutsche Künstlerbund in
Weimar have the same progenitor. It is the director of the Berlin
academy, Anton von Werner. Without this gentleman it seems no
true progress, no real movement is possible in the German art
world."[13]

The government gained a secondary and unintended benefit from
the secession's departure. Ever since the international art exhibition
of 1891, some conservative groups as well as organizations con-
cerned about public morality had criticized the annual salon for
its international tendencies and for its leniency toward morally
dangerous art. The Berlin Men's Association for Fighting Immoral-
ity had recently appealed to the Kultusminister Robert Bosse that
lascivious works of art, if they could not be excluded from the salon
altogether, should at least be isolated in special rooms, a petition the
Kultusministerium rejected with impressive politeness.[14] Political-
ly more serious was the accusation that native artists were placed at
a disadvantage by the presence of foreign exhibitors, who were un-
fairly favored by the juries and hanging committees. This charge
linked the familiar populist complaint of the small artist, struggling
for his share of the market, with a suspicion, increasingly evident
among the bourgeoisie, of foreign commercial competition and per-
nicious moral influences. Soon "French impressionism" became a
label for all undesirable foreign art, most of which was far from im-
pressionist, and from the middle of the 1890s on the term was used
to mobilize public resistance to modernism.

Opposition to "modern" and "foreign" art was voiced in many,
sometimes unexpected, quarters. Maximilian Harden's *Zukunft,* for
instance, published a widely noticed attack on impressionism as
well as on international art exhibitions in Germany; in the 1890s
however, the most explicit statements of this attitude still came
from conservative and Catholic groups.[15] "This ridiculous fad for

13. Leistikow, "Über den deutschen Künstlerbund," p. 201.
14. Vorstand des Berliner Männerbundes zur Bekämpfung der Unsittlichkeit to
Bosse, 28 December 1896, ZStA Merseburg, Kultusministerium, Rep. 76 Ve, Sekt. 1,
Abt. IV, Teil IV, Nr. 9, III, p. 30.
15. Werner Schuch, "Internationale Kunstausstellungen," *Zukunft,* 21 November
1896.

the foreign," the conservative *Reichsbote* declared in 1897, served only to corrupt German art and the German art market. The newspaper castigated international shows, the many awards given to foreigners, and the government's policy of permitting duty-free art imports; it concluded: "The wealthy, educated circles in Germany still have to understand far more clearly than they do at present that they owe it to the Fatherland and to their honor to favor German art and thus spur it on to great achievements."[16] Neither the emperor nor the Kultusministerium shared in this blanket rejection of international art, and the salon's policy of inviting foreign artists to exhibit continued unchanged; but the rebuff of a group that the public had associated with impressionism from its inception could be used to demonstrate the government's concern for the health of German art.

A few months after the secession had withdrawn from the salon, a bureaucratic epilogue underlined the extent to which it was now isolated from official art institutions; it also reveals the emperor's insistence on making the break as sharp as possible. By virtue of having won the large gold medal, three members of the secession— Liebermann, Frenzel, and the painter Richard Friese—were on the jury of the annual salon. On 3 March 1899 Bosse wrote to the head of the Imperial Civil Cabinet, Hermann von Lucanus, that, since the members of the secession had declared they would no longer submit works to the salon, "suggestions for awards to artists belonging to the newer secessionist direction [but who might not yet have joined the Berlin Secession] were not to be expected." Nevertheless, he asked whether the emperor should be informed of the possibility that the three gold medalists might continue to serve as jurors.[17] Lucanus consulted Werner, who replied that under the circumstances it was only logical for those members of the secession who held the large gold medal to resign from the jury. As the medals were authorized and donated by the emperor, he would naturally be concerned about the composition of the jury and should be informed.[18]

16. *Reichsbote*, 14 February 1897.
17. Bosse to Lucanus, 3 March 1899, ZStA Merseburg, Königliches Geheimes Civil-Cabinett, Rep. 2.2.1, Nr. 20564, pp. 213–214.
18. Werner to Lucanus, 14 May 1899, ibid., pp. 215–216. Werner was never less than frank in his opinion that the separation initiated by the secession should be made absolute. See, for instance, the interview published in the winter of 1900 and later reprinted in a book on Berlin artists, in which Werner was quoted indirectly as follows: "The question of art was not at issue. Let everyone paint what and how he wishes. What mattered to him was purely the question of the *artist*. He had always

Three days later Lucanus notified Werner that the emperor, who had been briefed on recent developments, agreed with Werner's position.[19] This led Bosse to send the emperor a somewhat defensive explanation: he had not suggested the exclusion of Liebermann, Frenzel, and Friese because he believed they themselves would recognize that they should no longer act as judges. Although he agreed with Werner that it would be illogical for them to serve on the jury, he strongly doubted the wisdom of excluding the three men by Imperial Decree. Most informed artists thought the secession would not last; an imperial order removing the three from the jury would needlessly intensify the conflict. "It would cause enormous excitement among those affected, and stir up a good deal of dust in art circles and the press," because the order could be interpreted as an "act of personal degradation." In any case, Bosse concluded, even if Liebermann and his colleagues remained on the jury, they would be in the minority.[20] They had, in fact, no intention of serving as jurors, but the emperor seized the opportunity created by the withdrawal of the secession to dismiss them officially. A Cabinet Order to the Kultusminister stated that "in the view of His Imperial Highness, the three secession members who held the large gold medal had by their

championed the profession as such. He favored a genuinely free and independent class of artists. That alone was the reason for his well-known opposition to the secession." The interview continued with a direct quotation: "Either—or! If the gentlemen do not wish to exhibit with us—good. But then they should accept the consequences. They should resign from the Verein Berliner Künstler, and those who are members of the academy should not claim the right to serve on the jury. But no; they seem only interested in sharing the rights and prerogatives of the Verein, and for the rest go their own ways. What good can come of that! The solidarity of Berlin artists is broken, and the entire profession and the defense of its interests must suffer as a result. And, further, we don't agitate and intrigue, but I possess undeniable evidence that people on the other side have fewer scruples. Naturally that makes personal relations in the Verein and elsewhere much more difficult . . . in these matters I don't compromise. And can anyone be surprised that members of the academy who as holders of the gold medal had the right to sit on the annual jury were excluded? It is scandalous that they refuse to accept our exhibition rules and organize their own show, and yet want to judge the exhibitors in the Grosse Berliner Kunstausstellung. That just doesn't go!" Later in the interview Werner is quoted as reiterating: "Once again, let everyone paint what and how he wishes; but the interests of the class and profession and of the great cause [of art] must be protected. That is far more important than 'impression' and 'feeling.'" Julius Norden, "Bei Anton von Werner," in *Berliner Künstler-Silhouetten* (Leipzig, 1902), pp. 24–25, 27.

19. Lucanus to Werner, 17 May 1899, ZStA Merseburg, Königliches Geheimes Civil-Cabinett, Rep. 2.2.1, Nr. 20564, p. 217.

20. Bosse to William II, 4 June 1899, ibid., pp. 218–222.

total opposition to the Great Berlin Art Exhibition excluded themselves from any participation in [the management of] this exhibition."[21]

<div style="text-align:center">II</div>

After negotiations between secession and salon broke down at the end of 1898, the first concern of Liebermann and his colleagues on the executive committee was to organize a show of their own. The future of the secession depended on their success, and they had only a few months in which to bring it about; the show could not be delayed much beyond the opening of the salon in May 1899 without creating serious dissatisfaction among the membership. "If we don't attempt an exhibition immediately, by this summer," Frenzel declared at a meeting of the committee in February, *"we are bankrupt"* — a statement italicized in the minutes.[22] The leaders were not sure of the rank and file. At the same meeting the question was raised whether the financial risk of building a gallery was acceptable "if we can't be assured that the members of the secession will remain loyal to the movement." The committee's labors to bring about the show, which exemplify how the new group learned to function, are worth tracing in detail.

From the first the committee believed that the secession was not ready to stand on its own, but needed outside support. It asked other organizations to join in its boycott of the salon, and gained what it regarded as a significant victory when one of the factions into which the Munich Secession had by then split, the Luitpold Gruppe, rejected the invitation of the Berlin Ausstellungskommission and decided to exhibit with the secession instead.[23] Solidarity with other movements seemed so important that the committee promised space in its still-to-be-acquired gallery to artists in Karlsruhe and Dresden, although this would eliminate space for some of its own members.[24] On 10 March the Berlin Secession joined the Munich chapter of the

21. Cabinet Order of 8 June 1899, ibid., p. 224.
22. "Protokoll Buch," 7 February 1899. Similar feelings are expressed in the minutes of the 16 February meeting. During the critical period from January to March the executive committee met twenty-one times. In March the committee decided that for the time beng it would have to continue to meet every Tuesday and Thursday evening.
23. Ibid., 26 January and 3 March 1899.
24. Ibid., 26 January and 22 February 1899.

Kunstgenossenschaft and two secessionist groups in Munich in pro-
testing the attacks on the architect Paul Wallot in the Reichstag ses-
sion of 1 March.[25] Wallot's designs and decorations in the Reichstag
building had led to members' demands that he be replaced by anoth-
er architect. It was the first of several instances in its history when
the Berlin Secession opposed not the emperor and the bureaucracy
but the views on art held by the people and by its elected or self-ap-
pointed representatives. For the time being, however, these issues
were overshadowed by the urgent need for a gallery.

To save time and money, the committee hoped to rent suitable
space or remodel an existing structure. When a search found no gal-
lery or potential gallery of sufficient size and quality, it reluctantly
decided to build. Raising the necessary funds became a major con-
cern. Liebermann, the wealthiest member of the committee, threat-
ened to give no money at all unless everyone in the secession con-
tributed at least a small sum, since he did not want to be accused of
turning the secession into his personal plaything.[26] It was decided to
appeal to the membership, but also to approach outside donors for
five-year loans. By 16 February, 10,000 marks had been pledged by
Liebermann, Leistikow, and a few friends. A month later the total
had risen to 57,000 marks, about two-thirds of the estimated cost of
building and furnishing a gallery large enough to display several
hundred works.[27] In the end the cost turned out to be closer to
120,000 marks, a sum that was raised by the middle of the year. A
complete list of donors has not survived, but they included Walther
Rathenau, Richard Israel, and the bankers Julius Stern and Carl Für-
stenberg, and it is safe to assume that Jewish participation was sig-
nificant. The director of the National Gallery, Hugo von Tschudi,
helped interest wealthy patrons in the project and may have con-
tributed himself, thus further infuriating William II.[28]

25. Ibid., 10 March 1899; "Ein Protest der Münchner Künstler," *Berliner Tage-
blatt,* 9 March 1899.

26. "Protokoll Buch," 31 January 1899.

27. Ibid., 16 and 27 February, 6, 10, and 13 March 1899. On 22 February the com-
mitee also decided to cover operating expenses by increasing membership dues from
60 to 80 marks a year.

28. Ibid., 31 January 1899. Israel had bought the Leistikow landscape whose rejec-
tion by the salon was the immediate cause of the secession. To protest the jury's deci-
sion he offered the painting to the National Gallery, an offer Tschudi was delighted to
accept. For years afterwards, opponents of the secession, Werner among them, cited
the painting's presence in the gallery as proof that the state did not discriminate
against secessionist artists, without mentioning that the work had been a gift. Stern
was an important collector of modern art. Fürstenberg contributed out of personal
regard for Leistikow and Liebermann; his taste in art was rather conventional. See his

The committee found an advantageously located garden lot, adjoining a theater, in the Kantstrasse in the developing quarter north of the Kurfürstendamm. The owner of the theater held a lease on the garden, and for a time appeared willing to enter into a partnership with the secession to build and manage the gallery, but the parties could not reach an agreement. The possibility that the secession might build and operate the gallery itself was considered and rejected because it "would place us under too heavy an administrative burden . . . The danger is great," the minutes conclude, "that the secession will disintegrate if our building plans do not materialize. The idealists among our members who would continue the struggle despite this defect . . . are few enough."[29] By the last week of February matters had come to a standstill. On the twenty-fifth the committee, acting on the suggestion of Liebermann and Leistikow, visited the cousins Bruno and Paul Cassirer in their recently opened art gallery to discuss alternate building sites. In the course of the conversation the cousins indicated that they might be prepared to take over the administration of the secession's affairs. With this difficulty seemingly resolved, the committee, at a second meeting with the Cassirers, approved Liebermann's proposal not to search further for a financial partner but to appoint an administrator to manage the exhibitions and sales, and build the gallery on its own, if possible on the site in the Kantstrasse.[30]

The agreement with the Cassirers brought the secession into contact with two men who were to influence the movement, each in his own way, throughout its history. The cousins belonged to a Jewish family from Breslau that had rapidly become assimilated after the emancipation edicts at the beginning of the nineteenth century. The Cassirers had grown wealthy in the timber trade, in engineering, and in the manufacture of copper and steel cables. Some members of the family had married gentiles; on the whole, however, the family was notable for the unusual number of intermarriages between its various branches. Bruno Cassirer married his first cousin, Paul Cassirer's sister. Another cousin, the philosopher Ernst Cassirer, married his own first cousin, as did Paul Cassirer's brother, the neurologist Richard Cassirer; Ernst Cassirer's parents had themselves been first

memoirs, Carl Fürstenberg, *Die Lebensgeschichte eines deutschen Bankiers*, ed. Hans Fürstenberg (Wiesbaden, 1961), pp. 139–140, 142, 331–332, 334.

29. "Protokoll Buch," 22 February 1899.

30. Ibid., 25 and 27 February 1899.

cousins. These and similar links gave the generation that entered the arts and professions in the 1890s a distinct family style that consisted, according to one observer, of a blend of intellectual independence and eccentric stubbornness, tempered by disdain for bourgeois presumptions and anxieties, which they found exemplified above all by the emperor.

Bruno Cassirer was born in 1872. After attending art schools and studying art history at the universities of Berlin and Munich, he started a gallery and a publishing firm in 1898 in partnership with his slightly older cousin Paul.[31] The gallery, located in the Viktoriastrasse, a residential street on the southern edge of the Tiergarten, was furnished and decorated by Henry van de Velde, as his first commercial project in Berlin. In his somewhat gushing review of the gallery's first shows, the young Rainer Maria Rilke noted the unusual atmosphere. The reading room, he wrote, "contains nothing obtrusive; everything is intended as backdrop for a good, quiet visit . . . As one leans against the long reading table, bent over an album of Böcklin prints or holding a volume of the Goncourts, one is filled with contentment and unconsciously, almost without gratitude, accepts the pleasure afforded by this comfortable environment." The gallery opened with a show of works by Degas, Meunier, and Liebermann, each in a separate room. "Next to the unreflective, painterly instinct of Degas," Rilke thought, "Max Liebermann appeared almost as a seductive experimenter. He seems to be growing away from the elegant negligence of his masterly sketches toward a brilliant impressionism, in the literal sense of the word, which unfolds two-dimensionally in opulent color."[32]

Other exhibits of modern foreign and German artists followed, planned and hung with unusual care, and their success indicated

31. Heinz Sarkowski, "Bruno Cassirer: Ein deutscher Verlag 1898–1938," *Imprimatur*, new series, 7 (1972), p. 107, mistakenly assumes "that the founding of the secession led to the opening of [the Cassirers'] salon." The secession, whose first show did not take place until May 1899, was still in limbo when the Cassirers opened their gallery.

32. Rainer Maria Rilke, "Der Salon der Drei," *Sämtliche Werke* (Frankfurt am Main, 1965), V, pp. 451, 453. Compare Rilke's impressions with the description by a painter whose works were shown in the gallery: "The exclusive character of the enterprise was reflected in the very simple decor, whose smallest details were innovations in Berlin—from the gray linen covering that replaced the traditional dark red wallpaper to the hanging of paintings from gold cords instead of nails. Another innovation was the reading-room, designed by van de Velde, . . . where arty young men and ladies, bent over their reading, enjoyed the sacred atmosphere while awaiting the great moment when their work, too, would be accepted and displayed." Erich Hancke, *Max Liebermann* (Berlin, 1914), p. 391.

that the gallery was filling a need, although it was not the only place in Berlin where modern art could be seen and bought. Fritz Gurlitt, whose family had been associated with art in Berlin for generations, offered works by such German painters as Arnold Böcklin, Anselm Feuerbach, and Wilhelm Leibl, and an occasional French impressionist, in his gallery in the Potsdamerstrasse. Across the street the Keller and Reiner Gallery, which followed the Cassirers' lead in the fall of 1898 by commissioning van de Velde to design one of its rooms, showed paintings by Leistikow and other members of the secession, and in November held an exhibition of neoimpressionists. A friend of Liebermann, Hermann Pächter, occasionally offered a few paintings by French impressionists for sale. The Schulte Gallery, until recently the home of the Eleven, continued to show some modern works, although its general policy remained conservative. If the Cassirers had a more immediate and lasting impact, it may have been because they conceived each exhibition as an integrated whole, in which they tried to indicate thematic, psychological, and historical connections among the works of different artists and schools, rather than scatter a few modern paintings in the midst of conventional and more readily saleable canvases.[33] Their approach was aided by friendships they formed with Leistikow and Liebermann, who helped plan their shows and lent them the many works that were needed for a unified presentation.

The gallery's association with a publishing house was another factor in its success. By 1901 the Cassirers had published books by three of the most influential museum directors in Germany: Wilhelm Bode, Alfred Lichtwark, and Hugo von Tschudi. Other works included a pamphlet on Degas by Liebermann and van de Velde's

33. In his memoirs, *Und alles is zerstoben* (Vienna, 1937), p. 296, the art historian Werner Weisbach writes about the first exhibitions of the Cassirer Gallery: "At this time a good deal of activity in support of modern art began in Berlin. A significant role in this process was played by the art gallery of Bruno and Paul Cassirer . . . directed by the latter with great knowledge and understanding . . . Most of the shows, which changed every month, were important artistic events. They presented the most magnificent works of the French impressionists and of van Gogh, revealed the significance of contemporary German artists, and introduced new talent. Anyone who followed these distinguished shows acquired a comprehensive acquaintance with the modern art of many different countries." Throughout his life Paul Cassirer continued to stress the development from earlier to modern art, and he liked to illustrate the links in his exhibitions. Characteristic of his approach is a 1911 show of German and Scandinavian impressionist and expressionist graphics, which the visitor could compare and relate to works by Goya, Guys, Daumier, Manet, Degas, and Renoir. See the review by Johannes Sievers, "Ausstellung 'Zeichnende Künste' in der Berliner Sezession," *Kunst für Alle*, 26 (1911–1912), p. 211.

programmatic study on the renaissance of modern interior design. Finally, the cousins' association with the secession as its administrators gave them a key position in the modern art movement in Berlin. The energy and expertise generated by these linked activities could not be matched by the traditional art dealer, who saw himself more as a businessman with cultural leanings than as champion of an aesthetic program.

Although their enterprise was a cultural, if by no means a financial, success, the Cassirers were too self-willed to collaborate for long. In August 1901 they dissolved the partnership. The press became Bruno Cassirer's exclusive property; his cousin took over the gallery, pledged not to reenter publishing for seven years, and remained the secession's sole business manager. Bruno Cassirer's formal connection with the secession had ended, but he continued to support it in a number of ways over the next decades. In 1902 he founded the journal *Kunst und Künstler,* a better-edited and better-designed sucessor to *Pan;* first under Emil Heilbut's editorship, then under Karl Scheffler's, it developed into Germany's leading art periodical, and became a publicity organ and a friendly, if far from uncritical, observer of the secession.[34] The expanding list of Bruno Cassirer's firm included important works on art, art history, and aesthetics. Another special concern of the press was the illustrated book, which offered opportunities to artists from Slevogt to Grosz. The press was a pioneer in modern book design, a subject on which Cassirer held strong views. We must overcome the prejudice, he wrote in a characteristic passage, "that only designers schooled in the English tradition are qualified to work on our books. The deadly sterility of the achievements of [Morris and his followers] should have been enough to warn us. What other art form is judged by the standards of correctness, neatness, and perfect adaptability!"[35] He was serious in regarding books as a form of art. His ideal book design achieved the integration of image and word, with illustrations, typography, and other design elements not discreetly subservient to the text, but equal in their claim on the publisher. This orientation affected the appearance of all the works published by his press, even those without illustrations. His cousin Ernst Cas-

34. Günter and Ursula Feist have published an anthology of articles from the journal under the title *Kunst und Künstler: Aus 32 Jahrgängen einer deutschen Kunstzeitschrift* (Mainz and East Berlin, 1971). See also my review of this edition in *American Historical Review,* 77, no. 5 (1972), pp. 1472–73.

35. *Almanach 1920 des Verlags Bruno Cassirer* (Berlin, 1919), cited in Sarkowski, "Bruno Cassirer," p. 116.

sirer's edition of Kant's works, which he designed and published between 1912 and 1918, must be among the most beautiful scholarly texts produced in the Wilhelmine era, although, as Ernst Cassirer commented, the publisher could never quite forgive philosophy its self-sufficient independence from illustrations.[36]

After the First World War the proportion of literature on Cassirer's list increased, while that of books on art declined. The change was caused in part by his lack of enthusiasm for expressionism and other styles that succeeded impressionism, an attitude that he shared with his closest artistic advisor, Karl Scheffler. In the 1920s *Kunst und Künstler* became increasingly conservative; despite some enterprising titles, the press, too, in the last fifteen years of its existence — Cassirer emigrated to England in 1938 — assumed a traditional, distinguished, but somewhat old-fashioned character. Cassirer became troubled by the intensified antagonism between cultural values and modern life, and some of the books he published in the late 1920s and early 1930s addressed themselves to the social and psychological misery of the period. He had no instinct for politics, however, and this part of his program was off target and unimpressive. He was neither a revolutionary nor a reformer, but an innovator within a narrow band of high culture in the framework of educated and propertied society, whose decay he did not fully recognize and some of whose conventional aspects strongly attracted him. He was a gentleman farmer who efficiently worked the estate in the Mark he had inherited from his father, and for years he served as president of the German Harness Racing Association; his stable won the National Derby eight times.

In these attitudes, as in most respects, he differed from his cousin Paul. The two men shared a love of art and literature, which they approached with tastes schooled on international models, and they were alike in their tenacity. But Bruno Cassirer remained far more the German publisher than did his former partner, who spent much of his time abroad and who viewed social and ideological developments in the empire with considerable skepticism. Their personalities were equally antithetical. Bruno Cassirer was reserved, pragmatic, slow to reach decisions, and, once he had reached them, "not gifted with the power of letting go"; his cousin was impulsive, "constantly in motion and moving others," known for his verbal brilliance, with a speculative mind that never lost its playful, experimen-

36. In his contribution to the Festschrift for Bruno Cassirer, *Vom Beruf des Verlegers* (Berlin, 1932), cited in Sarkowski, "Bruno Cassirer," pp. 134–135.

tal quality.[37] Scheffler, who disliked him but recognized his gifts, called Paul Cassirer "one of the most audaciously unbiased men of his time [*er gehörte zu den verwegensten Vorurteilslosen der Zeit*]." In return, Paul Cassirer joked about Scheffler as the Parsifal of impressionism, who felt his purity threatened by every painter after 1900.[38]

Like his cousin Bruno, Paul Cassirer was an amateur painter in his youth, but he turned to writing early on. He first appeared in print in 1894, at the age of twenty-three, with a prose poem in Stefan George's *Blätter für die Kunst* and a naturalistic play, *Fritz Reiner*, whose hero is a talented painter but fails as a human being.[39] In the following year, he published a novel, *Josef Geiger*, a study of the artists and hangers-on of Munich bohemia, whom he described as a "strange mixture of beery philistines and decadents."[40] The publisher of the novel was Albert Langen, who had just launched the satirical journal *Simplicissimus*, which Cassirer helped edit.

Both the novel and the play rise above the literary treatment of art and artists standard at the time. Although their interpretation of psychological motives is inadequate, they contain all the material needed for such an analysis. They are the work of an intense observer, who writes about ideas and behavior with a dramatic realism that is softened neither by sentiment nor by fashionable assumptions. The central figure of *Fritz Reiner*, for instance, is an impressionist, but he is not presented as a cultural hero. On the contrary, he wonders whether impressionism constitutes "the true, genuine art . . . the only art," and speculates that someday he himself might revert to painting costume pieces and historical scenes: "When [the romantic painter Peter] Cornelius appeared, everyone shouted 'Hail, salvation is here! Hail! Hail! Hail!' Now we think of his style as an aberration, a decline. But someday impressionism, too, may seem a step backward." Using Reiner as his mouthpiece, the author satirizes the messianic pretensions of some artists, notes how odd it is that artists "always have the good fortune of living among interesting people," and ridicules the policy of giving medals and academic titles to artists, and the artists' eagerness to receive them. "To honor us we are made professors. To honor us we are

37. Georg Schwarz, *Almost forgotten Germany* (London, 1936), p. 214; Stefan Grossmann, "Paul Cassirer," *Das Tagebuch*, 7 (1926), p. 93.

38. Karl Scheffler, *Die fetten und die mageren Jahre* (Munich, 1948), p. 122.

39. Paul Cassirer, "Nachtstück," *Blätter für die Kunst*, 3 (August 1894), p. 95; *Fritz Reiner, der Maler* (Dresden and Leipzig, 1894).

40. Paul Cahrs [Paul Cassirer], *Josef Geiger* (Paris and Leipzig, 1895), p. 98.

equated with scholars . . . and we put up with it. Don't you see how insulting it is? We are not scholars, we are painters. Can you imagine Professor Michelangelo!"[41]

The novel and play enjoyed a *succès d'estime* but failed to satisfy their author. He looked for another activity that would appeal to his interest in art as well as in literature, and seemed to find his vocation as an art dealer and publisher. Later it became apparent that the role of middleman had never been wholly acceptable to him. In his memoirs, Scheffler suggests that Cassirer's talents predisposed him to be another Lichtwark or Tschudi, and the position of museum director with sufficient leisure to write scholarly and critical articles might indeed have suited him best. But his temperament and the standards of the Prussian bureaucracy would never have allowed him to reach a senior position in the museum administration. Consequently, in Scheffler's words, his "unusual energy was condemned to indirect creativity. At most Paul Cassirer could be effective through the talents of others, as a publisher, gallery owner, head of a theater."[42]

Cassirer never completely settled for Scheffler's "indirect creativity." Although he renounced literary ambitions, he continued to write occasional essays and lectures — a talk on Ruisdael for a study group associated with the gallery, some privately printed short stories, and, in later years, effective articles in defense of modern art.[43] But the emphasis of his activities now lay elsewhere, in his gallery and, after 1908 when his agreement with Bruno Cassirer permitted him to reenter the field, in his publishing firm. The first authors of the new Paul Cassirer Verlag included art historians and critics as well as such avant-garde writers as Heinrich Mann and René Schickele. Soon afterwards he started a separate press for graphics and luxury editions, to which he gave the name *Pan Presse*, an enterprise run for years at a loss, whose books and portfolios equalled the high standards set by his cousin's firm, Bruno Cassirer Verlag. Both the publishing house and the *Pan Presse* came to be closely if informally associated with the Berlin Secession.[44]

41. P. Cassirer, *Fritz Reiner*, pp. 46, 67, 75.

42. Scheffler, *Die fetten und die mageren Jahre*, pp. 121–122.

43. See, for instance, the undated fragment on Ruisdael, written between 1898 and 1901; and *Das Märchen vom Ewigen Weh*, privately printed, both in the Stanford Coll. GASC, Cassirer Collection I, Paul Cassirer Correspondence and Manuscripts, and II, Publications. Cassirer's later articles on art and the art market are discussed in chapters 6 and 7.

44. Wolfgang von Löhneysen, "Paul Cassirer — Beschreibung eines Phänomens," *Imprimatur*, new series, 7 (1972), pp. 161–162, 172–176.

In view of their personalities and inclinations, it is not surprising that Bruno and Paul Cassirer had more than a simple business relationship in mind when in February 1899 they offered to become the secession's managers. Customarily art organizations, whether established or secessionist, entrusted such matters as paying rent and taxes, keeping the books, and dealing with customers to a businessman who was essentially an employee, although his pay might consist wholly in a share of the profits from the sale of art works, catalogues, and admission tickets. The Munich Secession had given its manager, a prominent attorney, an advisory role in policy as well; he participated in scheduling exhibitions and similar matters. When the Berlin Secession was founded, several members of the executive committee imprudently offered the administrator's position to Georg Malkowsky, the editor of the art journal *Deutsche Kunst*. As compensation he demanded a substantial commission on all sales, the contract for printing the exhibition catalogues, and other rights — among them making *Deutsche Kunst* the official journal of the movement and excluding all publications but *Deutsche Kunst* and the catalogue from sale in the secession gallery. Months of negotiations were required to free the secession from an arrangement that would have turned it into the appendage of an undistinguished journal and brought far greater financial benefits to Malkowsky than to its members.[45] The Cassirers did not look to the secession for economic support. Their only financial demand was a 5 percent commission on sales to cover their expenses, which would include paying an accountant and secretarial help. Rather than restricting the sale of publications, they urged the secession to display as many good art journals as possible, foreign as well as German, and they were prepared to let others, even Malkowsky, print the catalogue, although in the end their firm published it "for the secession."[46] What they did want was to share in the leadership. Specifically, they asked for seats on the executive committee, without a vote but with

45. Malkowsky, who was prepared to "direct *Deutsche Kunst* into a modern channel," threatened legal action and unfavorable publicity if he was not appointed. The negotiations with him are outlined in the "Protokoll Buch" in the entries for 18 January, 2 February (with references to meetings on 14 and 16 May 1898), and 3, 16, and 25 March 1899.
46. Ibid., 25 March 1899. The Cassirers' advocacy of foreign art brought them into opposition with the conservatives on the executive committee. It had been decided that the secession would open with an exhibition of German works. On 16 March one of the cousins, left unidentified in the minutes, raised the possibility of including foreign artists in the second annual exhibition, to be held in 1900. Engel, Herrmann, Klimsch, and Frenzel objected: the public should know that "in our gallery it would

the right to advise on all matters, including the selection of paintings.

Somewhat evasively, the committee agreed that the Cassirers' position would be identical to that held by Privy Councillor Adolf Paulus in Munich, whose authority was left undefined but did not include the right to serve on juries or to vote in meetings.[47] This decision did not satisfy the Cassirers. After consulting Liebermann and Leistikow, their main supporters, they raised their demands: membership on the executive committee, with one vote between them; the title of "Sekretär der Berliner Sezession" – distinguished from Leistikow's title, "Schriftführer," which in this context might be translated as "corresponding secretary" – in which capacity they would countersign all official correspondence. Further, "they were by no means willing to renounce the right to serve on juries"; finally they suggested waiving all commissions on sales below 50,000 marks in return for small, regular payments to cover expenses.[48]

The minutes of the meeting of 6 March summarize the committee's "very long debate" on these demands: "Leistikow declares with great firmness that he is wholeheartedly in favor of accepting the conditions. Liebermann says that he tried everything to make the gentlemen more modest in their demands; as they have insisted on them he also favors acceptance. In opposition, Frenzel, Engel, Herrmann, and Klimsch emphasize that while it would be desirable to have the Cassirers as managers, their demands cannot be accepted by the committee because they conflict with the statutes [which reserved the right to vote and serve on juries to the regular members, who, without exception, were artists]." The committee agreed to convene a general meeting and to recommend the proposal to the membership; Leistikow's suggestion that the committee resign if the members voted against its recommendation was turned down.[49]

find a specifically German exhibition." Nevertheless in 1900 the secession showed numerous works by foreign artists, a development that contributed to the subsequent resignation of Frenzel, Engel, and others, some of whom later attacked the secession and Paul Cassirer for favoring foreign over German art. See also the comment in a discussion on the decor of the new gallery: "Because van de Velde is a foreigner we shall turn to him only in an emergency. After all, our first show is meant to be a *German* show" ("Protokoll Buch," 20 March 1899). The emergency evidently arose, because the gallery was furnished with chairs and benches produced in van de Velde's workshop.

47. "Protokoll Buch," 3 March 1899.
48. Ibid., 6 March 1899.
49. Ibid.

As soon as the committee adjourned, its two conservative members, Frenzel and Engel, met with an alternate member of the executive committee, the painter Willi Döring, who resigned from the secession some years later. The three decided that the Cassirers' demands — in effect to be treated as artists and regular members of the secession — were unacceptable and should not be submitted to a general meeting; they felt the demands "might cause a split, which would be extremely hazardous at present. It would be most damaging to us if construction [of the gallery] were to begin just when resignations, etc., destroy the secession's credit and compromise belief in its cohesion and ability to survive."[50] The cousins consequently scaled down their demands, and a compromise was reached. On 10 March Bruno and Paul Cassirer were offered and accepted the position of "Secretaries of the Berlin Secession with the same rights as Privy Councillor Paulus in Munich: seat and advisory vote in the meetings of the Berlin Secession and the meetings of the executive committee."[51] Actually, they gained far more. The minutes specify that, among other rights, "their names would be listed together with those of the executive committee on invitations to artists"; from the start, catalogues listed them as members of the exhibition committee, which was not the case with their Munich counterpart. They also participated in selecting and hanging works, for which no precedent existed in the juries of the academy, the Verein Berliner Künstler, or the annual salon. The formal and informal agreements that brought the two men to the leadership of a movement that, but for themselves, consisted entirely of working artists formed the basis for Paul Cassirer's election to the presidency of the secession ten years later.

The Cassirers' first task was to advance the building of the gallery. The site in the Kantstrasse was highly desirable, and the lease-holder offered it on reasonable terms; part of the plot belonged, however, to the city of Charlottenburg, one of seven municipalities that were soon to combine into Greater Berlin. Charlottenburg intended to buy the privately owned area when the lease expired in 1906, and to combine it with its own land into a public square. In the meantime, the city was prepared to issue at most a permit for a temporary structure, and the city attorney feared that even that step would increase the cost to the city when it acquired the land by eminent domain. On 13 March the executive committee was informed that

50. Ibid.
51. Ibid., 10 and 13 March 1899.

the mayor and the city attorney would not permit construction of the gallery.[52] By a fortunate accident, an uncle of the Cassirers, Max Cassirer, was a member of the city council; his nephews interested him in the secession's proposal, and at a meeting of the council on 16 March he was able to reverse the decision. If construction began at once, the gallery might still be completed by the middle of May and open at the same time as the salon, but new obstacles arose. The building inspector refused to issue even a provisional permit before 30 March at the earliest, and he "hinted at fundamental difficulties, which suggest that certain parties are plotting against our project."[53] Max Cassirer intervened once more, and with other liberal council members induced the inspector to issue the building permit.[54] To take advantage of the trees on the site, the architect Hans Griesebach designed an asymmetrical white stucco structure, a squat tower for the administrative offices, and six rooms, which could hold some 330 paintings, sketches, and lithographs, and fifty pieces of sculpture. Lovis Corinth called it a "quaint little building that caused every passerby to grin."[55] The contractor completed work on 19 May; one day later the gallery opened to the public, the walls still so moist that the pictures had to be taken down every evening and rehung the following morning.

III

The first show of the Berlin Secession was a conspicuous social and political success. Nearly two thousand invited guests appeared—most of the men, a newspaper noted, in white tie and tails, as the invitation specified. Among the guests were Max Koner, chairman of the current salon, who had not given up hope of healing the split among Berlin artists, and, surprisingly, the president of the Royal Academy, the only senior official present except for the liberal Lord Mayor of Charlottenburg. After an address by Liebermann, which a reporter called "as conciliatory as it was self-assured," and a

52. Ibid., 6, 10, and 13 March 1899.

53. Ibid., 25 March 1899.

54. *Berliner Lokal-Anzeiger*, morning edition, 29 March 1899. At this time the secession was reorganized into two bodies: an association of artists, whose work would be shown in the secession's exhibitions, and a limited company, Ausstellungshaus der Berliner Sezession, which was responsible for the construction of the gallery and for other financial matters, with Leistikow and Liebermann as managing directors. "Protokoll Buch," 10 and 20 March 1899.

55. Lovis Corinth, *Das Leben Walter Leistikows* (Berlin, 1910), pp. 54–55.

brief reply by the mayor, welcoming German art, whatever its direction, to the city, the gallery was opened. A banquet for the artists and their families and friends concluded an event that, except for its assertion of independence from imperial and bureaucratic tutelage, could hardly have been more respectable.[56]

The same note of moderation and breeding characterized the show itself, which did not achieve the brilliance and shock effects of subsequent exhibitions. It consisted of a balanced survey of secessionist painting and sculpture throughout Germany. The great names represented—Liebermann and Leistikow among Berlin artists, and such guests from Munich and elsewhere as Leibl, Böcklin, Uhde, and Thoma—contributed little that was new; instead, they showed mostly works in a familiar vein, some painted a decade or two earlier. Among emerging figures, only a handful seemed to stand above the many dozens of competent but scarcely innovative, let alone revolutionary, talents. That despite these shortcomings the secession impressed a broad public, more than a few connoisseurs, and was discussed extensively in the press, indicates Berlin's receptivity toward a movement eschewing the traditional and official in art; it also suggests how feeble an artistic institution the salon had become.[57] The Glaspalast attracted many more visitors than the little building in the Kantstrasse, both in 1899 and in subsequent years; but they formed a generally passive majority, drawn in the main from the lower middle class and segments of the middle class whose cultural demands did not extend to non-German ideas, books, and art. Among the minority who sought more in art than a

56. The opening was thoroughly reported in the Berlin press. See, for instance, the liberal publications *Berliner Tageblatt, Vossische Zeitung,* and *National-Zeitung,* all of 20 May 1899; and the conservative *Kreuzzeitung* and liberal *Freisinnige Zeitung* of 21 May 1899.

57. Characteristic reviews are the very favorable discussions by Georg Voss in *National-Zeitung,* 20 and 21 May 1899, and by Fritz Stahl in the *Berliner Tageblatt,* 20 and 27 May 1899; the brief but relatively positive notice in the *Kreuzzeitung,* 21 May 1899; the review in the art journal *Kunst für Alle,* 14 (1898–1899), p. 314; and the antagonistic article in *Vossische Zeitung,* 24 May 1899, by the doyen of Berlin art critics, Ludwig Pietsch, whose point of view was far more conservative than the editorial policy of his paper. Pietsch had some influence on the emperor, whose guest he had been on some of his vacation trips, and was a friend of Werner. His article, "Die Ausstellung der Sezession," praised the works of some of the Munich painters, failed to mention Liebermann, Leistikow, and other Berlin painters by name, but described their paintings in such terms as "botched work and artistic sacrilege disgrace the walls [*die Wände verunzierenden Stümpereien und Kunstfrevel*] . . . [these] disgusting daubs . . . testify partly to lack of talent, inability, and ignorance, partly to a total absence of feeling for the truth and beauty of nature, and partly to serious diseases of the eye and the brain."

few hours' elevated relaxation, the secession soon overshadowed
the salon.

In later years, social differences between visitors to the secession
and to the salon were often noted, although never systematically
analyzed. One of the most differentiated assessments appeared in a
1911 article by Julius Bab, a critic who wrote for Social Democratic
papers and regularly contributed columns on cultural affairs to lib-
eral and moderate German and Austro-Hungarian publications:

Berlin-West, high finance, the upper middle class—in particular its Jew-
ish elements, who in this area are very influential—but also university grad-
uates, insofar as they do not hold official positions: all these usually go to
the Kurfürstendamm [where the secession had moved in 1905] rather than
to Moabit [the district in which the Glaspalast was located]. The daughter
of a good family, the adolescent from the West End, the culturally eager
student, the young and overeducated coffee-house man of the world—they
make up the secession's public, a public that is actually just as naive and
piously obedient as are the visitors to the salon: the officer's daughter, the
maiden aunt from the provinces, the office clerk, and the shop girl—al-
though their nature compels them to adopt a somewhat more critical and
negative pose . . . Further, it is characteristic and significant that the
leaders of the labor movement, though not the workers themselves, are
in touch with the secession and not with the salon.[58]

Among people seriously concerned with art, not only the support-
ers of modernism but also its opponents found the secession more
important for the moment than the salon. For both groups, the
achievement of the individual exhibitor in the secession mattered
less than the coming together of artists whose technical competence
was on the whole acknowledged even by critics friendly to academic
art; these artists nonetheless rejected the traditional, state-support-
ed conduits of aesthetic communication, and instead declared that
they could do better on their own. Insofar as the cultural life of the
capital and of the country as a whole had political and ideological
facets, the opening show of the secession can be compared to an ear-
ly election victory by a new political party, which arouses strong
positive and negative reactions merely by the fact of its existence.

A more frivolous element strengthened the secession's impact: its
novelty and small size exerted a snob appeal that the salon could not
match. The emperor's well-known disapproval did not inhibit
members of his inner circle and some senior officials from visiting
the gallery. Only a few days after the opening, the chancellor of the

58. Julius Bab, "Vom Berliner Bildermarkt," *Pester Lloyd*, 7 September 1911.

Reich, Prince Hohenlohe, appeared in the Kantstrasse and commented favorably on the exhibition. When, in an excess of zeal, the commandant of the Berlin garrison forbade officers to enter the gallery in uniform—equating the secession with cabarets of dubious repute—its shock value was enhanced, as was its appeal to the curious and to those who wanted to show their opposition to a concept of art that had produced the Siegesallee. The exhibition hours had to be extended, and the catalogue was in such demand that it was reprinted.[59] Sales of paintings and sculptures by members of the secession totaled 33,000 marks, and the executive committee was able to begin repaying the money advanced to finance the gallery. By 1902 the secession had reduced its debt by three-fourths.[60]

The catalogue contained a brief introduction, taken from Liebermann's speech at the opening of the gallery, whose central paragraphs announced the program of the new group:

Our exhibition differs from customary exhibitions not by what we are showing—for masterworks cannot be stamped out of the ground—but by what we do not show.

We present only a small number of works, and only works by German artists. We are convinced that the massive accumulation of paintings and sculptures goes against the best interests of the public and of art itself. The eye of the visitor is only too quickly fatigued by a long flight of rooms, crammed with paintings, where genuinely good works, always few and far between, are crushed by the weight of mediocrity.

That our first exhibition is limited to the art of our country is not a sign of parochialism. We want to start by presenting a survey of German art to-

59. A luxury edition was also published. The 1899 catalogue was an undistinguished mixture of Gothic and Latin typefaces and clashing designs, much inferior to the subdued elegance of later volumes. The text was preceded by a muddy pen-and-ink signum by Martin Brandenburg, showing Sisyphus struggling with the boulder, which the executive committee felt appropriately symbolized the secession's task; "Protokoll Buch," 20 March 1899. The back cover was stamped with another symbolic emblem by Ludwig von Hofmann. Both designs were deleted in subsequent years, Hofmann's being replaced in 1901 by a black-and-white version of Thomas Theodor Heine's charming poster for the secession.

60. The two international art exhibitions held in Germany in the 1890s had total sales far greater than the secession's 33,000 marks: 915,905 marks in Berlin in 1891, and 681,873 marks in Munich the following year. But these figures include sales by artists from all nations represented. In the Paris international exhibition of 1900, the 303 German exhibitors sold works for a total of 28,881 marks. The cost of German participation was over 200,000 marks. Heinrich Deiters, *Geschichte der Allgemeinen Deutschen Kunstgenossenschaft* (Düsseldorf, [1906]), pp. 38, 46; *Bericht des Hauptvorstandes der Allgemeinen Deutschen Kunstgenossenschaft über die Betheiligung der Deutschen Künstlerschaft an der Weltausstellung in Paris 1900* (Berlin, 1901), p. 34.

day. If in coming years foreign artists entrust their works to us, we shall be delighted to welcome them as our guests . . . but it seemed unworthy for German artists to mask any weakness we may have behind borrowings from other countries.

In selecting the works for our exhibition, talent alone, whatever its style, was the determinant . . . We do not believe in a single, sacred direction in art. Any work, whatever its style, that expresses feelings honestly seems to us to constitute art. Only craftsmanlike routine and the superficial production of those who regard art as a cow to be milked are excluded on principle.[61]

At the heart of Liebermann's statement is the denial of the authority of any particular style or manner, a guiding principle that the leaders of the secession were to reaffirm throughout its existence. The admission that not every work even in a small show could be of high quality — candor rare in exhibition catalogues — became another fixture in secessionist literature. Also interesting are the explanation for the absence of foreign artists and the promise that they would be included in future shows — a victory for the Liebermann-Leistikow faction. Nevertheless, the secession was serious in its effort to present a survey of modern German art, which would incidentally bind other secessionist groups more firmly to its cause. In the total of 187 exhibitors, Berlin artists were a minority. Forty-six painters came from Berlin, compared with 57 from Munich — among them Corinth and Slevogt, who would soon settle in Berlin and join the secession — and 9 from Dresden. Other guests were from such cities as Karlsruhe, Frankfurt, and Stuttgart; four painters represented the artist colony in Worpswede; even two Swiss, Arnold Böcklin and Ferdinand Hodler, who were regarded as essentially German, took part.[62] As a result, space was very limited, and some members of the secession did not exhibit at all, either because they chose not to submit works or because their entries were rejected. Most exhibitors showed between one and four works; of the members of the

61. *Katalog der Deutschen Kunstausstellung der "Berliner Secession"* (Berlin, 1899), pp. 13–15.

62. J. P. Hodin's assertion in his monograph, *Edvard Munch*, (New York, 1972), p. 103, that Munch was not invited to exhibit because "he was considered an eccentric, a slightly undesirable interloper," is the kind of facile invention, based on ignorance, that is too often met with in references to the secession, particularly in the non-German literature. It would be difficult to find stronger admirers of Munch at the turn of the century than the leaders of the secession, the same men who had protested the closing of his Berlin exhibition a few years earlier. Munch was not invited in 1899 because the opening exhibition was meant to be exclusively German; dozens of his works were included in subsequent shows.

executive committee, only Liebermann went beyond that number with four paintings and four pastels and sketches. At the same time, the major German painters of the previous generation, whose pres- ence was politically valuable to the secession, were not held to any limit. Leibl was represented by fifteen paintings and sketches and Böcklin by ten paintings.[63]

The diversity of styles in the exhibition was dominated by vari- eties of naturalism; works influenced to a greater or lesser degree by impressionism or *art nouveau* were in the minority. The themes treated were equally conventional: landscapes, portraits, some alle- gories with classical or Teutonic allusions. Only a few items could be considered social criticism: two etchings and a drawing by Käthe Kollwitz and several works by Hans Baluschek, among them a painting, *Choirboys*, showing an aggressively unidealized group of adolescents, burdened by all the conflicts of their age, with their middle-class teacher and tenements in the background. Not as open- ly grim but equally scathing were sketches by two regular contribu- tors to *Simplicissimus:* Ferdinand Recnicek's studies of "High Life", and Eduard Thöny's cartoons of Prussian officers, which have be- come classic exposés of the brutality and decadence of militarism. In the approximately 380 items in the exhibition, however, this dozen did not loom large.

The same was true of the few paintings and sculptures that might

63. After Böcklin's death in 1901, the academic sculptor Reinhold Begas, who had been shocked at the artist's willingness to exhibit with the secession, accused Lieber- mann and his colleagues on the executive committee of having exploited the "dying eagle" for their own ends. The same bitter animosity led to the exclusion of Adolph von Menzel's works from the opening show. Private owners had lent the executive committee several oils, gouaches, and sketches by Menzel, which, it was hoped, would demonstrate the link between modern German art and one of the great pain- ters of the previous generation. To make certain that the eighty-four-year-old Menzel, whom the emperor had showered with honors, would not be embarrassed by exhibit- ing his works with the new group, the committee asked for his personal approval, which Menzel gave. But two days before the opening of the exhibition, the *Kreuzzeit- ung* printed a letter in which Menzel claimed that his pictures were being included without his knowledge. When the committee pointed to his written consent, Menzel published a second statement to the effect that he had forgotten that "I had actually given my consent while momentarily distracted." The executive committee thanked him for withdrawing his charge; but the members declared themselves "unwilling to make use of a right granted us 'while momentarily distracted,'" and withdrew the pictures from the show. It was then learned that the old man had been persuaded, probably by Werner or his friend the painter Paul Meyerheim, to accuse the secession of unethical behavior. The incident, which tells something of the atmosphere of the time, can be pieced together from acounts in the Berlin press; see, for instance, *Kreuzzeitung*, 18, 20, 24, 26 May 1899; *Berliner Tageblatt*, 19 May 1899; *Freisinnige Zeitung*, 25 May 1899.

be regarded as overtly erotic: a *Bacchanalia* by Franz Stuck and an-
other by Lovis Corinth, whose gross theatricality was undoubtedly
offensive to some viewers; perhaps also an allegory, *In Elysian
Fields*, by Franz Stassen, in which a nude man and woman greet
robed newcomers; and a moderately impressionistic nude by
Erich Hancke, Liebermann's future biographer. But any academic
exhibition could outdo works such as these in explicit or allusive
treatments of sexual motifs.

The general absence of socially and sexually offensive themes
once more raises the question why the secession was so strongly
opposed. I have suggested that the very existence of the group, re-
gardless of its program, would have been troubling to many. Anton
von Werner was not alone in fearing the effect of a split in art organi-
zations and the development of competing markets. The secession
also aroused hostility for having voluntarily withdrawn from an
organization, the annual salon, which was patronized by the emper-
or, was sponsored by official bodies, and received a subvention from
the state. In Prussia the pattern usually ran in the opposite direc-
tion. Association with the state was desired; it was rare for a group
to break such an advantageous link. The secession was, of course,
far from objecting to official patronage; its members had left the sa-
lon merely to free themselves from a jury dominated by traditional-
ists, and they did not regard this move as in any sense bringing them
into conflict with the state. But people whose thinking on public
issues was shaped by loyalty to the government could see the matter
in a different light. Considerations of this nature, however, formed
only one source of opposition to the group. Other, and I suspect
more important, motives had to do with the secession's thematic
and stylistic characteristics, even if little about them was aggres-
sively avant-garde.

Although art that might be condemned as politically anarchic was
scarcely to be found in the exhibition, an affinity did exist between
the use of working-class themes by Uhde, Liebermann, and their fol-
lowers and the themes and milieus of the dramas of Gerhart Haupt-
mann or, to mention a somewhat earlier work, Theodor Fontane's
classical novel *Irrungen Wirrungen*, an account of an affair between
a Guards officer and a laundry girl that outraged some Prussian con-
servatives. The parallels rarely coalesced into direct borrowings—
Käthe Kollwitz's use of Hauptmann's *Weavers* is the major excep-
tion—and specific political points of view that transcended a general
human sympathy for the poor were even rarer. But in rejecting their
idealistic or romantic predecessors, as well as in their interest in the

unadorned world of the poor, the naturalistic authors and the naturalistic and impressionist painters found themselves in a similar historical position; moreover, the readers of the novels and plays that explored the lives of the uprooted, or dissected middle-class standards, also formed the audiences for secessionist movements throughout Germany. Some members of the Berlin Secession had close personal relations with modern authors; Leistikow and Hauptmann were friends, for instance.[64] It was not surprising that people who were offended by the vogue for social comment and criticism in contemporary literature would place the secession in the same politically and morally dangerous camp, despite the fact that, with the change from naturalism to impressionism, any identifiably political element in art almost always disappeared.

In Wilhelmine Germany even the absence of overt comment in paintings of peasants, fishermen, and men and women in old-age homes could be disturbing. Liebermann had by now left his early naturalism behind; but the works of his first period—such as *Orphanage in Amsterdam*, which was shown in the exhibition—and the paintings of the many secession members who had worked or continued to work in this vein aimed for realism without the sentimental or anecdotal additions that traditionally rendered lower-class motifs agreeable. William II expressed a common attitude in demanding that art should elevate, either by depicting ideal beauty or by arousing patriotic or other noble sentiments. At most, amusing comments were acceptable in such appropriate contexts as peasant weddings, children playing, old gentlemen dozing on park benches while courting couples found each other around them. The naturalism of the Berlin Secession was nothing like this. Two pages in the exhibition catalogue define the difference. The sculptor Walter Schott, who was not a member of the secession, had been asked to lend the exhibition one of his busts of William II, which was reproduced at the head of the section of illustrations, evidently as a statement that the paintings, drawings, and sculptures reproduced on subsequent pages were the kind of German art the emperor *ought*

64. Corinth, *Das Leben Leistikows*, p. 62, mentions Leistikow's literary associates in the 1890s: Hauptmann; the critic and collector Julius Elias, who was related to the Cassirers; Otto Brahm, the director of the *Freie Bühne*, the private theater that first performed Hauptmann's plays; the publisher Samuel Fischer; the authors Max Halbe, Otto Erich Hartleben, and Peter Hille. Paul Cassirer, who became an intimate friend after he settled in Berlin, disagreed with Leistikow's good opinion of Hauptmann, but he predicted "it would take years for the avant-garde to recognize the brutal sentimentality behind Hauptmann's social conscience."

to support. Schott's bust was in the worst official mode: the emperor enveloped in the uniform of the Gardes du corps, lifeless except for the pathos of absolute authority, the whole framed by the dramatic folds of a cavalry cloak. The illustration that immediately followed exemplifies the very different kind of art that the secession valued: a sketch by Leibl of a peasant in nondescript clothes, sitting on a chair, filling a small pipe. No message is conveyed except that of a man resting after work and of the relationship of his body to its surroundings—wall, windows, chair; but Leibl's undemonstrativeness is a firm denial of the inspirational or entertaining mission of art.[65]

This denial was reiterated by others, most forcefully by Liebermann, not only in his paintings but also in articles and lectures that exerted a strong influence on many younger artists. Liebermann declared that contemporary German art should not tell a story—not in observance of a universal principle but because it had to overcome its aridly academic recent past. Subject matter was meaningless, or, rather, it was significant only insofar as it stimulated the imagination and emotion of the artist: "a well-painted turnip is as beautiful as a well-painted Madonna."[66] Obviously the principle of thematic indifference worked against social criticism; it was equally antagonistic to the affirmation of social and political attitudes approved by the emperor, the Protestant church, or the Agrarian League. In the eyes of radical Prussian conservatism, which was then turning from its old beliefs to the more viable modern ideology of a racially defined German nationalism, this detachment was, in fact, highly political. To a view of the world that sought salvation from domestic and external dangers in a disciplined and obedient society ruled by the politics of national unity, the secession's apolitical stance could appear as a symptom—even as a source—of the contagion.

If many Germans were offended by the approach to subject matter that characterized the first exhibition of the Berlin Secession, they were no less disturbed by some of its stylistic tendencies. The move-

65. Ferdinand Stuttmann, *Max Liebermann* (Hanover, 1961), p. 47, suggests that "even such a liberal-minded group as the secession could evidently not afford to disregard custom, and thus [a] bust of Emperor William II appears in first place [among the illustrations]." But catalogues of the period by no means invariably included such a portrait, nor did the emperor's picture ever again appear in a secession publication. The reason for the bust's presence is more likely reflected in the family tradition: it was meant to declare that the secession was showing the best German art, and juxtaposing the emperor with the tired peasant was a joke typical of Paul Cassirer.

66. Max Liebermann, *Die Phantasie in der Malerei* (Frankfurt am Main, 1978), p. 49.

ment from the naturalistic illusion of reality to a more subjective naturalism, which can be traced in the work of Liebermann, Uhde, and others in the 1880s, and their subsequent breakthrough to a modified impressionism, presented the art public with new problems of appreciation and comprehension. Impressionism did not dominate the opening show, but it was sufficiently in evidence to cast its aura over the whole. That the secession's impressionist paintings were misunderstood and derided is not surprising. It was only a few years earlier, after decades of resistance and indifference, that the French public and collectors had at last accepted their own impressionists. In Germany in 1899 impressionism, whether native or foreign, was still a relative novelty. When the works of Manet, Degas, Pissarro, and Renoir appeared more frequently in German exhibitions and galleries, they were accepted more rapidly than in France, in part because the decisive battle had already been won there; but dislike of impressionism also remained more intense in Germany.

In a country that politically and psychologically had entered the virulent phase of nationalism, impressionism was handicapped by its alien origin. Underlying the xenophobic rejection was another concern, however, which was aroused by the symbolic function of art. The annihilation of a realistic depiction of the world, begun by later naturalism, was carried much farther by impressionism. Its dissolution of form into color and atmosphere could be understood as yet another assertion of the ambiguity and instability not only of the physical environment but of social and political conditions as well. It is not surprising that many, especially among the more conservative elements of the upper, middle, and lower middle classes, fighting to maintain their status in a time of severe demographic and economic changes, reacted with intense anxiety to an art that questioned familiar assumptions and showed them an unknown world.

Fear of impressionism because it cast doubt on accepted reality was not unique to German society; the phenomenon would not have existed had it not reflected universal concerns. In France, too, impressionism had been opposed on grounds of social morality. But once the shift in taste had occurred, impressionism in the hands of the masters and of their myriad mediocre followers became as much the art of the well-situated middle class as the martial set pieces of Ernest Meissonier and Alphonse de Neuville or the exotic eroticism of Gustave Moreau had ever been. That step was never taken in Germany. Impressionism found an expanding market in museums

and private collections, but it never became the art of the German bourgeoisie. A large part of the population continued to regard it as an alien element, and much of the ideological resistance it encountered derived from this sense of its strangeness and of its dangerous un-German modernity. Opposition to a way of painting that some Germans had learned from foreign artists and were introducing to Germany was a declaration of political faith as well as an expression of cultural anxiety—two concerns that help explain the intensity and long duration of the war over impressionism, a war in which the opening show of the Berlin Secession was the first major battle.

To outline the variety of the opposition's motives is to indicate its fragmented character. Economic worries of the art proletariat were not easily fused with the vague cultural unease weighing on parts of the middle class, nor with the dynastic rigidity of William II. Indeed, the secession was to help bring these disparate elements closer together, but they never coalesced into a true common front. The emperor, in collaboration with Anton von Werner, could do much to inhibit the secession; yet even in ministries and other central agencies, such as the academy, over which he had a measure of direct control, the emperor's campaign against the modern in art was not invariably supported. Two key posts, the directorships of the Berlin museums and of the National Gallery, were occupied by men who wholly disagreed with him and who used government funds and private donations to enrich state and municipal collections with works of impressionists and other contemporary artists. Their example and help led other Prussian and German museums in the same direction.

Robert Bosse's efforts to prevent the emperor from "degrading" the secession members who held the large gold medal have been mentioned earlier. At the same time as this episode took place, two days before the opening of the secession's first exhibition, the Landeskunstkommission, with the approval of the government representatives on the board, recommended that the state buy a Liebermann oil for the respectable sum of 25,000 marks. The following year it recommended the purchase from the Cassirer Gallery of a landscape by Leopold von Kalckreuth, soon to be president of the oppositional Deutsche Künstlerbund.[67] Not all conservatives, how-

67. In 1897 the commission had rejected, by a vote of 11 to 5, the purchase of another Liebermann oil and of a study for the *Shoemakers*, the painting bought in 1899. See decisions of the commission, 11 May 1897, 18 May 1899, and 9 June 1900, ZStA

ever defensive their political posture, turned away from German impressionism; purchases of the work of secession members, and commissions for portraits by them, indicate that a market for modern art existed among the conservative elite, even if it could not compare in importance with purchases by the liberal upper middle class of Berlin, Saxony, and western Germany.[68]

The unitary, repressive character of the Wilhelmine "system" has recently been stressed by some historians, who suggest that the court, the ministries, the traditional state-allied elites, and their supporters throughout the country collaborated closely and methodically to inhibit further development of responsible constitutional government and hold back the liberalization of German society. Tendencies in this direction clearly existed, and probably grew stronger in the years before 1914. But as the reactions to the birth of the secession indicate, the response to modernism could be frag-

Merseburg, Königliches Geheimes Civil-Cabinett, Rep. 2.2.1, Nr. 19908, unpaginated. At that time the commission was chaired by a senior official of the Kultusministerium and consisted of the president of the Academy of Arts, museum directors, directors of art academies (among them Anton von Werner), and painters, sculptors, and architects. Although the commission's recommendations, which were usually accepted by the government, expressed aesthetic and sometimes ideological preferences, they were strongly influenced by the availability of funds. As in awarding medals in the annual salon, the emperor possessed ultimate authority over the purchasing budgets of the state museums, which he exercised at least intermittently when major expenditures were considered.

In response to an Imperial Rescript of 29 August 1899, the minutes of the commission meetings from 1901 on were no longer deposited in the Geheime Civil-Cabinett. From 1911 on they are part of the files of the Kultusministerium. The chairman in 1911 was a member of the highest aristocracy, Count August von Dönhoff-Finckenstein, who held the title "Landhofmeister im Königreich Preussen." He was assisted by two privy councillors in the Kultusministerium as government commissioners, and sixteen officials and artists. The conservative point of view was strongly represented on the commission, although this did not guarantee its approval of traditional or patriotic works. On 8 May 1911, for instance, the commission rejected paintings by two prominent academicians, Max Schlichting, a former member of the secession, and Hans von Petersen, both vocal leaders of the opposition to modern art. In October 1913 Liebermann was elected by the academy as one of its representatives on the commission and confirmed by the Kultusministerium. ZStA Merseburg, Kultusministerium, Rep. 76 Ve, Sekt. 1, Abt. I, Teil I, nr. 3, unpaginated, entries of 8 May 1911 and 27 October 1913.

68. In 1899 members of the Berlin Secession exhibited portraits of the Duchess of Schleswig-Holstein, the Baronesses Mumm and Reibnitz, and Baron Gleichen-Russwurm (who may, however, have been the painter of that name). Portraits of members of the academic and literary establishment included a painter of Ernst Dümmler, the chairman of the Monumenta Germaniae Historica, by Dora Hitz, who after Käthe Kollwitz was the most important woman artist in the Berlin Secession. Members of other secessionist groups contributed portraits of Bismarck, a Bavarian princess, and other notables.

mented and contradictory. It is true that the arts were not a matter of major national concern; and indifference, or the willingness to tolerate diversity in an area of marginal importance, must have played a part in diluting effective repression. Still, it was an area in which government policy and the attitudes of the educated classes constantly met and affected each other; certainly the symbolic and educational functions of the arts were taken seriously by the emperor and conservative interest groups—probably too seriously. Nevertheless, they could not impose their vision of a cultural war, with lines clearly drawn, even on their own natural allies. In the ministries the concept of a neutral bureaucracy repeatedly hobbled more activist approaches, and the belief in the benefits to Germany of a less narrowly directed development in culture, society, and politics remained widespread. The response to the Berlin Secession in 1899 and over the course of the next decade and a half suggests that it was not so much the comprehensiveness of the opposition to modernism as the exceptional intensity and recklessness of what opposition there was that constitutes the truly significant historical force in the Wilhelmine era, both at the time and in its influence on the future.

4

GERMAN IMPRESSIONISM AND THE
CONFLICT OVER ART AT SAINT LOUIS

I

The favorable reception of the secession's first show, and the new group's air of permanence, contrasted strongly with its previous difficulties. Once the problems of organization were solved, it became apparent that the secession was responding not only to the needs of a few dissatisfied artists but also to the interests of at least some members of the public. Official opposition had proved unavailing in part because Max Liebermann, Walter Leistikow, and others were determined to free themselves from controls inherent in the traditional system of exhibition and patronage, but basically because neither emperor and academy nor Verein could inhibit the market for modern art that was gradually developing in Berlin. Their failure had implications beyond the aesthetic and commercial; inability to block innovation in the small but highly visible world of art was widely regarded, whether optimistically or anxiously, as a sign that social and political changes in the larger national sphere were possible, even imminent.

The secession itself drew a different, narrower, lesson from the welcome it was given: it could afford to be more selective and venturesome than had seemed possible at the start, when works of doubtful quality were accepted to gain the support of other German secessions. When the second annual exhibition was organized, Liebermann and his followers on the executive committee overrode their more conservative colleagues who wished to exclude foreign works; they thus took the risk of disturbing the secession's constituents among the Berlin public, who were still learning to accept modern German art, for the sake of accustoming them to modern art from other countries as well. The second exhibition, which opened in May 1900, was somewhat larger than its predecessor, and Berlin artists were still outnumbered by guests from Munich, Karlsruhe, and other German art centers. But the show also included the works of forty-four foreigners, among them Pissarro, Renoir, Whistler, and

Zorn.[1] By 1902 the increasingly rigorous jury had reduced the size of the annual show by one-fourth. The number of Berlin artists now matched the number of those from the rest of Germany, and foreign guests made up one-fifth of the total. Among the sensations of the 1902 show were twenty-eight pictures from Munch's *Frieze of Life*. Other foreign exhibitors were Kandinsky, Monet, and Manet, whose five paintings were hung on a "wall of honor."

In a further effort to educate the public and broaden the market for modern art, the secession began to hold regular winter exhibitions of watercolors and graphics—something that was fairly unusual at the time. "It is a regrettable fact," stated the introduction to the first winter catalogue,

that the public slights the graphic arts, although they deserve particular attention. Just as the pencil most readily follows the intentions of the artist, so a sketch provides the most immediate insight into his creativity. Unfortunately the immediacy of a sketch all too often disappears in the laborious and difficult process of oil painting.

Drawings undoubtedly make greater demands on the collaborative imagination of the viewer; they merely suggest what the artist wants to express. But only the viewer who has penetrated the hieroglyphics of the drawing will fully understand the completed work of art.[2]

This characteristically uncompromising and didactic statement introduced an exhibition of nearly 700 items, among them numerous works by Max Klinger and Liebermann, smaller groups of works by Käthe Kollwitz and Leistikow, and thirty-five sketches, cartoons, and book-jacket designs by the *Simplicissimus* contributor Thomas Theodor Heine, who had become closely associated with the secession. In 1903 the winter show included sixty-three works by Aubrey Beardsley, and nearly as many sketches by one of the most important newcomers to the group, Max Slevogt; there were also many works by Zorn, Kollwitz, Edvard Munch, and Heinrich Zille, who was one of the few secession members who was a socialist, a less realistic, less overtly political, more humorous Berlin counterpart of Théophile Steinlen. What incredible progress, commented the

1. According to a possibly apocryphal story then current in Berlin, Hugo von Tschudi wanted to acquire a painting by Whistler for the National Gallery, and asked Leistikow to act as his agent. Whistler refused: his work would be out of place in the gallery of a ruler who did not understand art. The anecdote is told in Werner Weisbach's memoirs, *Und alles ist zerstoben* (Vienna, 1937), p. 256.

2. "Vorwort," *Katalog der vierten Kunstausstellung der Berliner Secession* (Berlin, 1901), pp. 7–8.

critic Oscar Bie, that graphics, "this intimate, modest type of art, can attract a spoiled public for months." In the course of a few years, he believed, Berlin had changed from a cultural backwater to a "significant arena in which the conflict between subservient and free art is waged, one grouped around the emperor, the other centered on the secession."[3]

In this struggle, the secession found an important ally in the Cassirer Gallery, which held six to eight major shows a year and soon became Germany's leading gallery of modern art as well as an influential showplace of such hitherto ignored old masters as El Greco.[4] Its unusual position is indicated by the fact that, as late as 1910, no dealer in Vienna specialized in modern French art. The Gallery became the main conduit for French impressionism and post-impressionism to Central Europe, and greatly strengthened the international character of the secession. Other private galleries opened and further increased the range and variety of art to be seen in the capital. Sales rose significantly. Almost from the start, the secession was financially secure, covering its expenses and regis-

3. Oscar Bie, "Berliner Kunstausstellungen," *Neue Deutsche Rundschau*, 14 (1903), pp. 515, 517. See also Hans Rosenhagen's similar appraisal in "Die Kunstausstellungen von 1902: Berlin," in *Jahrbuch der bildenden Künste* (1903), p. 8. Nevertheless, years later Liebermann still complained that the public was insufficiently interested in the graphic arts; see his opening address at the black-and-white exhibition of 1909, reprinted in his collected writings, *Die Phantasie in der Malerei* (Frankfurt am Main, 1978), p. 180. The Royal Academy of Arts rarely showed graphics. In 1911 Karl Scheffler wrote: "Drawing has become an independent means of expression, a language of its own, a language of which the academy is still completely ignorant"; see "Notizen über die 23. Ausstellung der Berliner Sezession," *Kunst und Künstler*, 10 (1911–1912), p. 188.

4. In 1903, for instance, the gallery showed works by Munch, Bonnard, Vuillard, Degas, Monet, Goya, El Greco, and Fantin-Latour, as well as oils and graphics by members of the secession. The following spring it held the first large show in Germany of paintings and watercolors by Cézanne, whose reputation was still far from secure. *Kunst und Künstler*, 2 (1903–1904), p. 378, noted: "Paul Cassirer offers an exhibition of the difficult-to-understand, magnificent, powerful artist Cézanne." Hans Rosenhagen wrote: "After the Cassirer Gallery had repeatedly shown individual works [by Cézanne], and had seen them decisively rejected by the public and the great majority of critics, the attempt had to be made to demonstrate Cézanne's significance by means of a more comprehensive exhibition"; "Von Ausstellungen und Sammlungen," *Kunst für Alle*, 19 (1903–1904), p. 401. By the 1907–1908 season, which ran from September through the following June, the gallery scheduled ten different exhibitions, beginning with sixty-nine Cézanne watercolors, six oils by Matisse, and thirty-five works by Munch. Among artists represented in the following exhibitions were Leistikow, Beckmann, Liebermann, Corinth, Slevogt, and Nolde. For two weeks in March the gallery showed twenty-seven van Goghs, together with works of the French impressionists. The season concluded with an exhibition of nineteenth- and twentieth-century art, dominated by twenty-eight oils and thirty-eight drawings by Goya. Paul Cassirer, *X. Jahrgang: Ausstellung 1–10* (Berlin 1907–1908).

tering a modest profit each year; yet it was still far from posing a serious economic threat to the salon, since conventional art continued to dominate the German market. In 1901 the salon earned over 500,000 marks from admissions and sales, and only slightly less the following year, while the secession's returns amounted to at most 100,000 marks. But the number of exhibitors in the salon was far greater—over six times as many in 1903—and immediate sales were less important to the secession than the effective exposure an artist's work received, and the opportunity he had of meeting potential buyers in quiet, elegant surroundings.[5]

In the catalogue of the 1903 exhibition, the painter Wilhelm Trübner wrote that such unofficial shows as the secession's had become the center around which the art world revolved, and that they did not subject artists to the patronage control of princes, the church, and guilds, as in earlier days.[6] That may have been too optimistic. An art historian who knew many members of the secession later wrote that Berlin artists rarely again earned as much as they had in the early years of the century, but that it was questionable whether their work benefited from dependence on largely ignorant middle-class buyers.[7] Still, the salon was more of a marketplace; the shows of the secession—their economic concerns notwithstanding—were more social and cultural events, which attracted not only devotees of the modern but also many people of traditional outlook. Baroness Spitzemberg, whose diary is one of our best sources on court society in Imperial Berlin, commented on her visit to the secession's second annual show: "Together with much that is incredible, the exhibition contains many beautiful paintings, as well as magnificent statues and sculpture."[8] For the transformation of the cultural atmosphere that the secession attempted, educating such viewers as Frau von Spitzemberg to tolerance or even sympathy was as important as finding buyers.

The secession's effectiveness increased as new talents emerged among its members and as it attracted established artists from other parts of Germany to Berlin. An example of the former was the sculptor August Gaul; among the newcomers from Munich, Karlsruhe,

5. The salon's income is reported in "Grosse Berliner Kunstausstellung," *Kunst für Alle*, 18 (1902–1903), p. 98.

6. "Vorwort," *Katalog der siebenten Kunstausstellung der Berliner Secession* (Berlin, 1903), unpaginated.

7. Weisbach, *Und alles ist zerstoben*, p. 372.

8. *Das Tagebuch der Baronin Spitzemberg*, ed. Rudolf Vierhaus (Göttingen, 1960), entry of 19 June 1900, p. 396.

and elsewhere, the two most significant by far were Lovis Corinth and Max Slevogt.

Gaul was born in 1869, the son of a Hessian stonemason. He attended the local art school while working as an apprentice mason and, still in his early twenties, came to Berlin to continue his studies at the Institute for the Fine Arts. As assistant to Reinhold Begas, the doyen of official sculpture, he contributed the four oversized lions at the base of the "National Monument" of William I, and as a result received a fellowship that took him to Rome for a year. After his return to Berlin in 1898, he could no longer tolerate the academic environment and style, but was unable to find buyers for his work, and supported himself and his family with odd jobs until Paul Cassirer offered him a contract that gave him the economic security to devote his whole time to sculpture.[9]

Gaul was a founding member of the secession and exhibited two bronzes and a marble frieze in the opening show, without arousing much interest. In 1902 he finally won a major commission; he was chosen to execute one of several sculpture groups with which the Berlin city council intended to beautify the eighteenth-century square beyond the Brandenburg Gate. Part of Gaul's design consisted of standing eagles, which were depicted true to nature, with their wings closed. When requested in the emperor's name to change the birds to the usual heraldic eagles with spread wings, Gaul refused and withdrew from the project.[10] He sold little until he was elected to the academy in 1904 and the National Gallery, at Hugo von Tschudi's urging, purchased a large bronze lion the following year— distinctions that led to numerous private sales. Even then Gaul remained almost unknown to the general public until a granite fountain with six bronze ducks, "the least official of monuments," donated by Paul Cassirer to the city of Charlottenburg, made the sculptor a popular favorite and a celebrity in Berlin.[11]

Gaul occasionally chose human beings as subjects, but the vast majority of his sculptures and graphic works depicted animals. A sound knowledge of skeletal structure and musculature, and exact observation of the living animal, underlay his ability to stylize and

9. Tilla Durieux, *Meine ersten neunzig Jahre,* ed. Joachim Werner Preuss (Berlin, 1971), pp. 108–109.

10. The episode was widely reported at the time; see, for example, the column "Nachrichten von Berlin," *Kunst für Alle,* 18 (1902–1903), p. 416.

11. The fountain, which soon acquired the coy nickname *Streichelbrunnen* because so many passersby petted the bronze animals, still stands on the Steinplatz, not far from the location of the secession's first gallery.

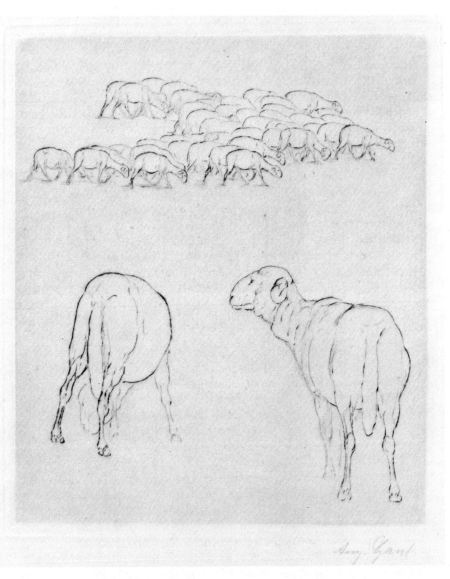

August Gaul. *Sheep.* ca. 1905. Etching, 6″ × 5⅛″.

simplify almost to the limits of realism. His bronzes, in particular, which range from larger than lifesize to miniatures of a few inches, convey the image of ideal types that encompass the uniqueness of each individual member of the species. Even his smallest figurines suggest the quality of skin, fur, or feathers without sacrificing the spatial integrity of good sculpture. Gaul was primarily interested in interpreting the routine habits of animals—grazing, playing, at rest. The dramatic, let alone the heroic, is rare in his work, which expresses a deep pantheistic empathy with all living creatures by means of calm, highly sophisticated craftsmanship.

Even before he became well known, Gaul was an important member of the secession. His intelligence and a readiness to shoulder administrative tasks made him useful, and in 1902 he was elected to the executive committee. The intimate friendship that he soon formed with Paul Cassirer increased his influence. Cassirer valued Gaul's judgment, not only in the secession's affairs but also in his gallery and press. Gaul's most important achievement in this respect was to bring together Cassirer and Ernst Barlach in 1906, thus initiating an exhibiting and publishing relationship that was to last for two decades. After Gaul's death in 1921, a painter who had known him well in the years before the First World War wrote that "he was a pillar of the secession, and yet the least secessionist of artists."[12] The need for an independent art organization was evident to him, but to an unusual degree he himself remained untouched by the forces that characterized the new group. He could appreciate such modern sculptors as Meunier and Rodin, or the very different Barlach, without being influenced by any of them. His work is timeless, not in the sense of greatness reaching from generation to generation, but in its independence of particular styles, movements, and aesthetic conventions.

Slevogt and Corinth were very different from this self-contained minor master, whose subject matter and approach precluded more than regional recognition. When they joined the secession and then moved to Berlin they were already fairly well known, if controversial, artists. Slevogt developed into one of Germany's leading painters and its greatest illustrator. Corinth gained an international reputation, although in Western Europe and America he has not yet achieved the place that the critic Hilton Kramer regarded as his

12. Erich Hancke, "August Gaul," *Kunst und Künstler*, 21 (1922–1923), p. 199. See also Fritz Stahl, "August Gaul," ibid., 2 (1903–1904), pp. 89–98; Curt Glaser, "August Gaul," *Kunst für Alle*, 28 (1912–1913), pp. 232–239.

due when he wrote fifteen years ago: "It is now the hour for his great work to enter into its rightful position in our histories, our museums, and, above all, in that part of our lives where art—rather than the vagaries of artistic fashion—really counts."[13]

Corinth was born in 1858. His father was a tanner in East Prussia, and his well-to-do family enabled him to study at German academies and for nearly three years at the Académie Julian in Paris. By the time he settled in Munich at the age of thirty-two, he combined great technical competence with a frequently crude realism, expressed in broad brushstrokes and strong colors that no academician would have accepted. It still took him years to find his own style; he attempted a great variety of subjects and his work continued to be uneven. But together with many failures, he had already painted portraits, figure studies, and landscapes that are remarkable for their psychological and emotional substance as well as for their virtuosity. A self-portrait from 1896, which shows the artist next to a skeleton, in front of the prisonlike grillwork of his studio window, with only one pane opened to the world, is typical of the heavy symbolism that long persisted in Corinth's art. The painting's theatricality and lack of reserve would have been inconceivable in a work by Liebermann; yet its bombast neither diminishes the excellence of its composition and execution nor lessens the determination with which the artist seeks the truth about himself. Corinth is sometimes compared to Richard Strauss, an association especially illuminating of his work in the 1890s and the early years of the new century.

Corinth joined the Munich Secession when it was founded in 1892. His autobiography explains the move in characteristically blunt terms: "I had the instinctive sense that I could get ahead in this clique."[14] But even in the new group, modernists were greatly outnumbered, and Corinth was among those who seceded a second time to form the Freie Vereinigung. He was awarded a gold medal in the salon of 1895 for a still highly conventional *Descent from the Cross*. Four years later the Munich Secession rejected his *Salome with the Head of Saint John*, presumably for its disturbing mixture of brutal realism and morbid sexuality. "I showed the painting to my friend Walter Leistikow, who was then in Munich to make propaganda for the Berlin Secession," Corinth later wrote. "He was

13. Hilton Kramer, "Lovis Corinth," reprinted in *The Age of the Avant-Garde* (London, 1974), pp. 98–99.

14. Lovis Corinth, *Selbstbiographie* (Leipzig, 1926), p. 109.

enthusiastic, begged me to send the work to the Berlin Secession, which would be delighted to show it, and expected that the painting would have a tremendous success."[15]

Corinth had felt dissatisfied in Munich for some time, and Leistikow, speaking both for himself and for Liebermann, was able to persuade him to move to Berlin, which became Corinth's home for the rest of his life. His friend, the art critic Hans Rosenhagen, predicted that Berlin would be more receptive to the roughness and experimentation of Corinth's work than Bavaria, and the new environment immediately proved liberating. Corinth's brushwork and color became lighter, his conception and execution more hurried — sometimes recklessly so, and his production increased greatly. He signed a contract with the Cassirer Gallery, an artschool that he established proved very profitable, and his work began to sell. Karl Scheffler later wrote that although Liebermann always remained the most influential painter of the first generation of Berlin Secessionists, Corinth was the only one who became genuinely popular.[16]

Slevogt's path to Berlin was similar. He was born ten years after Corinth, in 1868, the son of a Bavarian officer who was killed in the Franco-Prussian War. At sixteen he entered the Munich Academy, studied there and at the Académie Julian for five years, and, after trips to Italy and Holland, settled in Munich in 1890. An early painting, *Nude on the Couch*, turned a commonplace studio motif into an exploration of spatial depth and of the significance of ordinary objects — stove, chair, washbasin — distributed in the room. Slevogt regarded the work as a technical failure; others condemned it as low and degrading. The painting is significant, Slevogt's biographer wrote, "because it was one of the first he exhibited, it attracted some attention, and it had a poor reception, which affected Slevogt's position for years. Not only had the Munich public never fully overcome its aversion to realism, it must have taken the painting's lack of surface elegance and bravura as inexcusable flaws, and its absence of literary content as a sign of triviality. For the rest of his time in Munich, Slevogt was dismissed as 'that hideous painter.'"[17]

Like Corinth, Slevogt joined the secession, and the following year the new splinter group, the Freie Vereinigung, or Free Society. In 1896 he began to contribute cartoons and illustrations to the new *Simplicissimus;* this association led to a close friendship with Paul

15. Ibid., p. 118.
16. Karl Scheffler, *Talente* (Berlin, 1921), p. 57.
17. Hans-Jürgen Imiela, *Max Slevogt* (Karlsruhe, 1968), p. 28.

Cassirer, who at that time still lived in Munich. The opening exhibition of the Berlin Secession in May 1899 included several paintings by Slevogt, among them the triptych, *The Prodigal Son*, which became one of the successes of the show. The following month, however, the Munich Secession, in response to citywide criticism, removed his *Danaë* from the annual summer exhibition. The painting shows a severely foreshortened nude asleep, while in the foreground an old servant tries to catch a rain of gold coins in a cloth whose green and red pattern jumps out from its brown, ochre, and graywhite surroundings. The contrast of colors, of rest and movement, the illusion of depth, and the assured brushwork make the painting interesting if not successful. But the stolid ugliness of the two women and their commonplace environment were felt by many to be a perversion of the mythological theme, an offense against the classical ideal.

Again Berlin exploited the opportunity created by Bavarian philistines. Cassirer asked Slevogt to send the rejected canvas to his gallery and offered him a contract for three or four years, "on the condition that we represent you for this period, that is, you agree to sell your work only through us—portraits excepted—and we commit ourselves to pay you at least 4,000 marks annually for your pictures."[18] Slevogt accepted, and by October the Cassirer Gallery had organized his first major show, which combined thirty-four of his paintings with works of Manet, Degas, and Puvis de Chavannes. Cassirer urged him to leave Munich, and after some hesitation Slevogt moved to Berlin in 1901. For him, as for Corinth, the departure from Munich coincided with important changes in his work. It became freer and brighter: his 1902 portrait of the baritone Francisco d'Andrade as Don Giovanni—the exuberant white-and-gold figure singing before a backdrop depicting a corner of the Don's palace—solved long-standing compositional problems and brilliantly interpreted the singer and his role.

In 1902 Corinth and Slevogt were elected to the executive committee of the secession. Before they came to Berlin, the group had been dominated artistically as well as politically by Liebermann. Now he was joined by two men of comparable ability, if not yet achievement. Their presence infused the group with a degree of vitality that, even with the help of such associates as Leistikow and

18. Cassirer to Slevogt, 24 September 1899, quoted in ibid., p. 52. At that time 4,000 marks was approximately equivalent to the salary of a Gymnasium professor or the pay of an army captain.

Gaul, Liebermann could never have supplied. He and the two new-comers were sufficiently self-confident to eschew rivalries and to cooperate effectively in guiding the affairs of the secession. The unity of leadership was strengthened by the friendship that linked Slevogt and Liebermann with Paul Cassirer. Between Corinth and Cassirer the relationship was not as close; neither found the other truly sympathetic, and Cassirer, while admiring Corinth's talent, did not care for the pathos in much of his work. But for some years they collaborated closely. After Cassirer started his own press, he published two books by Corinth—a manual on the technique of oil painting, which was reprinted, and the biography of Leistikow; Corinth also illustrated the Song of Songs and the Book of Judith that appeared in the series of luxury editions Cassirer brought out under the *Pan Presse* imprint. Leistikow, who had great influence over Corinth, did much to defuse incipient clashes; Corinth later wrote with some exaggeration that when Leistikow died in 1908 the secession fell apart.[19]

It may have been Cassirer who first called the three painters "the constellation of German impressionism," a propagandistic statement that proved useful in the public debate on art in Germany, but that was inevitably misinterpreted.[20] The phrase was not intended to suggest that Liebermann, Slevogt, and Corinth had been decisively influenced by French impressionists and now painted like them. Rather it tried to give a concise name to the manner they had achieved after shedding much of the realism and naturalism of their early years—a process that paralleled the development of the French impressionists but led to different results. *Plein-air* painting was nearly as important to the modern Germans as it had been to the French. Their colors were less atmospheric, however; they placed greater emphasis on line and movement; and their treatment of human beings reveals a fascination with the particularities of the individual that is not equally evident in French impressionism. Still life, a major genre for French impressionism, was less important to the Germans; it is almost absent from Liebermann's work.

The German painters also differed considerably among themselves. Despite the freedom of his mature style, Liebermann never left the realm of objective reality. Slevogt and Corinth were more

19. Corinth, *Selbstbiographie*, pp. 149, 151.

20. According to Corinth's widow, the painter Charlotte Berend-Corinth, the phrase originated with Cassirer; see Imiela, *Max Slevogt*, pp. 107, 383n.

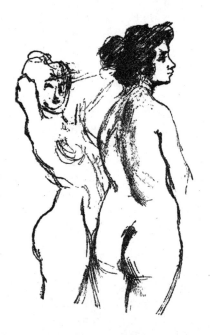

Lovis Corinth. *Two Nudes.*
From the catalogue of the 1901 summer exhibition
of the Berlin Secession. Pen and ink, 3″ × 2″.

openly emotional in color and line; Kramer refers to the "poetic, indeed unbearably tragic . . . loose and freewheeling" qualities of some of Corinth's portraits. But none of the three ever fully detached himself from the powerful synthesis of German humanism and German realism that constituted their cultural background and artistic heritage.[21] "Corinth cannot be called an impressionist," Scheffler wrote a few years before the artist's death; "rather he is a very powerful studio painter, who has understood impressionism and has worked his way through it."[22]

Nevertheless, the term *German impressionism*, or its occasional variant *Berlin impressionism*, had a strong impact; it was a rallying cry for friends of modern art, a target for its enemies. Generally it was taken to refer to a conception of art developed or copied from the French and championed by the Berlin Secession in opposition to those artists who worked within a supposedly native German tradition. One would think that anyone seeing a Renoir and a Slevogt, or a Monet and a Corinth, side by side, could remain in no doubt that these works emanated from different cultures and assumptions and employed different methods. It should have been equally obvious that the leaders of the Berlin Secession were German artists; all international influences notwithstanding, no comparable works were painted in other countries. Nor, finally, did the mass of secessionist artists ever work in one particular style, although the group included not a few mediocre imitators of Corinth, and even more of Liebermann. But despite the inaccuracies attached to the term, *German impressionism* helped define the image of the Berlin Secession as it developed from a local group to the center of an informal alliance of modernist movements throughout the country.

The secession's growth into a force of national significance was accompanied by large and small crises. Not every member found it easy to accept the authority claimed by Liebermann and his associates, nor were they all irrevocably opposed to the official art establishment. After the emperor defined his aesthetic ideals in his speech celebrating the completion of the Siegesallee, Liebermann wrote to the president of the Munich Secession: "To my regret I cannot deny that the recent imperial address on art expressed the belief of many of our colleagues." "Of course," he added, "the emperor can at most slow down the movement, and even that is scarce-

21. Kramer, *Avant-Garde*, p. 98.
22. Scheffler, *Talente*, p. 61.

ly to be feared if the secessions—to which, in general, the more talented artists belong—remain united."[23]

At the time Liebermann wrote, one of the founders of the Berlin Secession, Franz Skarbina, had already resigned from the executive committee and the movement. His mild, conciliatory personality caused him to feel more at ease with his many friends in the Verein Berliner Künstler than in the opposition. In the spring of 1902 two further members of the executive committee, Otto Engel and Oscar Frenzel, left together with fourteen other regular members. The sixteen constituted the traditionalist wing of the secession, most of whom had also opposed the showing of works by foreign artists; they rejoined the Verein, but for a year or two insisted on exhibiting as a separate group in the annual salon—a demand in which Skarbina characteristically did not join. Gaul, Slevogt, and Corinth were elected to fill the vacancies on the committee, which the following year was expanded by two seats, initially filled by Wilhelm Trübner and Louis Tuaillon. Trübner, whose increasingly broad, colorful, and heavily textured brushwork never obscured a basically realistic outlook, was at this time reaching the peak of his powers. Until his death in 1917 he remained among the best-known and most successful painters in Germany. Tuaillon, born in Berlin of French parents, had recently returned to Berlin after eighteen years in Italy. He was an unusually gifted neoclassicist, whose equestrian statue of Emperor Frederick III before the Bremen dome won him the large gold medal in 1906, membership in the academy, and eventually the order Pour le mérite—marks of official recognition that never lessened his allegiance to the secession.

These changes in leadership could only strengthen the secession, even as they underlined the differences that separated it from other art groups. More complicated was a conflict with the independent artists in Munich. After the 1902 exhibition, the two major secessionist groups in Bavaria threatened to show their work elsewhere unless they were given more space in the future. Negotiations proved unavailing because the demand went against the executive committee's policy of limiting the size of the annual show; the Munich members of the Berlin Secession, including Fritz von Uhde, then resigned, as did the Berlin members of the Munich secessions. Only a newer Munich splinter group, the Scholle, or "Native Soil,"

23. Liebermann to Hugo von Habermann, 31 December 1901, quoted in Werner Doede, *Die Berliner Secession* (Berlin, 1977), p. 24. On the emperor's speech, see chapter 1.

exhibited in Berlin in 1903.[24] Opponents of modern art were delighted at the split in the common front, and Anton von Werner thought it possible that the Berlin Secession itself might soon break up. But in little more than a year, government policy had brought the independent groups together again.

Opposition from the emperor and from those who followed his lead in government departments and the old art organizations had contradictory effects. On the one hand, it kept the core of the secession united; on the other, some secession members were troubled by the almost automatic denigration of their work in much of the conservative press and by the difficulty of obtaining government commissions. Loss of earnings directly caused by secession membership was not rare. When in the fall of 1903 the Landeskunstkommission unanimously recommended the purchase of a Leistikow landscape by the National Gallery, the Kultusminister refused to forward the recommendation to the emperor, "because Leistikow is organizationally active as leader of the 'secession,' " a decision that was reported in the press.[25]

For William II, *secession* had come to represent more than art that he disliked; he used the term to castigate poor taste in a variety of areas, from scholarship to women's fashions. When the Austrian emperor paid a state visit to Berlin, the city architect Ludwig Hoffmann decorated the bleachers for the official guests with small laurel trees, placed not in the traditional round green tubs but in trapezoid tubs painted in bright colors. After the conclusion of the visit, William thanked Hoffmann: "Everything was outstanding; but I want to tell you one thing . . . never again show me such secessionist junk like the trees in those tubs."[26]

The emperor's insistence that the secession was worthless inevitably worked against the gradual lessening of animosity between the traditionalist and modern camps, and had the immediate effect of preserving official patronage almost wholly for the former. But imperial protection could not solve the problems in the traditionalists' own ranks. The differences in status between academicians and the great majority of members of the Verein Berliner Künstler ran too deep, and the number of painters and sculptors trying to earn a living was far beyond the capacity of the government to support. All

24. Reports on the dispute appeared in *Kunst für Alle*, 18 (1902–1903), p. 224, and in *Kunst und Künstler*, 1 (1902–1903), pp. 151–152.

25. *Kunst für Alle*, 19 (1903–1904), p. 152.

26. The anecdote is told by Hoffmann's brother-in-law Werner Weisbach in *Und alles ist zerstoben*, pp. 297–298.

that most artists could hope for was that adherence to officially approved standards would serve as a recommendation in the overcrowded open market, access to which continued to be primarily through the annual salon. Consequently, any effort to improve the quality of the salon by more selective screening ran counter to the interests of the majority of its supporters. In 1902 and again the following year, the jury, chaired by Arthur Kampf, a highly regarded painter of historical scenes, invited a few French artists to participate *hors concours*; at the same time, it raised the standards of acceptance for German submissions, which led to the rejection of some 2,200 paintings in 1903. The results were a crisis in the Verein and public protests from chapters of the Allgemeine Deutsche Kunstgenossenschaft throughout Germany, whose members' work had been turned down.

Shortly before the opening of the 1903 salon, the emperor, as its patron, intervened with a letter to the organizing committee, "which energetically objected to various decisions taken by the committee."[27] A pamphlet by Hans Holtzbecher, a member of the Verein, condemned the jury's "extreme subjectivity"; it had even turned down the work of men who had served as jurors the previous year.[28] The pamphlet, a copy of which was submitted to the emperor, further accused the government representative on the organizing committee—the same Privy Councillor Müller who in 1898 had angered the emperor for recommending compromise with the incipient Berlin Secession—of indifference to the economic difficulties of the mass of German artists; Müller was reported to have expressed the hope that next year's jury would be even stricter. It was the example and popular success of the secessions, according to Holtzbecher, that had led the committee to adopt its damaging policies; even worse, the state, by buying "mediocre foreign works," was confusing young German artists about the standards they should emulate, while the great majority of critics unaccountably supported the secessions rather than good German art. He appealed to the emperor to squash the "Hydra Secession," which was even threatening to pervert the nation's image abroad through its influence on Theodor Lewald, the head of the imperial commission organizing Germany's participation in the Saint Louis International

27. "Nachrichten von Berlin," *Kunst für Alle*, (1902–1903), p. 317.

28. Hans Holtzbecher, *Die grosse Berliner Kunstausstellung: Eine Flucht der Künstler in die Öffentlichkeit* (Berlin, 1903). See also the editorial comments in *Kunst und Künstler*, 1 (1903), pp. 441–442; and the sarcastic discussion of the pamphlet's claims by H[ans] R[osenhagen] in *Kunst für Alle*, 18 (1902–1903), p. 512.

Exposition. To restore conditions in Berlin, at least, Holtzbecher proposed turning the salon more exclusively into a vehicle for Berlin artists. He also suggested appointing a second body of judges to whom the jury's decisions could be appealed, although, he thought, artists whose work had been accepted in ten previous salons should in any case be jury-free, as academicians already were. This last proposal, which would have restricted the jury's authority primarily to newcomers and the obscure, was rejected by the emperor and the academy.

In the end, the art proletariat gained little more than symbolic sustenance from William II. He contented himself with conveying some words of encouragement to the reform party that had emerged in the Verein, and with vetoing the Landeskunstkommission's recommendation that the National Gallery purchase a painting by the offending chairman of the salon, Arthur Kampf, who had made himself even more unpopular by proposing that a few works by members of the Berlin Secession be included in a loan exhibition of German art at the Chicago Art Institute.[29] A conservative critic, Albert Dresdner, drew the moral of the conflicts between salon and secession, and within the salon itself, with a quotation from Goethe's *Wilhelm Meister: "Alle Schuld rächt sich auf Erden,* and the 'old art' must now pay for its sin of rejecting unfairly and without comprehension the new impressionist direction. The representatives of traditional painting should have tried to separate the little that was genuinely new and creative in impressionism from its bad and dishonest substance." Their intolerance, Dresdner thought, had inevitably led to disaster. Not only was the salon of 1903 thoroughly bad, but it "has been forced to bow before the power of its old antagonist, and has contritely opened the gates to French impressionists—Manet, Pissarro, Renoir, etc.—thus giving excellent publicity to these foreign and truly overrated artists."[30]

Comments such as these and the protests of the art proletariat indicate the distance the secession had traveled since its founding in

29. Reported in *Kunst für Alle,* 18 (1902–1903), p. 576. Kampf exhibited at least once as guest of the Berlin Secession. His attendance at one of the secession's official dinners was noted as a rare example of *Zivilcourage* on the part of a man holding a prominent semiofficial position. Alfred Lichtwark, letter of 7 April 1903, in *Briefe an die Kommission für die Verwaltung der Kunsthalle,* ed. Gustav Pauli (Hamburg, 1924), II, 44. Kampf, who lived until 1950, became director of the Royal Institute for the Fine Arts after Werner's death in 1915. When Hitler assumed power, Kampf painted pictures glorifying the new regime.

30. Albert Dresdner, "Berliner Kunst—Die Grosse Berliner Kunstausstellung," *Der Kunstwart,* 16, no. 23 (1902–1903), pp. 525–526.

1898. Although it always retained a preeminently Berlin and north German character, the group was beginning to affect the entire German art world, and in the eyes of its critics, in particular, now stood for a national, indeed international, force. The affinity that existed between the secession and the work of certain foreign artists, an affinity emphasized by the exhibition policies of Paul Cassirer, at once its secretary and the head of his own gallery, gave the group a political and ideological cast that was only partly justified, and that not all of its members welcomed. To those more extreme German conservatives who also had an interest in cultural affairs, and to rabid anti-Semites, the secession appeared to be yet another carrier of the corruption they feared was sapping the nation's strength. No other modernist movement in the country attracted the same intense opposition, ranging from uncomprehending laughter to a virulent, anarchic populism that demanded eradication of the cancer. The Berlin Secession was singled out for obvious reasons. Other German princes did not indulge in William II's implacable, noisy opposition to modern art, and the words and actions of the emperor enjoyed a unique resonance. Inevitably, events in the capital attracted nationwide attention, and the influence of Berlin not only in politics but also in literature and the fine arts was far greater than ever before. If its environment kept the Berlin Secession in the public eye, the group was also the most advanced among German secessions in the first years of the century. Its leaders, furthermore, were not men who quietly pursued their profession; they never hesitated to publicize and defend their point of view in lectures and in print. Finally, no other German secession was headed by a Jew.

Dresdner not only attacked the secession and "its native and foreign sympathizers" for perverting art—"the artist no longer creates art, it is the viewer who is supposed to create art out of suggestions," an unsympathetic variant of the secession's desire to stimulate the "collaborative imagination of the viewer"; he also accused Liebermann of attempting to dominate museums, exhibitions, public opinion, and the art market.[31] The theme of the profit motive overpowering German art was taken further by a Dr. Volker, in *Hochland*, the recently founded Catholic periodical, whose title, promising discussion of significant issues on an elevated plane, stood in astonishing contrast to the alternately threatening and sneering tone of

31. Albert Dresdner, "Berliner Kunst," ibid., 16, no. 3 (1902–1903), pp. 144–147; "Berliner Kunst—Die Ausstellung der Berliner Sezession," ibid., 16, no. 18 (1902–1903), pp. 286–290.

the essay. To Volker the Berlin Secession constituted "the bankruptcy of the imagination, and a complete victory of French impressionism." Impressionism he defined as a "sensual force rather than an intellectual and emotional assimilation," and thus an "un-German way of seeing nature." After these preliminaries the author proceeded to particulars:

It is characteristic and significant that the transmitters of this type of art and its first critical heralds are — I don't want to say Jews, but rather, and this is the essential point — representatives of the specific Jewish spirit residing in the West End of Berlin. That many Germans join and follow them is not surprising. The zeal and activity of these people has suggestive power. And it brings concrete advantages. They have turned the Jew-infested Berlin West End [das verjudete Berlin W] into an art market of the first magnitude, and they have learned how to take complete control of this market. The Cassirer Gallery, which might as well be called "Liebermann Gallery," is nothing but a miniature version of the secession, whose affairs rest in clever 'cashier' hands.[32]

Volker saw no prospect of Berlin's curing itself. The annual salon, he wrote, could not act as a counterweight to the secession because it, too, had become internationalized; it was dominated by professional art organizations; it was too much of a market, and too dependent on the state. Regeneration, the author concluded, was possible only if the provinces rose up against Berlin, "but not with words, with deeds."[33]

To claim that the secession's dominant values were un-German and sensual, propagated by foreigners and Jews for economic gain, was simply to direct a standard anti-Semitic accusation against a new target. It came to be a staple in the agitation against the secession and other modernist movements, which was to increase considerably in the coming years, although even in 1903 neither the tone nor the message of Volker's essay was unique. Attacks such as his coincided with a more respectable desire, felt and expressed by a growing segment of the middle class, for the development of a truly national art that could serve as an inspiration and guide for the German people. The art journal with the highest circulation in the country, Kunst für Alle (17 – 18,000 copies in 1910), and such popular cultural periodicals as Der Kunstwart (23,000 copies shortly before the First World War) discussed art mainly from a moral,

32. Dr. Volker, "Die Berliner Kunstausstellungen," Hochland, 1 (1903), pp. 252, 253.
33. Ibid., p. 254.

idealistic, and patriotic point of view; they evidently reflected the concerns of their middle-class readers, although both publications strove for some balance in their editorial policy and printed articles and reports sympathetic to the modern direction.

Der Kunstwart carried Dresdner's denunciations of cosmopolitan art, but in 1907 it celebrated Liebermann's sixtieth birthday with a congratulatory essay by the editor, Ferdinand Avenarius, and opened its pages to Scheffler's defense of impressionism as the only true modern art.[34] The column on art in Berlin for Kunst für Alle was written by Hans Rosenhagen, Corinth's friend, who regularly discussed the exhibitions of the Berlin Secession and the Cassirer Gallery in glowing terms.[35] The general orientation of the journal, however, was very different, in accordance with the views of its editor, Friedrich Pecht, who regarded Menzel's bourgeois realism as the height of modern art. Pecht thought of himself, it has been said, "as a patriot helping to unite the nation by fostering a national art [consisting of a] realistic description of German scenes free of foreign influence, especially French."[36] Other writers looked for an infusion of religious, mystical forces; the art historian Henry Thode, Cosima Wagner's son-in-law, for instance, proclaimed the dawn of a more spiritual German art and asserted that any aesthetic direction or style that did not serve the ideals of moral health and love of the fatherland was a luxury the nation could ill afford.[37] With Böcklin having died in 1901 and Menzel in advanced old age, the hopes for this new renaissance rested mainly on Max Klinger and the painter Hans Thoma, whose work fused realism with romantic and fantastic elements into a glorification of the German countryside. The

34. Der Kunstwart, 20, no. 20 (1906–1907), pp. 413–421, 460–462, 467. Scheffler's article appeared in ibid., 19, nos. 4, 5, 6, (1905–1906) pp. 177–182, 251–267, 312–315. Der Kunstwart is too often dismissed as a monolithically anti-Semitic and nationalist publication. See, for example, the assertion that "all artists of the [Berlin] secession subject to international influences were mercilessly opposed by Der Kunstwart" in Sigrun Paas's naive dissertation, Kunst und Künstler (Heidelberg, 1976), p. 46.

35. For instance, his review of the 1903 spring exhibition of the secession praises its elitism and exceptional quality; Kunst für Alle, 8 (1902–1903), pp. 393–406. In a second article on the same subject he states that "no German exhibition has presented so much great art" and congratulates its organizers for their unselfishness in providing space for many important works of native and foreign guests; ibid., p. 422. For other very favorable comments, see ibid., pp. 93, 186–190, 244, 264–265, 356–360. In the fall of the same year, an exhibition at the Cassirer Gallery was characterized as yet another in a row of "always outstandingly good shows"; ibid., 19 (1903–1904), p. 100.

36. Kenworth Moffett, Meier-Graefe as Art Critic (Munich, 1973), p. 42.

37. Henry Thode, Schauen und Glauben (Heidelberg, 1903).

Berlin Secession, it should be noted, exhibited works by Klinger and Thoma from its first show on.

The honest, if naively misconceived, search for an "innately German" art, one that could help resolve the difficulties of life in the industrial age, differed significantly from the know-nothing cultural anti-Semitism of Volker and his associates, and for the time being its appeal seemed greater. In its suspicion of the course post-impressionist French art was taking it even affected some members of the secession. Kollwitz, for instance, was so irritated by the success Matisse enjoyed in his first German exhibitions that she associated herself with a movement protesting the support foreign artists received in Germany.[38] But all seriousness and respectability notwithstanding, the longing for a truly German art had practical implications that came close to satisfying the aims of the secession's most radical enemies. An attitude was being created that could deplore the exaggerations and intolerance of the aggressive faction, while sharing many of its hopes. Drawn by the image of German art as a national force, distinct from the art of other societies, expressing and fostering virtues held to be specifically German, some early supporters of modernism gradually turned against the Berlin Secession. In the course of a few years, Rosenhagen changed from a champion to one of the most relentless opponents of the secession.[39] It was also at the time the secession became firmly established on the national scene that the architect and teacher Paul Schultze-Naumburg, whom Liebermann had once praised as a sensible commentator on modern art, took the first steps in a long intellectual and political journey that led to a senior position in the cultural hierarchy of the Third Reich. The accusation that the secession was an alien perversion, claiming artistic independence but in truth caring only for profit, lodged in the vast, confused body of German middle-class idealism, which in the long run could not muster the strength and common sense to reject it.

II

The Berlin Secession had made a place for itself among the groups fostering modern art in Germany. It remained to be seen how far the bureaucracies of Prussia and the Reich would observe the emperor's

38. See chapter 6.

39. In her published dissertation, *Kunst und Künstler*, p. 16, Paas categorizes Rosenhagen as "belonging absolutely" to the modernist camp, and fails to discuss his change of front.

personal dislikes and treat the secessionists as un-German disturb-
ers of the cultural peace or, on the contrary, learn to fit them gradual-
ly into their programs. If official patronage continued strongly to
favor the traditional, the purchase of secessionist works by the major
state museums indicated at least a less than solidly antimodernist
front, and the possibility of further movement on the domestic
scene. The test whether the government would acknowledge
the secession to the *outside* world as a new force in German art
came with the international exposition that the United States or-
ganized to celebrate the centennial of the Louisiana Purchase — the
first major international art exhibition organized after the Berlin
Secession was founded; planning for the Paris Exposition of 1900
having got under way well before the secession existed.

Germany did not welcome the American invitation to send an
exhibition to Saint Louis, nor attach much importance to it at first.
How its attitude changed is a case study of reluctant economic and
cultural imperialism. When the invitation arrived in Berlin in the
fall of 1901, the relevant ministries and the emperor were united in
trying to avoid acceptance, if it could be done without giving of-
fense. The government's budget was strained; numerous interna-
tional fairs, congresses, and trade shows had been held in recent
years; industrialists and government officials spoke of the country's
general "exhibition fatigue." But the government yielded step by
step, in response to pressure from Washington, the significance at-
tached to American goodwill, concern over the intentions of other
powers, who were themselves fearful of being overtaken by rivals,
hope for commercial benefits, and the pleas of German-Americans
that the Reich's presence in Saint Louis would foster the national
image and strengthen Germanness abroad. Its early intention to
authorize at most a small delegation of observers and private exhibi-
tors changed to plans for a modest show concentrating on arts and
crafts and finally to a comprehensive exhibition of German cultural
and material achievement, with a budget that eventually rose to
nearly 5 million marks. The German pavilion in Saint Louis — a
truncated, overdecorated copy of Frederick I's Charlottenburg
Palace, without the wings that give the structure its balance and
logic — symbolized the ultimate surrender of common sense to
the forces of prestige politics and international competition.[40]

40. A Bavarian paper noted that the emperor's "order to model the German pavil-
ion in Saint Louis on the [Prussian] Charlottenburg Palace evoked no enthusiasm
whatever outside Berlin"; "Die deutsche Kunst in Saint Louis 1904," *Münchner*

In October 1901 the Reich's secretary of state for foreign affairs, Baron von Richthoven, consulted his counterpart in the Interior Ministry, Count Posadowsky-Wehner, on the recently received American invitation. Posadowsky's reply was almost wholly negative: after the large private and public expenditures for the Paris exhibition of 1900, industry and trade could not be expected to make further sacrifices. Germany had been more than adequately represented at the previous American international exposition, the Chicago Fair, less than ten years earlier. It was questionable whether commercial advantages could be expected, since American fairs had never been very productive for their foreign exhibitors. The reports of the German consul in Saint Louis gave reason to doubt that the fair would be ready in time.

These considerations, together with the "unfavorable conditions of the Reich's finances," suggested that Germany should not take part. Posadowsky added, "If, however, your office were to regard it as desirable to demonstrate some receptivity to the invitation of the Government of the United States . . . one might possibly consider a show of the fine arts, perhaps in conjunction with certain branches of the applied arts."[41] He ended by asking whether the Foreign Office could determine the intentions of other major European powers. These still remained largely uncertain. The Foreign Office thought that Italy had probably declined the invitation; England might not do more than sponsor private exhibitors, but London inquired what Germany's plans were, a question already raised by Austria. In the spring of 1902 only two of the great powers had reached a firm decision: Russia would not take part, and France would. Speakers in

Neueste Nachrichten, 21 April 1903. Germany was not alone in relying on architectural achievements of former generations to convey the desired image. The French pavilion in Saint Louis was copied after the Grand Trianon; the English, after a wing of Kensington House. On the concept of prestige in German foreign policy at this time, see, among others, Ilse Kunz-Lack, *Die deutsch-Amerikanischen Beziehungen, 1890–1914* (Stuttgart, 1935), pp. 232–233, where the author writes of the Foreign Office's "in part exaggerated efforts to gain the goodwill of the United States at the turn of the century and afterwards"; see also Emil Wächter, *Der Prestigegedanke in der deutschen Politik von 1890 bis 1914* (Aarau, 1941). I have briefly analyzed the events discussed in the following pages in my article "Art and the National Image: The Conflict over Germany's Participation in the St. Louis Exposition," *Central European History,* 11, no. 2 (1978), pp. 173–183.

41. Posadowsky to Richthoven, 25 October 1901, ZStA Potsdam, Auswärtiges Amt, Rep. 09.01, Bd. 1, Nr. 51 (500), pp. 90–94. The quoted passages are from p. 93 verso.

the National Assembly were commenting that the official occasion of the fair, the centenary of the Louisiana Purchase, offered excellent opportunities for cultural diplomacy.[42]

The reluctance of most European governments to commit themselves came as an unpleasant surprise to the Americans, who began to press for acceptance in principle, leaving the extent of participation for subsequent negotiations. In January 1902 the American embassy in Berlin sent the German government a memorandum, which expressed the hope that Germany would be present in Saint Louis "and especially that there will be a representation of German art and articles of art workmanship worthy of the Empire." The underlying message was clearly that Berlin should not discourage the others.[43] During the same days, the German ambassador in Washington wrote the chancellor, Count von Bülow: "I, too, believe that it would be of little value for German industry to send exhibits to Saint Louis. On the other hand, I would regard it as an act of international good manners if Germany were to participate in some way; if she were, so to speak, to present her visiting card . . . Perhaps it would be advisable to call an art exhibition into being."[44]

By spring a consensus was emerging in Berlin that a blanket refusal of the invitation was out of the question, and that an art show would best resolve the dilemma. In March Posadowsky began to consult the head of the Allgemeine Deutsche Kunstgenossenschaft, and in April he informed him that while the Reich would not officially participate in the fair, the government might sponsor an art exhibition. How would the artists feel about this?[45] At the same time the Prussian Kultusminister, Konrad von Studt, entered the picture. He reported on the matter to the emperor, and asked the president of the Royal Academy to give him his views on how best to organize the exhibition. On 24 April Studt wrote Richthoven that the emperor would like to have more German artists exhibit in America and felt that Saint Louis provided a good opportunity for expanding the interest in German art. In return, the emperor hoped that German exhibitions would include more American works.[46]

42. The Foreign Office files contain extensive correspondence on the responses of various governments to the American invitation; see, for instance, ibid., pp. 97–98, 102–103; ibid., Rep. 09.01, Bd. 2, Nr. 51 (501), pp. 12–13, 51.

43. U.S. Embassy to Foreign Office, 10 January 1902, ibid., p. 17.

44. Theodor von Holleben to Bülow, 9 January 1902, ibid., p. 19.

45. Posadowsky to H. Kayser, 14 April 1902, ibid., p. 53.

46. Studt to Richthoven, 24 April 1902, ibid., p. 64.

Studt was not as independent a man as his predecessor, Robert
Bosse, whose resignation William II had demanded in 1899. "Of all
my ministers," the emperor was later quoted as saying, "Studt is the
best. . . He carries out my orders simply and reliably, and takes no
notice of anything else."[47] But Studt did not share the emperor's pas-
sionate distaste for modern art, and as a conscientious civil servant
who wanted the German exhibition in America to succeed, he felt
obliged to follow the advice of the liberal official responsible for art
in his ministry, Erich Müller. Accordingly, he wrote the chancellor:
"So far as the art show is concerned, even at this early stage I should
like to express the view, based on experiences we had at the Paris
International Exposition, that it seems inexpedient [again] to en-
trust the [Allgemeine] Deutsche Kunstgenossenschaft with sole
responsibility for the show. On the contrary, as was already pro-
posed in various quarters for the Paris Exposition, it might be pref-
erable for the government to form a central committee, consisting
in the main of well-known artists, which would organize the
show."[48] Studt's suggestion seemed unexceptionable. As it was
general knowledge that the exhibition of mainly academic art that
the Kunstgenossenschaft had sent to Paris had neither been well
reviewed nor attracted buyers, the chancellor agreed, evidently
without thinking it necessary to consult the emperor on what most
people would regard as an administrative detail. William II remained
in ignorance of his government's move to assure broad representa-
tion of German art at Saint Louis until the committee — incorporat-
ing modern as well as traditional artists, and immediately labeled
an "art parliament" by the press — burst on the scene the following
spring.

In the meantime, the process of authorizing an official exhibition
and expanding its scope continued. In August Posadowsky wrote
Richthoven that, although he still opposed official participation in
Saint Louis, a position in which he was supported by the Prussian

47. Robert von Zedlitz-Trützschler, Kultusminister from 1891 to 1892, quoted in
J. C. G. Röhl, *Germany without Bismarck* (Berkeley and Los Angeles, 1967), p. 267.
48. Studt to Bülow, 26 June 1902, ZStA Potsdam, Auswärtiges Amt, Rep. 09.01, Bd.
3, Nr. 51 (502), p. 71. Even the Kunstgenossenschaft's official report on the German
art exhibition in Paris admitted certain weaknesses, which it blamed largely on
organizational problems beyond the control of the association. But the report also
rejected as exaggerated the widespread criticisms of the show, and specifically de-
nied suggestions that the work of secessionist artists was inadequately represented.
*Bericht des Hauptvorstandes der Allgemeinen Deutschen Kunstgenossenschaft über
die Beteiligung der Deutschen Künstlerschaft an der Weltausstellung in Paris 1900*
(Berlin, 1901), pp. 24–25.

ministers of culture and trade, he would put his doubts aside if foreign policy considerations demanded it; moreover, he was prepared to appoint a commissioner to plan the German contribution if the government decided on an official presence. This issue fell within the authority not of the Reichstag but of the Bundesrat, the council of representatives of the various German states, who were appointed by their governments and met under the chairmanship of the emperor or chancellor. Posadowsky continued: "Consequently, all now depends on obtaining His Majesty's decision on whether a proposal to accept the American invitation should be laid before the Bundesrat. In the opinion of this office it would be advisable to limit German participation in the main to the areas of art, arts and crafts, and education. This intention should be stated when the matter is submitted to His Majesty the Emperor, and also in the proposal to the Bundesrat."[49]

At the beginning of October, after the emperor had returned from his summer cruise on the Baltic, the Foreign Office submitted an *Immediatbericht*, recommending limited German participation; it was accompanied by a similar report from the chancellor, who also suggested the appointment of a senior official in the Interior Ministry, Theodor Lewald, as imperial commissioner.[50] For this position William II preferred the man who had been in charge of the German exhibition in Paris, another example of his far from nominal involvement in appointments on the second or even third level; but as this official declined for reasons of health, Lewald was chosen.[51] On 23 October a proposal drafted by Posadowsky was sent to the Bundesrat, stating that considerations of policy and prestige and commercial factors demanded that Germany accept the invitation. As financial constraints rendered large-scale participation out of the question, a concentration on the arts seemed advisable. At present French art dominated the American market, but the Louisiana Purchase Exposition was an opportunity to do something about it. Since German artworks last appeared in great numbers at Chicago

49. Posadowsky to Richthoven, 7 August 1902, ZStA Potsdam, Auswärtiges Amt, Rep. 09.01, Bd. 3, Nr. 51 (502), p. 68.

50. Foreign Office to the emperor, and Bülow to the emperor, 2 October 1902, ibid., pp. 75–79, 95.

51. William II's marginalia on Bülow's report; refusal of Privy Councillor Richter, 17 October 1902; and Bülow to emperor, 27 October 1902, with William's marginalia; ibid., pp. 95, 98, 101, 106. Adolf Wermuth, later finance minister and Lord Mayor of Berlin, who served as Reichskommissar at the expositions in Melbourne and Chicago, discusses the activities of the commissioner and the interest the emperor took in the German exhibitions in his memoirs, *Ein Beamtenleben* (Berlin, 1922).

in 1893, "the exceptional increase of wealth in America has stim-
ulated the demand for artistic adornment of the home to such an
extent that today German art has the best possible chance of re-
gaining a solid position." A week later the Bundesrat approved
acceptance of the invitation and appointment of a Reich commis-
sioner, and voted the necessary funds, which were not specified
but were assumed to be a few hundred thousand marks.[52]

As in previous international expositions, ultimate responsibility
for the German effort rested with the chancellor of the Reich and
the secretary of the interior; executive responsibility lay with one of
the latter's assistants, in this case Lewald, who was appointed
Reichskommissar für die Weltausstellung and relied on the minis-
tries of the German states and on national professional and trade
organizations in planning the various exhibits.[53] Lewald, an able,
tough-minded official, who rose to assistant secretary of the interior
during the First World War, was not the man to welcome marginal
assignments. Shortly after his appointment, he traveled to Saint
Louis to inspect American preparations for the fair. From there he
wired: "Exhibition more magnificent than I expected. Dimension
of buildings enormous, will demand great expenditures on decora-
tions, construction of a German pavilion essential. Therefore
urgently request at least 2 million in next year's state budget."[54]
This sum had not yet been granted, but in January 1903 the press
could report that the Reich's budget for the year included an item
of 1.5 million marks for the German exhibition.[55]

After his return Lewald continued to push for an expansion of the
Reich's effort, even though, as he wrote, German business feared the
risks and suffered from *Ausstellungsmüdigkeit*, and the United
States had not yet succeeded in persuading most European powers
to do as much as they had done in Paris in 1900; only France was
clearly preparing a major exhibition of industry and the arts. Le-
wald contrasted the eagerness with which Washington and the
exhibition management pursued foreign exhibitors with "na-
tionalistic tendencies" in the population, "which feed the belief

52. Bundesrat Nr. 107, 23 October 1902, ZStA Potsdam, Auswärtiges Amt, Rep.
09.01, Bd. 3, Nr. 51 (502), pp. 90–93.
 53. Beginning with Milan in 1906, the Foreign Office assumed executive responsi-
bility for German participation in international expositions, a shift foretold in the
ministry's major role in the preparations for the Saint Louis Fair.
 54. Lewald to Foreign Office, 22 November 1902, ZStA Potsdam, Auswärtiges
Amt, Rep. 09.01, Bd. 3, Nr. 51 (502), p. 179.
 55. See, for instance, *Kölnische Zeitung*, 14 January 1903.

that American superiority had gradually encompassed all aspects of life, and which consciously aims at repressing all alien influences — in a sense applying the Monroe Doctrine to the cultural and economic spheres." American society should be disabused of this error: "An imposing German presence in Saint Louis would provide a strong counterbalance to these efforts and attitudes, and help revive and strengthen German influence. I can only urgently and vigorously recommend that, as at Chicago and Paris, Germany should seek to be the best represented foreign nation . . . therefore I regard it as highly desirable to go well beyond the program laid down in the budget proposals (limited to art, arts and crafts, and education) and so far as possible assemble a representative display of our industrial development." He concluded: "In the Palace of Fine Arts we have reserved suitable space for the German section. In view of the divisions between German artists, the organization of the show will cause great difficulties, which, however, it is hoped can be overcome."[56]

Lewald's arguments had not yet won the day, but the force of international competition was on his side, a fact on which the American organizers counted. In the oddly stilted language that marked most statements and publications of the exhibition management, its widely distributed information and propaganda organ, the *World's Fair Bulletin*, asserted in January 1903: "It is well understood that neither of these two governments [the French and the German] is willing to be excelled by the other in exposition display of a high artistic and educational character . . . The action of these two leading governments is surely to be strongly seconded . . . and [will] send a wave of emulation throughout all countries of Europe."[57] Countries such as Great Britain and Italy were, in fact, falling into line, and sales trips by various exposition officials, concluding with a European tour by David R. Francis, president of the Louisiana Purchase Exposition, did the rest. After an audience with William II, at the end of which the emperor presented Francis with a personally autographed copy of Houston Stewart Chamberlain's *Foundations of the Nineteenth Century*, the Reich was fully committed to a competition for supremacy with other major powers, all of which, as the *Official Guide to the World's Fair* was to say, "made zealous effort[s] to outdo each other

56. Lewald's report, 18 February 1903, distributed to heads of ministries, ZStA Potsdam, Auswärtiges Amt, Rep. 09.01, Bd. 4, Nr. 51 (503), pp. 122–123, 124–125.
57. *World's Fair Bulletin*, 4, no. 3 (January 1903), p. 1.

in the erection of characteristic buildings and the installation of their exhibits."[58]

The history of German planning for the Saint Louis Fair indicates that art was central to the government's deliberations from the first; yet even after it had been decided to mount a comprehensive exhibition, art remained a major but also a particularly complex factor in the preparations. Its subject matter and approach could never by wholly cleansed of ambiguities. Technological, commercial, and scientific exhibits would transmit the relatively unequivocal message of progress and know-how, reflective of the advanced standards of German civilization. Art might convey a similar impression of German vigor and creativity, but it also made statements about human beings, the relation of man to nature and society, the manner in which Germans viewed themselves and the world. The art show thus presented far greater challenges to Lewald and his staff than did other components of the exhibition. Not that an absolute difference separated art from such departments as Mechanics and Optics, Machine Construction, and Electrical Engineering. Many sponsors of industrial exhibits were conscious of the beauty of their products, and of their implications for the individual and society, as were visitors to the fair. After it opened, a German officer wrote the emperor about the thought-provoking contrast between the sophisticated design and careful finish of German locomotives and the far inferior American engines. "But," he added, "in America our locomotives would not last a year, while their own engines suit the rough and ready people here, and do very well."

Technology as well as art expressed the values of the society that created it, only art did so in a manner far more difficult to fathom. William II might not have acknowledged the problem: for him, art directly inspired by classical antiquity and the Renaissance was the best, just as the most efficient engine was the best. It was the role of modern academic art to provide the gloriole of idealism to the machines and procedures of the Reich as it entered the twentieth century. But even he would have admitted that people found it easier to reach unanimity on what was a good engine than on what was a good painting. Nor were organizers and exhibitors agreed on the purpose or purposes of the art show. For some the commercial aspects

58. *Official Guide to the Louisiana Purchase Exposition* (Saint Louis, 1904), p. 123. According to American figures, Germany in the end appropriated more money for buildings and exhibits than any other foreign power, followed by Japan and France. J. W. Buel, ed., *Louisiana and the Fair* (Saint Louis, 1904), IV, pp. 1399–1400.

predominated: the increase of German art in America or the prestige that accrued to those whose work was selected for Saint Louis and thus led to better sales and prices at home. Very different was the purpose of presenting a survey of the best of contemporary German painting and sculpture, which would help to give the world a picture of Germany's cultural concerns. In the minds of some this educational objective took on a pronounced ideological cast: the individual artists and their work mattered less than the total impression they conveyed of a unified, vigorous, idealistic society.

These commercial, aesthetic, and ideological problems were exacerbated, as Lewald had predicted, by the fact that German artists, unlike manufacturers or scientists, belonged to violently antagonistic organizations, whose differences showed no sign of abating, and whose animosity was welcomed rather than regretted by the emperor. The committee of artists of all persuasions that Müller and Studt had proposed might function as a temporary unifying force; until it was established in April 1903, Lewald collected information on the conditions of the American art market and on American tastes in art, which could help guide the organization of the show in Saint Louis and the selection of works to be sent there.

On the whole, the reports that the government received from its representatives in the United States were realistic appraisals, even if their treatment of cultural differences and their discussion of art exports in terms of mass-produced consumer goods do not lack a comic note. One fact established immediately was the economic insignificance of German art sales; from a commercial point of view, the art exhibition in Saint Louis would make little sense. According to a memorandum on the economic and aesthetic factors of the art market, drafted by an official in the Washington embassy, in the fiscal years 1899–1901, German art exports to the United States averaged $116,153 annually, a sum that rose to $198,461 in fiscal year 1902.[59] In general, however, the market for German art had stagnated over the past thirty years, while exports from France had increased considerably, and English exports to a lesser extent. The writer thought this was caused less by changes in American taste and unfamiliarity with contemporary German art than by German artists themselves. If a large part of Germany's art production failed to find a market at home or abroad, it was either because German prices were too high or because "Germany pro-

59. A. Quadt, "Promemoria," 17 October 1902, ZStA Potsdam, Auswärtiges Amt, Rep. 09.01, Bd. 3, Nr. 51 (502), p. 155.

duces more paintings of a certain type and quality than art lovers will buy, and not enough of other types, which would find a ready market." Many German paintings would be rejected in America, particularly by American women, who dominated the art market: "As in general they do not appreciate humor whenever it becomes even slightly coarse, they are not receptive to that entire category of German genre painting concerned with drinking [*die ganze Klasse deutscher Genrebilder, welche Trinksujets behandeln*]." According to the jury of the Philadelphia Exposition of 1876, German art was "actuated by the influence of subject rather than treatment." The same point had recently been made by a former American consul general in Berlin, who remarked that anecdotal painting was too prevalent in Germany. German landscape painting, on the other hand, was regarded as being too sober: "The viewer's ideas and feelings are not stimulated; he cannot put anything of himself in the picture."[60]

The embassy official did not believe that a major improvement in export figures was likely, although he thought that the average annual sales of $260,000 in the period between 1871 and 1882 could be reached again. (Even this proved too optimistic; in 1910 Germany was to export contemporary art valued at $133,305 to the United States, far less than the French and English totals of $594,021 and $472,030, respectively.)[61] He also doubted that the Saint Louis Exposition would help to increase sales, since the city was not a major cultural center: "For those not traveling on business it is at most a brief stop on the way to the Far West." Nonetheless, the exposition afforded an opportunity to show Americans that contemporary German painting was equal to the best that Europe had to offer. To make that point, however, would call for a practical rather than a pious approach. Instead of selecting works by the great masters of the past, the organizers should choose "only the achievements of living artists who represent German painting of the present and future. All directions should be considered, even if they have not yet reached complete maturity, except for paintings that represent a decline or perversion of a given style. In that regard, certain excesses of impressionism in particular, which are especially evident in figure painting, should be excluded."[62]

60. Ibid., pp. 144, 147–148, 149, 151–152.

61. P[aul] H[ennig], "Einfuhr von Kunstwerken in Amerika," *Kunst und Künstler,* 10 (1911–1912), p. 621.

62. Quadt, "Promemoria," pp. 159–160.

After a conversation with Halsey C. Ives, the American official in charge of art at the exposition, the German consul in Saint Louis reported to his ambassador that conditions for German art were decidedly unfavorable because the French controlled the market. "Here in Saint Louis, for instance, the homes of the few rich people who are interested in art, or at least believe they must feign such an interest if they are to be regarded as 'cultured,' contain French works almost exclusively . . . The French are in fashion, and for the average American, Paris is the Mecca of the fine arts." Only if the very best paintings and sculptures were chosen could German art have any impact: "I have been strongly advised that the selection process should take the secessionist school adequately into account as it is thought that this school conforms to the taste of the American public today, and would do well here. The extremists, who could give a distorted image of German conceptions of art, the so-called 'faddists,' should be excluded." To which the ambassador noted in the margin: "Very true, but the line is often rather difficult to draw."[63]

Uncompromising practicality marked a report by the acting consul general in New York on his conversation with an art dealer, who predicted that German artists could increase their sales substantially if they would accommodate themselves to local tastes. They should choose more poetic subjects and avoid harsh colors. The consul added that such paintings might not be very original, but they would sell: "Strange though it seems, in their oil paintings the pragmatic Americans prefer poetically muted subjects and colors. Anything that appeals to their empathy with children, family, and nature can count on success as long as the treatment is correspondingly poetic and tender . . . disturbing subjects had better be avoided."[64]

German artists and art organizations also expressed their views. Since the spring of 1902 a representative of the secretary of the interior occasionally met with officials of the Kunstgenossenschaft, who expected to be asked to organize the show but declared themselves willing to consider improvements in the method of selecting the works. More far-reaching changes were suggested by the president of the Academy of Arts, Hermann Ende. In a memorandum to

63. Frederick C. Rieloff to Theodor von Holleben, 10 June 1902, ZStA Potsdam, Auswärtiges Amt, Rep. 09.01, Bd. 3, Nr. 51 (502), pp. 10, 14. ("Cultured" and "faddists" appear in English in the original.) Holleben forwarded the report to Berlin with a note expressing his strong agreement.

64. Bünz to Speck von Sternburg, forwarded to Bülow, 6 February 1903, ibid., Rep. 09.01, Bd. 4, Nr. 51 (503), pp. 198–200.

the Kultusminister, Ende pointed to the cultural influence Paris exerted in the United States and to subventions by the French government and favorable customs regulations as explanations for French dominance of the American market. But he thought Germany was also to blame: "It is no secret that the exhibitions in Philadelphia and Chicago did nothing to change unfavorable opinions of German art. If German art is to recapture the well-to-do American public, the opportunity presented by the coming international exposition in Saint Louis must be grasped to make up for past mistakes." Above all, the jury system must be changed. In the past, a quota had been established for each chapter of the Kunstgenossenschaft proportionate to the size of its membership, and each chapter selected its share of works for the exhibition. Mediocre or even poor shows were the result. "We should seriously consider applying a different method in Saint Louis, possibly the system used in 1878 (Paris), when only a few artists were entrusted with the task of choosing appropriate works."[65] In practical terms, this implied the replacement of the Kunstgenossenschaft by a special national jury detached from local pressures — the very recommendation the Kultusminister made to the chancellor.

While the government deliberated on the planning of the art show, and while the Kunstgenossenschaft was claiming its traditional authority over the selection process, one man attempted to gain control of the entire enterprise. In February 1903, the sculptor Cuno von Uechtritz circulated a memorandum entitled "In Reference to Art" to the relevant authorities; in it he argued that only an art commissar, sensitive to the political implications of art, could avoid the failures that Germany had recently suffered in international exhibitions.[66] Uechtritz, who held a minor teaching position in Berlin and served as president of the local Deutsch-Amerikanische Verein, was best known for winning first prize in a contest for a monument in Lübeck, which was withdrawn after protests by the town's association of art lovers. He had worked on the Siegesallee; a symbolic group, *The Crown as Guarantor of Peace*, had just been purchased by the emperor for the House of Peers; and he was now completing a monument to Saint Hubertus, patron of the chase, which after its unveiling was described as a baker's Christ-

65. Ende to Studt, 28 June 1902, ibid., pp. 6–7.
66. Copy of Uechtritz's memorandum of 14 February 1903, ibid., Rep. 09.01, Bd. 5, Nr. 51 (504), pp. 100–102 verso; covering letters by Uechtritz, 14 March 1903, and internal Foreign Office memorandum, 15 March 1903, ibid., pp. 99, 103–106.

mas display and as the absolute worst that Berlin court art was capable of.[67] But Uechtritz could not be ignored altogether since he had had a talk with the emperor on the political significance of art, in the course of which, as his memorandum stated, "His Majesty declared himself in complete agreement with my views, and ordered me to work toward their implementation." The immediate result had been an interview with the Kultusminister, who "also had agreed with my views." Now Uechtritz offered himself for the position of art commissar, who would have sole responsibility for German art at Saint Louis. The commissar was to be supported by a committee of state-appointed experts; together they would act as organizers and jury, and thus avoid the "fortuitousness, one-sided party politics, and egotism" that had characterized the Kunstgenossenschaft's activities at earlier expositions.[68]

Uechtritz's discussion of the political functions of art did not extend beyond generalities: "At home [art] can stimulate patriotism in the populace; abroad it can increase respect for, and attachment to, the German people, and can be more persuasive and—since it is constantly on view—exert a more lasting effect than propaganda tracts and the polemics of political leaders." Besides sponsoring exhibitions, the state, in cooperation with American patrons, should establish art academies, "which under German leadership would stimulate the sense for art in America . . . so that as Steuben organized the American army, Germany will organize American art."[69]

In a second memorandum, "Art as the Pioneer of German Interests in the U.S.A.," Uechtritz advocated selecting works on religious themes for Saint Louis; historical paintings should be sent only if they depicted individuals and events familiar to Americans. "A few portraits of the emperor and Bismarck would be suitable; for the rest one should concentrate on the heroes of science."[70] That was sound advice if themes rather than treatment were to determine the selection, but Uechtritz was too much the light-weight for his ideas to affect the organization of the German show. Already in April he was complaining that the Reichskommissar had appointed a commission for the art show, just as Uechtritz had proposed, but

67. "Chronik," *Kunst und Künstler*, 3 (1904–1905), pp. 131–132; *Kunst für Alle*, 18 (1902–1903), p. 290.

68. Uechtritz, memorandum of 14 February 1903, pp. 101–102.

69. Ibid., pp. 100–100 verso.

70. Undated memorandum [late May 1903] submitted to the Kultusminister, passed on to the Foreign Office on 24 June 1903, ZStA Potsdam, Auswärtiges Amt, Rep. 09.01, Bd. 6, Nr. 51 (505), p. 103.

that he, Uechtritz, was not among the members; he doubted that the emperor would be pleased with the group's composition.[71] Inquiries must have revealed to the government that the emperor's interest in the sculptor was not very serious. In June the Kultusminister sent a confidential letter to the foreign secretary, in which he agreed with Uechtritz that on idealistic as well as political and commercial grounds German art should be fostered abroad. But, he continued, "I would not expect any significant benefit from the participation of Professor von Uechtritz, who according to his memoranda appears to regard himself as qualified to organize the show. His works have not gained him a high reputation among artists, nor does he possess the personal qualities that would enable him to play a leading role in the art world." Studt enclosed a copy of the latest memorandum, in which Uechtritz once more offered his services to the government on the basis of his thorough acquaintance with American conditions—a claim the foreign secretary dismissed in the marginal comment "Subject has never been in America."[72]

By the time this episode reached its tragicomic end, Lewald, who thought of Saint Louis largely in terms of international rivalry and the gain and loss of political prestige, had come to agree with Studt that a strong German presence demanded the participation of all factions of German artists.[73] When, early in March, the Kunstgenossenschaft tried to force his hand with an invitation to discuss the organization of the art show, Lewald played for time by asking that the meeting be postponed on grounds that he would soon leave on another trip to the United States. He was quietly holding talks with the governments of the major German states, and on 28 March announced the formation of a consultative committee of thirty-nine members, chosen on the recommendation of the various German states; this group was to decide whether the art exhibition in Saint Louis should be entrusted to the Kunstgenossenschaft once again or to an ad hoc group of artists, museum directors, and art dealers. Lewald added that the second option, which he advocated in the

71. Copy of Uechtritz to Posadowsky or Studt, 25 April 1903, ibid., Rep. 09.01, Bd. 5, Nr. 51 (504), p. 145 verso.

72. Studt to Richthoven, 24 June 1903; Uechtritz, undated memorandum; ibid., Rep. 09.01, Bd. 6, Nr. 51 (505), pp. 98–99, 106.

73. Lewald seems to have leaned in that direction from the start. See Lichtwark's account of conversations with Lewald and German and American officials in December 1902, in *Briefe an die Kommission*, II, 37–39, 41–43. For Lewald's view that Germany was facing determined foreign competition, see, for instance, his address to Munich artists, printed in his official newsletter, *Mitteilungen betreffend die Weltausstellung in St. Louis 1904*, no. 1 (5 March 1903).

name of the Reich, had the approval of the governments of Prussia, Bavaria, Saxony, Baden, Württemberg, Hesse, and Saxe-Weimar.

The committee covered almost the whole spectrum of German art: it included the current and immediate past presidents of the Kunstgenossenschaft; leading figures of its local chapters; the president of the Prussian Academy of Arts, Hermann Ende; and the director of the Prussian Institute for the Fine Arts, Anton von Werner. Also among its members were three of the country's most progressive museum directors—Tschudi, Lichtwark, and Pauli; two art dealers; the heads of two of the three secessionist groups in Munich; and two leaders of the Berlin Secession, Klimsch and Leistikow.[74] At a meeting in the Reichstag building on 4 April, boycotted by the Kunstgenossenschaft, the committee reached the foregone conclusion and, with the open approval of Lewald, appointed a smaller committee to twenty-one to take charge of the exhibition.

The appearance of this broadly constituted body caused a sensation. Not only was the Kunstgenossenschaft deprived of its by then traditional control over German art at international exhibitions, but the "art parliament" replacing it was the most genuinely representative national group of artists and art experts in Germany's history. Moreover, this surprising result, which contravened the emperor's well-known opinions, had been achieved in the normal course of government business through negotiations between the imperial commissioner and the federated states.

Lewald's decision was motivated not by aesthetic, let alone political, convictions, but by his determination to lead Germany to victory in Saint Louis. In this campaign the Kunstgenossenschaft could not be regarded as an elite regiment. Its record at previous international exhibitions was criticized in the ministries and even by some conservative newspapers; such senior Prussian officials as Studt and Müller condemned its jury system, in which traditionalism combined with respect for the wishes of the majority of its members to guarantee a safely conventional, mediocre exhibit. No improvement could be expected as long as the local chapters had a major voice in the selections and acceptances were governed by the size of each chapter rather than by the quality or even the reputation of the individual artist.

74. Ibid., no. 5 (2 April 1903). See also reports in the press, such as "Die deutsche Kunst in Saint Louis 1904," *Münchner Neueste Nachrichten*, 21 April 1903; "Die Frage der Organisation der deutschen Kunstabteilung . . . ," *Vossische Zeitung*, 26 April 1903; and *Kunst für Alle*, 18 (1902–1903), pp. 366–368.

For his part, Lewald placed national effectiveness above custom and particularist interest. He must have been aware of the emperor's dislike of modern art, which would benefit from the new system, but he was covered by the approval the chancellor and Posadowsky had given to Studt's proposal nearly a year ago, and by the emperor's silence on the matter in the intervening months, if his encouragement of Uechtritz could be dimissed as a transitory impulse. Under these circumstances, Lewald faced the expected opposition of the Kunstgenossenschaft with equanimity. As early as 2 April, its president lodged formal protests with Lewald and the chancellor, a well-publicized emergency meeting of the Berlin Verein voted nearly unanimously to join in his representations, and in May delegates to a special national congress authorized the leadership, by a vote of 241 to 39, to "take all necessary steps with the chancellor of the Reich to retain control and management of the German art exhibition in Saint Louis for the Kunstgenossenschaft."[75]

In support of its position, the association denied that its presentation of German art at international expositions had been ineffective or inequitable, thus contradicting recent statements by some of its own leaders, and castigated the elitism that accorded splinter groups an influence far out of proportion to their numbers. It claimed that twenty-three of the thirty-nine members of Lewald's consultative committee, and fifteen or sixteen of the second committee of twenty-one, followed the "so-called secessionist direction," although in 1902 only 306 out of the association's total membership of 3,055 belonged to secessions.[76] Not only was this breakdown highly arbitrary—the two art dealers, for instance, were counted as supporters of the secessions although neither had ever been interested in modern art—but it passed over differences between secessionists

75. Heinrich Deiters, *Geschichte der Allgemeinen Deutschen Kunstgenossenschaft* (Düsseldorf, [1906]), pp. 48–49.

76. "Die Weltausstellung in St. Louis und die deutsche Kunst," *Weser-Zeitung*, 31 December 1903. This long retrospective analysis of the conflict between the Kunstgenossenschaft and its critics, contributed by an anonymous correspondent in Berlin, was almost certainly written by Anton von Werner. Its style and arguments closely resemble statements known to be his, such as the interview with Julius Norden quoted in chapter 3. The text also refers to the confidential report on the American art market by the German embassy in Washington; this document was known to Werner, who had been given access to certain diplomatic and consular reports from the United States. Posadowsky to Richthoven, 24 July 1903, ZStA Potsdam, Auswärtiges Amt, Rep. 09.01, Bd. 6, Nr. 51 (505), p. 88. While this book was in press I found a draft of the letter in Werner's handwriting in his papers, ZStA Merseburg, Rep. 92, Nachlass Anton von Werner, VId, pp. 126–136.

themselves, many of whom were scarcely less traditionalist than Werner.

Characteristically, too, the association's accounting ignored any artist who was not a member. In the press, in debates, and in subsequent articles and pamphlets justifying its stand, the Kunstgenossenschaft equated itself as a matter of course with German art: artists who did not belong to the Kunstgenossenschaft were disenfranchised; for the Reich's cultural mission abroad their work did not and could not exist. Within the scope of its membership, however, the association insisted on strictly proportional representation: "The federal states and the various art centers must be treated according to the number of their artists. It is not the task of the imperial government to compare and weigh the significance of the various factions and of their artistic directions . . . If Munich has 1,000 artists and Berlin only 500, Munich has a claim on twice the space in exhibitions designed to represent German art. That is an incontestable and honorable principle, which has always guided policy in the past, despite the various directions that have always existed in art."[77]

When challenged, the restrictive guild mentality of the Kunstgenossenschaft could do no better than insist on its monopoly over German art and to maintain the principle of numbers above quality. According to this view, if Germany's best painter had the misfortune of belonging to a small local chapter, it was appropriate that only one of his paintings be selected for Saint Louis, while a popular mediocrity in a large chapter might exhibit three or four. The justice of this doctrine was borne out not only by tradition and the need for a strictly equitable union policy that alone might alleviate the economic difficulties of the contemporary artist, but also by the fact, constantly reiterated in discussions and in print, that the emperor himself supported it. "Passions of party ought not raise themselves as judges over the supreme fount of justice in the German empire."[78]

The emperor's response to the intrusion of modern art into the Reich's cultural policies abroad was as uncompromising as that of the Kunstgenossenschaft. He was infuriated by Lewald's initiative. Friedrich von Holstein, head of the political department of the Foreign Office, wrote to a friend on 20 April: "The newest item is that

77. *Weser-Zeitung*, 31 December 1903. See also Deiters, *Geschichte der Kunstgenossenschaft*, pp. 46, 48–51.
78. *Weser-Zeitung*, 31 December 1903.

His Majesty has flown into a rage over the Reichskommissar in Saint Louis." Holstein added that Werner, Begas, and others were complaining to the emperor, and that Lewald's career might be in jeopardy.[79] The emperor's anger must have been heightened when Werner claimed that Lewald intended to turn the exhibition entirely over to the secessions, although this untruth was hardly necessary to spur him to action. That a show representing the empire before the world was to include a large number of works by such painters as Liebermann and Slevogt was a prospect that could only disgust him. He did not attack the art parliament in public statements, but, advised by Werner, set in motion a complete reversal of government policy. The Kultusminister's advisor on art, Müller, who was rightly suspected of having originated the idea of the art parliament, was relieved of his post and was left in no doubt that the emperor's anger had put an end to his career.[80] The interior secretary was instructed, either directly by the emperor or by the chancellor, to rescind the arrangements that Lewald had concluded, with his approval, with the German governments. With the ground thus cleared, Werner and two other representatives of the Kunstgenossenschaft had a meeting with Posadowsky and Lewald, and on 14 July the interior secretary announced that the imperial government had restored complete responsibility for the art show in Saint Louis to the Kunstgenossenschaft.[81]

79. Holstein, Lebensbekenntnis, ed. Helmuth Rogge (Berlin, 1932), pp. 221–222.

80. Lichtwark reports Müller's statement to that effect in Briefe an die Kommission, II, 61. Müller's dismissal did not turn his office in the Kultusministerium into a conservative stronghold. His successor, Friedrich Schmidt-Ott, later a minister under the Weimar Republic, soon tried to induce the emperor to be more tolerant. At his suggestion the Berlin art historian Heinrich Wölfflin used the occasion of a meeting with the emperor to outline the significance of impressionism, but was immediately interrupted by an order, widely publicized in the press, "to stand firm against the modern direction." See, for instance, the report of the incident in the Rheinisch-Westfälische Zeitung, 14 June 1904.

81. Hans Rosenhagen, "Deutsche Kunstzustände," Kunst für Alle, 19 (1903–1904), pp. 65–67. Few specifics are known about the communications between William II and Werner in the spring of 1903. Lewald subsequently stated that Werner influenced the emperor to oppose Lewald's plan; Holstein, Lebensbekenntnis, p. 222n. At the time both supporters and opponents of the Kunstgenossenschaft believed that the two men had joined to destroy the art parliament. In a pamphlet published in defense of his conduct, Werner denied the assertion in the Reichstag by a member of the moderately liberal Freisinnige Volkspartei that in August 1903 he had transmitted an order of the emperor to the interior secretary, calling for the return of the exhibition to the control of the Kunstgenossenschaft; Anton von Werner, Die Kunstdebatte im Deutschen Reichstag am 16. February 1904 (Berlin, 1904), pp. 7–8. The charge was mistaken since the decisive steps had been taken by July, but Werner said nothing about his earlier dealings with the emperor.

The government's replacement of one officially constituted body by another group, without previous consultation and without giving reasons for the change or even notifying the committee that it had been disbanded, was unusual but not illegal. More doubtful was the unilateral abrogation of agreements between the imperial executive and the federal governments; yet no state seems to have raised the matter officially. For the emperor and Werner, their unabashed use of power had both desired and unfavorable results. Modern art had once again been shown that it counted for little in official Germany. The Kunstgenossenschaft retained its privileged position and was able to organize the art show in Saint Louis on uncompromisingly conservative lines, undisturbed by minority views. The exhibition turned out to be even more homogeneous than could have been hoped, because with one exception the secessionist chapters of the association refused to participate—a refusal maintained in the face of appeals to their patriotism by the leadership of the Kunstgenossenschaft. Less desirable was the departure of these groups from the association and the founding at the end of the year of a new national organization, the Deutsche Künstlerbund. The very thing that Werner most feared had occurred; the institutional cohesion of German artists was destroyed, and the political power of the Kunstgenossenschaft, which had just mastered its most severe challenge, began to decline. Perhaps equally unexpected, and intensely disagreeable to the emperor as well as to Werner, was the reaction to their coup in the press and the Reichstag, which turned their assertion of the conservative principle in art into a political scandal.

III

The successful campaign waged by the Kunstgenossenschaft to regain control of German art at the Saint Louis Fair was followed by measures to improve its selection system and make it more defensible politically. In September the association's leadership issued new rules for the submission and selection of works for exhibition in Saint Louis. One clause specified that the artists, but not the scholars and art dealers, who had served in the disbanded art parliament would be coopted on the juries of their local chapters. In part this concession may have been intended as a sop to Lewald, but it was little more than an empty gesture; most of the men on the art parliament would have been elected to the local juries in any case. Its significance was further diminished by a second rule, which established a superior central jury, dominated by representatives of the

traditional groups.[82] This break with the association's principle of
equality was strongly resented by the membership, which began to
agitate for its repeal. In the face of growing dissension, the president
of the Kunstgenossenschaft, the sculptor Offermann, resigned; find-
ing a successor proved difficult until Werner assured the executive
committee that its efforts to assemble a strong show for Saint Louis
would receive the special support of the imperial government. A
professor at the Saxon Academy of Arts, Privy Councillor Kiessling,
thereupon accepted election as president.[83]

In the first week of October the three secessionist groups in Mu-
nich demanded the right to appoint their own juries and exhibit in
their own rooms in Saint Louis, an ultimatum that the association
rejected. On 25 October the Berlin Secession announced that it
would boycott the show. Some weeks afterward, the leadership of
the Kunstgenossenschaft gave way before the protests of its mem-
bers and removed half of each chapter's selections from the veto
power of the central jury, although it retained a vaguely defined ulti-
mate authority to assure the integrated character of the exhibition.
Spokesmen for the government and the association later liked to
point to this change as proof that the secessions had been fairly
treated, since at least half of their choices would have been accept-
ed; they failed to add, however, that the change had been made only
after the Berlin Secession, with its large number of controversial ar-
tists, had withdrawn from the show.[84]

At a general meeting of the Munich Secession on 11 November,
the members voted not to send works to Saint Louis. Uhde's com-
munication of this decision elicited a barbed response from the
Kunstgenossenschaft: "If you . . . persist in your rejection, we shall
publicly accuse you of severely endangering a most significant na-
tional cause out of petty motives, at a time when it is the absolute

82. According to a letter from the chairman and secretary of the Kunstgenos-
senschaft to the Munich Secession, 29 November 1903, "in the section for painting of
this central jury, which consists of twelve individuals, the secessions and the clubs
associated with them would be represented by four delegates." *Kunst für Alle*, 19
(1903–1904), p. 195. Nevertheless when Posadowsky defended the government's ac-
tions in the Reichstag, he attempted to claim that the secessions and their sympa-
thizers had been given half of the votes on the central jury; Posadowsky, session of 16
February 1904, *Verhandlungen des Reichstags: Stenographische Berichte* (Berlin,
1904), CVIIIC, p. 1004.

83. Hans Rosenhagen, "Deutsche Kunstzustände," *Kunst für Alle*, 19 (1903–
1904), p. 68. See also "Die deutsche Kunstabteilung in St. Louis," an anonymous
rebuttal to Rosenhagen's analysis, ibid., pp. 141–147.

84. See, for instance, Posadowsky, session of 16 February 1904, *Verhandlungen des
Reichstags,* CVIIIC, p. 1004.

duty of all to close ranks before the non-German world!" Nevertheless, on 1 December, Uhde, speaking in the name of the secessions of Berlin, Dresden, Karlsruhe, Stuttgart, and Weimar, repeated his refusal. After declaring that the Kunstgenossenschaft ignored true achievement, he continued: "We will not subject ourselves to the judgment of a central jury, whose artistic competence we deny, and which has the power of deciding that not a single one of our paintings will be sent to Saint Louis. We protest against the claim that this exhibition will be a mirror of German art. We demand that the German secessions receive the recognition their achievements deserve. Then we would contribute our best, and do all in our power to ensure that German art emerges with honor from the competition of nations." One of the other two secessionist groups in Munich followed suit, while the more conservative decided to cooperate with the Kunstgenossenschaft, arguing that although its planning was imperfect, "the composition of the central jury, which has the authority to correct the provisional judgment of the local juries, appears to guarantee that it will measure up to its task. Furthermore, honor and his patriotic duty oblige every German artist to fight for the common cause . . . and thus help erase from memory the defeats that German art suffered in Chicago and Paris."[85]

The departure of the secessions deprived the exhibition not only of the avant-garde but of practically every eminent conventional artist as well, among them Albert von Keller and Hans Thoma, both of whom had been members of Lewald's art parliament. To make up for the loss, the organizing committee invited works from splinter groups, which might be only loosely associated with the local chapters. The artists' colony at Worpswede received such an invitation; it specified that the group, having five members, was entitled to wallspace of 1 meter 11 centimeters in Saint Louis—a pedantry that evoked some amusement when it was subsequently quoted in the Reichstag.[86] The committee also felt compelled to borrow works of a previous generation of artists from the state museums, a change that to some extent compromised the original purpose of offering America a survey of contemporary German art and winning a market for it. The collaboration between government and Kunstgenossenschaft grew still closer when Werner, who already had a seat on the central jury, became Lewald's advisor on the art budget, a position that was

85. *Kunst für Alle*, 19 (1903–1904), pp. 194–196.
86. Count Waldemar Oriola, Session of 16 February 1904, *Verhandlungen des Reichstags*, CVIIIC, p. 1009.

soon expanded, at the recommendation of the secretary of the interior and the Kultusminister, to that of Lewald's representative in organizing the art exhibition.[87]

The completeness of the victory gained by "officially approved, narrow-spirited royal Prussian subaltern art," as Leistikow characterized it, hastened a step that the opponents of the Kunstgenossenschaft would almost certainly have taken eventually. Members of the secessions and members of the Kunstgenossenschaft who did not approve of its intolerance, together with a few art critics, museum officials, and collectors, met in Weimar from the fifteenth through the seventeenth of December and founded a new national organization, under the protection of the grand duke of Saxe-Weimar, the Deutsche Künstlerbund. Although the secessionist spirit was instrumental in creating the Künstlerbund, it drew its members from adherents of a great variety of styles. Only individuals, not entire organizations — whether secessionist or traditional — could apply for membership, which was granted on the basis of achievement. The Künstlerbund was founded, Leistikow wrote, not to support a particular direction in modern art, but "to replace the old, antiquated Kunstgenossenschaft with a new, vigorous organization, which will represent all truly creative artists more effectively and more fairly."[88] At the banquet celebrating the event, Liebermann declared, paraphrasing Frederick the Great, that a union had been created "in which everyone could find salvation according to his particular faith."[89]

The ideas behind the new organization were spelled out most fully by the art critic and museum director Count Harry Kessler in a pamphlet that proved to be a particularly effective and provocative statement of the secessionist position. Kessler found nothing unusual in the efforts of the Kunstgenossenschaft to suppress the work of artists who were individualists. "The only novelty is to see the highest organs in the state taking part in the business. But the goal is always the same: to eliminate individualism in art so that the many others may have a chance. To oppose this firm tendency of human nature, we must create a counter-force, which will enable talent to

87. Werner, *Die Kunstdebatte*, pp. 8, 20.

88. Walter Leistikow, "Über den Deutschen Künstlerbund und die Tage von Weimar," *Kunst für Alle*, 19 (1903–1904), pp. 204, 205.

89. "Vermischte Nachrichten," ibid., p. 199. On the founding of the Künstlerbund, see also Lovis Corinth, *Das Leben Walter Leistikows* (Berlin, 1910), pp. 71, 76–77; Johannes Kalckreuth, *Wesen und Werk meines Vaters: Lebensbild des Malers Grafen Leopold von Kalckreuth* (Hamburg, 1967), pp. 295–298.

follow its artistic conscience in safety . . . For there can be no doubt, in art only the exceptional has value . . . Everything else is not only worth less; it is worth nothing."[90] It was the task of the new group, he believed, to help the secessions fight for this principle, to combine their fragmented efforts into a national movement.

The principle that brought the Künstlerbund into being: to protect and further individualism in art, and to do so forcefully but without seeking to influence art or tolerate outside influences — that principle conforms to the essence of art.

And that same principle will also have to be accepted in the political life of the nation.

For the modern state concerns itself with art. The state owns galleries, organizes exhibits, builds, and rewards. And these matters are not "minor," as politicians like to claim, issues that should not disturb the course of "grand" policy. On the contrary, they are the ultimate reasons for politics. In the final analysis politics in different forms always fulfill the same task: to guard and smooth the way for the highest, most varied, and broadest development of a people — that is, for its ideal, intellectual, and artistic gifts. To do that is the purpose of parliaments, battleships, and chambers of commerce. Even high politics is only a means for this purpose. Thinkers, poets, artists stand at the center; everyone else approaches the center to the extent that his actions touch these living spirits, who constitute what is of permanent value in their people.

For that reason anyone who has a voice in these matters bears a heavy responsibility. And since the state draws art into its realm, we must demand that even politics evaluate art according to its true significance, and treat it according to the only applicable principle, the principle of freedom.[91]

Kessler did not address the ultimately unanswerable question of who was to decide what was and what was not good art. In practical terms his pamphlet simply demanded that the state and its "highest organs" relinquish the claim of absolute authority, and give the creative artist sufficient "freedom" and support to keep from being

90. Count Harry Kessler, *Der deutsche Künstlerbund* (Berlin, 1904), p. 13. In July 1904 Kessler traveled to London to appear as a witness before a select committee of the House of Lords investigating the expenditure of public funds for art. In the course of his testimony Kessler declared: "It has been an old custom in Germany to entrust to [the Kunstgenossenschaft] the organising of exhibitions, and especially of foreign exhibitions. The consequence was that those foreign exhibitions were organised on very democratic lines — that is to say, artistically democratic lines: the artists who really worked were pushed out either by amateurs or by people who, somehow or other, had got a great power in the Association." Great Britain, *Parliamentary Papers,* vol. I (*Reports,* 5, February – August 1904), "Select committee on the Chantrey Trust," p. 179.

91. Kessler, *Der deutsche Künstlerbund,* pp. 26 – 28.

crushed by the academy and the art proletariat. In the tradition of the elitist humanism of Fichte and Wilhelm von Humboldt, the pamphlet called on the state to guarantee freedom not for a particular course of action but freedom for the creative spirit to soar wherever it wished.

During the discussions on the structure of the new organization, Leistikow, strongly backed by Kessler, once again argued against the "democratic principle of the equal vote" in art associations, which placed the dilettante on the same level as the artist, and had turned the Kunstgenossenschaft into a lobby for the economic interests of mediocrities. The elitist concept that he and Liebermann had introduced to the management of the Berlin Secession was carried even further in the new group. All business was entrusted to an executive committee of thirty individuals, elected for five-year terms, during which time they held absolute authority, including the power to decide on membership applications, appoint juries, and replace those who left the committee. A strong contingent from the Berlin Secession was elected to the committee: Liebermann, Leistikow, Slevogt, Corinth, and Tuaillon; but also such very different artists as Klinger and Thoma, Henry van de Velde, the industrialist and writer Eberhard von Bodenhausen, and Kessler; among the Munich representatives were Uhde and Keller. As president the conference elected Count Leopold Kalckreuth, who was to hold the office for twenty-five years; Liebermann, Uhde, Klinger, and Kessler were elected vice-presidents.

Kalckreuth, then a painter in his late forties, former president of the Karlsruhe Secession, had only recently achieved national prominence. His subdued impressionist technique could lend tension and vitality to his soberly romantic treatments of the German countryside—farmers sowing or bringing in the harvest, old women tending geese—and to his many depictions of north German harbor and river scenes. The philosopher Wilhelm Dilthey rather equivocally praised his paintings for their truthfulness and "a certain heavy greatness of conception." Self-portraits and portraits probably constitute Kalckreuth's most interesting work, among them such ambitious psychological analyses as the 1888 portrait of his wife and those of his intimate friend Alfred Lichtwark, of Lichtwark's mother, and of Paul Cassirer.

As the scion of a prominent noble family, reserve officer in the Prussian foot guards, descendant of two Prussian field marshals and married to the great-granddaughter of a third, Kalckreuth was an unusual choice to head a group that openly opposed the art policies

of the emperor and of the Prussian establishment. In his politics he was a monarchist, he regarded Houston Stewart Chamberlain's confused paean on cultural nationalism, *Foundations of the Nineteenth Century*, as an epochal book; when he accepted the presidency of the Künstlerbund, nothing troubled him more than the possibility that "the socialists will take up the cause of the artists."[92] But Kalckreuth was a man of independent views. In his youth he had disregarded the wishes of the German government by accepting Liebermann's invitation to send a painting to the Paris International Exposition of 1889, an act of disobedience for which, as a reserve officer, he was forced to apologize to the emperor. He judged the imperial system by the more frugal Prussia of several generations earlier, and in many respects he found it wanting. In art circles he was known as a cautious, fair-minded man, perhaps better suited to lead the new association than the combative Liebermann, who had also been mentioned for the post. Kalckreuth's social position seems to have been a further reason for choosing him. The Künstlerbund might appear less subversive to the emperor if it was led by the bearer of a name well known in the history of the monarchy.

Immediately after his election, Kalckreuth requested an interview with the chancellor to explore the possibility that the Künstlerbund might take part in the American exhibition even at that late date. Bülow was either unable or unwilling to receive him, a rejection that led *Simplicissimus* to publish a cartoon, captioned "German Art and Bülow," in which a guard turns away a bedraggled supplicant, representing art, from the fortress of state with the words: "First have Herr von Werner fit you with a decent uniform, then you may call again."[93] Instead, Kalckreuth saw Posadowsky and offered him a show of the best-known German painters and sculptors if one-third of the space available for German art in Saint Louis were assigned to the new organization. Posadowsky could not accept this proposal, which would have reopened the conflict that had recently been settled by the emperor's and Werner's intervention; but he suggested that direct talks with the leaders of the Kunstgenossenschaft might yet lead to an acceptable arrangement. Kalckreuth's proposals were, however, categorically rejected by Werner, who had just published an attack on the competence of "the

92. J. Kalckreuth, *Wesen and Werk*, pp. 252, 297.

93. *Simplicissimus*, 8, no. 43 (19 January 1904). A related cartoon appeared in ibid., no. 45 (2 February 1904).

matadors of the secessions" that was unusually outspoken even for him.[94] All the association was prepared to do was to accept works for submission to the local and central juries, although, it was added, the paintings borrowed from museums would leave little or no space for the latecomers. In light of this derisive response, Kalckreuth gave up his efforts.

On all sides, the issue was clearly felt to have gone beyond the familiar disagreements between artists over exhibitions. The importance of choosing paintings and sculptures that would best represent the nation before the world was stressed not only by the emperor, Lewald, and the Kunstgenossenschaft, but by the secessions as well; their cultural patriotism and competitiveness were more moderate, however, and concerned less with asserting German uniqueness and superiority than with demonstrating Germany's contribution to an international standard. It was this sense of the link between art and the nation, variously interpreted, that intensified bitterness everywhere and made the quarrel significant to the general public. Not only art periodicals but the daily press published commentaries on the art parliament and its destruction; throughout the fall and winter of 1903, the planning for the Saint Louis Fair continued to be discussed in print. Interest rose further in the first weeks of the new year, when the budget committee of the Reichstag referred to the matter while considering the regular item in the national budget for support of German art abroad as well as a government request for an increase in the special appropriation for Saint Louis.

The press reported the clash between several committee members and Posadowsky over the government's preparations for Saint Louis, which, it was noted, was sure to lead to debates in the Reichstag and the Prussian Landtag. In a long analysis, the *National-Zeitung*, organ of the National Liberal party, regretted that Posadowsky and Lewald had renounced their evenhanded approach, and identified Werner as a "major actor behind the scenes" in bringing about the reversal. The newspaper predicted that the Reichstag and Landtag would use the occasion to "illuminate the relationship between state and government with the vital, progressive art of our time, and to show that it is impossible to continue in the customary ways if national interests of the highest ideal and material significance are not to be endangered." The article ended by urging that "measures should be adopted even now to give the art section in Saint Louis a

94. "Zuschrift," *Düsseldorfer Anzeiger*, 24 December 1903.

different and better form. If goodwill is present, it might still not be too late."[95]

It was not in the power of the Reichstag to change specific policies; all it could do in this instance was to approve or reject the annual budget, a decision that would not hinge on the view members took of the government's handling of matters at Saint Louis. But in Reichstag proceedings, budget debates afforded one of the best opportunities to offer suggestions, present grievances, and attack the government. The two relevant budget items were scheduled for consideration in the middle of February. The government expected difficulties, but it foresaw neither the length of the debate, which began in the late afternoon of 15 February and continued for six hours on the following day, nor the bitterness of the criticism.

Nine speakers took part, representing a broad spectrum of political opinion, from the Free Conservatives to the Catholic Center party, the National Liberals and Progressives, to the Socialists. Posadowsky spoke twice in defense of the government; he was assisted by the official who had served as Reichskommissar for the Paris Exhibition and by the Saxe-Weimar representative in the Bundesrat, who denied a charge that Prussia had tried to dissuade the grand duke from supporting the Künstlerbund.[96] One of the two Catholic Center party deputies saw little to deplore in the victory of the Kunstgenossenschaft: artists were a contentious lot, he said; their differences should not be taken too seriously. Yet even he did not sanction the government's actions. Although most members of his party were no admirers of the secession, they "believed that Germany's delegation to the exhibition should have included the secessionist minority."[97] The other speakers were united in sharply condemning the government for betraying its national responsibilities by favoring one group of artists over another, and six accused the government of breaking its agreement with the federal states, an act that Ernst Müller-Meiningen, a member of the Freisinnige Volkspartei, called a revival of Prussian absolutism.[98]

95. "Die deutsche Kunst in St. Louis," *National-Zeitung*, 23 January 1904. Similar comments appeared in much of the liberal and progressive press.

96. The charge was the occasion of a cartoon, in *Simplicissimus*, 8, no. 48 (23 February 1904), in which an earlier ruler of Saxe-Weimar tells his minister: "The people in Berlin want to regulate our art, dear Goethe, but I won't ask them for advice until we introduce a new model of military boot."

97. Theodor Kirsch, Session of 16 February 1904, *Verhandlungen des Reichstags*, CVIIIC, pp. 1024–25.

98. Ibid., p. 1016, Müller-Meiningen was one of the younger leaders of his party. In 1917 he opposed the Peace Resolution. After the First World War he became Bavarian minister of justice.

Posadowsky tried to turn away the storm by declaring that as the Reich's secretary of the interior he was not responsible for Prussian policy—a specious argument, since one of the issues was precisely the Reich's submission to Prussia. Further, he suggested that the secessions, far from being badly treated, had been unwilling to work with the traditional groups: "Their outlook is based on the concept of absolute individualism, while they regard the Kunstgenossenschaft as representing the rights of the mass [of artists]." When the government would not give them control of the exhibition, they excluded themselves, he said.[99] The Reichstag showed some sympathy for Posadowsky's position; speakers called him a whipping boy and a sacrificial lamb who was shielding the true culprits, but he was not believed. The leader of the Free Conservatives, Wilhelm von Kardorff, whose son Konrad was one of the more promising young painters of the Berlin Secession, did not hesitate to accuse the government of lying.

Comments by a man like Kardorff, a member of the oldest Mecklenburg nobility, undoubtedly made a stronger impact than the attacks of the Socialists, whose ferocity was discounted from the start. In previous debates Kardorff had alluded to impulsive and inaccurate statements by the emperor; now he criticized what he regarded as the emperor's inappropriate influence on the cultural policies of the empire:

The secretary of the interior . . . had declared that one cannot, after all, prohibit His Majesty from expressing an opinion on art matters. Who would want to forbid it? But we are not in an absolute state here, nor in Prussia [Very true!], but in a federal union, the German Reich, and here the will of one man cannot be decisive. Let me suggest that the taste of even the greatest ruler might err by recalling Frederick the Great's opinion of Shakespeare . . . And when I consider what the aesthetic direction that dominates Prussia today has wrought in Berlin [Very true!], well, than I must admit to a certain feeling of anxiety [Very true! Laughter].[100]

Less polite were the objections raised by the Progressives and the Socialists. After discussing the part that Anton von Werner, as the emperor's agent, had played in selecting works for exhibition in Saint Louis, the Socialist leader Paul Singer continued: "The secession is categorized by a judgment, which, having been uttered by the

99. Ibid., p. 1004.
100. Ibid., p. 1022. Kardorff, one of the most striking personalities in the Reichstag, was the founder of the Central Association of German Industrialists, and chairman of his party from 1880 to his death in 1907.

emperor, presumably possesses aesthetic character; the secession is regarded as 'art of the gutter.' Now, gentlemen, if court artists are called upon to make a selection from the paintings that were submitted for the show in Saint Louis, it is entirely understandable under present conditions that only those works are chosen that suit the attitude of the highest authority. But such an approach is totally wrong. Art cannot be regimented, nor can artists be drilled [Very true! on the Left]." Elsewhere Singer castigated the inequitable use of public funds as an expression of the emperor's personal rule.[101] The National Liberal deputy Count Oriola asserted that "no one, regardless how high his position in the country, could compel art to move in directions other than those that it thinks right to choose itself."[102] The speech by the Progressive Müller-Meiningen was punctuated by barely veiled attacks on the emperor:

Prussia is about to be subjected to a court aesthetic, which . . . will apply [the emperor's words] *sic volo, sic jubeo* to this area of culture . . . Many segments of the population complain that the flunkies and Byzantine flatterers, who unfortunately surround the monarch, don't indicate the dangers of establishing such absolutist art . . . Gentlemen, educated people everywhere – significantly without distinction of party affiliation – ask what this court aesthetic has achieved? Failure wherever we look! . . . Millions of educated Germans remain convinced that the great international movement of modernism, . . . which seeks nature – that is, truth – in art, will not and must not let itself be commanded like a regiment of foot guards . . . Nowhere has infallibility as little scope as in art. As representatives of the German people we have the duty . . . to ensure that a dictatorship in the realm of art is not supported by public funds, but that art is free . . . The history of art and culture has shown that art will go its own way despite kings and emperors who want to enchain it [Loud cheers on the Left].[103]

The defense that the government ought to favor the Kunstgenossenschaft because it did, after all, stand for the great majority of artists, was rejected by the Progressive deputy Heinrich Dove with the comment that "here, as so often, Caesarism is exploiting democratic concepts."[104] Developing this theme, the second Socialist speaker, Albert Südekum, summed up the debate.

101. Ibid., p. 996. Singer, whom Lenin admired, was one of the founders of the Berlin workers' organization, and head of the Socialist delegation in the Reichstag.

102. Ibid., p. 1006.

103. Ibid., pp. 1018–20. In the same speech, Müller-Meiningen compared William II and Charles X of France, to the latter's advantage.

104. Ibid., p. 1023. Between 1910 and 1918 Dove was chairman of his party. For some years he also served as vice president of the Reichstag.

The conflict that occupies us may be characterized as follows: One group of German artists is byzantine in the extreme, another group – whatever else it might be – is not, and is punished for this failure. The autocratic impulses at work do not in the least hesitate to offend the individual states and courts, just as they offend individual directions in art. An evil hatred of vigorous individuality is evident, which Count Posadowsky merely cloaked when he said that especially on [the Socialists'] part it was careless to oppose [the government], since the majority principle, which we uphold, is observed by the Deutsche Kunstgenossenschaft. Yes, indeed, gentlemen, we are for the majority principle in its proper sphere – and for the protection of individuality where that is necessary! We do not want an art republic with William II at its head.

When ruled out of order for mentioning the emperor in a hypothetical context, Südekum corrected himself; he had meant to say "with Anton von Werner at its head."[105]

A subsidiary concern, which nevertheless occupied much of the Reichstag's time, was to determine the nature of modern art, the technical competence of its followers, and the moral and political implications of their works. On these matters the speakers showed little unanimity. The praise of French impressionism by two deputies – one of whom said that "anyone who saw last year's Manet exhibition in Paul Cassirer's gallery will admit that this modern art has taught us to see nature" – was rejected by a third. Südekum called Count Oriola a reactionary for demanding that modern art stay within the limits of good taste.[106] Singer argued that influential groups opposed the Berlin Secession not because it produced such a painting as Liebermann's *Avenue of Trees*, which had been praised by Peter Spahn, the leader of the Catholic Center party, "but because some of its works show life as it really is," because it attempts "to depict reality – even to depict suffering and poverty." This claim was partly denied by Dove, who agreed with Oriola in his dislike of "the art of misery," but nevertheless found far more genuine talent in "the movement that [Oriola] assumed was undermining authority, than in the direction that may imagine that its products support authority [Very true!]"[107] Repeatedly, the debate threatened

105. Ibid., p. 1026, Südekum, an expert on communal administration and author of a well-known work on the living conditions of the urban poor, belonged to the revisionist wing of the Socialist party. During the Weimar Republic he was one of the leaders of the right-wing Socialists.

106. Peter Spahn, Otto Henning, Ernst Müller-Meiningen, Albert Südekum, ibid., pp. 992, 999, 1017, 1025. Between 1912 and 1917 Spahn was head of his party's delegation in the Reichstag. During the last year of the war he served as Prussian minister of justice.

107. Singer, Dove, ibid., pp. 996, 1023.

to disintegrate into disputes over personal taste, but the speakers always reverted to their opposition to the emperor's personal rule and to the principle that "we do not want the government to support only one direction in art."[108]

To the politically interested public, the most significant aspect of the debate was the measure of agreement it revealed among men who usually were political antagonists. German and foreign newspapers took note of the fact—"somewhat remarkable," according to the London *Times*—"that National-Liberal and Conservative speakers like Count Oriola and Herr von Kardorff found themselves for once on the same platform with the Radicals and Socialists"; the same point was made by the *New York Times* of the same day in almost identical language.[109] The Progressive *Berliner Tageblatt* called the event a "great parliamentary day . . . a strange parade before the Supreme Art Lord." And the political review of the week in a subsequent issue of the paper concluded that "the Germany of today apparently rejects a Medician graciousness that likes to impose its own views, and separate creative artists into sheep and goats. It is the first time in our country that such a rejection has made itself strongly felt."[110] The conservative Christian *Reichsbote* said: "The speakers of all parties found themselves in a rare state of unanimity. All traced the evil that is badly damaging German art to court influence and Director von Werner's dislike of the newer movements in art."[111] A feuilleton in the *Frankfurter Zeitung* began with the words: "*E pur si muove!* The world does move, even in Germany." And a lead article in the same paper, "A Protest against Berlin's Autocratic Art Policies," speculated that the Reichstag de-

108. Oriola, ibid., p. 1010.

109. *Times* (London), 17 February 1904; "Kaiser, as Art Critic, Flouted in Reichstag," *New York Times*, 17 February 1904. See also the editorial "Gutter Art," ibid., 18 February 1904. *Die Jugend*, 1904, vol. 1, p. 180, dedicated a quatrain to Werner, in which modern art was praised for miraculously bringing unity to German politics:

> Die herrliche, junge, deutsche Kunst,
> die man geschmäht und gesteinigt,
> Sie hat das grösste der Wunder vollbracht,
> hat des Reichstags Parteien vereinigt!

110. *Berliner Tageblatt*, 17 February and 21 February 1904. See also the same paper's attacks on Werner's role, "Deutsche Kunst in St. Louis," 16 February 1904, and its lead article, "Krone und Presse," 18 February 1904. An equally hopeful conclusion was reached by Ferdinand Avenarius, the editor of *Kunstwart*, in one of the most thorough and balanced accounts of the episode, "Zur Reichstagsverhandlung," *Der Kunstwart*, 17, no. 11 (1903–1904), pp. 613–618.

111. *Der Reichsbote*, 17 February 1904; see also the lead article "Der Staat und die Kunst," in the *National-Zeitung* of the same date.

bate represented "a reaction brought about quietly and without notice by the pressures of an art dictatorship, as it was called today, which has been practiced in Berlin for years, and which on every occasion exerted a powerful influence on the governments of Prussia and of the empire. The vigorous defense of the secessions in the case of the Saint Louis Exposition, and the founding of the Künstlerbund in Weimar, provided a firm base for this reaction, which has now suddenly and in a sense unexpectedly burst out in parliament."[112]

Several papers probed for the specific political motives of the Reichstag's unanimity, especially for an explanation of the surprising adherence of the Center party. The Progressive *Vossische Zeitung* suggested that "the Center party may have realized how little sympathy it could expect, particularly in educated circles, if it pursued politics antagonistic to art. The court's preference for 'official' Berlin art may also have caused friction in south German Center groups."[113] A related interpretation, couched in more violent terms, appeared in the Socialist *Vorwärts:*

Whence this clerical miracle of the Center's conversion to the forbidden gutter art? It is simply the familiar sharp politics of the party. Just as the Center party feigns active support for the politics of social reform so that it can overcome socialism, it now pretends understanding and love for the "healthy" secession, for "genuine" *plein-air* painting, so that by appealing to these sympathies it can the more relentlessly indulge in its Heinze-agitation [*Heinze-Hetze*, a reference to the party's support in 1900 of a more rigorous censorship law, the so-called Lex Heinze]. Who would then dare to interpret the clerical war against *Simplicissimus*, the proscription of the nude in art, as black, backward barbarism? Have we not heroically defended modern art even against the condemnation of the court? Only the excesses in art are our target, only the excesses! This is the tactic that explains the miracle.[114]

The Conservatives' role in the debate was variously explained by pointing out that Kardorff would scarcely regard his secessionist son as subversive, that the debate gave Conservatives an opportunity to express their dislike of the emperor's entourage, and that the party was currently engaged in a conflict over social legislation with Posadowsky. That even moderate Conservatives were far from united

112. "Der Reichstag und die deutsche Kunst" and "Ein Protest gegen die Berliner autokratische Kunstpolitik," *Frankfurter Zeitung,* 18 February and 17 February 1904.
113. *Vossische Zeitung,* 16 February 1904.
114. *Vorwärts,* 16 February 1904.

behind Kardorff in sympathy with the secessions is indicated by the Conservative party's newspaper, the Berlin *Post*, which two days after the debate attacked Posadowsky "for showing insufficient courage in the face of the enemy when defending the emperor's views on art."[115]

The opposition to the emperor's art policies expressed by most of the major parties was indeed a temporary coming together of resentment and outraged common sense rather than a step toward genuine political collaboration. No doubt the Socialists would have liked to exploit the unifying potential of the issue for more substantial efforts, but the other parties were not willing to move beyond their customary retrospective criticism of government decisions. It was a long-established convention of German politics that even adherents of the government block need not agree with the government in all areas. The bourgeoisie had acquired freedom of action in certain "liberalized segments" of public affairs, to use Gerhard A. Ritter's term, primarily in economic and cultural matters, so that one might safely object to the government's handling of art patronage without fear of being labeled a *Reichsfeind*. But direct criticism of the emperor was still taboo, and that the Free Conservatives, the Catholic Center party and the Progressives had unmistakably reached that point was symptomatic of a growing concern among the nonsocialist parties over the emperor's rashness and freedom from accountability.

The debate on the art exhibition in Saint Louis marks a stage on the way toward the more violent, if equally impotent, outburst of public and political opinion over the *Daily Telegraph* interview — and in the latter episode the emperor took greater care in observing his constitutional responsibilities. In February 1904 the secessions and the principle of equity and honest dealing in domestic policy won a moral victory, however little such a victory meant in German politics, and a bit more. In his second reply during the debate, Posadowsky declared in somewhat ambiguous language that when it came to organizing future exhibitions, the imperial government would take greater care to collaborate with the German states.[116] The government did, in fact, pursue a more balanced policy at subsequent international expositions, with the result that the issue that had exercised Reichstag and press in 1904 almost disappeared. Even the emperor, dismayed by the torrent of criticism to which

115. *Die Post*, 18 February 1904.
116. Posadowsky, Session of 16 February 1904, *Verhandlungen des Reichstags*, CVIIIC, p. 1020.

he had been subjected, became for a time more discreet in his public pronouncements on art. His private statements, however, which were occasionally revealed in the press, remained violently antagonistic to modernism.

Immediately after the debate, a special meeting of the Verein Berliner Künstler deplored the Reichstag's criticism of the Kunstgenossenschaft, blaming it on effective propaganda by the Künstlerbund and especially by the Berlin Secession. In the following weeks, members published a number of pamphlets attempting to influence the coming debate in the Prussian Landtag, and to head off a possible Reichstag resolution on the issue. The executive committee of the Kunstgenossenschaft issued a report on its election procedures, seeking to prove that the juries would not have been prejudiced against modern art.[117] A combative pamphlet by the Berlin chapter depicted the secessions as small groups of ambitious artists, driven by the desire for economic gain and the urge to be different: "In their passionate straining after constant originality, the wish to be new and unique at all costs, they themselves have succumbed to dogmatic one-sidedness. Academic routine, which they opposed . . . was replaced by something worse. Every year brought a new fashion, mostly imported from abroad: *plein-airism* was succeeded by impressionism, then by pointillism, neo-impressionism, symbolism, and mysticism – until at last by way of 'sensory colorism' they reached the dizzy heights of amorphism, the complete dissolution of form."[118]

Much the same thing was said by a leading member of the Berlin chapter, the painter Max Schlichting, who accused the Berlin Secession of working against the "national interest" because local artists were always a minority in its shows: "In 1903, out of 173 square meters of paintings, they were allowed only 70 square meters, while other Germans were given 46 square meters, and about one-third of the total area – 57 square meters – was left to . . . foreign artists." Members of this organization, which, to add insult to injury, was ruled by a self-serving elite, should not, he thought, receive government appointments such as professorships, since they might be subject to conflicts of interest that could not be reconciled with their duty to the state.[119]

117. Hauptvorstand des Allgemeinen Deutschen Künstlerbundes, *St. Louis und die deutschen Künstler* (Berlin, 1904).

118. Vorstand des Vereins Berliner Künstler, *Kunstgenossenschaft und Secession* (Berlin, 1904), p. 6.

119. Max Schlichting, *Staat und Kunst* (Berlin, 1904), pp. 13, 18 – 20. More moderate expressions from the same camp were Hermann Knauer's *St. Louis und seine*

Potentially the most effective of these publications was Werner's self-defense. Without diminishing, or wishing to diminish, the part he had played in returning control of the show to the Kunstgenossenschaft, Werner demonstrated that some of the accusations raised against him were based on misunderstandings or inaccurate dates, or were flawed in other ways. He conveyed the impression of a statesmanlike administrator of the arts who had fallen victim to the machinations of a small group that did not recognize the primacy of the national interest or the need for collegiality among artists. But in presenting himself and the Kunstgenossenschaft as champions of all honest art, whether modern or traditional, he went so far as to assert that in the 1890s Albert von Keller had offered him the presidency of the Munich Secession. Werner would scarcely have made such a claim—the basis for which seems to have been a joking remark by Keller, vaguely recalled and taken seriously—if he had not been badly rattled by the Reichstag debate. Keller immediately issued a denial, characterizing Werner's assertion as grotesque, and the result was further public embarrassment.[120]

Werner's apologia, the association's pamphlets, and the defense of modern art that Kessler had earlier written on the occasion of the founding of the Künstlerbund were distributed to members of the Landtag before they debated Prussian art policies on 14 April. In this body, whose members were elected by severely limited suffrage, favoring the conservatives, the debate was far more subdued than it had been in the Reichstag. The emperor was not attacked directly, but the deputies expressed a similar concern for the equitable treatment of the arts.[121] On 10 May the Reichstag reopened the question.

Welt-Ausstellung (Berlin, 1904), which pleaded for a reconciliation of German artists, and the attempt by the Berlin landscape painter Carl Langhammer at a balanced analysis of the conflict, "Zum Deutschen Künstlerstreit," *Kunst für Alle*, 19 (1903–1904), pp. 357, 359, which nevertheless dismissed the Berlin Secession as a "business enterprise."

120. Werner, *Die Kunstdebatte*, pp. 10–11. Keller's denial was published in *Kunst für Alle*, 19 (1903–1904), p. 314. In its issue of 2 March, the *Kreuzzeitung* dismissed the incident as insignificant and attempted a defense of Werner's actions. In a letter published in the *Vossische Zeitung* on 17 March, Werner insisted that Keller had raised the matter of the presidency of the Munich Secession with him.

121. Session of 14 April 1904, *Verhandlungen des Preussischen Hauses der Abgeordneten: Stenographische Berichte* (Berlin, 1904), CCCCLXX, pp. 3682–3768. A parody of the debate appeared in *Die Jugend*, 1904, vol. 1, p. 358, according to which "Kultusminister v. Studt declared that he, for his part, had always supported the absolute freedom of art. Of course, this freedom could not be allowed to degenerate into licentiousness. The state saw to it that the freedom it guaranteed applied only to the truly artistic. Any students of the arts who wished to know what the truly

Members of the Free Conservative, Progressive, and National Liberal parties offered a resolution asking the chancellor to "observe the principle of equity" in "distributing the moneys for support of German art." After a short debate, the resolution was adopted by a majority that the president of the Reichstag called "exceptionally large."[122]

By that time the Saint Louis International Exposition had opened — on 30 April 1904, a year later than intended—and with it the show of German paintings and sculpture. *Simplicissimus* had celebrated the departure of the artworks for America with a drawing of a modern harbor through which a crowned swan pulls a gondola containing a bored German maiden and William II in seventeenth-century costume, blowing a trumpet decorated with the imperial emblem. The caption read:

> Journey westward, syrupy-sweet
> German art and German beauty!
> Journey west, be sure to greet
> All whose stomachs aren't queasy.

> Greet all those who love you dearly,
> High and Highest Lords, and . . .
> Don't come back! Stay in the prairie!
> Fare thee well, preposterous phony![123]

And yet, despite the many predictions that German art as defined by the Kunstgenossenschaft would make itself ridiculous in Saint Louis, the art exhibition fared reasonably well with critics and the public. Reports to the government from observers in America could point to favorable discussions of the art show in such publications as the *New York Times*, the *Nation*, the *Boston Herald*, and the *Washington Evening Star*.[124] The small protest exhibition organized

artistic consisted of, could find a full description in the Royal Prussian Art Regulations, section 17, paragraphs 5 – 7."

122. Session of 10 May 1904, *Verhandlungen des Reichstags*, CC, p. 2836.

123. *Simplicissimus*, 8, no. 46 (9 February 1904):

> Zieh nach Westen, syrupsüsse
> Deutsche Kunst und Herrlichkeit!
> Zieh nach Westen hin, und grüsse
> Jeden, der vor dir nicht speit.

> Grüsse alle, die dich lieben,
> Hohe, höchste Herren, und . . .
> Kehr nicht wieder, bleibe drüben!
> Fahre wohl, Theaterschund!

by modern German painters in a gallery on Chouteau Avenue, outside the fairgrounds, was ignored by the public, while providing further evidence to the emperor and others of the modernists' unpatriotic divisiveness. By summer a number of paintings had been sold, and when prizes were distributed the show garnered a respectable share of medals and honorable mentions. Contrary evaluations were sufficiently rare for the government to conclude that the conflict in the press and the Reichstag had been much ado about nothing. One negative report to Bülow, who passed it on to the emperor, came from the German consul general in Chicago, who two years earlier had tried, and failed, to bring a comprehensive show of modern German painting to the Art Institute. Germany's industrial and scientific exhibits in Saint Louis were a success, the consul wrote. "Only our paintings were excluded from the general praise — they are totally ignored. Although, personally, I, too, find the work of most secessionists bad, and had to laugh at the local description 'the anarchists among artists' ['correct,' the emperor wrote in the margin], nevertheless those among them who have achieved genuine maturity have replaced the old school in America, and almost all the traditional German masters have been pushed aside."[125] Even the final report of the Kunstgenossenschaft acknowledged some flaws in its organization of the show and in the choice of works, while expressing satisfaction at the overall success.[126]

The German show consisted almost entirely of mediocre and bad paintings, but it blended too well with the rest of the art at the exposition to deserve, or evoke, special criticism. Judging from the catalogues, some thematic and compositional tendencies separated the various national sections, and perhaps also small variations in tech-

124. Naturally enough, these were far outdone by the German-American press, which ran such front-page headlines as "Germany Far in Lead. Exhibit at World's Fair Is Superior to That of Any Other Country" (*Chicago Record-Herald*, 1 October 1904).

125. Report of 8 February 1905, ZStA Potsdam, Auswärtiges Amt, Rep. 09.01, Bd. 14, Nr. 51 (513), p. 7. Several years later an officially sponsored exhibition of modern German paintings and sculpture, which included the work of many members of the Berlin Secession, was finally brought to Chicago and other American cities. In his English introduction to the catalogue, the German art historian Paul Clemen wrote: "Naturally, the official exhibitions at Chicago and St. Louis comprised, more or less, representations of official art, and the voices that spoke at those world fairs were too many and too loud for the quiet and pure voice of art to be heard." *Exhibition of Contemporary German Art* (Chicago, 1909), p. 5. See also W. R. Valentiner, "Die deutsche Ausstellung in New York," *Kunst und Künstler*, 7 (1908–1909), pp. 373–375.

126. Richard Müller, Hans von Petersen, and Max Schlichting, "Bildende Kunst," *Amtlicher Bericht über die Weltausstellung in St. Louis 1904, Erstattet vom Reichskommissar* (Berlin, 1906), II, pp. 172–175.

nique; but the similarities were far greater.[127] Whether executed in the studio or outdoors, the paintings that the world sent to Saint Louis were predominantly academic, running the gamut from classical allegories and religious and historical costume pieces, some spiced with *fin de siècle* decadence, to pedestrian interpretations of the more pleasing aspects of contemporary life, whose "realism" was as derivative and standardized as the symbolism of adjoining canvases depicting wood and water nymphs, Magdalens, and witches. Genuine exceptions were rare.

The very large American exhibition—comprising 903 paintings, 115 murals, and 352 watercolors and pastels—included one oil by Whistler, another by Sargent, characteristically awarded the grand medal of honor, and some paintings by Eakins, Homer, Childe Hassam, and a few minor talents. In the French section, one Pissarro, one Puvis de Chavannes, two Renoirs, and works by Fantin-Latour, Monet, Sisley, and a few precursors of impressionism were submerged in a melange of nearly 900 scenes from French history, patriotic homilies, and clothed and unclothed salon art. The core of the British section was a retrospective show of major academic figures who had recently died—Millais, Watts, Burne-Jones, Leighton—supported by the similar work of such living artists as Alma-Tadema, Poynter, and Herkomer, although the Glasgow followers of Whistler were also represented. The Austrian exhibition, which had been boycotted by the Vienna Secession, was of almost unrelieved academic cast.[128] A higher standard seems to have been

127. The description that follows is based largely on *Official Catalogue of Exhibitors: Universal Exposition St. Louis, U.S.A. 1904; Department B Art* (St. Louis, 1904); *Official Guide to the Louisiana Purchase Exposition* (Saint Louis, 1904); the English edition of *International Exposition St. Louis 1904: Official Catalogue of the Exhibition of the German Empire*, ed. Theodor Lewald (Berlin, 1904); and *Art*, volume VII of *Louisiana and the Fair*, ed. J. W. Buel (Saint Louis, 1905), the information and statistics in which do not always agree with the data in the catalogues. Reproductions of many of the German works shown in Saint Louis are contained in earlier catalogues of the annual Berlin salon. Ironically, the introduction to the art section in the *Official Catalogue of the German Empire* was written by a champion of modern art, Alfred Lichtwark. Lewald had invited his contribution at the time of the art parliament, and it survived the reversal of policy. The essay is a sober, covertly antiacademic historical survey; the author praises Liebermann and regrets that "modern German art is insufficiently connected with the life of the nation" (p. 154).

128. The secession had been assigned a room for the work of its members, which it wanted to devote largely to an exhibition of paintings and murals by Gustav Klimt. When the Austrian ministry of education opposed such a concentration on the work of a single artist, the secession withdrew. The resentment some members felt over the intended "Klimt exhibition" contributed to the split in the secession the following year, and to its decline as an artistic force.

maintained only by the small exhibitions of Holland and, especially, Sweden, which included works by Larsson and Zorn.

Germany, the fourth-largest exhibitor after the United States, France, and England, displayed 317 paintings and drawings and 80 sculptures in the Palace of Fine Arts; additional works that the jury regarded as less important — among them a sculpture by Uechtritz — decorated the German pavilion and the architectural, industrial, and trade exhibits.[129] Most significant by far was the retrospective part of the show, which included works by Menzel — notably his *Rolling Mill* — Feuerbach, Marées, Leibl, and Spitzweg. Apart from a few specimens of reserved modernism, among them an interior and a landscape by Skarbina, the remaining 280 paintings and drawings were of unexceptional academic character. One-tenth dealt with historical themes: *Charles V and Fugger, Frederick the Great at the Bier of Schwerin, Tyrolean Militia in 1809.* Another quarter consisted of didactic and anecdotal works with such titles as *Poacher's End, At the Lawyer's, A Deathbed Marriage.* The rest were still lifes, landscapes, a large number of portraits, and photographically exact depictions of official ceremonies, such as *The Opening of the Kaiser Wilhelm Canal* and *The Congress of Berlin,* one of six paintings by Werner, who was tactless enough to exhibit more works than any other artist in the German section.[130]

These paintings differed from their French counterparts in little beside the choice of national symbols, a less frequent and less perfumed treatment of the nude, and, to make up for this deficiency, a tenacious search for "inwardness." In the aggregate, the collection indicates clearly enough the kind of art that satisfied the aesthetic demands of a dominant segment — probably the majority — of upper- and middle-class Germans during the imperialist age: ethereal beau-

129. A "loan collection" of works from American museums and private owners contained a few paintings by such modern German artists as Uhde, described by the *Official Guide* as defying imperial criticism by throwing off the yoke of academic tradition (p. 68).

130. That the politically most powerful painter in Germany received and accepted preferential treatment from the central jury was widely resented. Max Creutz, for instance, called the German exhibition a one-man show of Werner's works; "Die 'Fine Arts' auf der Weltausstellung in St. Louis," *Kunst für Alle,* 19 (1903–1904), p. 569. Werner's behavior throughout the conflict over the Saint Louis exhibition did nothing to improve his popularity. When, shortly after the Reichstag debate, Hermann Ende resigned as president of the Academy of Arts, Werner offered himself as one of the two candidates for the position, but lost the election to the architect Johannes Otzen by a wide margin. Although he continued to receive important honors, Werner's political power gradually faded after 1904, as did the influence of the organizations with which he was most closely associated.

ty, usually of nature rather than of persons; elevating or humorous
episodes, with renderings of *The Stag at Bay* and other scenes of
animals being killed assuming a place halfway between these two
extremes; and dramatic incidents in history. The show contained
scarcely a reference to the urban, industrialized world. Menzel's
Rolling Mill, painted thirty years earlier, had by now acquired the
aura of a remote classic. Less than half a dozen out of the 280 con-
temporary works—notably Johannes Martini's *Breakfast in the
Locomotive Workshop*, Adolf Fischer-Gurig's *East Frisian Shipyard*,
and *The Old Age Home in Lübeck* by Gotthard Kuehl—treated spe-
cifically modern phenomena, and Kuehl's painting was a modest
variation on a theme that Liebermann had introduced to German art
in the 1870s.[131] In this realm of pretense and denial, the acme of ac-
ceptable truth consisted in idealized portraits of monarchs, nobles,
senior bureaucrats, and their wives. The aesthetic and moral diffi-
culties that these works presented were intensified by the fact that
their fantasies had to be expressed in the technical vocabulary of
correct academic realism. An Oriental odalisque or the nostalgic vil-
lage smithy rendered with an impressionist unraveling of color and
dissolution of line would never have served the purpose.

Bad as it was, however, German official taste as defined by the
Kunstgenossenschaft and displayed in the German section of the
exposition was no worse than that of most other countries repre-
sented in Saint Louis. It was not the content of the show but the
troublesome history of its organization that rendered it unusual.
Artists had been excluded not only on aesthetic grounds, but also for
being ideologically suspect. When pushed by the emperor, German
officials showed less tolerance of aesthetic variety, let alone dissent,
and were less hesitant than their counterparts in France and
England to take extraordinary steps to send what was meant to be a
cohesive, unitary image of national art to St. Louis.[132] Whether visi-

131. Kuehl had helped Liebermann organize the unofficial exhibit of German art at
the Paris exposition of 1889. In 1903 he declined the presidency of the Kunstgenos-
senschaft and soon joined the Künstlerbund. After the Saint Louis Fair, Martini ex-
hibited as guest of the Berlin Secession.
132. The conventional character of other major national exhibitions was caused
less by government policy than by the fact that the great majority of artists worked in
conventional modes. Various groups and galleries collaborated in assembling the
American and French shows. In England the Royal Academy dominated the organiza-
tion of the exhibition. At the time, the Royal Academy was severely criticized for its
management of certain funds for the fine arts, the Chantrey Trust, but seems to
have selected the works for Saint Louis in an equitable manner. One art organization
eventually dropped out of the show when its members were not granted one-fourth of
the space allotted to England. As mentioned in note 128 above, the absence of the

tors to the exhibition grasped that intention cannot be determined, but it is doubtful that the miles of visual cotton candy in the Palace of Fine Arts conveyed a political message to anyone. In the final analysis, of course, it was not the visitors, the outside world, that mattered; the audience to convince was oneself.

Greater confidence in the strength and unity of German society might have made the frantic efforts at aesthetic censorship unnecessary. As it was, the world was offered a one-sided view of German art, with its message of a united, confident, and disciplined people, at the cost of further bitterness and dissension at home. It is questionable whether a false image was worth this price. And it must be repeated that the link between moral, let alone political, subversion and the secessions was tenuous, to say the least—a discontinuity that the emperor failed to understand but one that was nevertheless recognized by some Germans on the right as well as the left.

During the Reichstag debate, the conservative *Reichsbote* commented: "The view is widespread in influential circles that the secession and socialism are spiritually related; but that is not the case. We know painters of genuine conservative, royalist convictions who are members or sympathizers of the secession. Political opinions differ in modern art just as they differ in traditional art. Radical approaches may be found everywhere."[133] Similarly, the socialist *Vorwärts* warned its readers not to assume that the emperor's dislike of the secession meant that the group stood for political progress. The paper thought the fact that in the debate nearly all bourgeois speakers defended the secession, spoke against it: "Anyone who has followed the development of the secessionist movement in Germany knows that from year to year, in accord with the taste of the buyers of its works, it has grown tamer and has almost completely renounced the ambition to interpret the serious and harsh problems of this seething age. Most of the secessionists would be welcome at the imperial court had the taste of one powerful individual not been captured by their rivals."[134] In the words of the London *Times*, for "authoritative quarters" to believe that painters of the secession chose their subjects to promote social discontent was a "singular suspicion."[135]

Vienna Secession from the Austrian exhibition was caused by the secession's plan to use most of the space allotted to it for a show of the work of Gustav Klimt.

133. *Der Reichsbote*, 17 February 1904.
134. *Vorwärts*, 18 February 1904.
135. *Times* (London), 17 February 1904.

The secessions were not revolutionary, and neither the cohesion of the Reich nor the authority of the emperor would have suffered if a Liebermann landscape had been hung next to Werner's *William II Congratulating Moltke on His Ninetieth Birthday*. On the contrary, the nation and the dynasty could only have benefited from the emperor's greater receptivity to moderate forces in German society and culture; but by 1904 the possibilities for such a rapproachement were gone, if they had ever existed. Their absence, in this instance as in many others, must be ascribed in part to the emperor's inability to control his predilections for the sake of his political interests—indeed, for the sake of his and his family's political survival.

What made the emperor's views on art historically significant, in addition to this inability, was the fact that many Germans agreed with them and, finally, what might be called their exemplary function: if the emperor could regard painters whose work he disliked as *Reichsfeinde*, so could any decent German. Bismarck had gone far toward eliminating the concept of compromise from German politics; the emperor continued and further legitimized the process by which Germans were taught to deal with any and all differences as though they represented moral and ideological absolutes.

It is this attitude that helps turn the conflict over German art at the Saint Louis International Exposition into something of a paradigm of the Wilhelmine era. All the elements that were important in this instance were present and interacted throughout the period: the anxious imperialism that initially raised the budget of the Reich's participation in the fair from a few hundred thousand marks for an art show to nearly 5 million for a comprehensive exhibit; the attempt at rational and objective management and its perversion by imperial fiat, cheered on by elements of the upper and middle classes that were struggling to maintain or regain their status and security, in this instance the academic art establishment led by such men as Anton von Werner and the art proletariat; and, finally, the straining for a national image and self-image of solidarity and oneness.

The conflict over Saint Louis defines the attitudes of opposing sides in German society at a certain time, but it also affects their subsequent behavior. The alliance between an autocratic aesthetic and the populism of the Kunstgenossenschaft, which excluded the secessions from Saint Louis, gave rise to further and more intense quarrels. Only a few years later, fear of the modern, and fear that foreigners and Germans influenced by alien modes were depriving artists working in a presumed German tradition of their livelihood exploded in chauvinistic and anti-Semitic attacks on modern art and

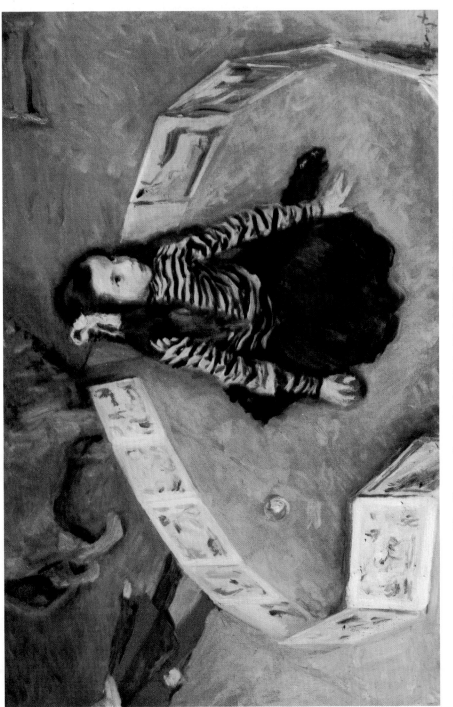

Max Slevogt. *Portrait of a Little Girl.* 1901. Oil, 39½″ × 59″.

on its organizations with a virulence that would have been unthinkable a short time before. There can be no doubt that the emperor's insulting, dismissive treatment of the secessions, and the bureaucracy's reluctant concurrence, unwittingly paved the way for this new outburst. Yet the violence and vocabulary of this later clash, and of the clashes that followed, also suggest that the conflict over Saint Louis points to forces that transcend the limits of the Wilhelmine era.

THE SECESSION AS A NATIONAL FORCE

I

The years following the conflict over German art at the Saint Louis International Exposition were politically and artistically the most successful period in the life of the Berlin Secession. During this time, German impressionism, the collective designation for artists closely associated with the secession, produced some of its best work and gained a measure of authority over German art it was never again to equal. With a naiveté unusual for him — a reflection, perhaps, of his pleasure at the magnitude of the achievement — Max Liebermann declared in 1907 that "yesterday's revolutionaries had become today's classics."[1] Even the cultural environment in Berlin and in Germany, although shaken by bitter antagonisms, was in some respects hospitable. The taste for innovation, for breaking away from nineteenth-century models or for reworking them radically — which marked literature, music, architecture, and the applied arts at least as much as painting and sculpture — had become firmly enough established in segments of the middle class to make it increasingly difficult to ignore this part of the public and to depreciate the works that appealed to it.

The quarrel over Saint Louis was the last time before 1933 that academic art played a dominant role in German cultural policies. The academy did not disappear, and no doubt retained its appeal to many, but academic art in the pseudonaturalistic vein of Anton von Werner and his peers was no longer taken seriously even by the Prussian bureaucracy. Instead, a variety of styles won degrees of acceptance — some touched to a greater or lesser extent by the break-up of line and diffusion of color that impressionism had introduced, others deriving from German romanticism and realism. Hans Thoma and Leopold von Kalckreuth — the former with an affinity for the mystic and fantastic, the latter more realistic and psycholog-

1. "Vorwort," *Katalog der dreizehnten Ausstellung der Berliner Secession,* in Max Liebermann, *Die Phantasie in der Malerei* (Frankfurt am Main, 1978), p. 174.

ical—pointed the way toward a reinterpretation of German nature that, especially in Thoma's work, owed little to impressionism.

Of the painters who followed their lead, some were free of ideological concerns, or relatively so. For others, the inspiration drawn from the regional particularities of the German land and people was intensified by fascination with modern versions of Teutonic mythology; these tales supported their narrowing image of life as a fated conflict between honor and treachery, Germany and the world. The Werdandibund, organized in 1907 to develop arts and crafts in accordance with the values of regionalism and populism, was an institutional expression of the hope that a new and innately German art might emerge from these beliefs. Related tendencies can be found in some of the rural artist colonies that sprang up in the 1880s and 1890s. With few exceptions, their work was unimpressive, but it forms a fairly well defined entity in German painting of the time. Its preferred themes were the countryside and the village; its favorite atmosphere was one of stillness and brooding; the human values conveyed were those of grimly romanticized peasants, for whom tilling the soil and defending it to the death against alien threats were one and the same. Side by side with these somber evocations of nature as a guide through the struggle of life were the essentially urban, symbolic, and decorative concerns of *Jugendstil*. At the turn of the century, the Vienna Secession proclaimed its version of *Jugendstil*, intensified with borrowings from neo-impressionism and such cult figures as Aubrey Beardsley, as the modern European style. Only a few years later, the early indications of a more genuinely original way of painting, soon to be called expressionism, began to appear, not least among the members of the Berlin Secession.

All of these directions can be called modernist, in the sense that they grew out of, or reacted against, German art of the preceding two generations—in contrast to the academy, which tried to embalm the achievements of the 1850s and 1860s and render them harmless. Those artists who vociferously opposed modern art, by which they meant French impressionism and neo-impressionism, and who presented themselves as champions of severely threatened native traditions—not only in aesthetics, but also in social and political matters—were themselves a modern phenomenon, and one with a considerable future. It is evident that aesthetic differences and the distinction between detachment and ideological commitment ran as deep among the newcomers as did the division between impressionism and academic art. Even innovative forces in related disci-

plines, which might appear to share a common outlook, were unsteady allies. Architecture and design, in particular, could combine experimentation in their own fields with conservative anxieties about what was being done elsewhere. Typical is the complaint of leading figures of the Werkbund, the new national organization formed to restore good design and workmanship to the architecture and applied arts of industrial Germany, that impressionism was ruining the quality of German draftsmanship. But however fragmented and contentious the cultural scene, the appeal of impressionism, in its native as much as in its French form, was spreading.

Developments in art criticism and scholarship contributed to the new receptivity and themselves illustrate the cultural shifts that were taking place. Explorations of the foreign sources of contemporary German painting, and the study of art history from a perspective defined by impressionism and neo-impressionism, changed the character of German writing on art. The scholarly literature became more sophisticated and at the same time found a wider public. Bruno Cassirer ceased to be the only major publisher whose list was almost entirely devoted to artists still fighting for recognition and to rediscovered old masters whom the standards of classical correctness had rejected. His firm was joined and in some areas overtaken by competitors—by his cousin Paul Cassirer, by the more conservative Eugen Diederichs, or by Reinhard Piper, who brought out such characteristic expressions of the new attitude toward art as the aesthetic studies of Wilhelm Worringer and most of Julius Meier-Graefe's major works.

The impact of this literature on public taste and on the purchasing policies of the German government and state museums was reinforced by the proliferation of art criticism favorable to impressionism and by art journals seriously interested in modern art, first among which was still Bruno Cassirer's *Kunst und Künstler*. What might be called an international outlook developed in the cultural bureaucracy of some of the German states, most notably in Weimar under the leadership of Count Harry Kessler and Henry van de Velde. After Kessler was forced to resign his position as director of the Weimar museums in 1906, as a result of intrigues that exploited public objections to a Rodin exhibition as immoral, it was particularly the administrations of the three independent Hansa cities that supported progressive policies in the fine arts. Even in Prussia, government patronage was becoming more inclusive.

In this contradictory, strife-torn, but more open environment, the Berlin Secession prospered. By 1904 almost all of Germany's better-

known painters and sculptors whose work did not follow strictly traditional lines were members or corresponding members; the Berlin impressionist Lesser Ury, who had quarreled with Liebermann, was probably the most important exception. Even an outsider such as Thoma, despite his attacks on impressionism, regularly sent paintings to the annual summer exhibitions, which had become the most important shows of contemporary art in Germany. The secession's special strength — that it represented not one style but many — continued to prove its worth, as did the policy of including foreign works in the annual exhibitions; their presence established an international standard and the cosmopolitan aura in which the secession felt most at home. Works by Manet, van Gogh, Munch, and Cézanne were shown repeatedly; often they formed the center around which everything else was grouped. The exhibition marking the secession's tenth anniversary, for instance, honored Cézanne as "the father of the newest direction in modern art."[2] The familiar names were joined by such newcomers as Seurat, Matisse, and Picasso, and interspersed with their works were the paintings of Germans who, like Lovis Corinth, were leaving impressionism behind, or for whom it already constituted a familiar part of the past — painters like Max Beckmann, Lyonel Feininger, and Emil Nolde, who became members in the second half of the decade.

The struggle with the emperor and the founding of the Deutsche Künstlerbund had demonstrated the political effectiveness of the secession and had raised its self-assurance — too much, perhaps, since a belief in the inevitability of progress made it difficult to take the opposition as seriously as it deserved.[3] It was regarded as a hopeful sign that Die Kunsthalle, an insignificant Berlin art journal that had fought the secession since its opening exhibition, ceased publication in 1905 for lack of public support. The emperor himself seemed for a time to have moderated his views. In a speech on 18

2. "Vorwort," Katalog der achzehnten Ausstellung der Berliner Secession, ibid., p. 177.

3. In an essay written after the First World War, the art historian Julius Meier-Graefe described the attitude of his generation of artists and intellectuals in these words: "We knew where we were drifting . . . Dreadful things were happening up there, back there, from where we were governed . . . The emperor and his minions were part of it: an inextricable confusion of fictions. But what did all that matter to us? Theirs was an alien world, and our pride wanted it to remain alien. Even the attempt to take that world seriously would have laid us open to ridicule . . . it provided us with models for our paintings and stories; other than that it was a necessary evil — like a bus or a postage stamp — toward which one remained as passive as possible. We wrote social dramas, but never gave a thought to socialism," "Einleitung," Die Doppelte Kurve (Berlin, 1924), pp. 9 – 10.

October 1904 he even appealed for a reconciliation of the antago-
nisms in contemporary art, although under conservative auspices; if
young artists of different schools would only study the unequaled
achievements of the past, he suggested, they might reach mutual
understanding.[4] Nor did he oppose the election of August Gaul and
of two foreign members of the secession, Jozef Israëls and Anders
Zorn, to the Academy of Arts. When an association of art lovers
under the emperor's patronage commemorated the opening of the
Kaiser Friedrich Museum by commissioning an official portrait of
the head of the Prussian museums, Wilhelm Bode, and Bode asked
that Liebermann paint the portrait, his choice was accepted despite
its provocative character.

But the emperor did not cease to interfere with the jury of the
annual salon, for instance disapproving several of its recommenda-
tions in 1906. After accepting Zorn into the academy, he rejected his
subsequent nomination for the order Pour le mérite, because, he
declared, Zorn was too fond of erotic themes. Nor would he agree to
the government's honoring Liebermann on his sixtieth birthday in
1907 with a retrospective show in the new quarters of the academy.
The idea originated with Friedrich Schmidt-Ott, Erich Müller's
successor in the Kultusministerium, who "hoped in this manner
to bring about a reconciliation with the secession, or at least to
detach Liebermann from it." Bode was asked to win the emperor's
approval, but on broaching the subject was at once interrupted:
"What an idea! To inaugurate the beautiful new building of my
academy with an exhibition honoring the chieftain of the seces-
sion!" To his chancellor, Bernhard von Bülow, he complained that
Liebermann was "poisoning the soul of the German nation."[5]

The limits of the emperor's tolerance were revealed even more
clearly the following year. The director of the National Gallery,

4. *Das persönliche Regiment*, ed. Wilhelm Schröder (Munich, 1907), pp. 168–169.

5. Bernhard von Bülow, *Denkwürdigkeiten* (Berlin, 1930), II, p. 378. The attempt to
honor Liebermann is related by Wilhelm von Bode in his memoirs, *Mein Leben*, 2
vols. (Berlin, 1930), II, pp. 198–199. From Holland, where he was painting, Lieber-
mann wrote his sister about the flood of letters and telegrams congratulating him on
his birthday: "Only the emperor is missing from the well-wishers, but I hope to bear
even that, the more so as His Majesty's favorite artists are not precisely favorites of
the muses. But the academy, the Print Room [of the National Gallery], the Kaiser
Friedrich Museum, and the other art institutions have all sent congratulations." Ru-
dolf Pfefferkorn, *Die Berliner Secession* (Berlin, 1972), p. 70. To mark the occasion,
Bode published an article on Liebermann in *Kunst und Künstler*, in which he charac-
terized him as one of the most German of contemporary artists. This judgment, he
later wrote, "released the *furor teutonicus* among all hyper-Germans and anti-Sem-
ites"; *Mein Leben*, II, p. 199.

Hugo von Tschudi, wanted to buy several paintings of the Barbizon school from a Dutch dealer, together with works by Delacroix, Courbet, and Daumier, which Paul Cassirer had offered to the museum. When the emperor, whose approval was needed, inspected the pictures, he stopped in front of the paintings by Delacroix and declared that the director "could show such stuff to a monarch who understood nothing of art, but not to him." Tschudi replied that these were, in fact, the best works in the group, and an argument began in the presence of several witnesses, which the emperor ended by agreeing merely to the purchase of two Théodore Rousseaus, a Corot, and a Troyon.

Tschudi's budget for the year was already spent, but he bought the four paintings for 400,000 marks in the expectation of a supplemental appropriation. This disregard of the rules led Werner to suggest to the emperor that the opportunity had come to rid oneself of a troublesome champion of modern art. William II, still smarting from Tschudi's open defiance, withdrew his approval of the purchases — or, according to another version, claimed that he could not recall ever giving it. Tschudi, on the contrary, insisted that he had the emperor's word and that it was up to the government to find the money. Finally private donors raised the 400,000 marks, and presented the paintings to the National Gallery. Tschudi went on extended leave in the Far East, after which, it was supposed, he would be retired for reasons of health.

In the meantime the *Daily Telegraph* affair broke and Bülow, not wanting to add fuel to the charge of autocratic rule, urged that Tschudi be retained, a suggestion the emperor could not reject. Nevertheless, Tschudi's position in Berlin had become very difficult, and he was glad to accept the directorship of the Bavarian museums, which the Bavarian government offered him in an obvious slap at the emperor.[6] Tschudi's departure lost the secession an influential ally, one of the first Prussian officials to have acquired

6. On the conflict between Tschudi and the emperor, see especially the autobiography of Bode, who was present at the quarrel between the two; ibid., II, pp. 200–204. See also the somewhat different versions in the memoirs of Karl Scheffler, *Die fetten und die mageren Jahre* (Munich, 1948), pp. 238–240; and Hermann Uhde-Bernays, *Im Lichte der Freiheit* (Wiesbaden, 1947), pp. 403–404, as well as the various editions of Lichtwark's correspondence. At the time the incident was widely discussed in the press, and led to questions in the Reichstag, with some of the same speakers who had participated in the debate on the exhibition in Saint Louis renewing their attack on the emperor's tendency to regard Prussian art policies as his personal domain. Werner's papers document his close collaboration with the emperor in trying to dislodge Tschudi. I plan to discuss this episode in a separate study.

modern works for the state collections. His successor, Ludwig Justi, was more of a diplomat, yet he, too, went to great lengths to open up the National Gallery to secessionist paintings and sculptures. In 1912 he overcame an expected imperial veto of the gallery's first purchase of a painting by Slevogt by orchestrating a conspiracy with the Kultusminister, the head of the emperor's Civil Cabinet, and the emperor's son August Wilhelm. Instead of recommending the painting to the emperor, who would almost certainly have turned it down, the four men decided to show him photographs of *two* works by Slevogt. As his son expected, the emperor, presented with a choice, was satisfied with rejecting one painting and, having made his point, accepted the other. At his next visit to the gallery, however, it was still thought safer to hide the painting until the emperor had left the building.[7]

Wherever the emperor wielded budgetary control or the power of veto, his opinions on art continued to carry weight; elsewhere he was largely ignored. Changes in taste were one reason; another was the sporadic and inconsistent nature of his involvement in cultural affairs. Ferdinand Avenarius, writing in *Der Kunstwart* a few years before the war, thought that what little influence William II still retained derived from the German tendency toward servility rather than from the persuasiveness of his ideas, which he no longer advocated with his former determination. In view of the German desire to be led, even in matters of art, Avenarius concluded, "It is perhaps just as well that the emperor thinks and speaks about art as he does; a ruler who would assert true leadership in the arts would make it more difficult for us Germans, constituted as we are, to develop independent judgments."[8] The secession's efforts to foster this independence benefited from the emperor's flightiness; but perhaps its members did not recognize as clearly as they might have that in the arts, as in other areas of German cultural life, the emperor, while anything but a leader, reflected and reinforced attitudes that were widely held.

In 1904 the secession's lease on its gallery had run out; the group moved further west to the Kurfürstendamm, where it built a new gallery in modified classic style, with a garden and café separating the building from the street. A new corporation, headed by Kalckreuth, Walter Leistikow, and Paul Cassirer, was the legal owner of

7. Christopher With, "The Emperor, the National Gallery, and Max Slevogt," *Zeitschrift des deutschen Vereins für Kunstwissenschaft*, 30 (1976), pp. 86–94.

8. Ferdinand Avenarius, "Kaiserliche Äusserungen," *Der Kunstwart*, 20, no. 20 (1906–1907), p. 451.

the building, which also contained office space for the Deutsche Künstlerbund. The executive committee held to its policy of small shows, and the nine public rooms into which the new gallery was divided did not appreciably increase its exhibition space. To demonstrate that the secession was no longer a local movement, the gallery was inaugurated in 1905 with the second annual exhibition of the national Künstlerbund, an event that continued the close collaboration that had existed between the two groups from the start.[9] Although every year one or two members resigned or died, the total membership increased, with a majority coming from places other than Berlin. By 1906 the secession had five honorary members, 75 regular members—including two foreigners, Munch and van de Velde, who spent much of their time in Germany—and 84 corresponding members, among them Degas, Forain, Kandinsky, Klimt, Klinger, Monet, Steinlen, Valloton, and Zorn. Three years later, the number of regular members had risen to 97 and of corresponding members to 119, including Bonnard, Lavery, and Matisse.

Financially, too, the secession prospered. Dues, admissions fees at the shows, and sales commissions more than covered operating expenses, and the market for modern art continued to expand, although only the more prominent members could count on a comfortable income from the sale of their work. The catalogue of the 1906 winter exhibition of graphics, which had brisk sales, lists Liebermann drawings at 200 to 600 marks each. Other prices varied from 120 to 400 marks for Kandinsky, 100 to 300 marks for Corinth and Käthe Kollwitz, and 100 to 150 marks for Leistikow; these figures are put in perspective by the prices asked for van Gogh drawings: 400 to 1,000 marks each.[10] The catalogue of a later show of-

9. Curt Glaser, "Die Geschichte der Berliner Sezession," *Kunst und Künstler,* 26 (1927–1928), p. 19. How deeply the secession was involved in the planning of the exhibition is indicated by a letter from Leistikow to Kalckreuth, 22 September 1904: "We here are of the opinion that one cannot do too much to make the coming exhibition as imposing and valuable as possible. [Paul] Cassirer has therefore suggested . . . that we send three-man committees to the various art centers to speak to the artists in person and if possible, to acquire specific works for the exhibition." Stanford Coll. GASC, Cassirer Collection V, Miscellaneous Papers. The show was a considerable success in the fight to advance the cause of modern art, demonstrating, according to the Berlin correspondent of the largest Bavarian newspaper, the moral and aesthetic bankruptcy of officially sanctioned art; Georg Fuchs, "Der Deutsche Künstlerbund in Berlin," *Münchner Neuste Nachrichten,* 31 May 1905. To publicize the exhibition, Thomas Theodor Heine designed a poster that, in allusion to the emperor's well-known statement, showed a girl gathering a bouquet of roses growing in the gutter.

10. *Katalog der zwölften Kunstausstellung der Berliner Secession: Zeichnende Künste* (Berlin, 1906). At 1,000 marks, the large van Gogh drawings were the most expensive items in the show, except for five studies by the now nearly forgotten Ber-

fered a large Liebermann oil for 30,000 marks; his *Horseman on the Beach* and two landscapes by Wilhelm Trübner were listed at 25,000 marks each; Corinth's *Bathsheba*, for 15,000 marks, and a Max Slevogt self-portrait, for 10,000 marks. Other exhibitors demanded far less. Kalckreuth, for instance, asked 5,000 marks for a landscape, and Konrad von Kardorff, 1,200 marks each for two views of Berlin.[11] But even the lower figures were good prices at a time when, according to the 1910 census, only 11 percent of wage earners had an annual salary above 3,000 marks, and when a middle-level official was expected to support himself and his family on 4,000 to 6,000 marks a year.

Sales, of course, were never the secession's primary concern. Above all, its exhibitions served as a showcase, their resonance amplified by the many private galleries that displayed and sold its members' work. The most important of these continued to be the Cassirer Gallery. The close ties between the two institutions made possible the efficient management of the secession's business and assured it a secure financial base, which, as the future was to show, could not easily be maintained under different arrangements. The connection with the Cassirer Gallery also directly benefited some, but not all, of the secession's members. Cassirer made no secret of his belief that the group included mediocre as well as good artists, and he did not hesitate to follow his taste when serving on the annual jury or selecting paintings and sculptures for exhibit in his own gallery. Some members never exhibited there; at the same time, he showed the work of artists who were not associated with the secession—Oskar Kokoschka, for instance, who signed a contract with him—or members whose work the jury had rejected.

As the one man on the executive committee and the jury who not only was not an artist but owned a gallery, Cassirer's position was highly unusual and invited criticism. He could be unconcerned when radical enemies of the modern pointed to the art dealer and publisher among the leadership as proof that the secession was a trick to make money out of a gullible public. But it is obvious that a neat separation of interests between the secession and his firm was not always possible, or at least could not always be clearly demonstrated; more than Liebermann or Leistikow and others on the

lin sculptor Hugo Vogel, once a member of the Eleven, who had lost his professorship at the Institute for the Fine Arts as a result of the Munch affair.

11. Werner Doede, *Die Berliner Secession* (Berlin, 1977), appendix E.

committee, he was dependent on the trust the members placed in him. In fact, the secession's affairs ran smoothly for nearly ten years; the most serious discord that surfaced was in the form of a few complaints about Cassirer's authoritarian methods, the other side of the coin of his effective administration.

Both its opponents and its friends recognized that the secession had emerged strengthened from the conflict over Saint Louis. Both groups also perceived its fundamental characteristics in much the same way, although their similar perceptions led to widely diverging conclusions. The secession was regarded as revolutionary, or potentially revolutionary, for going against the traditional tastes of much of educated society, for denying the authority of the emperor and bureaucracy in the realm of aesthetics, and for doing so with some success. Because it emphatically acknowledged its debt to modern French painting, and because of the close ties it maintained with a number of foreign artists, the secession was seen as an international, cosmopolitan element in German culture. In the eyes of its adherents, these inspirations and borrowings from other societies did not diminish the group's native character. The secession, they believed, consisted of German artists interpreting their environment and themselves; its enemies could only oppose the secession as an alien, subversive force. Finally, it was recognized on all sides that the actual work of the secession, the paintings and sculptures of its members, pursued a variety of individual possibilities and employed a variety of styles, instead of seeking the effective expression of generally accepted standards that remained the ideal of the traditional artist. That this difference was not absolute does not diminish its significance. Originality, in the minute quantities in which it tends to appear, might be found everywhere; it was not the exclusive property of the secession, although the secession was more receptive to it. It was also only too true that not every artist who discarded existing assumptions had anything original to say. Yet, over all, the secession's supporters and enemies obeyed opposing ideals: the relatively unfettered striving for an individual style, against the goal of creating this individuality within traditional norms. And these ideals not only guided and constrained the working artist, but had meaning for society in general.

Even many Germans who seemed to accept the inevitability of change found it difficult to tolerate the rejection of the present and of the immediate past. They preferred a more gradual, respectful adjustment, and as a corollary could believe that artists should, as the phrase had it, "work within the German tradition," which was

not the academic tradition, but which academies sought to convey and make attainable to the present. The longing for relatively peaceful continuity, difficult though it was to reconcile with the history of art, certainly expressed more than purely aesthetic concerns; partly for that reason, it was strongly held: aesthetic tradition could be associated with social and political tradition, and destruction of the former implied danger to the latter. Most, if not all, of the secession's members found no contradiction between experimentation and indebtedness to earlier generations. But to the uncommitted or hostile viewer, the immediate message of their work was one of rejecting the past, of discontinuity, and of explorations into the unknown rather than allusion to the familiar.

In its own unique configuration of individuals and environment, the secession bore out Renato Poggiolo's remark that "for modern art in general, and for avant-garde [art] in particular, the only irremediable and absolute aesthetic error is a traditional artistic creation, an art that imitates and repeats itself."[12] The secession's programmatic statements made the same point, rejecting the possibility of applying absolute standards in the creation or appreciation of a work of art. In the introduction to the catalogue of the second annual exhibition in 1900, Liebermann wrote: "Art is a continual coming into being; a continual coming into being and fading. If it petrified into dogma, art would die."[13] In the next year's catalogue, he wrote: "We hope the public will look at these works in the same spirit in which we selected them. We did not seek an academic ideal of beauty, but the power with which the artist expressed that which to *him* seemed beautiful,"[14] And in 1902: "The more a jury tries to choose works not by imposing traditional academic patterns, but according to the individuality expressed in them, the more it will have to rely on taste. And as we know, not only is there no disputing taste, taste is also subject to constant change . . . Taste is altered by every new aspiring genius: the artist imposes his concept of beauty on us, and we must obey, whether we like it or not—and mostly we don't like it, because the new compels us to learn again." In a direct reference to the emperor and academy, he added: "Not even the most powerful prince, no one but the artist alone, determines the paths that art must follow . . . It would be the ruin of art if we tried to create something new by studying existing masterpieces."[15]

12. Renato Poggioli, *The Theory of the Avant-Garde* (Cambridge, Mass., 1968), p. 82.

13. Liebermann, *Die Phantasie in der Malerei*, p. 170.

14. Ibid., p. 171.

15. Ibid., pp. 172–173.

Liebermann repeated the point in 1906: "Rules of aesthetics apply at most to the art of the past; contemporary art gradually evolves its own." And again in 1907: "We regard art not as something completed but as something coming into being . . . The task of the secessions is to fight for the classics of the future . . . The painter's talent does not consist in slavishly copying nature but in the power with which he conveys the impression that nature made on him." And once more in 1908: "Painting and sculpture belong to the free arts. We are second to none in admiring the masterpieces that have come down to us; but we regard it as a fatal error to abstract a firm ideal from these works, which each artist must follow."[16] For the same year's black-and-white exhibition, which included many drawings by Franz Krüger, the most gifted interpreter of Berlin society in the 1830s and 1840s, Liebermann wrote: "Every age has its own art. Only the ignorant or malicious would compare artists of different eras without taking note of their specific demands and conditions. To seek the spirit of Daumier or Menzel in Krüger would be as unfair as to expect to find his calm realism in the artists of our own day."[17]

Finally, in a speech celebrating the secession's tenth anniversary, Liebermann expressed his belief that the Berlin Secession would "remain necessary as long as artists exist who want to carry out their own concepts, rooted in the present, instead of expressing dominant aesthetic beliefs, which, as they are abstracted from works of the past, are of more historical character." He continued:

Even if the secessions should disappear, they would rise again in different form and under other names, because whenever a style has become dominant it is pushed aside by what follows, and must be pushed aside. Those who count as modern today may tomorrow be thrown on the scrap heap by their still more modern successors. We are all children of our times . . . Only the artist can advance art; policies that are meant to advance and support art tend to be destructive. An age that is receptive to art will help the artist develop to his fullest potential, help him realize his idea; but an age that is antagonistic to art will impose a demand on the artist that he cannot fulfill without becoming false to himself: the realization of whatever the age idealizes.[18]

This individualistic and individualizing point of view accorded the artist as much freedom as he was capable of achieving, while insisting on the subjectivity of taste, the impermanence of styles

16. Ibid., pp. 173, 174, 175.
17. Ibid., p. 176.
18. "Zehn Jahre Sezession," ibid., p. 179.

and aesthetic dogma, and minimizing any specific Germanness in art. It could only be profoundly disturbing to many Germans, including German artists. It offended their belief in fixed verities, or their wish to recover the hypothetical stability of an earlier age, if only because the ideas that the secession conveyed — in themselves familiar and respectable — were meant to apply to the present. Historicism, whose individualizing principles were closely related to the statements by Liebermann just quoted, never troubled Wilhelmine Germany because the freedom from value judgments that historicism supposedly expressed could have important conservative implications, and because its object was the interpretation of the past. The secession's subjectivity, although it may have added to the understanding of the art of earlier times, primarily justified changes in the present and future. Its guiding concern was less the development of the artist within the historical and ideological framework of German art — a framework that its propagandists had great difficulty defining, and on which they never reached agreement — than it was the development of individual artists who happened to be German. As Germans, they possessed a cultural heritage that would always influence their work; but they were also Europeans and saw no inevitable conflict between the two conditions, to the point of being willing to draw on foreign sources to revitalize German art.

These attitudes were antithetical to the beliefs of too many elements in German society and culture not to give rise to further sharp conflicts. As the Berlin Secession achieved a commanding position in German art, opposition to it also increased. Despite the new acceptability of the experimentation in art, large segments of the upper and middle classes continued to reject it, as they always would. The nationalist and populist hatred of impressionism did not diminish; on the contrary, as the radicalization of German conservatism intensified in the years before the war, modern art that could be dismissed as foreign, Jewish, or otherwise alien became ideologically significant to greater numbers of people. New links were being forged or existing bonds strengthened between their xenophobia and populism and parts of the art community.

The old problem of the art proletariat had not been resolved. The number of unemployed and underemployed artists continued to grow, and their marginal economic existence fueled an easily mobilized envy of the successful, un-German secession. In 1895 the Reich census listed 6,390 men and women who gave "artist" as their primary occupation. By 1907 this figure had risen 36 percent to

8,724; 1,476 of these were women. Not included in the totals were students, studio assistants, apprentices, and art teachers in primary and secondary schools. That a great many of these people could do no more than eke out a living, at best, was well-known. As late as 1910, however, Paul Drey, writing on the economic basis of the fine arts, had to admit that precise information on the financial circumstances and income of German artists was not available. But overproduction in art was thoroughly documented. Between 1900 and 1908 the annual exhibitions of the Munich chapter of the Kunstgenossenschaft sold between 10.9 percent and 19.6 percent of all works exhibited. An official of the Munich city government estimated in 1907 that approximately 40,000 art works had been exhibited in the city in the past year—"a level of production that could not possibly be matched by the demand."[19] Nor was overproduction limited to the art proletariat: "It is an open secret that even established painters, professors at academies, whose work had received critical praise, often do not sell a painting from one year to the next."[20] The academies continued to bear the brunt of the blame for training young people for a profession that offered no economic security.[21] Since half of Germany's artists belonged neither to the Kunstgenossenschaft nor to the rival Künstlerbund, and thus could not benefit from their insurance and pension programs, other groups were formed to lobby for expanded state support for the arts, medical insurance for the self-employed artist, broader copyright laws, and similar goals, but these efforts met with little support from the various governments and political parties.[22]

19. The statistical tables for 1895 and 1907 are reprinted in Paul Drey, *Die wirtschaftlichen Grundlagen der Malkunst* (Stuttgart and Berlin, 1910), p. 307; see also pp. 80, 247, 312.

20. Konrad Lange, "Über Bilderpreise," *Kunst für Alle*, 18 (1902–1903), p. 15. Lange believed that prices were too high primarily because artists raised their prices for reasons of prestige and from a false sense of competition and thus spoiled the market.

21. Lu Märten, *Die Wirtschaftliche Lage der Künstler* (Munich, 1914), pp. 76–86. See also Joachim von Bülow, *Künstler-Elend und -Proletariat* (Stettin, 1911); Arthur Dobsky, "Kunst and Sozialpolitik," *Kunst für Alle*, 28 (1912–1913), pp. 520–525.

22. Märten, *Die wirtschaftliche Lage*, p. 177. Theda Shapiro, *Painters and Politics* (New York, 1976), p. 122, believes that the Socialists were the only political party that supported modern art—which was not the case in the conflict over the Saint Louis International Exposition—and refers to "a unique discussion in the Reichstag on the economic situation of artists, [in which] a Socialist deputy recommended—with approbation of the left—appropriating 75,000 marks for artists' stipends beyond what the Länder were already granting in order, he said, to enable young artists to work in total freedom without starving." The discussion she refers to, however, lasted little more than a minute, consisting merely of a suggestion by a member of the Catholic Center party, not a Socialist, in the course of a speech on the Reich budget,

Not all members of the secession were free from economic con-
cerns. Yet the group as a whole had an aura of well-being that was
especially easy to resent because of its position at the center of the
Berlin art market and its international connections. For the asser-
tively Germanic schools of art, with their glorification of the land,
the secession became almost a necessary antagonist, a threat, whose
urban, cosmopolitan, and intellectual affinities best defined their
own positions. The secession prospered, but it remained under at-
tack. Two battles in this continuing war impressed contemporaries
as illuminating the cultural antipathies of the period with special
clarity; from today's perspective, as well, they exemplify the forces
ranged with the emperor and the Kunstgenossenschaft against the
secession. The first was the attempt in 1905 by the art historian
Henry Thode to rouse public opinion against the secession as the
archenemy of German art; it was followed in 1911 by a broader-
based attack on the aesthetic and economic influence of the seces-
sion and of the foreign art it championed, the "Protest of German Ar-
tists." A third clash with equally serious political implications, but
originating in the secession's own ranks, is discussed in chapter 6,
"Toward Fxpressionism," because it pertains to the growth of this
new way ِ seeing and painting, which was to raise hostility to
modernism in Germany to new heights.

II

Thode's initial target was not the secession but the art critic and
historian Julius Meier-Graefe. Meier-Graefe, one of the founders of
Pan in 1896, did not belong to the secession's inner circle and
showed little interest in the work of most of its members, although
he regarded Corinth as the best German painter of his generation.
But he was an intimate friend of one of the minor figures of the
group, the painter Leo von König, and was on good terms with Lie-
bermann and Çassirer, who some years after this episode was to
publish one of Meier-Graefe's many books. Together with Meier-
Graefe's praise of French impressionism and neo-impressionism,

that the sum of 75,000 marks, which in past years had been earmarked for restoring a
medieval castle, should in the coming year go to stipends for artists. Since the speaker
included composers, journalists, and poets in this category, he was advocating sup-
port for a half a dozen painters and sculptors at most. The minutes of the debate indi-
cate no response to his proposal, which did not find a place in the budget. Session of
11 March 1908, *Verhandlungen des Reichstags: Stenographische Berichte* (Berlin,
1908), CCXXXI, pp. 3761–67.

these associations sufficed in Thode's eyes to identify the secession as the financial and cultural inspiration for Meier-Graefe's theories, which Thode feared were imperiling German culture.

In 1904 Meier-Graefe published his most important work yet, the three-volume *Entwicklungsgeschichte der modernen Kunst,* a comparative analysis of European painting, which emphasized aesthetic, painterly qualities rather than the usual historical, social, and biographical data. The *Entwicklungsgeschichte* proved to be a pioneering study in modern art history. In his customarily enthusiastic and aggressive style, Meier-Graefe described the history of painting as a development from the linear to the painterly, with impressionism a logical and, so far, ultimate peak. Modern German art had scarcely shared in this development, Meier-Graefe argued; its two most popular figures, Adolph von Menzel and Arnold Böcklin, represented false starts and dead ends. Böcklin, in particular, he considered a threat: "Like a boulder Böcklin blocks off the future . . . We must free ourselves from Böcklin."[23] The following year Meier-Graefe expanded his criticism of Böcklin in a book whose title paralleled Nietzsche's epic condemnation of Wagner: *Der Fall Böcklin.* In his book on Meier-Graefe, Kenworth Moffett writes: "In the *Entwicklungsgeschichte* Meier-Graefe had charged that Böcklin stood between Germany and art; he next undertook to remove this obstacle. The effect was explosive. It seems fantastic to us today that a polemical book on art could evoke such a widespread reaction as did *Der Fall Böcklin.*"[24]

True popularity, which had evaded Böcklin for most of his life, came to him in the late 1880s; critics began to praise him as an unrecognized master who had anticipated many of the ideas of the new romantic reaction against realism, without falling into decadence or compromising the innately German spirit of his art. His sentimental landscapes, such as the five versions of the *Isle of the Dead,* and his seascapes with tritons and naiads, painted in garish colors and a smooth, glossy finish on canvases that grew to monumental dimensions toward the end of his career, became extremely popular. At the turn of the century no other artist's work was reproduced as frequently as Böcklin's; photogravures of his paintings found a ready market among the bourgeoisie, for whom the fine arts had recently

23. Julius Meier-Graefe, *Die Entwicklungsgeschichte der modernen Kunst: Ein Beitrag zur modernen Ästhetik* (Stuttgart, 1904), II, 644.
24. Kenworth Moffett, *Meier-Graefe as Art Critic* (Munich, 1973), p. 52. I am indebted to this careful, informative study.

joined literature and music as an essential component of *Bildung*
Böcklin's combination of literalness and allegory, similar in some
respects to the manner of Rossetti and Burne-Jones, but often of
a fleshly eroticism, presented no great problem to the average
viewer. His work was clearly superior to academic art yet, in its
slick realism of detail, not too different from it, and it was un-
touched by the ambiguities and distortions of impressionism. This
difference, in particular, made Böcklin valuable to the cultural pa-
triots, for whom—more than Menzel—he became the prophet of a
new German art; an art, it was claimed, that grew out of German
Renaissance and romantic painting, and that could now be put up
against impressionism as equally modern yet more profound and
idealistic.

That Böcklin was Swiss rather than a German national only in-
creased his attraction for the upholders of an ethnic imperialism. At
Böcklin's death in 1901, Avenarius wrote in *Der Kunstwart:* "What-
ever Böcklin touched became spiritual. Art in this sense, northern,
Germanic art, is all that he created. No matter how many ideas he
took from the south, even ideas concerning subject matter, he took
them as a conqueror who seeks to expand Germany's possessions. If
our art is to endure the fight with foreign powers, with foreigners
both inside and outside our borders, it will nowhere find a weapon
stronger than Böcklin's immortal work."[25] But Böcklin's intensity
and independence also impressed the most sophisticated. Meier-
Graefe himself had once admired the paintings he now ridiculed,
and it was not only for political and propagandistic purposes that the
Berlin Secession named Böcklin one of its first honorary members
and included ten of his paintings in its opening show.

In *Der Fall Böcklin*, Meier-Graefe claimed that far from pointing
the way to the future, Böcklin's art, with its monumental, decora-
tive characteristics, transgressed against the inherent requirements
of easel painting. The theatricality of his themes, his literary allu-
sions, and his crude colors, trivialized even further by the slick sur-
face, were devices to impress and shock, rather than the results of a
genuine development either of the artist or of art itself. On the con-
trary, according to Meier-Graefe, Böcklin had deliberately detached
himself from his predecessors instead of reacting against them and
building on their achievement, and had done so for the sake of popu-
lar success. In the final analysis, for Meier-Graefe *Der Fall Böcklin*
was a case of individual and artistic morality. On one level, Meier-
Graefe's arguments rested on his developmental view of the history

25. Quoted in ibid., p. 53.

of painting. This concept was suggestive but one-sided, and he pushed it far too aggressively. On another level, and the one that counted, his book expressed the reactions of a critic with a European rather than a narrowly German outlook, a writer whose unusual independence of mind enabled him to penetrate the chorus of general approbation and recognize the weaknesses and absurdities in Böcklin's work, and who was shocked not only by its aesthetic but also by its ethical and political implications. Meier-Graefe was not a strong theorist; he wrote far too much, paid no attention to his own inconsistencies, and was often obscure. But he had the gift of seeing his subject firmly in its environment. *Der Fall Böcklin* ended by pointing to the larger lesson of Böcklin's art and its popularity:

With a little thought we may reach the conclusion that all the many misconceptions current in our fatherland are merely symptoms of the same phenomenon — a state of affairs that has existed since the new empire came into being, with its soldiers and bureaucrats, its impressive industries and its abundance of money. But with these things alone, no matter how powerful they are, it is impossible to reach the objective that our aesthetic theories call harmony. In the larger national context, the objective is called culture. What Böcklin lacked, what this new Germany lacks today, is in effect the same. The case of Böcklin is the case of Germany.[26]

The response to this denunciation of cherished cultural values was immediate and forceful. Several dozen articles and books attacking Meier-Graefe appeared in the same year as *Der Fall Böcklin*, and the debate continued for years afterwards.[27] The rebuttal that

26. Julius Meier-Graefe, *Der Fall Böcklin* (Stuttgart, 1905), pp. 269–270. In 1933, two years before his death, Meier-Graefe repeated this charge in a remarkable passage in an essay on the future of art: "It was not the worthlessness of the work of Böcklin and his circle that was worrying — we had a surplus of bad paintings — but the manner and fervor of the admiration they aroused . . . His admirers saw in Böcklin not the destroyer of aesthetic principles, not the dramatic producer of a barbarian phantasmagoria, but the creator of new German symbols. That was the bacillus. It poisoned the intellectuals of the nation . . . The inability of the visionaries [such as Böcklin] to satisfy aesthetic laws was blamed on the limitations of art, and it was thought imperative that these rules be enlarged — all in the name of a more or less conscious nationalism . . . This led to the isolation of German art, parallel to political developments . . . In reality these intellectuals only said what the imperialism of the regime dictated in a different vocabulary." "Was wird aus der Kunst?" *Neue Rundschau*, 44, no. 7 (1933), pp. 11–12.

27. Some titles are listed under "Writings about Meier-Graefe," in Moffett's *Meier-Graefe as Art Critic*, pp. 194–197. Not all replies were aggressively polemical. Among those critics who kept a moderate tone was Ferdinand Avenarius, who regretted Meier-Graefe's dogmatism and defended the literary allusions in Böcklin's work in "Worauf kommt's an?" *Der Kunstwart*, 19, no. 1 (1905–1906), pp. 1–5; see also Alexander von Gleichen-Russwurm's long and not wholly unfavorable review in the *Frankfurter Zeitung*, 7 July 1905.

provoked the widest discussion was Thode's *Böcklin und Thoma.*
Thode, professor of the history of art at Heidelberg, had for years agitated for a religious and patriotic German art, the first flowering of
which he perceived in the paintings of his close friend Thoma and of
Böcklin. When Böcklin died, Thode celebrated him as a sacral figure
whose work would help free the German people from artificiality
and error and return it to a mystic Norse and medieval oneness with
"heaven and earth, clouds and the sea."[28] The appearance of Meier-
Graefe's *Entwicklungsgeschichte* and his monograph on Böcklin,
which he perceived as two cunning blows aimed at German idealism, caused Thode to announce eight public lectures on "new German painting" in the summer semester of 1905. The lectures in the
university's major auditorium were attended by nearly a thousand
students and members of the general public; stenographic copies
were distributed to the newspapers before a revised version was published in October, and an exhibition of the works of Böcklin and
Thoma in the Heidelberg city hall completed what was intended as,
and turned out to be, a significant cultural demonstration.[29]

Thode's lectures, like his writing, had a fluent academic elegance,
often rising to the rhapsodic; the interjected personal attacks and
insults appeared to be the comments of a gentleman reluctantly
forced to call things by their right names. He would have passed
over Meier-Graefe's books with the silence they deserved, he announced in his opening lecture, but felt compelled to speak since
"they do not merely express the opinions of one man but the doctrine of a great party, steadily increasing in power, which is headquartered in Berlin, and since I regard this doctrine as extremely
dangerous." Meier-Graefe's views were "the results, which I had
long expected, of a concept of art advocated by the fanatic admirers
and lovers of French impressionism, who had gone so far as to call
Manet a genius." Inevitably such people treated German art with
contempt, but now the lines were clearly drawn: "The other side
has shown its true colors, and I shall show mine. These lectures give
witness to my thoughts on modern art, but also protest against that

28. Henry Thode, *Arnold Böcklin* (Heidelberg, 1905), p. 7. The essay originally
appeared in 1901. Thode's approach to art is characterized by his explanation of the
"disturbing fact" that Böcklin drew his themes from Greek antiquity rather than
from German mythology: Wagner's *Ring* was not yet completed when Böcklin's ideas
were maturing. See ibid., p. 10.

29. Some information on the background to the lectures and on the audience's
reaction is contained in Thode's letters, in Hans Thoma, *Briefwechsel mit Henry
Thode* (Leipzig, 1928), pp. 242–243, 247.

one-sided view of art, proclaimed by foreigners, which Berlin in particular is trying to foist on Germany." Thode identified the force scheming to change German taste as "a relatively small, well-organized group, composed . . . [first] of artists more intimately connected with the art dealer than was ever the case in the great ages of art; second, of art dealers who have made a place for themselves as agents of the new alongside the traditional art associations and the great exhibition organizations; third, of art historians and critics, writers who champion modern art out of a conviction whose honesty we do not question, but frquently with the fanatical delusion that the newest is the best; and, finally, of scribblers, pursuing economic interests."[30]

The cause this group represented was pernicious on ethnic as well as aesthetic grounds, which for Thode were, in any case, inseparable: "Aesthetic appreciation is not limited to mere sensual pleasure, stimulated by form and color. Were that the case, the subject matter would indeed be unimportant, as many assert it is . . . that would be conceivable only if we were purely sensual creatures. But we are intellectual beings." Consequently, even the best still life cannot evoke as elevated a reaction as the Zeus of Phidias or a Madonna by Raphael. The Berlin group's second basic error was its insistence that art was international rather than national: "As though such a thing as international art can even be imagined! What today might be called international because it can be found everywhere is, and always will be, French." To French art Thode opposed German art, the four basic elements of which he defined in the second lecture as "powerful expression of feeling, universalism of vision, utmost respect for nature—or, better, love of nature, and the richest inventiveness."[31] The meaning of these qualities, and how it was that other cultures did not possess them, Thode failed to explain, presumably because for him and for the greater part of his enthusiastic audience he was merely stating generally accepted truths.

The next four lectures surveyed European art in the nineteenth century; in them Thode sought "in particular to identify what is

30. Henry Thode, *Böcklin und Thoma* (Heidelberg, 1905), pp. 2, 3, 9–10. Accusing impressionism and neo-impressionism of being driven by the profit motive remained a staple of Thode's aesthetics. At the end of the war, in a short book, *Das Wesen der deutschen bildenden Kunst* (Leipzig and Berlin, 1918), he still warned of the international challenge to German art, which made use of the corrupt and corrupting weapon of money.

31. Thode, *Böcklin und Thoma*, pp. 16–17, 40. This lecture also appeared as an article, "Deutsche Weltanschauung und Kunst," *Süddeutsche Monatshefte*, 2, no. 10 (1905).

German – that is to say, what is great and genuine – and what we must recognize as alien and incompatible elements that are to be rejected." Thode based his analysis on the principle that all great art derives from religious need. Consequently *l'art pour l'art* was a delusion, which led to moral as well as aesthetic decline. In nineteenth-century painting, which had drifted from its social and ethical moorings, "calm unity was replaced by flickering unquiet."[32] The fateful belief that subject matter was insignificant introduced themes even to German art that degraded women and appealed to low sexual fantasies. Impressionism, which possessed the quality of true art neither in its sensuality nor in its imagination, was also innately un-German: "How does it relate to the German character? Does it suit us Germans? No! Never!" But the decline was being reversed by the very artists, led by Böcklin and Thoma, that Meier-Graefe had maligned. "Even if this German art is not yet acknowledged everywhere, we have every right to be proud and self-confident, and, while giving other cultures their due, we can oppose our art to theirs with the certainty of victory!"[33]

The two final lectures discussed Böcklin, Thoma, and other German painters whose work had remained uninfluenced by impressionism, and who were creating the art of the future; Thoma was presented as superior even to Böcklin because in his inspiration he was entirely German and expressed better than anyone else the strength and simplicity of the German people, a point Thode had already made in his essay on Böcklin four years earlier. Thode concluded that his lectures and the positive and critical responses they evoked proved that the conflict over modern art was a confrontation between two philosophies: realism and idealism. "The basis for these lectures throughout has been idealism! And idealism, we may safely assert, has always been the *Weltanschauung* of true art, and, we might add, especially of German art."[34]

In itself, nothing Thode said was new. It was his skillful assembling of familiar claims and accusations into a consistent theory of German aesthetics that caused a storm of approval in Heidelberg

32. Thode, *Böcklin und Thoma*, pp. 46, 97. In this context, "flickering unquiet [*flackernde Unruhe*]" is an ancestor of the National Socialist phrase *unarische Hast*. This is not the only suggestion of subsequent developments in Thode's style and vocabulary; for instance, he speaks of *entartende Kunst* (p. 50).

33. Ibid., pp. 108–111, 126. Oddly enough, toward the end of his life Thode wrote a book about the now forgotten painter Paul Thiem, praising him for demonstrating that a healthy and consequently German impressionism was indeed a possibility.

34. Ibid., p. 177.

and throughout Germany. His views were given additional weight by his academic position, by the scholarly setting of his lectures, and also by their seemingly defensive occasion. Thode presented himself as merely responding to Meier-Graefe's attacks and to the Berlin Secession, the real power behind them; in this way he gave his supporters the important advantage of being able to see themselves as the threatened majority in a conflict not of their own making. What Thode partly masked in cultivated prose, other writers stated openly. The musicologist and cultural critic Karl Storck argued in an essay on German art that the spirit of nationalism, the essential force in the drive toward German political hegemony, was equally essential if German culture was to gain universal authority.[35] In *Der Fall Meier-Graefe,* the poet Ernst Schnur accused Meier-Graefe of writing "to advance his own financial interests and those of the Berlin Secession," which Schnur called an "art movement of specifically Jewish character."[36] Two major exhibitions of works by Böcklin and Thoma, quickly organized in Berlin to exploit and feed the interest of the public, caused a critic to observe that "as long as the aesthetic judgment in this country is dictated by Frenchmen and even Orientals, it isn't surprising for Böcklin to be repeatedly depicted as a kind of Barbarian."[37] Statements such as these, of little interest in themselves, suggest the extent to which nationalism and populism in the arts reacted to Thode's lectures as to a rallying cry.

The lectures were given even greater publicity by Liebermann's angry reaction to them. After reading newspaper accounts of the first lecture, apparently supplemented by letters from members of the audience, he sent a letter to the *Frankfurter Zeitung,* which published it after moderating some of the language. Liebermann asked whether Thode should judge modern art when his competence in his own area of specialization, the art of the sixteenth century, was questionable—a reference to numerous attributions by Thode that were disputed at the time and since have been proved wrong. Thode's assertion that the success of impressionism in Germany depended on the machinations of a Berlin clique closely linked to an art dealer seemed to Liebermann akin to saying that "Richard Wag-

35. Karl Storck, "Deutsche Kunst," *Deutsche Welt,* 8, no. 2 (1905).
36. Quoted in Moffett, *Meier-Graefe as Art Critic,* p. 59. Privately Thode also attributed commercial motives to Meier-Graefe. See Thode to Thoma, 31 July 1905, in Thoma, *Briefwechsel,* p. 249.
37. Willy Pastor, "Zwei deutsche Kunstausstellungen," *Der Kunstwart,* 19, no. 2 (1905–1906), pp. 112–113.

ner owed his fame solely to the circumstance that Henry Thode was his son-in-law." He concluded that whatever Thode's views, he should fight for them honestly: "But when a professor at one of Germany's major universities seeks to defeat his opposite in a purely artistic disagreement with such personal insinuations as 'lack of national feeling,' 'aping the French,' 'lack of poesy,' and other by now fairly rusty weapons from the armory of anti-Semitism, it only proves that he cannot refute him with arguments. In other words, Privy Councillor Thode knows just as much about modern art as he does about the art of the past."[38]

Thode refused to answer, telling his Heidelberg audience that the level of Liebermann's letter was too far beneath that of his lectures. Instead Johannes Langbehn, author of the populist classic *Rembrandt als Erzieher*, which praised Germany as the last citadel of culture in an age awash with modernity, and his associate, the painter Momme Nissen, persuaded Hans Thoma to send a rebuttal to the *Frankfurter Zeitung*. Thoma called Meier-Graefe's book an "almost unheard-of challenge to the essence of German art," which Thode was courageously defending in his lectures. "We are not prepared to have Berlin pass off reheated cabbage as the laws of art, nor are we prepared to have German ways and the German spirit insulted by the proclamation of a fad that is already old-fashioned in Paris, and against which we can put up better things." Liebermann's allusion to anti-Semitism he found troubling: "It could lead to strange inferences if Liebermann were to declare that all who disagree with him and Meier-Graefe are anti-Semites, and I am convinced that not too many of his own compatriots [*Volksgenossen*] would follow him . . . and link such a conclusion, with its possibly disastrous implications, to an aesthetic question."[39]

In a second letter, Liebermann dealt fairly gently with Thoma, whose friendship for Thode, he said, had misled him. Thode was the aggressor; Liebermann merely objected to the intolerance with which Thode proclaimed his own views as the ideals of the whole German people.[40] This response caused Thode to break his silence. In five "Corrections to Max Liebermann's Reply," he defended his scholarly competence, declaring that he had been misquoted in the press; that he had no part in the distribution of his lectures to news-

38. Letter of 28 June 1905, *Frankfurter Zeitung*, 7 July 1905.
39. Letter of 10 July 1905, ibid., 13 July 1905.
40. Letter of 14 July 1905, ibid., 18 July 1905. See also Liebermann to Bode, 15 July 1905, in *Künstlerbriefe aus dem neunzehnten Jahrhundert*, ed. Else Cassirer (Berlin, 1919), pp. 401–402.

papers and others, a practice the *Frankfurter Zeitung* had condemned as contrary to academic usage; that the publication of his lectures in book form would demonstrate that he was not supporting his opinions with phrases and slogans but with sound arguments; and that he had never attacked Liebermann but, on the contrary, had "given the recognition that is due to his consequential studies of certain natural phenomena and to his great dexterity."[41] This referred to the fifth lecture, in which Thode compared Germany's "first two decided representatives of *plein-air* painting"— Uhde, who "translated foreign models into a German language of feeling," and Liebermann, whose work, "it should be freely admitted, demonstrates great dexterity and a thorough study of those natural phenomena that are important to him. In this sense he is a striking and interesting personality. But if we ask from the point of view of the general approach we have followed here: is his art essentially German? we would have to say no."[42] "Liebermann could just as easily work and live in Holland or France; he lacks any specifically German quality. Despite its technical dexterity and refined treatment of light and shade, his art has no originality."[43]

Thode's smug equation of "German" with "originality" was of a piece with his matter-of-course decision that some German artists were German while others were not. That Liebermann denied him the right to make such judgments both enraged and puzzled him. "It is monstrous," he wrote to Thoma during those days, "that we are no longer allowed to express our opinions on general questions of art—that someone defending Germanness is made out to be immoral. In its exemplary features this whole affair is significant and has broad implications."[44] Thode's assertion in his "Corrections" that he was misquoted may, however, have had some truth to it. The *Frankfurter Zeitung* expressed the belief that the lectures were not accurately copied, and the printed version of the lectures do not contain the precise words Liebermann objected to. But Thode himself stated that he had revised the lectures for publication, and the differences between Liebermann's quotations and the printed text are too slight to constitute a defense.

41. Letter of 19 July 1905, *Frankfurter Zeitung,* 21 July 1905.

42. *Deutsche Eigenart,* which I inadequately translate as "essentially German," is another of Thode's anticipations of National Socialist terminology, a fact deserving notice only because the term had the same meaning to Thode as it was to have under the Third Reich.

43. Thode, *Böcklin und Thoma,* pp. 100–101.

44. Thode to Thoma, 26 July 1905, in Thoma, *Briefwechsel,* p. 247.

In a "Last Word," Liebermann expressed satisfaction that Thode denied making some of his defamatory statements and wondered whether he would also disown an equally objectionable passage from his latest lecture, which had just appeared in the Heidelberg newspaper. He repeated his earlier charge that Thode had been proved incompetent as a scholar and critic, relying on high-flown phrases rather than facts, and ended: "I distinguish between good and bad art. For him, sentiment only too often makes up for lack of ability. For that reason I reject as strongly as I can the praise Herr Thode has conferred on my work."[45] A few years later he wrote Bode that, basically, the exchange between Thode and himself had been a conflict between mystic adherents of a "national art" and those who, like Liebermann, believed that "true art is *nonpartisan:* whoever tries to exploit it for other purposes is on the wrong track."[46] Thode privately characterized Liebermann's final letter as a cesspool from which he turned with disgust, but he was clever enough to keep quiet; nor did he respond to Meier-Graefe, who only now joined the debate with a declaration that Thode and Thoma, having resorted to rhetoric and hair-splitting instead of answering the arguments in his books and in Liebermann's letters, were "guilty of intellectual dishonesty."[47]

In his annual address to the faculty and students of the Royal Institute for the Fine Arts, Anton von Werner dismissed the exchange

45. Letter of 22 July 1905, *Frankfurter Zeitung*, 25 July 1905. The exchange between Liebermann and Thode has been reprinted in full or in part; see, for instance, *Kunst und Künstler*, 3 (1904–1905), pp. 484–488, 529–531; appendix to Joachim Geissler, *Die Kunsttheorien von Adolf Hildebrandt, Wilhelm Trübner, und Max Liebermann* (Berlin, 1963), pp. 302–319. Geissler characterizes the dispute as "the decisive event, after the founding of [the Berlin Secession], in the ideological art struggle at the turn of the century" (p. 302), but he does not discuss it. Liebermann's three letters are reprinted in *Die Phantasie in der Malerei*, pp. 156–160.

46. Liebermann to Bode, 27 August 1905, *Künstlerbriefe*, p. 405.

47. Undated letter, *Frankfurter Zeitung*, 26 July 1905. Meier-Graefe criticized Liebermann's attack on the anti-Semitic connotations of Thode's terminology on grounds that, although Liebermann was correct, by raising the issue he made it easier for Thoma to avoid responding to the substantive arguments. Meier-Graefe continued: "Incidentally, Liebermann's remarks might give the impression that I am a Jew or of Jewish descent. I am glad to use this occasion to declare that this is not the case—not because I should not be delighted to share Liebermann's ethnic origins, but because I should like to exclude at least this confusing personal element from the discussion." Meier-Graefe, whose paternal grandfather was Jewish, was not believed. Thoma wrote Thode on 30 July 1905: "Meier-Graefe, who says he is not a Jew, is even more shameless than Liebermann"; Thoma, *Briefwechsel*, p. 247. Several years later an article defined Meier-Graefe's writings as "Französeln und Jüdeln." It is not surprising that on his death in 1935 he was vilified in the *Völkische Beobachter*; see Moffett, *Meier-Graefe as Art Critic*, pp. 59, 127.

Max Liebermann. *Bathers in Noordwyck.* ca. 1908. Pastel, 4⅝″ × 7⅛″.

of letters between Liebermann and Thode as a quarrel within the modernist camp, which it was to a pedagogue and bureaucrat who had lost touch with his field.[48] All participants in the controversy, from Meier-Graefe to Thoma, were convinced that the issue went far beyond aesthetics, and it is difficult for the later observer not to agree with Thode that its implications were significant. Two views of life, of the culturally and politically permissible, had clashed; the intolerance of one side found the tolerance of the other pernicious. These are abstractions, but the specifics are clear enough. Meier-Graefe and Liebermann condemned what they regarded as bad painting, but neither tried to prevent the exhibition and sale of such works; nor did they accuse their creators of immorality or of having abandoned their cultural and political fatherland. The economic, moral, aesthetic, and patriotic arguments were deployed entirely on one side, and their mingling, together with a more or less overt anti-Semitism, was to characterize the fight against successive waves of modernism by the champions of "German art" until the fight was won in the Third Reich. From that perspective, Thode's eight lectures appear programmatic.[49]

They did not, however, achieve their immediate purpose. The position of the Berlin Secession as the most prestigious group of painters in the country was not diminished, while Böcklin's reputation, which had been at the core of the quarrel, began to fade. The decline has been attributed to Meier-Graefe's book. Moffett, for example, has written: "Only a glance at the Böcklin literature reveals how little was written on that artist after 1905. And what did appear was defensive and restrained. One feels that by pointing to the absurd, unintentionally comic aspect of Böcklin's pictures, Meier-Graefe had freed many from unconscious insincerity."[50] But it would be unusual for one book to have such a direct effect; more

48. Anton von Werner, *Rede bei der Preisverteilung in der Königlichen akademischen Hochschule für die bildenden Künste* (Berlin, 1905), p. 4.

49. It is impossible to say how Thode, who died in 1920, would have responded to National Socialism, but it might be noted that at least one National Socialist critic regarded him as a precursor. In an article with the portentous title "Was zu Heidelberg begann," Edgar Schindler wrote: "Today everything is different. The great Führer himself and his supporters call upon German art to be first and foremost German. What began in Heidelberg—when for the first time a courageous man in public life demanded that the internationalism in art be checked—has now come to fruition. The knowledge of what is German in art has sunk deeper and deeper into the universal consciousness of the nation." Quoted in Moffett, *Meier-Graefe as Art Critic*, pp. 127, 155.

50. Ibid., p. 59. A similar judgment is expressed in Richard Hamann and Jost Hermand, *Stilkunst um 1900* (Munich, 1973), pp. 366–367.

likely *Der Fall Böcklin* caught a fairly strong, if far from general, shift of taste in the fine arts—a shift away from the grandiloquent, the mystical, and the sentimental, which in itself was a factor in the success that the Berlin Secession was experiencing. Meier-Graefe's polemic may merely have made it easier for people to reject an art that, Thode notwithstanding, could no longer satisfy them.

III

The second major attack on the Berlin Secession and on the kind of art it stood for originated—as its name, *Protest deutscher Künstler*, indicates—with artists themselves rather than with critical responses to art, as in the dispute triggered by Meier-Graefe and Thode. In the later episode, Thode's racial aesthetics and his condemnation of French art resurfaced, accompanied by a strong emphasis on the condition of the art market and the economic problems of German artists, factors to which Thode had merely alluded. The issues he had addressed from the podium, in a mostly abstract, veiled manner, were now dealt with pragmatically by large numbers of people on both sides of the front dividing art and attitudes toward art in Germany; the relationship of the two episodes to each other is not unlike that of a theory and the attempt to give it concrete social and economic expression.[51]

The instigator of the "Protest of German Artists" was the landscape painter Carl Vinnen. As a young man, Vinnen had rejected his academic training in Düsseldorf and Karlsruhe for a more personal, emotional approach to painting. He joined the artist colony at Worpswede near Bremen, defended Paula Modersohn-Becker against academic criticism, and became a member of the Berlin Secession, exhibiting with other Worpswede artists in the opening show. His unusually luminous colors and broad brushwork suggested to some a talent struggling for expression, but in time he revealed himself as merely another tame representative of the neoromantic, consciously Germanic landscape movement of the period. He resigned from

51. Thode himself tried to put his ideas into practice two years after his Heidelberg lectures, by founding with Siegfried Wagner and others a league for the regeneration of Germany through German art, the Werdandibund. The new group even attracted a few members of the Berlin Secession, among them such a socially engaged artist as Hans Baluschek; they resigned when they recognized its anti-Semitic and antisecessionist program. The Werdandibund managed to organize one exhibition and then dissolved. See Karl Scheffler, "Werdandi," *Kunst und Künstler*, 6 (1907–1908), pp. 195–199.

the secession, and in 1903 left Worpswede and settled near Munich. The same year he was awarded a small gold medal in the Berlin salon, but for some reason the prize did not lead to wider recognition and financial success. By 1910, at the age of forty-seven, he had come to believe that his relative failure and the difficulties experienced by other painters whose work resemble his were caused by the manipulation of the German art market. He wrote two articles on this evil, castigating in particular the purchase of a van Gogh by the Bremen Museum, which he circulated among members of the German secessions and of the Künstlerbund. After receiving comments from his readers he combined and revised the articles into a manifesto with the Ciceronian title "Quousque tandem," which he published together with the names of 140 supporters and extracts from their leters under the general title *Ein Protest deutscher Künstler.*[52]

Vinnen's career was typical of many: early rebelliousness masking an absence of originality and ending in what might be called a knowing or sophisticated conventionality, an outcome that in his case was painful and embittering. As a working artist who had been associated with a variety of organizations, he knew something of the major factions of the German art world; under different circumstances he might have been a useful intermediary among them. Vinnen did not deny the debt Germany owed to modern French painting; indeed, he opposed what in the preamble to his manifesto he called "chauvinistic Teutomania" and rejected official painters "with their reactionary system" and other mediocre artists as unwelcome allies in his campaign to help German art. But despite his protestations, his arguments and demands were no less intolerant than Thode's, and far more openly populist.

Following the defensive preamble, the manifesto began with a one-sentence paragraph that set the theme and tone of the whole: "In view of the great invasion of French art, which for the past few years occurred in the so-called progressive art centers of Germany, it seems to me a necessity for German artists to raise a warning, without being deterred by the objection that their only motivation is

52. Carl Vinnen, *Ein Protest deutscher Künstler* (Jena, 1911). The pamphlet was published by Eugen Diederichs, Germany's "leading publisher of conservative, nationalistic, and populist cultural literature" in the decade before the First World War; Karlheinz Rossbacher, *Heimatkunstbewegung und Heimatroman* (Stuttgart, 1975), p. 102. The list of 134 names Vinnen appended to his "Protest" does not include those of six respondents quoted or mentioned in the manifesto. On the "Protest," see also Lothar-Günther Buchheim, *Der Blaue Reiter* (Feldafing, 1959), pp. 32–34.

envy." Vinnen first indicted Germany's critics and journalists, who, he admitted, had helped their readers understand modern art, but who lately had become an autonomous, irresponsible force, creating fashions and elevating theory above instinctive creativity. To illustrate this typical populist charge against modernism, the manifesto pointed to the Rhineland Sonderbund, a secessionist movement founded in 1908 with Liebermann as an honorary member; in 1910 it had organized an important exhibition of German and French painters, including neo-impressionists and Fauves. The Sonderbund catalogue praised the newcomers in the pretentious, fuzzy prose that modernists could use as readily as the art patriots; Matisse, for instance, was singled out for having "drawn the linear essentials from Cézanne's plastic constructions." To Vinnen, on the contrary, the Fauves were merely "the newest Parisian eccentrics," taken up by a sensational press that fed on the aesthetic snobbery of a rootless or misguided public. Characteristically, he immediately softened his accusation: modern French art had once fructified German art, but now "speculation has taken hold . . . German and French art dealers work hand in glove, and under the guise of supporting art flood Germany with great masses of French pictures." What is worse, "on the whole we are granted only leftovers, only those paintings not bought by the French themselves or by the great American princes of finance." Furthermore, the prices paid for these "old studio remnants by Monet, Sisley, Pissarro, etc.," are far too high, and are sure to decline.[53]

That people paid too much for inferior art was of interest only to themselves and to economists, Vinnen wrote. "More important is another issue: Why does the speculative purchase of foreign art pose such a serious danger?" Because, he believed, it led to the "overestimation of alien ways, which do not suit our native tendencies . . . *And when alien influences seek not only to improve us but to bring about fundamental changes, our national characteristics are gravely threatened."* If Monet, Cézanne, and van Gogh could not produce strong successors in France, it is hardly surprising that their German imitators failed even more miserably. Yet again Vinnen added a reservation: "Certainly the exhibitions of the Berlin Secession, strongly influenced by the French, are among the most stimulating in Germany; technically they are fascinating and interesting. But if we draw the balance of the past eleven years [of the secession's history], the glittering surface cannot hide the gaping artistic deficit in the

53. Vinnen, *Ein Protest deutscher Künstler*, pp. 2, 3–5, 6.

new generation." Young German painters are unable to develop because, largely for the sake of quick recognition and economic success, they are aping French models that are themselves part of a steep decline. In the process the Germans lose their cultural identity and become Frenchified [*Französlinge*], which is a misfortune not for German art but also for the German people. *"Let us repeat it again and again: a people can be raised to the very heights only through artists of its own flesh and blood."*[54] Again, as in the judgment of Thode and of the embattled leaders of the Deutsche Kunstgenossenschaft, artists influenced by certain foreign models had undergone an ethnic change: they were no longer German.

The flood tide of French art carried a further peril, according to the "Protest," in that it deprived German artists of the support they need by causing the state to buy foreign works. Vinnen cited the recently founded museum in Posen, which had expended its entire purchasing budget on its first acquisition, a study by Monet. This brought him back to the manipulation of the art market: "A corner in Daumiers seems to be in preparation to succeed the current boom in Cézannes and van Goghs. But before then we shall probably experience the merchandizing of El Greco, whom Meier-Graefe rediscovered a few years ago, and who under the label 'Greatest Spanish Painter' was at once claimed by the extreme modernist movement." The enormous prices paid for these works consume millions every year that otherwise could be spent on native German art.[55]

"Quousque tandem" concludes with an appeal to patriotism and idealism: "The *undignified disdain* for valuable national characteristics, today so widespread among our aesthetes, cannot lead to great achievements . . . A great, powerfully upward-striving culture and people like ours cannot forever tolerate spiritual usurpation by an alien force. And since this domination is being imposed on us by a large, well-financed international organization, a serious warning is in order: let us not continue on this path; let us recognize that we are in danger of losing nothing less than our own individuality and our tradition of solid achievement."[56]

The manifesto was followed by the names of critics and artists who had responded to Vinnen's circular and by fifty-six pages of their comments; to this Vinnen appended a brief statistical survey on the purchase of foreign art in Germany, the main point of which

54. Ibid., pp. 7, 8, 9 – 10, 11 – 12. Italics in the original.
55. Ibid., pp. 14 – 15.
56. Ibid., p. 16.

was that Germany spent far more on foreign art than foreigners were spending on German art. In 1909 Germany had imported paintings and graphics valued at nearly 20 million marks, while exporting German art worth 12,308,000 marks—"an import surplus of 7,606,000 marks, that is twelve and a half times the amount the Prussian and Bavarian states spend annually on modern art." Once more, however, Vinnen felt compelled to moderate his argument slightly: "I should find it regrettable if these figures were to bring about a kind of boycott of foreign art in Germany . . . but such sums should induce us to undertake a sound, critical review of foreign art, in order to determine what is so outstanding that we simply must acquire it. Only true masterpieces could justify the withdrawal of such vast material support from German art."[57]

The 140 names that Vinnen listed as backing his appeal included those of some twenty museum directors and writers on art; among them were such conservative stalwarts as Fritz von Ostini and Albert Dresdner, but also the former supporter of the Berlin Secession, Hans Rosenhagen, who had now turned against it, and two champions of German impressionism, Richard Graul, director of the arts and crafts museum in Leipzig, and Fritz Stahl, the art critic of the *Berliner Tageblatt.* In a one-sentence statement, Graul agreed "on the whole" with the manifesto. Stahl defended the secessions and the art dealers associated with them, and pointed out that far more academic art than modern art was being imported from abroad. Germany was rich enough, he concluded, to buy good foreign art as well as good German art.[58]

Stahl's letter, which Vinnen published although it rejected his main arguments, was not unique. Several other responses were largely or partly critical. For instance, Franz Servaes, who almost twenty years earlier had written a glowing review of the first show of the Eleven, began with the statement that his attitude toward art was entirely international. The critic Albert Lamm, who despised expressionism, nevertheless voiced his concern "that an energetic attack on activites in Berlin might confuse people's judgment on modern art in general. No one helped the Berliners more than Henry Thode, when he defined the boundaries of 'German art' so narrowly that the work of Liebermann, Trübner, Slevogt, . . . and others among our best artists was excluded." The president of the Munich Secession, Hugo von Habermann wrote that he could not respond to

57. Ibid., p. 80.
58. Ibid., pp. 60–62.

the manifesto with a simple yes or no. While he disliked many of the theories and techniques of the most modern directions in art, and had no doubt that much shoddy work was being done under their banner, he had no sympathy for artists' protests against any specific style or movement."[59] These comments, often responding to Vinnen's own reservations and modifications, were clearly intended to begin a dialogue; they faded before the vociferous approval of the great majority, however, and not only Vinnen but also the press counted their authors among his supporters.

The main themes of the commentators in agreement with Vinnen were the excesses of fashion, the fatal German liking for the foreign and exotic, and the dangerous power of art critics in the service of speculators and dealers. One writer expressed feelings of disgust and impotence in the face of "sinister and rapidly expanding circles of aesthetes and stock exchange jobbers." Another wrote: "As you say, naive creativity is being replaced by the intellectualizing reflections of the art critic, a trade that soon will be claimed by any halfway talented person. Our able writers are in the hands of the Berlin-Paris speculators! And oppose our own best talents! A sad spectacle for anyone with eyes to see."[60]

Concern for the economic well-being of German artists and a violent dislike of neo-impressionist and expressionist painting were other common themes. The critic Fritz von Ostini blamed the fashion for the most modern French art on "unscrupulous business practices of French art exporters and their German helpers" who were shipping paintings to Germany that no one in France was willing to buy. "The French despise us to such an extent that their arrogance is turning into insolence. The most pathological paintings of van Gogh's insane period, the rejected experiments and barely prepared canvases from Cézanne's estate, have been acquired with pleasure by the good German simpleton. Today he is being told that the greatest artworks are the jokes of the publicity-mad Henri Matisse, whom the French themselves have long ago ceased to take seriously, and tomorrow—tomorrow it will be the work of Picasso, the cubist!" Rosenhagen ridiculed a show by Cassirer of works by German expressionists and by Picasso, Braque, and van Dongen: "Thank Heavens the German public—even that part that goes to the Cassirer Gallery and is accustomed to strong fare—is as intelligent as the visitors to the *salon d'automne,* and finds these painters uproarious-

59. Ibid., pp. 27, 29, 41, 50.
60. Ibid., p. 37, 45.

ly funny." Nevertheless, he felt, such shows exerted a destructive influence on young German artists and perverted the art market.[61]

Prominent among the signatories were such leaders and theorists of the new Germanic art as Paul Schultze-Naumburg, the Worpswede painter Hans am Ende, and Thoma's friend Momme Nissen. Thoma himself and Thode were absent, the latter presumably because Vinnen had disclaimed affinity with "the Werdandi sentimentality."[62] The president of the Academy of Arts in Berlin, Arthur Kampf, signed the manifesto, as did a member of the first executive committee of the Berlin Secession, Otto Engel, who had left the group in 1902. Perhaps more surprising, the signatories also included nine current members and sixteen corresponding members of the Berlin Secession. Several in this group, such as Habermann, disagreed with Vinnen. Others publicly recanted after they realized the character of Vinnen's campaign; most prominent among them was Wilhelm Trübner. Nevertheless, that they had signed even the original, unrevised circular indicates a lack of political instinct, as well as an ambivalent attitude toward the latest developments in art.

Probably characteristic of this group are the emotions that led Käthe Kollwitz to add her name to the manifesto. Soon after the *Protest deutscher Künstler* appeared, she explained her motives and regrets in a letter to her son Hans. A visit to the annual exhibition in the Lehrterstrasse had so depressed her with its masses of mediocre art, she wrote, that she decided to go to the National Gallery to recover. "I walked upstairs to the French collection, and as soon as I entered the first room—the one with the marvellous bust by Rodin—my heart sank at the thought that I had signed Vinnen's protest. For here I saw once again French artists represented by good examples of their work, and I said to myself that German art simply needs the Latin infusion. The French are innately more gifted painters; The Germans lack a sense of color . . . Of course, I had had similar thoughts before signing Vinnen's manifesto, but the latest blessings from Paris so enraged me that I signed anyway. I should have told myself at the time that the whole Matisse episode would fade again, and that one must calmly await its end."[63]

61. Ibid., pp. 59, 66.

62. Ibid., p. 16. In a brief article in the *Süddeutsche Monatshefte,* Thoma distanced himself from the "Protest."

63. Letter of 20 May 1911, in Käthe Kollwitz, *Tagebuchblätter und Briefe,* ed. Hans Kollwitz (Berlin, 1948), p. 120. Of the other regular members of the Berlin Secession who signed the manifesto, several were so inconspicuous that I have been unable

Käthe Kollwitz cannot be reproached for disliking Matisse and envying his success in German exhibitions. But that someone with her political and social concerns could be blind to the implications of associating herself with a manifesto directed at the very people and organizations that were defending modern art, including her own work, suggests not only political naiveté but also how difficult it was for some early members of the secession to tolerate the newest art. To others on both sides of the issue, Vinnen's message was clearer. The art patriots and populists, whose help he disclaimed, were quick to welcome the *Protest deutscher Künstler* as the strongest blow struck in years against cosmopolitan art, and they reinforced it with their own, far less ambivalent attacks. An anonymous pamphlet on the sickness of German art claimed to expose the destructive intent of international Jewry and of its local agents, Cassirer and his followers.[64] Critics praised the justified anger of German artists who at last had awakened and recognized their true enemies. A long book by Thomas Alt on the maltreatment of German art by the moderns, which appeared during the same months, gave further impetus to the new wave of opposition to German impressionism and its successors.[65]

The critics of Vinnen's manifesto were equally combative and, it turned out, more competent. Immediately after the appearance of the *Protest deutscher Künstler*, the Künstlerbund issued a declaration, signed by Liebermann, Klinger, and Kalckreuth, that the economic difficulties of German artists could be solved if they would

to find examples of their work. Somewhat less obscure were Heinrich Linde-Walther, a member since 1902, and Jacob Alberts, a protégé of Liebermann, who had joined the Eleven in the late 1890s. Alberts resigned from the secession soon after the Vinnen episode. The best known, after Trübner and Kollwitz, was Martin Brandenburg, a founding member, and a close friend of Hans Baluschek. Brandenburg painted stylized, mystical landscapes and visionary parables such as his *People under the Cloud*, which depicts dozens of men and women, mostly in grim or depressed attitudes, beneath a flat cloud that weighs heavily on them. Why Brandenburg signed the "Protest" is not known, but he remained in the secession for the rest of his life.

64. *Die kranke deutsche Kunst; Nachträgliches zu "Rembrandt als Erzieher"* (Leipzig, 1911), p. 32.

65. Thomas Alt, *Die Herabwertung der deutschen Kunst durch die Parteigänger des Impressionismus* (Mannheim, 1911). A review in *Kunst für Alle*, 27 (1911–1912), p. 412, characterized the work as a "truly German act." Soon after his book appeared, Alt gave two lectures in Bremen, arranged by Vinnen and others associated with the "Protest," in which he attacked the director of the Bremen museum — Gustav Pauli — the Berlin Secession, and Paul Cassirer. Pauli and Cassirer responded forcefully, and a conflict, which became known as the *Bremer Kunststreit*, ensued in public debates and in the press.

paint better pictures. Corinth, Slevogt, Kessler, Lichtwark, Cassirer, and others published articles or letters against Vinnen. Their refutations, together with fifty original contributions, were collected in a pamphlet entitled *Deutsche und französische Kunst*, which had been reprinted twice by the end of the year.[66] The seventy-five contributors were artists, museum directors — among them the heads of the Bremen and Posen galleries, whom Vinnen had singled out for favoring alien art — dealers and collectors, and writers on art, including Wilhelm Worringer, Henry van de Velde, and even Arthur Moeller van den Bruck, who only a few years earlier had written an article on the danger of overvaluing French art and had dismissed Liebermann as a third-rate imitator.[67] Now Moeller van den Bruck suggested that modern German painting did not yet exist in the same sense that modern German music, philosophy, and architecture existed, but that it might grow out of the achievement not only of Munch and van Gogh, but also of Daumier, the impressionists, and Cézanne. That being so, and to counter the influence of native academic art and persuade the art proletariat to choose a different livelihood, he felt Germans should buy as much French art as they possibly could.[68]

The forty-eight artists whose statements were printed included the leaders of the Berlin Secession, one of the main figures of the Worpswede group, Otto Modersohn, and representatives of other secessions; among them were Wilhelm Trübner and Gustav Klimt, whom the "Protest" reminded of an agitator in a Viennese farce, who kept shouting: "Something must be done for the common man."[69] The presence of this senior elite was to be expected; more significant was the participation of many younger artists, whose work was still in contention, not only among the general public, but within the secessions themselves; this group included Max Beckmann, Max Pechstein, Wassily Kandinsky, Franz Marc, and August Macke.

66. *Deutsche und französische Kunst*, ed. Alfred Walter Heymel (Munich, 1911). The first small edition was entitled *Im Kampf um die Kunst; Die Antwort auf den Protest deutscher Künstler*. Heymel, a writer, collector, and the founder of one of the most important German publishing houses, the Insel Verlag, was friendly with many members of the Berlin Secession. He was assisted in gathering contributions by Franz Marc and Reinhard Piper, whose firm published the pamphlet. See Piper, *Mein Leben als Verleger* (Munich, 1964), pp. 296–297.

67. Arthur Moeller van den Bruck, "Die Überschätzung der französischen Kunst in Deutschland," *Der Kunstwart*, 18, no. 22 (1904–1905), p. 501. See also his pamphlet *Nationalkunst für Deutschland* (Berlin, 1909).

68. *Deutsche und französische Kunst*, pp. 148–149, 152.

69. Ibid., p. 61.

The old and new generations were unanimous in proclaiming the international leadership of French painting in the nineteenth century, and the need for Germans to become acquainted with postimpressionism and the Fauves, whatever the value of particular artists, through exhibitions and museum purchases. They declared themselves confident that young German painters, far from being guided by powerful critics, were capable of finding their own way, and called the "Protest" a campaign of middle-aged failures who envied the success of others. One member of the Berlin Secession, Walter Bondy, wrote that Vinnen and his followers were embittered "because their [early] enthusiasm had not brought the hoped-for results. Long ago they were little revolutionaries; now they are becoming little reactionaries. If Herr Vinnen at least had the courage to say: 'All French art is trash. Leave the Alien humbug, turn from the spoiled ragout to your own healthy pork with sauerkraut, to your cheerful Matjesherring with fried potatoes, to your Germanic unity gravy.' But he didn't have the courage to say that . . . He only warns. He warns us not to eat too much of the good foreign food . . . and naturally assumes that we all have his weak stomach." Corinth contributed a passionate, sarcastic attack on mediocrity hiding behind misunderstood patriotism, while Beckmann thought it didn't matter whether untalented artists copied Böcklin or Matisse: "They need some easy model to make up for the emptiness of their imagination."[70]

The claim that most modern French paintings in German collections were inferior products bought at exorbitant prices was ridiculed; several writers referred to one of Vinnen's supporters who had gone so far as to denounce the Mannheim Gallery's purchase, at the high but not unreasonable price of 100,000 marks, of Manet's *Execution of Emperor Maximilian*, which he called "an insipid work, uncharacteristic of the artist."[71] Gaul wrote that in a way he agreed with Vinnen: "I would love to hang some of Cézanne's and van Gogh's 'studio remnants' on my own walls, but the high price demanded by the evil art dealer [Cassirer], despite our good friend-

70. Ibid., pp. 33–36, 37, 85.

71. The writer was Fritz Erler, who belonged to the Munich secessionist group Die Scholle. Peter Selz regards him as "probably the most interesting member of the group. He combined the strong and bright color of impressionism with the linear-decorative tendencies of Art Nouveau." Selz, *German Expressionist Painting* (Berkeley and Los Angeles, 1974), p. 40. On 14 April 1911, *Vorwärts* reported that an artillery general had criticized Manet's painting as unrealistic "from the military point of view." The price paid by the museum is put in perspective by the offer of the Berlin National Gallery in January 1911 of 225,000 marks for Böcklin's *Triton Family*.

ship, makes that impossible."[72] Several writers acknowledged that the "Protest" was right to complain of the poor market for German art abroad, but suggested that the government itself bore part of the blame by ignoring or disparaging the work of leading German painters and sculptors.[73] Vinnen's two most serious charges were easily disproven. Pauli, whose acquisition of van Gogh's *Poppies* for the Bremen Museum had been the immediate cause of the manifesto, pointed out that in the eleven years he had been in office the museum had bought thirteen modern French and eighty-four modern German paintings. Ludwig Kaemmerer, the director of the Posen Museum, declared that far from accounting for his entire purchase budget, the Monet landscape mentioned in the "Protest" belonged to the Posen art club, which had given it to the museum on permanent loan. The 60,000 marks that the museum had been able to spend on modern art since its founding had gone entirely to works of living German painters—a third of it to signatories of the "Protest."[74]

That the attack on unnamed art dealers was directed at Paul Cassirer was stated repeatedly. In a brief essay Slevogt wrote that while "people fear the material success and spiritual influence of French painting, they fear even more its living champions, who have tilled the German soil with an iron plow and have made it receptive to the new—it is they who are the true targets. People are angry at the Berlin Secession and at the Paul Cassirer Gallery in Berlin. These two institutions, closely allied, mutually committed, productively linked—despite their contestable relationship—through the exceptional personality of Paul Cassirer, have from the first fought for a new attitude in Germany. They started the new movement, and without compromising have led it ever since." The painter and book designer, Emil Rudolf Weiss, wrote that the "Protest" was directed at two men, Meier-Graefe and Cassirer: "Admittedly for years he [Cassirer] was alone in showing the great French masters from Delacroix to Cézanne, and did so for his own pleasure and because he believed that Germans . . . needed to see their work. He thought it superior to German painting, and understood that it had the most, and the most important, lessons to teach. Only an exceptionally naive Werdandi-type will count it a crime that eventually he also made money from the paintings." The twenty-four-year-old August

72. *Deutsche und französische Kunst*, p. 36.
73. See, for instance, Ulrich Hübner, ibid., p. 40.
74. Ibid., pp. 3–4, 8–9.

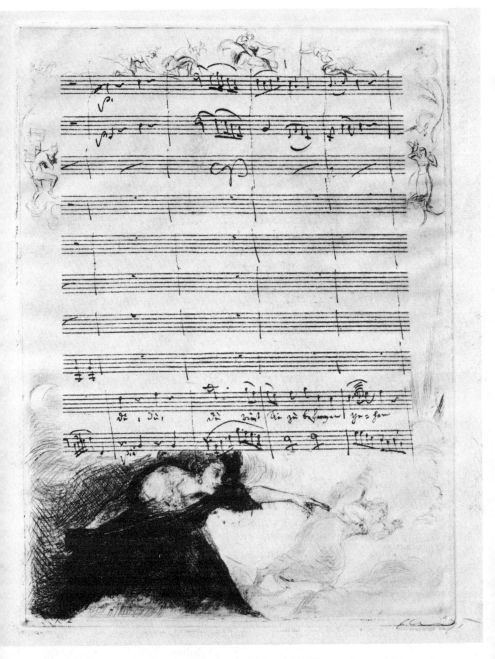

Max Slevogt, "Du, du, du." One of forty-seven illustrations of Mozart's manuscript score of *The Magic Flute,* the seventeenth publication of the *Pan Presse* (Berlin, 1920). Etching, 9⅜" × 7".

Macke wrote that "we painters owe a debt of gratitude to Paul Cassirer and Hugo von Tschudi, the most distinguished among art dealers and museum directors, who, free from any petty considerations, committed themselves wholly to advance good painting. And all the others, who fearlessly and by no means to their own advantage fought for good art in Germany, especially the heads of our museums, have also earned the thanks of the young, rising generation. As have some art historians and critics, above all Meier-Graefe, whose name can be mentioned only with caution in educated German society."[75]

Cassirer himself wrote that it was an unfortunate phenomenon of modern times that artists knew less about the economic facts of their existence than writers, composers, or actors. The art market had barely been studied; reliable information on it was rare. He placed no value on import and export statistics, because "1. they are inaccurate and superficial, and 2. they cover pictures that are exhibited, not pictures that are bought. Nor do they differentiate between old masters and modern works, or establish whether a painting imported from Russia was actually painted there or previously had been bought in another country." In any case, exports and imports were by no means the most significant aspects of the art market. "It would be far more useful to learn the cause of the enormous overproduction . . . to learn how the domestic market is structured, to understand the influence of state and municipal agencies, and finally — what must be the most important question of all — to understand how the public makes its choice among the goods it is offered."[76]

Cassirer had hoped, he wrote, that Vinnen would illuminate these issues, and therefore had read the "Protest" with interest. But to his disappointment he found no information: only errors, complaints, and accusations. Vinnen's statistics were meaningless. Only a fragment of the sum Germany spent on art imports went to modern works. Cassirer estimated that in an average year the value of French impressionists' works imported to Germany did not reach 500,000 marks; in 1910 the total had been higher because a major collection was sold and several Manets came to Germany; even in that year, however, the figure could hardly have affected the economic condition of German artists. "But even if French paintings worth millions were brought to Germany, Vinnen's pamphlet could not put a stop

75. Ibid., pp. 32, 42, 83.
76. Ibid., pp. 154–155.

to it . . . No protest can inhibit a cultural movement that covers the world. What we mean by French impressionism in the largest sense is a cultural movement, not a technical quality or a commercial matter." Toward the end of his essay, which was as revealing as Slevogt's about the impulses behind the secession, Cassirer turned to the attacks on himself:

Why did I "put myself in the service of French art dealers?" Instead of dealing with French paintings, why didn't I sell the works of Herr Vinnen and his friends? When twelve years ago my cousin and I tried to bring French art to Germany, no one thanked us for it, and it was difficult to earn enough to keep the enterprise going. Had I dealt with [German academic artists], making money would have been no problem. Why did I have to speculate with French paintings? Tell me that, Herr Vinnen. Why not just as easily with German works? Wouldn't that have been more pleasant for me? I'll answer the question: because I regard bringing French art to Germany as a cultural deed. But even that wasn't the real reason. Simply because I loved Manet; because I recognized Monet, Sisley, and Pissarro as powerful artists, because Degas was among the greatest masters, and Cézanne the bearer of a philosophy of life.

The fable of a stock of cheaply acquired paintings is just that, a fable. To my regret I do not own a stock of French impressionists. It is certainly true that Durand-Ruel in Paris owns a large number of impressionists. How he acquired them, how the stupidity of the public and the hatred of French Vinnens forced him to retain the stock, is a story in itself. He never intended to collect these paintings, but he could not sell them. He was stuck with them, and had this "art jobber" not possessed the strength of character to lose his wealth rather than deal with the work of French academicians his stock would never have accumulated, and a few of the greatest French masters would have died in hunger and misery.[77]

Cassirer concluded by expressing his belief that the young generation would not follow Vinnen. Young artists might not always be intelligent and fair, but they were independent: "The young will rather fail in their own way than succeed with Vinnen's guidance."[78]

Measured solely by the quality of their arguments, the contributors to *Deutsche und französische Kunst* provided a devastating response to Vinnen's manifesto. The facts were all on one side; any moderately objective reader must have concluded that Vinnen and his associates had been inconsistent, ill-informed, and careless with the truth. Even populists now complained of the pamphlet's inadequacies. On a closer look it was found that the "Protest" was weak-

77. Ibid., pp. 162–163, 165.
78. Ibid., p. 167.

ened by its ambivalence, most notably in Vinnen's "Quousque tandem," with its shifts between admiration and fear of French art; as propaganda it was too self-conscious and gave away too much to the opposition. The many factual errors in the essay and in the supplementary letters were embarrassing. Worst of all, the extremes to which some of the contributors were prepared to go exposed them and their cause to ridicule. To dismiss a painting by Manet, a master of worldwide reputation who had now been dead for nearly thirty years, as a feeble pastiche, unworthy of being hung in a German gallery, or to castigate the periodical *Kunst und Künstler* for having its title page designed by a Russian instead of a native German, could only place the protestors in a comic light.[79] The *Protest Deutscher Künstler* was unable to raise an echo among the more prominent artists, or among the most active and promising members of the new generation. Here, too, Vinnen suffered complete defeat. After 1911 his name almost disappeared from catalogues and art periodicals; for the remaining ten years of his life he withdrew into the obscurity of the hopelessly misunderstood.

Nevertheless, Cassirer was right in thinking that Vinnen had raised important social and economic questions, even if he lacked adequate information and the capacity to discuss them logically. The proletarianization of the artist was a genuine problem, perhaps of little significance to society in general, but poisoning the institutions and atmosphere of German art. Calling attention to the human tragedies that resulted was justified, although little could be done about them in a capitalist system that provided no social security to the free professions and was unable to restrict the number of new artists seeking work each year. Moeller van den Bruck's advice that bad painters stop painting and take up other activities was as unlikely to be followed in Germany as elsewhere.

A second issue that Vinnen's "Protest" implicitly touched on affected fewer people, yet for those involved it was no less traumatic. Vinnen spoke for artists who had made their mark in the salon or the artist colonies and had won commissions from society and the state, but who nevertheless were denied the publicity and acclaim that came to those who exhibited with the Berlin Secession and the Künstlerbund. Their condition of partial success—praised by the

79. See Fritz Erler, *Protest Deutscher Künstler*, pp. 33–34. Karl Scheffler, the editor of *Kunst und Künstler*, responded to the criticism by calling Vinnen's manifesto boring; his contributors were mystifiers and liars, and above all bad artists, whose arts-and-crafts products no one wanted. *Kunst und Künstler*, 9 (1910–1911), pp. 557–558.

emperor, honored by the state, but ignored by most of the intellectual elite—was symptomatic of the peculiarly intense duality of German culture at the time. The sense of bitterness at being relegated to the ranks of the unfashionable, which was a product of this divisiveness, deserves attention as much as does the frustration of the avant-garde—perhaps even more because, as Thode and Vinnen indicate, the resentment of the conventional artist fed into demonstrations and actions that intensified rather than allayed the politicization of German culture. Once again Vinnen had pointed to a genuine problem, but his proposed solution missed the crux of the matter. Spending a few hundred thousand marks more on German art would scarcely have comforted the alienated artist or brought traditional and modernist groups closer together.

Both in its arguments and in its immediate effect on German artists, Vinnen's "Protest" was a failure. As a political statement, however, it was far from negligible. Vinnen had, after all, found many people to agree with him, and his arguments, themselves adopted from earlier champions of "German art," were to lead a tenacious existence. It is their mixture of the aesthetic and the political that gave them longevity. Like Thode before him, Vinnen was troubled by aspects of contemporary art; yet in the end, both men couched their identification of the aesthetically bad, and their proposals for combating and overcoming the evil, in political or, more accurately, in ideological terms. The hatred of the most modern in art—for Thode, still impressionism; for Vinnen neo-impressionism and especially expressionism—engendered feelings that were more powerful even than a narrow nationalism. Their strength is suggested by Vinnen's complaint that too many impressionists' and post-impressionists' works were being imported, while he said nothing about the far more extensive imports of academic art. For the sake of his fight against modernism, Vinnen quietly put aside his concern for the economic well-being of his fellow artists.[80]

80. That Vinnen was corrected on this point in his own pamphlet has already been noted. Other critics included Lichtwark, who wrote that no one ever objected to the importation of bad foreign art. "Incredible sums of good German money left the country for worthless daubs, and were lost to the national wealth and to the support of German art, at a time when paintings by Leibl, Trübner, or Liebermann could not be sold in Germany. [A protest movement] did not begin until the Berlin Secession and Berlin art dealers began to import the great French masters rather than second-rate Italian, Spanish, French, and English works"; "Der Sammler," *Kunst und Künstler*, 10 (1911–1912), p. 281. See also the reminiscence by Emil Waldmann, who asked why the opposition to imports became vocal only when French impressionists and neo-impressionists were brought to Germany; *Sammler und ihrergleichen* (Berlin, 1920), pp. 125–127.

The ideal of the unity of German art, which to Vinnen, as to Thode, implied a degree of uniformity, the rejection of elements perceived to be dangerously different, underlies the *Protest Deutscher Künstler*. The belief that artists had a messianic role to play in German society gave this ideal a dynamism that carried it far beyond the realm of art. At the time, many people, artists and others, were captivated by the notion of a cultural elite with a national mission. But its most forceful political implications were developed in the conservative camp, in the Bayreuth circle, of which Thode was only one of many spokesmen, by populist and anti-Semitic groups.

The artist as the carrier of national regeneration—the phrase conjures up visions of *Simplicissimus* drawings of narrow-chested aesthetes carrying the weight of the universe on their puny shoulders. Those who took the idea seriously, however, had an additional reason besides their inability to learn to see in new ways for being outraged by the avant-garde. Rather than unifying the German people, whose naive fascination with things alien was constantly stressed, some modern artists were misleading and dividing it; the very existence and acceptance of their work revealed a dangerous susceptibility to decay. In this demonology, impressionists were bad enough, but expressionists were far more deplorable because they seemed to be surrendering not only to Parisian sensuality but to the values of Africa. According to this view, modern German art that was based on cosmopolitan rather than German precepts betrayed both the principles of aesthetics and its own people. Thode, as already noted, interpreted the development as as assault on the german's idealistic *Weltanschauung*. His and Vinnen's counterattacks were directed at what they perceived to be the materialistic core of modernism, inflamed by the even crasser materialism of dealers and speculators. Materialism, which conservative and populist ideologues identified as the most serious threat to contemporary Germany, had already gone far toward corrupting German art. The same enemy had to be fought both in art and in the larger national arena.

Thode's *Böcklin und Thoma* and Vinnen's *Protest Deutscher Künstler* thus expressed a resistance to modernism that was not only deeply rooted in Whilhelmine society—as it seems to have been, and continues to be, in all societies—but that was closely bound up with vigorous political concepts, which is by no means always the case. Radical conservatism, xenophobia, anti-Semitism—all regarded the modern and the international in art as symp-

tomatic of major weaknesses in public and private life. The fervent dislike of this type of art felt by the emperor, who personified German unity, could only underline the perception of the modern as evil and heighten the sense of injustice at having to suffer it and its effects. Even William II was unable to make art a central political issue in Germany for more than a few days, but such demonstrations as Thode's and Vinnen's indicated the direction in which the political mainstream flowed, and revealed something of the strength of the current.

6

TOWARD EXPRESSIONISM

I

From its inception the Berlin Secession prided itself on encompassing a variety of styles, of which German or Berlin impressionism as exemplified by Max Liebermann and Max Slevogt, and sometimes but not always by Lovis Corinth, was merely the most prominent. The old-fashioned naturalism of Jacob Alberts, the pointillism of Paul Baum and Curt Herrmann, Karl Walser's satirical and decorative city scenes, the distorted, accusing realism of Hans Baluschek and Käthe Kollwitz—all were welcome. Soon the group was further diversified by such new members as Lyonel Feininger, Wassily Kandinsky, Ernst Barlach, Emil Nolde, and Christian Rohlfs, who, it was hoped, would be the successors of the first generation of secessionists. If it was to continue as a vital force, Liebermann declared repeatedly, the secession must take chances with the unknown: "It must seek and foster new talent."[1] At a meeting of the executive committee a few weeks before his death, Walter Leistikow defended one of the newest members, probably Max Beckmann, whose entries in the 1908 summer exhibition had been condemned both by the public and by his colleagues: "What does it matter if the works on show are not particularly good this year; next year they might be that much the better." He warned against ascribing failure hastily; the secession should encourage experimentation.[2] Similar expressions abound in the secession's official literature, and the eclectic character of the annual exhibitions indicates that they were not mere pious phrases.

1. See, for instance, Liebermann's speech opening the secession's annual show in 1909, reprinted in *Die Phantasie in der Malerei* (Frankfurt am Main, 1978), p. 177.
2. Lovis Corinth, *Das Leben Walter Leistikows* (Berlin, 1910), p. 82. For the widespread criticism of Beckmann, see Karl Scheffler's review of the 1908 annual exhibition, "Berliner Sezession," *Kunst und Künstler*, 6 (1907–1908), especially p. 370. Scheffler's article concludes: "It is the secession's permanent task to bring genuine new talents to the public's attention, and at the same time to exhibit those works of the past on which the new is based" (p. 376). In other words, Scheffler felt, acceptable innovation emerged from, rather than in opposition to, earlier achievement.

But the leadership's awareness of the need for continuing change did not imply total tolerance. To Liebermann and to most of the men who served on the executive committee during the secession's first decade, French impressionism was the decisive achievement in modern art; it set the standard for their own work and, they believed, for the work of the yet untested new generation. Munch and especially Cézanne were still welcomed with enthusiasm, but van Gogh already evoked more guarded approval; his work was criticized for tending toward the purely decorative and for stimulating facile imitation. Matisse and Picasso were encountered with considerable reserve. "I have enough self-assurance to believe that the only good thing about Futurists and Expressionists is their name," Liebermann wrote shortly before the First World War. "How can purely intellectual art be true art?"[3] Paul Cassirer's taste was more adventurous; the early paintings of Kokoschka fascinated him, and he believed in Barlach's greatness. Yet he, too, felt a special affinity for the works of the great French masters from Delacroix to Cézanne. Although the executive committee knew that German art must move beyond the achievements of the present and recent past, its members' emotions could not keep pace with intellectual recognition.

In part, the failure to understand and tolerate, if not approve, was a generational matter—the issue by which revolutionaries live, and which overtakes them if they survive long enough. But not all of the more important innovators who appeared in the second half of the decade were young. Kandinsky, born in 1866, and Nolde, born in 1867, were of the same generation as Leistikow and Slevogt, while Rohlfs was considerably older. More significant than differences in age was the emergence in German art of a sense of the individual and his environment that acknowledged and often emphasized elements of disruption, illness, and crisis. Similar aspects in the work of Munch and van Gogh struck such critics as Liebermann as interesting secondary features, or were accepted because of the artist's overall painterly achievement; now they became the core of a new style, which challenged the very essence of impressionism.

3. Liebermann to Max Jordan, 3 October 1913, in *Katalog 700* of Ackermann Antiquariat (Munich, 1979), p. 31. According to his pupil and biographer Erich Hancke, Liebermann valued Cézanne but did not love him; *Max Liebermann* (Berlin, 1914), p. 483. Hans Purrmann describes the cool reception given to the first Berlin exhibition of Matisse's paintings at the Cassirer Gallery, and to Matisse himself, in the winter of 1908; see *Leben und Meinungen des Malers Hans Purrmann*, ed. Barbara and Erhard Göpel (Wiesbaden, 1961), pp. 103–104, 117–119.

If the secession's general membership had had a greater say in the selection of works for the annual exhibition, it would scarcely have been more liberal than the jury. But because in this, as in all other matters, the executive committee had virtually a free hand, it was accused of partiality toward the old. Discussions of style fed into more general criticism of the manner in which the committee ran the secession's affairs. It is not possible to fix the time when the rivalries and petty intrigues that must exist in most groups of this kind coalesced into more serious disagreements. In his memoirs, Corinth mentions a first vague "outbreak of discontent" after the secession moved to its new quarters in 1905. By 1907, in an essay on the annual summer show, Karl Scheffler compared the secession to an extended family whose members politely masked their hatred for each other.[4] The nature of their dissatisfaction is easily recognized. As the movement grew more successful, some of its early élan was lost. Even a friendly observer could comment on its "bureaucratization" and on its desire to be all things to all men. Combining the work of established artists with that of the avant-garde was desirable, but presented practical difficulties. The shows once again became larger, and their themes were less clearly defined. As Oscar Bie commented in 1909, "The principle of intimacy, of the psychologically appropriate arrangement [of works] has been dropped long ago."[5]

Although the executive committee was elected annually by the general membership, its composition changed little from year to year. Since the departure of the conservative group in 1902, it had been firmly controlled by Liebermann and his allies, whose prestige was too great to give potential rivals much scope. Inevitably, people complained in private that Liebermann was dictatorial and intolerant and played favorites. A painter and critic who admired him profoundly nevertheless commented that Liebermann's influence was so considerable that it often aroused strong resentment. Others thought that the real power lay elsewhere. In discussing the aftermath of the conservative exodus in 1902, Corinth recalled, "No one really knew how the executive committee intended to carry on.

4. Lovis Corinth, *Selbstbiographie* (Leipzig, 1926), p. 151. Karl Scheffler, "Berliner Sezession," *Kunst und Künstler*, 5 (1906–1907), p. 339.

5. Oscar Bie, "Berliner Sezession," *Neue Deutsche Rundschau*, 20 (1909), p. 906; "Bilder und Menschen," ibid., 21 (1910), pp. 860–864. See also Max Osborn's comment that the secession had moved "from the aesthetic barricades to the realms of good taste, without [however] betraying its principles"; "Von der Berliner Sezession," *Der Kunstwart*, 20, no. 16, (1906–1907), pp. 226–227.

Everyone thought: 'Cassirer will see to it.' With his customary frankness Cassirer himself told me: 'Actually the secession is guided by Leistikow and me – even Liebermann doesn't really have anything to say about it.'"[6] If Liebermann's reserve and irony occasionally caused hurt feelings, Cassirer was more openly abrasive. Corinth, whose relations with him gradually grew strained, wrote in his memoirs: "His character was the opposite of underhanded; he even prided himself on openly announcing his plans; but, strangely, no one ever paid any attention until they had come true . . . Although he exploited every opportunity offered him, he absolutely refused to do anything he did not believe in. Consequently he offended many people." On occasion, after the hanging committee had done its work, Cassirer and the porter of the secession secretly rehung the show before it opened. At other times he added a painting that had been rejected – such as Nolde's *Harvest* in 1907 – or, worse, took one away that the jury had accepted. He agreed with Leistikow that democracy had no place in the fine arts, but he lacked his friend's diplomatic gifts, his sensitivity for the feelings of those whose works he disliked.[7]

Leistikow's death of cancer in the summer of 1908 deprived the secession of the man best able to resolve the personal and artistic disagreements among its members. His intimate friendship with two such different personalities as Corinth and Cassirer had helped keep the executive committee united, and the preservation of the secession meant much more to him than it did to Liebermann or Cassirer, for whom the group was an important but increasingly tiresome adjunct to their other activities. In the course of his illness, Leistikow had become less active in the secession's affairs, although he continued to sketch and paint until a few weeks before his death. His last sketchbooks, which are filled with abstract color studies, innovations only hinted at in his last paintings, suggest that he was on the verge of a new phase in his work. In a brief commemorative article, Ferdinand Avenarius, the editor of *Kunstwart*, compared Leistikow's paintings to Fontane's novels; the artist had interpreted the Brandenburg countryside and caught its melancholy, harsh beauty as no court favorite ever could. Another critic summed up Leistikow's life with the statement that in his art he had often been

6. Erich Hancke, "Der Nachwuchs der Berliner Sezession," *Kunst und Künstler*, 9 (1910–1911), p. 266. Corinth, *Selbstbiographie*, p. 150.

7. Corinth, *Selbstbiographie*, pp. 152, 154. Max Liebermann, "Rede zu Paul Cassirers 50. Geburtstag," reprinted in *Berliner Maler*, ed. Irmgard Wirth (Berlin, 1964), p. 182; Emil Nolde, *Jahre der Kämpfe, 1902–1914* (Flensburg, 1965), p. 81.

conservative, but that in his ideas he was modern, "an energetic radical."[8]

The presence of artists who had broken with impressionism clearly acted as a ferment in the affairs of the secession. That is not to say that innovation, even of the most revolutionary kind, necessarily led to conflicts with the established leadership. The newcomers who proved to be the most important for the future of German art, as well as for the secession in its remaining years, were Nolde and his associates or former associates of the Brücke circle, whose connection with the secession was stormy, and Barlach, who experienced no difficulties whatever. That the secession's juries never rejected Barlach's work no doubt helps explain the difference and incidentally indicates that the leadership was not as dismissive of the new as has sometimes been claimed. But personal temperament and attitudes also played a part.

Ernst Barlach was born in 1870, the son of a physician, in Wedel, a small town in Holstein. After studying in Hamburg, Dresden, and at the Académie Julian in Paris and failing to establish himself as an artist in Hamburg and Berlin, he returned to Wedel; for some years he lived there in isolation, sketched, worked with ceramics, and attempted to write novels and dramas. He was still searching for his own themes and style when, at the age of thirty-six, he traveled to Russia for two months to visit his brother, who was employed as an engineer in Charkov. The south Russian plain, reminiscent of his native countryside and yet significantly different in its vastness, gave Barlach the freedom to work on subjects whose excessive familiarity had until then inhibited him. The Russian landscape and people, he recalled in his autobiography, were "not alien or frightening; everything seemed to convey long-familiar tidings." To a Russian critic he wrote twenty years later: "I felt life coming toward me in forms that accorded with my feelings, and that contained every possibility, profundity, joy, baseness, the most terrible frightfulness. Without reserve I threw myself into this sea of shapes. My inner readiness, my native tendencies, I brought along—for all of these things were also part of me. No doubt that is enormously Russian; but it is also enormously German, European, and universally human. Later I analyzed: in German life the essential is hidden in conventional forms, and these forms are useless to me. But all such

8. Ferdinand Avenarius, "Walter Leistikow," *Der Kunstwart*, 21, no. 22 (1907–1908), pp. 239–240; Oscar Bie, "Leistikow," *Neue Deutsche Rundschau*, 20 (1909), p. 150.

Ernst Barlach. *Sleeping Peasants*. From *A Russian Sketchbook*. 1906. Charcoal, 4″ × 6¼″.

principles are doubtful, because in the long run I found nearly every-thing that the outside world could offer me here in Germany, in the countryside, on the coast, in the small towns."[9]

In 1907 Barlach entered two small figures in the summer show of the Berlin Secession, a female and male beggar, "symbols of the human condition, naked between heaven and earth"; he also made the acquaintance of Paul Cassirer, who offered him a contract and an annual stipend. Several years later Barlach wrote a friend that he had by then received 5,000 marks from Cassirer, who had not yet been able to sell a single one of his works. But he was becoming known. In 1911 he sold his first sculptures, and in the following year Cassirer published his drama *Der tote Tag*, with twenty-seven litho-graphs by the artist — the first of many plays and series of lithographs and woodcuts by Barlach that appeared under the Cassirer imprint. Since 1908 he had been a member of the secession, and in 1911 he was elected to the jury; he did not care for organizations and art poli-tics, however, and disliked life in Berlin. In 1910 he settled in Gust-row, an old town in Mecklenburg, some eighty-five miles east of Hamburg, where he remained and worked in increasing isolation for the rest of his life. Under the Third Reich Barlach was forbidden to exhibit, his plays were taken from the stage, his war memorials — which expressed sorrow and mourning rather than the glory of sac-rifice — were destroyed or removed, and one of his best later sculp-tures, *Thomas Recognizing Christ*, was displayed in the propaganda exhibition "Degenerate Art." He died in 1938.

Affinities exist between Barlach's early work and that of the first generation of expressionist painters, and he is usually thought of as an expressionist sculptor.[10] His drawings, lithographs, and wood-cuts, as well as his sculptures, transform and reduce direct visual impressions into a stylized monumentality, with which the artist seeks to convey his sense of universal and timeless human charac-teristics. In sculptures from the period after his Russian trip, such as *The Stargazers*, *The Resting Wanderer*, and *The Lonely Man*, emo-tion is no longer hinted at but has moved to the surface and envelops the figure. Few realistic details remain; yet in his wooden sculptures, at this time usually superior to his ceramics and bronzes, the large planes and curves of the surface are given added vitality by hundreds

9. Ernst Barlach, *Ein selbsterzähltes Leben* (Berlin, 1928), p. 65; Barlach to Boris Pines, 26 January 1926, in Ernst Barlach, *Die Briefe* (Munich, 1969), II, p. 51.

10. Peter Selz, for instance, writes that "After his Russian trip in 1906 Barlach be-came the most significant exponent of expressionism in sculpture"; *German Expres-sionist Painting* (Berkeley and Los Angeles, 1974), p. 64.

of shallow dents and chips of the chisel, in constant interplay with the massiveness of the whole.

A great technical and stylistic distance separated Barlach from the older secessionist sculptors, Louis Tuaillon, Fritz Klimsch, and August Gaul. Nonetheless, perhaps just because he worked in wood and bronze, the painters who made up the majority of the secession juries found him less disturbing than they did the Brücke painters. Besides, Barlach's work differed in important respects from that of the expressionists. In a letter to a friend written in December 1911, he rejected Kandinsky's treatise *Das Geistige in der Kunst*, which had just appeared; he was willing, he wrote, to believe that points, lines, and spots evoked in Kandinsky "a deeper emotional shock (that is, one going beyond an aesthetic reaction to the decorative)"; but he himself could find no emotional truths in the nonobjective: "I must be able to empathize." Significantly, Barlach used a German term that reflected the sorrow of the human condition: "Ich muss mitleiden können."[11] Nonobjective art was meaningless to him, and his willingness to abstract and to appreciate abstraction in the work of others was limited. He never employed the rigorous deformation that Lothar-Günther Buchheim has called a primary characteristic of German expressionism.[12] Acceptance of his work was further facilitated by a special emotional quality of his sculpture: the calmness evident even in such figures as *Panic* or *The Sword-Drawer*, which express and interpret the most violent feelings in a composed, stoic manner. He never shared the directness and aggressiveness of the Brücke painters, nor their occasional wish to shock.

Some of the artists who later became leaders of expressionism or influenced it significantly came into contact with the Berlin Secession and the Cassirer Gallery even earlier than Barlach. Nolde first exhibited in the secession's 1903 graphics show, and his work was included again in 1906 and 1907, while he was breaking away from his earlier semi-impressionist style. The following year he became a member, and Cassirer included ten of his paintings in a show along with works by Corinth and Beckmann. Kandinsky and Feininger exhibited in the 1903 black-and-white show and joined the secession in 1907 and 1909, respectively. Alexey von Jawlensky first exhibited with the secession in 1904. In 1908 the Cassirer Gallery showed a small collection of his paintings. The same year Cassirer

11. Barlach to Reinhard Piper, 28 December 1911, in Barlach, *Die Briefe*, I, p. 394.
12. Lothar-Günther Buchheim, *Otto Mueller* (Feldafing, 1963), p. 62.

included eight landscapes by Rohlfs in an exhibition that consisted mainly of paintings by van Gogh. The secession's winter black-and-white show in 1908 included the leading members of the Brücke — Erich Heckel, Ernst Kirchner, and Karl Schmidt-Rottluff — as well as works of such other young artists as Paul Klee and Max Pechstein. In the secession's 1909 show Pechstein exhibited three paintings, one of which was bought by Walther Rathenau, and two years later showed nine paintings in the Cassirer Gallery. In June 1910 Cassirer organized Oskar Kokoschka's first major show.

But with few exceptions, critics and the public ignored or condemned the work of these artists. Many were not even mentioned in the long articles on the secession's annual exhibitions that Karl Scheffler who, with Julius Meier-Graefe, was one of the country's two most influential critics writing on modern art, published in *Kunst und Künstler*. Beckmann gave hope for the future, he wrote in 1907, and Nolde offered interesting hints of talent; but two years later Scheffler still felt that the new artists had achieved little. In 1910 he commented fairly positively on the work of Pechstein, Rohlfs, and another Brücke member, Otto Mueller, while condemning a group show of avant-garde Munich artists at the Cassirer Gallery as boring and repulsive. He denounced the "First German Autumn Salon," sponsored by Herwarth Walden's literary weekly *Der Sturm* in 1913, for its proletarian outlook, a criticism from which he excluded only Franz Marc, and concluded: "If one surveys these groups of painters and sculptors, and adds to them the literary associates of *Der Sturm* with their adolescent boorishness, it seems as though one sees a miserably unhappy young generation raging against itself." Even twenty-five years later, Scheffler continued to hold the opinion that, in comparison with the leaders of the Berlin Secession, the following generation had little to offer.[13]

Meier-Graefe shared in this encompassing pessimism; it reflected, of course, not only an aesthetic judgment but also a sense that, unlike the German impressionists, the current avant-garde — by its gestures even if not always by its convictions — was rejecting the liberal, hopeful outlook of the educated, well-to-do bourgeoisie. In lectures first given at the Cassirer Gallery and later published under the title *Whither Are We Drifting?* Meier-Graefe deplored the cultural state of Germany. Hostility, he believed, separated artistic genius and the

13. Karl Scheffler, "Kunstausstellungen" and "Berliner Sezession," *Kunst und Künstler*, 6 (1907–1908), pp. 256, 370; "Berliner Sezession," ibid., 8 (1909–1910), p. 439; "Kunstausstellungen," ibid., 9 (1910–1911), pp. 308, 364; "Kunstausstellungen," ibid., 12 (1913–1914), p. 119; *Die fetten und die mageren Jahre* (Munich, 1948), p. 69.

mass of the population, which was being misled by the "dangerous dilettante," William II, "a well-intentioned emperor, who at times speaks like Barbarossa and would like to act like an American. What he regards as culture is a heavy burden for him, which holds him back whenever he wants to advance." For the small minority that took art seriously, Germany was a "wild, alien land," and impressionism, which had once promised to usher in a fresh flowering of German art, had proved to be not the dawn of a new day but a sunset. Despite their talent, the new revolutionaries could not halt the decline because they were the enfeebled beneficiaries of other men's struggles, and their violence was usually a pose. "Many of these wild men are at bottom more thoroughly academic than all the Anton von Werners put together."[14]

Not every champion of impressionism and postimpressionism was equally unsympathetic to expressionism, but Scheffler and Meier-Graefe certainly spoke for many members of the secession. Other critics went much further in condemning the stylistic anarchy and indecent themes of such painters as Kirchner, Schmidt-Rottluff, and even Mueller, whose obsessive sensuality did indeed fail to prevent his work from turning out to be as tamely academic as Meier-Graefe had predicted. As Carl Vinnen and the contributors to his "Protest of German Artists" demonstrated, expressionism and the Fauves gave many people new grounds for disliking the Berlin Secession, which, it was claimed, either sponsored these works or had propagated attitudes that inevitably led to the further degeneration of German art. At the same time, by reinforcing personal animosities within the membership, expressionism led to the secession's eventual breakup.

At the annual general meeting in January 1910, a group of members opposed to the "tyranny" of Liebermann and Cassirer elected Beckmann and Meier-Graefe's friend Leo von König to the executive committee. Declaring that they could not work with men who, they believed, would open the secession to the worst in modern art, Liebermann and Gaul resigned from the committee and were soon followed by Slevogt, Cassirer, and others. Eventually a compromise was reached. Liebermann and his associates returned to the committee—all but Cassirer, who took six months' leave from his position as business manager and did not participate in the jury for the 1910 summer exhibition.[15] The reformed committee's most important task was to arrive at a realistic policy toward the

14. Julius Meier-Graefe, *Wohin treiben wir?* (Berlin, 1913), pp. 24, 30, 108.
15. Werner Doede, *Die Berliner Secession* (Berlin, 1977), p. 37.

expressionist painters, but this was made impossible by personal disagreements and divided feelings among the newcomers; neither Beckmann nor König, himself a highly conventional artist, admired the Brücke group.

As a result, the 1910 annual show was a political disaster. Twenty-seven avant-garde painters were turned down by the jury, among them Heckel, Kirchner, Pechstein, Nolde, and Schmidt-Rottluff. Under Pechstein's leadership some of the rejected artists formed a new group, the New Secession; in May they opened their first exhibition, described by the slogan "an art show of those who were rejected by the Berlin Secession." Three more shows followed in the next year and a half; their quality was uneven, but the process of dislodging the Berlin Secession as the institutional center of modern art in Berlin and Germany had begun. A second incident of mismanagement caused further discord. In 1910, for the first time in its existence, the secession received financial support from a public agency, when the Berlin and Charlottenburg magistrates donated prizes for the most promising works in the annual exhibition. With glaring tactlessness, the jury awarded one of the prizes not to a young artist but to a well-established sculptor who had been a member of the group since its beginning. The new faction on the executive committee proved unable to change the secession's basic stance—a firm attachment to the leaders and the more talented followers of German impressionism, with only qualified support for artists working in different directions. In November König, who had hoped to become president in Liebermann's place, resigned from the committee and from the secession.

A mixture of artistic and personal differences characterized these conflicts, yet despite some strong claims and counterclaims the antagonisms rarely ran so deep as to preclude reconciliation. Pechstein, for instance, soon exhibited at the Cassirer Gallery, and by 1912 rejoined the Berlin Secession. In the next clash, however, which started only a few weeks after König's resignation, the antagonists were unforgiving.

At a special meeting of the secession on 8 December 1910, Liebermann had asked for specific criticisms of the executive committee and its policies. The discussion did not reveal any significant dissatisfaction. Two days later, however, Nolde, who had attended the meeting but had not spoken, wrote a letter to Scheffler; it began as a complaint about an unfavorable review but quickly turned into an attack on Liebermann and the secession as a whole. In the most recent issue of *Kunst und Künstler*, Scheffler had discussed an exhibi-

tion of graphics organized by the New Secession, which included a number of Nolde's drawings. Scheffler's comments on Nolde were limited to three sentences: "It is still not possible to say anything definitive about Nolde, the strongest temperament in the group. Even the best of his graphics always leave one with the feeling that technique holds the same kind of power over him as the broom held over the magician's apprentice in Goethe's poem. Nolde has some insight into the magical formula of art, but he still does not know how to use the formula like a true master."[16] This critique, typical of Scheffler in its facile word associations and literary allusions, was wrong-headed but not as harsh as might have been expected; Nolde, however, was not prepared to accept Scheffler's polite variant of "not proven," and saw a way of combining his sense of personal injury with the cause of modern art in general.

In 1910, at the age of forty-three, he had just made his first sale to a German museum, but his work was still little known, and he and his wife continued to lead, as they had for years, an economically precarious existence. Nolde's situation was complicated by his troubled, suspicious personality and his racial preconceptions. He pictured himself as fighting for German ideals against "the spread of French views and of shameless commercial activity" in the German art world, persecuted or misunderstood by "a press that could barely tolerate native German art." While he had refused to support Vinnen's "Protest of German Artists," with its hostility to expressionism and its opposition to the importation of works by van Gogh, Gauguin, and other painters he valued, he was at one with the "Protest" in condemning the prices paid for French art and in his cultural patriotism, which was cast in rigidly racial forms.[17] He believed in the creative power of unadulterated races, whose vigor, he feared, would degenerate as they mingled and adopted each others' styles. When he first saw paintings by Picasso he was uncertain whether to like them or not, because, as he later wrote, "I was tortured by not knowing whether cubism and constructivism were created by Jews, and originated in the Jewish mentality."[18] The volume of his auto-

16. Scheffler, "Kunstausstellungen," *Kunst und Künstler*, 9 (1910–1911), p. 152.
17. Nolde, *Jahre der Kämpfe*, pp. 146, 163. Nolde discussed Vinnen in a letter to a friend, reprinted in ibid., pp. 167–168; see p. 125 for Nolde's comment on "the astonishing prices for French pictures," which made his blood boil.
18. Ibid., p. 200. The sentences following this statement are somewhat ambiguous but suggest that Nolde might have approved of cubism if it had been "Jewish"; what he objected to was that Jews painted in the style of other races, "denying their own racial qualities."

biography dealing with the years between 1902 and the outbreak of war is all too accurately entitled *Jahre der Kämpfe.*

By 1910 Nolde had left his early quasi-impressionist manner behind; recently he had begun painting religious themes in bright, "burning," symbolic colors, the figures violently gesturing, their faces distorted by emotion. In the spring, one of the paintings, *Pentecost,* had been rejected by the secession jury, and Liebermann had expressed his dislike of the work in vigorous terms. Consequently, Nolde had joined the New Secession, while retaining his membership in the older group. In his letter of 10 December he thanked Scheffler for using two of his drawings to illustrate the review of the graphics exhibition, but characterized the accompanying text as feigning good will while in reality being as destructive as possible. Nolde reminded Scheffler of a promise, made long ago, to devote an entire article to Nolde's work; he forgave him the omission, however, in view of Scheffler's lack of independence as editor of a journal dedicated to promoting the commercial interests of a group of traditional artists, "who function more or less under the brand name Liebermann."[19]

The rest of Nolde's letter was an attack on Liebermann, who was accused of senility, of seeking publicity, and of painting and exhibiting as much as possible to maintain his position. As a result, "the entire young generation, more than sated, no longer can or wants to look at his work; it recognizes the artificiality of everything, how feeble and trashy [*schwach und kitschig*] not only his present paintings are, but a good many earlier ones as well." Nolde predicted that soon all of Germany would recognize the hollowness of Liebermann's work; he closed with the insinuation that Liebermann devoted so much energy to the affairs of the secession because his art was not substantial enough to occupy him fully. He sent a copy of the letter to Liebermann because, as he wrote in a covering note, he would not want Liebermann to learn of the letter second hand; "I also very much want you to know what youth thinks of you and your art."[20]

The comedy of a forty-three-year-old zealot presenting himself as

19. Nolde's letter, slightly shortened, was published by Scheffler together with his own reply in *Kunst und Künstler,* 9 (1910–1911), pp. 210–211. For the complete text, see Doede, *Die Berliner Secession,* pp. 63–64. In his reply, Scheffler denied that he had ever promised Nolde an article on his work; on the contrary, Nolde "had for years tried to force himself on us." See also Scheffler, *Die fetten und die mageren Jahre,* pp. 77–79.

20. Doede, *Die Berliner Secession,* p. 63.

the spokesman of youth could not erase the extraordinary venom of his attack. The executive committee called a special meeting of the secession's membership, to which it distributed copies of Nolde's letter together with a motion, drafted by Tuaillon, to expel the writer for having gone beyond the bounds of permissible criticism, damaging the good name and interests of the secession, and behaving in a dishonorable and cowardly manner.[21] In a letter to the members, Liebermann protested the motion and advised against expulsion: "What this gentleman thinks of me can matter as little to you, dear colleagues, as it matters to me." Still, at a meeting on 17 December, Nolde was expelled from the secession by a vote of 40 to 2, with 3 abstentions, a result that Corinth ascribed primarily to his own and Cassirer's efforts. Barlach, who hurried from Güstrow to attend the meeting, missed the vote but wrote Nolde that he would have voted with the majority. If one could keep up one's spirit only by harshly criticizing others, he said, one should do it privately: "Time will judge the contestants, but the contestants must not meddle in the judging." Nolde sued the secession for the insulting language contained in the motion for expulsion, but he lost the case and was ordered to pay costs both in the first trial and on appeal. Ordinarily the insults expressed in the secession's motion would be punishable, the appeals court declared; in this case, however, Nolde's scandalous attack on the grand old master made them seem excusable, a judgment Liebermann acknowledged with one of his frequent allusions to Frederician Prussia: "Il y a des sages à Berlin."[22]

The effect of Nolde's attack was a strong affirmation of Liebermann's standing in German art. But coming after a year or more of quarrels within the secession, it was so disturbing that Liebermann decided to resign the presidency at the next general meeting, which was scheduled to be held only nine days after the vote on Nolde had been taken. Nolde's expulsion rid the secession of a member whose beliefs were antithetical to most of its cultural and social values, and whose paranoid intolerance could only have led to further con-

21. In his autobiography, Nolde cited the most abusive disparaging terms, actually in the motion, as epithets shouted at him by Cassirer; see *Jahre der Kämpfe*, p. 148.

22. Liebermann's letter to the membership is printed in Hancke, *Max Liebermann*, pp. 483–486; Corinth's comment is in *Selbstbiographie*, p. 153. See also Barlach to Nolde, 26 December 1910, *Die Briefe*, I, pp. 354–355; Liebermann to Max Lehrs, 12 October 1911, Bodenheimer Collection, Leo Baeck Institute, New York. Additional references to the "Nolde scandal" can be found in Liebermann's letters to Lehrs, 21 December 1910 and 19 March 1911, ibid., and in two letters from Lichtwark to Liebermann of 17 December 1910, in Alfred Lichtwark, *Briefe an Max Liebermann* (Hamburg, 1947), pp. 262–265.

flicts had he remained; yet in him the group also lost one of the most powerful talents in modern painting. For Nolde, defeat meant the end of his hopes of destroying a clique that he imagined to be in league against him and still greater isolation, since even his fellow expressionists now found him too offensive. "I looked about me, and was alone," he said in describing the aftermath, "excluded by the old, abandoned by the young — rejected by two generations."[23]

Beyond the wider secession circle, however, Nolde's rudeness to Liebermann did not hurt him. He was praised and supported by some of the secession's many enemies; they saw him either as a champion of German art against the forces of internationalism, or — as Karl Osthaus, director of the Folkwang Museum in Hagen, perceived him — as a leader of the newest German painting, which was overcoming impressionism and destroying the dominant position of Berlin in German art. Nolde's own vivid despair at his disgrace did not interfere with his artistic development. His recently begun studies of primitive art and his interest in James Ensor, whom he visited in 1911, are reflected in such innovative paintings as *Masks*. In 1912 his sequence of pictures on religious themes reached a high point with his nine-panel altarpiece on the life of Christ and the triptych *The Life of Saint Mary of Egypt*. Like other expressionists, he was also painting prophetically apocalyptic pictures of war at this time. In the spring of 1913 he accompanied an anthropological expedition to the central Pacific, a voyage that led to further advances in his work.[24]

The clash between Liebermann and Nolde demonstrates once again how illusory it was to equate avant-garde painting at the be-

23. Nolde, *Jahre der Kämpfe*, p. 204; see also p. 196.

24. Selz, *German Expressionist Painting*, pp. 123–129, 289–291. Nolde's own version of the episode and its background, in *Jahre der Kämpfe*, pp. 145–153, moves beyond the strongly partisan to numerous and apparent inaccuracies. His treatment of Cassirer, for Nolde the arch-representative of the international commercial seduction of German art, is characteristic. It includes an account of a secession banquet, at which a financier loudly praised Liebermann's commercial acumen until silenced by others who were afraid that too much was being revealed, and at which Cassirer called out, "All of these artists are my slaves!" and Corinth stumbled from one female bosom to another (pp. 81–82). This is clearly an expressionistic set piece rather than a trustworthy recollection. But it is surprising that Nolde could so deceive himself as to describe an argument about modern art he and Cassirer had in 1908, which ended with Nolde declaring, "I hope none of my pictures will ever hang in his gallery!" — forgetting the exhibition of his work in the Cassirer Gallery from 8 January to 2 February 1908 (see pp. 143–144). After Cassirer's death in 1926 Nolde sent an oddly ambivalent comment to a friend: "He was my great enemy and a personality, explosive and stimulating." *Briefe aus den Jahren 1894–1926*, ed. Martin Urban (Hamburg, 1967), p. 177.

ginning of the century with social criticism and democratic or even anti-German attitudes. Had they seriously occupied themselves with Nolde at all, adherents of the Wilhelmine aesthetic could have objected to his style, to some of his subject matter, and to the violence and pessimism, incomparably more pronounced in his work than in the work of the German impressionists, that certainly did not convey a sense of contentment and pride in the artist's environment. But they would have found no lack of loyalty to Germany and the empire. Nolde was as aggressively patriotic as such a traditionalist and anti-Semitic enemy of modernism as Henry Thode, or as Thode's populist allies, the Volkers and Vinnens. Like them he demanded that art serve Germany, by which he meant that art should express his particular fantasy of the German spirit and genius. It could do so only, he believed, if it remained unsullied by alien influences. The line he drew between valuable and bad art did not coincide with Thode's or Vinnen's judgment, but the principle was the same; and in his thinking it acquired special weight from his mystical identification of racial purity as the source of true potency and creativity. "Some men," he wrote, "especially those who are already of mixed blood, wish intensely for everything—people, art, cultures—to become mixed, which would eventually lead to a world community of mongrels, bastards, and mulattoes. Of people with soiled faces and negative qualities . . . The sweetness of sin has no conscience. There is such a thing as straining after self-destruction. Some places in the tropics are [already] frightening examples of the result of a mixing of races."[25] This muddle of infantile fears and ambitions accompanied Nolde through life; it obviously fed his hatred of Liebermann, and not surprisingly carried him for a time into the National Socialist fold, although even there, to his astonishment, he remained an unwanted outsider.

Nolde cannot be blamed for reacting angrily to the secession's rejection of *Pentecost*. Typically, however, he universalized his anger and depicted his dispute with the secession as an ideological confrontation. In that respect, too, he belonged to the new wave. The conversion of personal issues into absolute political and ethical differences was not unique to the twentieth century or to Germany; but at that time and in that place it was becoming more widespread and acceptable, and it increasingly characterized German culture and society. The ideological, rather than aesthetic, attack on modernism, which the emperor had launched out of a belief in the affini-

25. Nolde, *Jahre der Kämpfe*, p. 126.

ty between academic art and political loyalty, which Thode waged in the name of a regenerated German art, and which Vinnen expanded by mobilizing the economic anxieties of the art proletariat, became with Nolde a struggle within the modernist camp as well.[26]

II

At the annual general meeting of the Berlin Secession on 28 December 1910, Liebermann announced that after twelve years in office he wanted to leave the presidency. His closest associates on the executive committee also resigned. After Slevogt refused to succeed Liebermann, Corinth was elected president. Liebermann was named honorary president with a seat on the executive committee; the empty places on the committee were filled by Barlach and by some of the best young representatives of German postimpressionism: Konrad von Kardorff, Robert Breyer, and Waldemar Rösler, whose name was frequently linked with Beckmann's as a pioneer of a more emotional and decorative manner of painting, which went beyond impressionism without going to the extremes of the Brücke. For the internal politics of the group, the change in leadership was significant, but it did not imply greater receptivity to expressionism. On the contrary, Corinth proved to be far more conservative in his exhibition policies than Liebermann and Cassirer. Besides, he cared little for the day-to-day business of the secession, or for the constant negotiations that were necessary to put together a good exhibition.

26. Nolde's racial beliefs do not negate his artistic archievement, but they cannot be passed over in any appraisal of his life and work. Werner Haftmann's labored defense of Nolde against the "absurd" reproach of anti-Semitism in *Emil Nolde: Unpainted Pictures* (New York, 1965), pp. 14–15, is an example of how such matters should not be discussed. Haftmann writes that "at first Nolde had sympathized with National Socialism," but he fails to mention that he had become a member of the party in North Schleswig, nor does he indicate that even after his "disillusionment" with National Socialism in 1940, Nolde continued to try to gain the support of such party leaders as Baldur von Schirach. It goes without saying that Haftmann does not ask whether Nolde's disillusionment was caused by National Socialist ideology and policies or by his being forbidden to exhibit his work.

Apposite to the political polarization of art in Germany, which Nolde exemplifies, are Theda Shapiro's comments in *Painters and Politics* (New York, 1976): "The Brücke painters, and the Italian Futurists in some aspects of their thought, veered toward the philosophies of native blood and soil just then being elaborated, philosophies which wound up on the extreme right in the 1920s . . . though the Schleswig peasant Emil Nolde was exceptional in his racism among the expressionists, they all shared his love of the soil and his unease with urban life—and neither feeling disturbed their advanced approach to painting or acceptance of other avant-garde beliefs" (p. 114).

Consequently, the 1911 annual show failed to impress most critics and had little impact on the public. It was not organized around one of the large collections of works by artists with established reputations, such as Munch, Toulouse-Lautrec, van Gogh, or Liebermann, which had drawn numerous visitors in previous years; nor did it include the work of German expressionists, who continued to hold their own shows under the name New Secession. Two paintings by Feininger constituted the high mark of the avant-garde acceptable to Corinth. The most discussed artists in the exhibition were men identified in Corinth's foreword to the catalogue as "French expressionists": Braque, Derain, Marquet, Picasso, Le Douanier Rousseau, considered a hoax by many visitors, and—among Germans—Beckmann, Rösler, and the sculptors Barlach and Lehmbruck. The exhibition was also arranged less effectively than in previous years. In his review Scheffler declared that another change in leadership was essential: "Good painters can paint, but can't organize. The secession needs to be directed by a nonartist."[27]

In his farewell address as president, Liebermann had expressed his confidence that the secession was more productive and stable than ever: "After the constant disturbances of the past years, we have finally removed those elements that stood in the way of collegiality in the executive committee and prevented the committee from working amicably and effectively with the members . . . Today the Berlin Secession represents a power in the Berlin art world . . . Perhaps just because our opponents imprudently worked to frustrate us, we have been able to raise the importance of Berlin as an art center . . . we have made Berlin into the German marketplace for modern art."[28] In reality, the secession was being passed over.

During 1911 expressionists and artists working in other styles organized exhibitions throughout Germany that added up to a comprehensive survey of avant-garde art, much of which could not be found in the secession gallery. The New Secession held two shows in Berlin that included works by Heckel, Mueller, Pechstein, Schmidt-Rottluff, Marc, Kandinsky, Jawlensky, and Nolde. "Nolde's

27. Karl Scheffler, "Berliner Secession," *Kunst und Künstler,* 10 (1911–1912), p. 437. See also Erich Vogeler, "Berliner Sezession 1911," *Der Kunstwart,* 24, no. 20 (1910–1911), pp. 105–108. In "Präsidentenwechsel in der Sezession," 29 January 1911, an anonymous art critic in *Vorwärts* had predicted that Corinth would not be as effective a leader as Liebermann.

28. For Liebermann's address and Corinth's acceptance speech, which stressed continuity with the former leadership, see *Kunst und Künstler,* 9 (1910–1911), pp. 302–304.

biblical scenes," Scheffler noted in *Kunst und Künstler,* "contain a certain brutal profundity and a caricatured classicism."[29] In the fall Berlin had the first of several "jury-free" shows of works rejected by the secession. In Munich, Marc, Kandinsky, Alfred Kubin, and Gabriele Münter left the New Artists' Association after Kandinsky's *Last Judgment* was rejected, and in December opened the first show of the Blaue Reiter group, which also presented works of such painters as Le Douanier Rousseau and Robert Delaunay. After it closed in Munich, the show was sent to Cologne and Berlin. A second exhibition by the same group in the spring of 1912 also included work by the French cubists, as well as Vlaminck, Malevich, and Klee.

The Düsseldorf Sonderbund, which had made Liebermann an honorary member when it was founded in 1908, held important shows in 1910 and 1911; under the leadership of Karl Osthaus it sponsored the fourth Sonderbund exhibition from May to September 1912, the most important exhibition of modern and contemporary art in Germany during these years, which served as the direct model of the New York Armory show in 1913. Without the pioneering work of the Berlin Secession, this exhibition would not have been possible, and it should be noted that Cassirer was a member of the organizing committee; nevertheless, the secession had never mounted an international effort of comparable magnitude.[30] Finally, Herwarth Walden's literary weekly *Der Sturm* started to publish modern graphics, beginning with a Liebermann lithograph; soon it was carrying the work of such artists as Kokoschka, Kirchner, members of the Blaue Reiter, futurists, and cubists. From 1912 on, Walden held small exhibitions of avant-garde art in Berlin, which led to the "First German Autumn Salon" of 1913.[31] Although members of the Berlin Secession took part in some of these shows, the impetus did not come from them; in the bursts of creativity and accomplishment that marked the avant-garde between 1910 and 1912, the secession had no more than a small share.

Despite members' unhappiness with his handling of the secession's exhibitions and administration, Corinth had no intention of

29. [Karl Scheffler], "Kunstausstellungen—Berlin," ibid., 10 (1911–1912), p. 218.

30. The exhibition was not without its own quarrels. Marc protested against decisions of the jury and planned an exhibition of "artists rejected by the Sonderbund," and dissension within the Sonderbund led to the breakup of the organization the following year. See Günter Aust, "Die Ausstellung des Sonderbundes 1912 in Köln," *Wallraf-Richartz-Jahrbuch,* 22 (1961), pp. 288, 290.

31. The activities of the various groups are discussed in Selz, *German Expressionist Painting,* chaps. 15–17, 19–21.

changing his policies, but in December 1911 he suffered a stroke that incapacitated him for the next several months. In arranging the 1912 annual exhibition, the executive committee felt compelled to rely heavily on Liebermann and on Cassirer, who had practically withdrawn from the secession's affairs since leaving the committee in 1910. In the little time available, the two men could not put together a strong, well-integrated show. Their most significant move was to persuade Pechstein to return; he exhibited twelve paintings in the 1912 summer show, and in retaliation was excluded from the Brücke. Without Pechstein's leadership the New Secession disintegrated, and the Brücke, which had shown signs of dissension for some time, broke up soon afterwards.

Corinth's health had improved by the end of the year, and he announced his candidacy for reelection. When a large group of members nominated Cassirer for the presidency, Corinth withdrew, and Cassirer was elected at the general meeting in December 1912. As a sign of reconciliation after this conflict, Corinth and Cassirer agreed on a major retrospective show of Corinth's works in the secession's gallery; it was opened with an address by Liebermann. The bond between the secession and Cassirer, which Slevogt had characterized during the Vinnen controversy as contestable but productive, was now closer than ever.[32] Scheffler, who had called for a nonartist as president but may have had himself in mind, openly condemned the choice of Cassirer. So did other critics sympathetic to modern art such as Julius Bab, who thought that, while the secession might do better with a competent administrator at its head than with a great painter, the decision was nevertheless a bad one: "To the extent that every association of artists is a group interested in effective exhibitions and good sales, the secession will probably not fare badly under the knowledgeable and energetic leadership of Mr. Cassirer. But if we keep in mind that such a group should also be a social organization, the self-government of free, creative spirits, then some of us will not welcome the presidency of this layman . . . It may be doubted that in the long run his choice will benefit the secession's development, its independence and harmony. That its exhibitions will be in good hands, however, Paul Cassirer has just demonstrated." Bab's last sentence referred to a recent exhibition in the Cassirer Gallery, which presented a historical survey of modern painting beginning with Géricault, Courbet, and Daumier, through Manet, Pissarro, and Degas, to Cézanne, van Gogh, and recent and contem-

32. Doede, *Die Berliner Secession,* p. 47.

porary German painters. With this show, Bab concluded, "the leader of yesterday's revolutionaries tries to place himself in that process of measured evolution whose history he is demonstrating."[33]

To Cassirer it was self-evident that the secession would decline into a conservative interest group like the Munich or Vienna secessions unless it was willing to sponsor contemporary art. Consequently, he forced the secession to change direction. The art historian Curt Glaser, a close observer of the Berlin art scene at the time, later judged that Cassirer had made the only possible choice. "A fundamental renovation was the only way for the secession to regain its vitality. The secession no longer had to compete merely with the Berlin salon—a fight it had won—but also with the many new artists' associations and exhibition groups . . . The secession had to make up its mind and declare itself. It had to state clearly whether it wanted to remain the group it had been ten years ago and relinquish the leadership of the avant-garde to the new associations, or whether it wished to join the new movement. Paul Cassirer chose the second way, and no doubt it was his only true option, but it was a decision of the mind rather than the heart."[34]

To keep the still sizeable conservative faction in check and mobilize a greater number of progressive or at least tolerant members, Cassirer reorganized the secession's administration. The executive committee was enlarged and a new committee in charge of exhibitions was added; both were headed by Cassirer himself. The separate jury for the summer annual was chaired by Slevogt. The old cadre led by Liebermann, Gaul, and Tuaillon was joined by such artists as Kollwitz, Barlach, and the young sculptor Georg Kolbe. To give young artists greater opportunities, Cassirer planned a new autumn exhibition in addition to the annual summer exhibition and the winter graphics show. For the 1913 annual show Cassirer obtained a large number of major foreign works: three Bonnards, seven Cézannes, eight van Goghs, ten Renoirs, three Toulouse-Lautrecs, eleven Seurats, as well as paintings by Matisse, Derain, van Dongen, Friesz, Marquet, and Vlaminck. One room, filled with pieces by Barlach, Gaul, Lembruck, Kolbe, and other German sculptors, was dominated by a single painting, Matisse's *Dance*. The profound af-

33. Julius Bab, "Berliner Kunst- und Theater-Brief," *Karlsruher Zeitung*, 11 December 1912.

34. Curt Glaser, "Die Geschichte der Berliner Sezession," reprinted in *Kunst und Künstler: Aus 32 Jahrgängen einer deutschen Kunstzeitschrift*, eds. Günter and Ursula Feist (Mainz and East Berlin, 1971), pp. 288–289.

finity between foreign art and the Berlin Secession was once more emphatically confirmed. Among German artists, Liebermann and Trübner each received a room. But the avant-garde was also well-represented, among them the former Brücke members Kirchner, Heckel, Schmidt-Rottluff, and Pechstein; Kokoschka showed four paintings, and Rohlfs and Beckmann, three each.

In his introduction to the catalogue, Cassirer wrote that "the concept of 'secession' makes it impossible that success should quiet the Secession. The Secession is not a point of rest, it is movement. It does not assure the existence of its members; on the contrary, its members are endangered because the Secession will always mobilize the power of newcomers." Thirteen members whose works had been rejected by the jury did, in fact, protest that outsiders had been unfairly preferred over them, but the undiplomatically strict selection contributed to the great success of the exhibition. In his review Glaser called it a landmark; thirteen years later, in his article on the history of the secession, he described it as a brilliant achievement, reminiscent of the best in earlier years. Even Scheffler found little to denounce, while Bab proclaimed it a triumph, which did great credit to its organizer. Once more, and surprisingly, the secession had seized the initiative.[35]

Since the relations between the secession and the government and art establishment became somewhat more amicable at this time, the secession's unexpected success in attracting a part of the avant-garde opened up interesting possibilities for modern art. Several incidents of practical as well as symbolic significance in the last years before the war suggested that official acceptance of German impressionism was increasing—a shift that could benefit those avant-garde artists associated with the secession. In 1912 the University of Berlin awarded Liebermann an honorary doctorate, reversing several earlier rejections, the most recent one in 1911 when a faculty member still argued that the university could not subject the emperor to such an affront.[36] Also in 1912 Liebermann was elected to the senate

35. Paul Cassirer, "Vorwort," *Katalog der sechsundzwanzigsten Ausstellung der Berliner Secession* (Berlin, 1913); Curt Glaser, "Die XXVI. Ausstellung der Berliner Secession," *Kunst für Alle,* 28 (1912–1913), p. 474, and "Die Geschichte der Berliner Sezession," p. 288; Julius Bab, "Berliner Kunst- and Theater-Brief," *Karlsruher Zeitung,* May 1913; Erich Vogeler, "Berliner Secession," *Der Kunstwart,* 26, no. 18 (1912–1913), pp. 437–439.

36. "Chronik," *Kunst und Künstler,* 9 (1910–1911), p. 161. Shapiro, *Painters and Politics,* p. 120, errs in stating that the Berlin Secession was "the only organization of artists not invited to participate in the festivities."

of the Academy of Arts; only the continued absence of Prussian decorations indicated the unusual path he had taken to the top.[37]

Slevogt and other members were elected to the academy; Tuaillon received the order Pour le mérite, and was given an honorary doctorate by the University of Berlin, which also awarded degrees to Leopold von Kalckreuth and Hans Thoma. In 1914 Wilhelm Bode, who as director of the Prussian museums contributed to the official acceptance of impressionism, was ennobled. The Kultusministerium even inquired whether Cassirer would accept the title of commercial councillor, a suggestion he rejected. This surprising approach was made in conjunction with the ministry's plans to mark the twenty-fifth anniversary of the emperor's reign with an art exhibition, organized under the banner of reconciling the various directions in art, in which the secession was invited to participate. After exploring the offer for some weeks, the executive committee decided against it, to the relief of Scheffler, who had written in the course of negotiations: "After having been boycotted for so long, [the secession] should be too proud to permit itself to be tolerated. The secession possesses a power and a legitimacy that is more lasting than that of the governmental academy. It should continue to seek true achievement, not official success."[38]

It is evident that the inroads impressionism had made in the taste of the upper and middle classes — a development probably not unrelated to the new wave of far more shocking works by expressionists and Fauves — was reflected in the behavior of senior bureaucrats and functionaries of the university and academy, who themselves belonged to these social groups. The secession was no longer the outcast it had once been, although disapproval of the art it represented remained widespread and some officials continued to hew to the old line. At a dinner celebrating the opening of the 1912 salon in the Lehrterstrasse, the deputy mayor of Berlin deplored the type of art

37. In 1910 Liebermann had been nominated for a seat in the senate, but after four rounds the "historical painter" Konrad Kiesel defeated him by 15 votes to 10. Minutes of the meeting of 7 October 1910, Akademie der Künste, Senat Akten, Abt. 2, nr. 2, Bd. II. Aside from medals won in art exhibitions, Liebermann had received decorations from a number of German governments, but it was not until the latter part of the First World War that Prussia followed suit. In a letter to his friend Max Lehrs, director of the Dresden Museum, Liebermann commented that he regarded the Prusian medal he had just received as symptomatic: "From now on there are no longer any parties for His Majesty, even in the fine arts"; 25 December 1917, Bodenheimer collection, Leo Baeck Institute, 57 (847). See also Liebermann to Lehrs, 19 January 1918, ibid., 59 (847).

38. Karl Scheffler, "Berlin," *Kunst und Künstler*, 10 (1911–1912), p. 414.

fostered by the rival group and threatened to withdraw the small annual subvention that the city had begun awarding to the secession the previous year. After the secession demanded a retraction of statements that, it claimed, could not be reconciled with the mayor's duty of representing all Berliners, he declared that he had been misunderstood; he had not attacked the German secessionists but had merely characterized the French paintings in the secession's summer show as "an alien drop in our blood, works that I cannot imagine were brought to us by a genuine interest in art rather than by lust for sensationalism and profit [sensationslüsterner Geschäftsgeist]." Among the paintings the mayor condemned as tricks to make money were van Gogh's Arlésienne and ten landscapes by Le Douanier Rousseau.[39]

In the same year Georg Malkowsky, who had tried to become the secession's business manager in 1899, published a book on art in the service of the state, arguing that government support for the arts should be limited to painting and sculpture that gave expression to the "idea of the state." He advocated cultural policies that would "awaken and foster the fertile recognition that the fine arts fulfill merely the lesser part of their task when they produced aesthetic pleasure; only by giving form to the ideas that move the [German] people as a whole does art reach its ultimate perfection." Malkowsky was not alone in regarding the secession as an enemy of the state. The critic Hans Rosenhagen, who had once supported the secession, now wrote that "the emperor cannot be blamed for snubbing the members of an art organization from whose ranks he constantly hears insults, and whose continued existence today is, in fact, predicated solely on their opposition to him." The emperor himself continued to intervene occasionally in the purchasing plans of the state museums and in the awards of commissions and prizes; for instance, he disallowed the jury's choice for the large gold medal for architecture in the 1913 salon and awarded the medal to his own candidate instead. When such acts became public they were criticized in the liberal and socialist press, but caused little stir. The

39. "Chronik," ibid., p. 472; for the mayor's correction, see ibid., p. 518. See also the discussions of the incident by Julius Bab, "Berliner Bildersturm," Pester Lloyd, 26 May 1912, and Erich Vogeler, "Berliner Sezession 1912," Der Kunstwart, 25, no. 19 (1911–1912) pp. 33–35. When the mayor, in his capacity as deputy head of the municipal commission for the arts, wished to visit the secession to choose works for purchase by the city. Liebermann and Cassirer informed him that his presence was not desired, a rebuff that led to further disputes and to Liebermann's resignation from the commission. See Liebermann, "Mein Austritt aus der Kunstdeputation," Berliner Tageblatt, reprinted in Die Phantasie in der Malerei, pp. 160–163.

great majority of the German people, Lichtwark wrote to Liebermann, "is firmly loyal to the emperor in rejecting every living force [in the arts] — not for political reasons or out of Byzantine subservience, but from conviction."[40] No doubt Lichtwark was correct; yet the secession had created its own world, which for the time being was relatively untouched by the alienation of the majority and the intermittent outbursts of the emperor and of some officials and critics.

Two scandals, although not directly connected with the secession, further illustrate the decline in cohesion and self-confidence of the governmental elites in the last years before the war, which afforded the secession greater scope. One incident involved Paul Cassirer; the other, Anton von Werner.

By the time the conflicts in the secession broke into the open, Cassirer's activities as art dealer and publisher had expanded considerably. His gallery had opened branches in Hamburg, Amsterdam, and London. The publishing house now supported strong programs in modern literature, art, and art history. Between its beginnings and the outbreak of war, the separate *Pan Presse* produced eleven luxury editions with original lithographs and etchings among them the *Book of Judith* and the *Song of Songs* illustrated by Corinth, a Heine novel illustrated by Jules Pascin, and Barlach's lithographs for his own drama *Der tote Tag.*[41] In 1910 Cassirer launched a new cultural and political periodical, also named *Pan* in allusion to the earlier *Pan* that Meier-Graefe and Richard Dehmel had founded in 1895. In conjunction with the journal, Cassirer started ed a literary association, the *Pan Gesellschaft*, which sponsored private performances of avant-garde plays, in which Cassirer's second wife, the actress Tilla Durieux, took part.

The sixth issue of *Pan* contained the first German translation of excerpts of Flaubert's Egyptian diary and was confiscated as pornographic by the Berlin police chief, Traugott von Jagow. The next issue of *Pan* published further excerpts, and was again banned. In the trial that followed, affidavits by Hauptmann, Hofmannsthal, and

40. Georg Malkowsky, *Die Kunst im Dienste der Staatsidee* (Berlin, 1912), p. 11; see also related statements in pp. 5, 10. Hans Rosenhagen, "Neuerwerbungen der Nationalgallerie," *Der Tag*, 14 October 1911. Paul Cassirer wrote a sharp rejoinder, which appeared in *Pan*, 2 (November 1911), pp. 95–96. Lichtwark to Liebermann, 2 April 1911, in Lichtwark, *Briefe an Max Liebermann*, pp. 267–268.

41. The list of Pan Presse publications in Wolfgang von Löhneysen, "Paul Cassirer—Beschreibung eines Phänomens," *Imprimatur*, new series, 7 (1972), is incomplete. Löhneysen's study is nevertheless the best informed and most comprehensive account of Cassirer's life and work in the literature.

other authors were presented for the defense, but Cassirer and his chief editor, Wilhelm Herzog, were fined 50 marks each. A coincidence turned this commonplace event, of interest only to a few intellectuals, into a national sensation. At about the time that Jagow confiscated the sixth issue of *Pan*, he had accompanied Berlin's censor of plays to a rehearsal of a Max Reinhardt production of Carl Sternheim's farce *Die Hose*, during which he made the acquaintance of Tilla Durieux. Afterwards he sent her a note, asking for a private meeting the following Sunday. Cassirer, who objected to the police chief forcing himself on his wife, declared that "as an ancient Hebrew I believe in an eye for an eye, a tooth for a tooth" and challenged Jagow to a duel with pistols. Jagow apparently had not known that the actress was Cassirer's wife. He sent a representative, a guards captain in dress uniform, to Cassirer's office to proffer his apologies, which Cassirer accepted, adding, however, that Jagow's letter had become known and that he could not guarantee that it would not be discussed in the press. One of the editors of *Pan*, the critic Alfred Kerr, had learned of Jagow's behavior; against the wishes of Cassirer and Herzog, he insisted on exposing Jagow in the pages of *Pan* as an official who confiscated Flaubert's diary as pornographic and at the same time used his position to get a date with an actress. Kerr was a gifted polemicist, a Berlin version of Karl Kraus, but vain and undisciplined; the portrait Corinth painted of him in 1907 perfectly conveys his self-dramatization and sense of mission. He had no difficulty in ridiculing Jagow, or with using the figure of the lecherous prude in uniform to castigate the double standards of Wilhelmine morality; but his assaults were too shrill not to muddy what should have been a clear case of official stupidity and hypocrisy.[42]

42. Jagow, whose politics were those of the extreme right, tried to revenge himself on Cassirer by denouncing him and his wife as traitors during the First World War. During the Zabern affair he sent a letter to the *Kreuzzeitung,* justifying the behavior of Prussian officers in Alsace on the grounds that they were almost in enemy country, a statement that caused another storm in the press. See Hans-Ulrich Wehler, "Der Fall Zabern von 1913/14 als eine Verfassungskrise des Wilhelminischen Kaiserreichs," in his *Krisenherde des Kaiserreichs, 1871–1918* (Göttingen, 1970), p. 71. He took part in the Kapp Putsch in 1921, and at his trial chose as defense attorney the same Jewish lawyer who had represented *Pan* in the pornography trial in 1911. For the Jagow affair, see Kerr, "Jagow, Flaubert, Pan," *Pan*, 1 (1911), pp. 217–223; Max Slevogt's cartoon, "Des Dichters Psyche," which had the legend, "Ick bin preu'scher Beamter—Sie Schweinhund, verdammter!", ibid., p. 224; Kerr, "Vorletzter Brief an Jagow," ibid., pp. 287–290; P. Cassirer, "Erklärung," ibid., p. 320; Kerr, "Nachlese" and "Die juristische Seite," ibid., pp. 321–326, 353; P. Cassirer, untitled announcement, ibid., p. 354; Kerr, "Prozess-Ballade," ibid., pp. 583–585; Wilhelm Herzog, "Die unzüchtige No. 7," ibid., pp. 587–590. Press discussion ranged from a full-scale attack on Jagow in the socialist *Vorwärts*, "Die Affäre Jagow-Durieux," 3 March

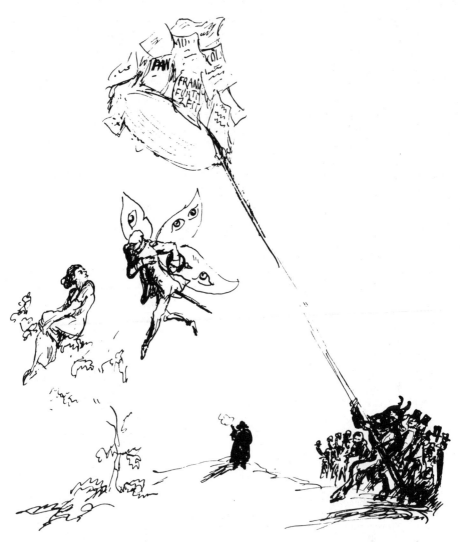

Max Slevogt. *The Police Chief in Fairyland.* 1911. Pen and ink, 5″ × 4″. In this cartoon on the Jagow affair, the police chief is fluttering toward Psyche, who swings on a flower, while a butterfly net of German newspapers, wielded by Pan, descends on him, and in the distance Domino approaches with a smoking pistol. The sketch, intended for publication in *Pan*, was replaced by another that attacked Jagow's censorship policies.

Even more widely discussed was the episode that led to the characterization of Anton von Werner as a threat to the state. In the years since the conflict over the Saint Louis International Exposition, Werner's position had been fortified by the highest official honors. He was a knight of the Order of the Red Eagle first class as well as of the order Pour le mérite, and in 1910 had been appointed privy councillor with the predicate "Excellency," which placed him on the same level as ambassadors and corps commanders. Since the death of Adolph von Menzel, no painter, writer, or composer had received such unusual marks of imperial approbation. It therefore caused a sensation when the German press announced in April 1913 that the annual salon had rejected a large number of Werner's paintings for political reasons.

Under such headlines as "The dangerous Anton von Werner," "An unparalleled scandal," and "Anton von Werner sacrificed," the newspapers reported that the 1913 Berlin salon which was celebrating the twenty-fifth anniversary of the emperor's reign as well as the centenary of Prussia's uprising against Napoleon, intended to include a retrospective show of Werner's works to mark the artist's seventieth birthday. Arrangements were far advanced when unidentified "high authorities" declared that the paintings, many of which dealt with the Franco-Prussian War, might antagonize French public opinion and should be withdrawn. The newspapers demanded to know who had made this decision, which was broadly criticized for showing undue concern for French susceptibilities while exaggerating the provocative character of Werner's paintings. The conservative *Post* categorized the decision as "cowardly and undignified," stating, "It is the duty of the Reichstag to discuss this preposterous affair, and to name the official responsible." In a second article the *Post* identified the Foreign Office as the culprit and continued: "Let us be frank. What can the German people expect from a ministry whose agents are afflicted with this degree of spinelessness, with a nearly hysterical sensitivity and lack of nerve? What can it expect of

1911, supported by satirical poems (3 and 4 March), to the assertion in the conservative *Post* on 2 March 1911 that the incident was an attempt to gain publicity for *Pan.* Kerr's role was extensively analyzed in the socialist periodical *Die Aktion,* which began publication in February 1911; see, for instance, nos. 10–14. Later accounts are included in Tilla Durieux, *Meine ersten neunzig Jahre* (Berlin, 1971) pp. 153–161, which contains some factual errors (for instance, the charge of pornography against Cassirer and *Pan* was not dismissed); and in the memoirs of Herzog, who was present when Jagow's representative called on Cassirer; see *Menschen denen ich begegnete* (Berne and Munich, 1959), pp. 467–472.

such men in a future crisis, when fate hands us the dice for a game of life and death!" According to the conservative *Münchener Zeitung*, "criticism of the government's action in papers from the far right to the extreme left is devastating, and coincides with the view we expressed yesterday: those who sully the nation's honor cannot possibly remain in authority." The *Frankfurter Nachrichten* regarded the removal of Werner's paintings as "the kind of pussyfooting that can only create shame at home and ridicule abroad." Even the *Kreuzzeitung* declared the action a blunder and expressed the hope that responsibility did not lie with a senior official but with an excessively zealous underling.[43]

While the government's care not to offend the French enraged the nationalist press, already agitated over anti-German demonstrations in Lorraine a few days before, liberal and socialist newspapers pointed to the reversal of roles. *Vorwärts* employed a Hegelian allusion: "Sometimes 'World History' does not lack irony after all! Court circles are coming round to our view, which never found much art in these battle paintings, but a great deal of chauvinism." The *Frankfurter Zeitung* commented that "for a change Anton von Werner must experience in his own skin what it means for an artist to be subjected to nonartistic considerations." It was ironic that Werner had fallen victim to nationalism in the arts: "Wasn't it just his circle and his following that fought—and, as we know, still fights today— against anyone who does not want to see art restricted by local or national frontiers." A Vienna paper thought the entire episode absurd: "Deference to France in this particular instance is entirely unwarranted; but people in Berlin seem at times to oscillate between an exaggerated patriotism and the other extreme."[44]

On 22 April the semiofficial *Norddeutsche Allgemeine Zeitung* denied that Werner had been forbidden to show his paintings for political reasons. Rather, it reported, the artist had offered the hanging

43. "Erbärmlich!" *Die Post,* 22 April 1913; "Die Bilderstürmer," ibid., 23 April 1913. Under the title "Kunst und Politik," the *Vossische Zeitung* of 21 April 1913 gave a full summary of the background of the case. See also "Wer war es?" *Münchener Zeitung,* 23 April 1913; "Der geopferte Anton von Werner," *Frankfurter Nachrichten.* 23 April 1913; "Eine Erklärung Anton v. Werners," *Kreuzzeitung,* 24 April 1913.

44. *Vorwärts,* 22 April 1913; "Der Fall Anton v. Werner," *Frankfurter Zeitung,* 23 April 1913. In a brief article, "Anton v. Werner 'staatsgefährlich,'" the liberal *Berliner Tageblatt* of 21 April 1913 declared that "art and artists should be excluded from all antagonism between nations." See also "Die grosse Kunstausstellung in Berlin. Eine Anton v. Werner-Affäre," *Die Zeit,* 22 April 1913; "Kurt," "Anton von Werner als Märtyrer," *März,* 7 (1913), pp. 179–180; and the poem by T. Rottel [i.e., Trottel, or idiot] apostrophizing "the dangerous Anton."

committee twenty-four works from which to select the retrospective; dissatisfied with the committee's choice, he withdrew them all. This defense of the government was immediately denied by Werner and found no acceptance in the press.[45] On 29 April the Kultusminister, responding to a question in the Prussian Upper House, stated that, when first approached in the summer of 1912, Werner himself had suggested that the exhibition organizers evaluate the political implications, in a time of international crisis, of showing his military pictures. According to the minister, neither he nor officials at the Foreign Office had seen grounds for concern, and they had notified the artist accordingly. That the exhibition did not come about after all was solely because Werner withdrew his works for unexplained reasons and refused to reconsider. Werner had no difficulty in demonstrating the inaccuracies in the minister's declaration. In a memorandum, "Facts and Corrections," which he distributed to a large number of friends and sympathizers, he listed witnesses and correspondence proving that he had been repeatedly informed that his paintings were politically dubious, in consequence of which he had refused to participate in the exhibition even with works that did not treat the Franco-Prussian War. One of his memoranda closed with the statement: "The admission that two of my paintings were rejected confirms my conviction that the pictures were excluded for *political considerations* — which, however, the minister in his unimpeachable declaration denies — and not for artistic reasons. The latter would have been impossible in any case, because as a member of the academy I am jury-free, something that no minister on earth can change."[46]

That the government had made a mistake and then lied to protect itself was obvious. Nor did it escape notice that several attempts were made to shift the blame to Werner, whose loyalty to the emper-

45. I was unable to consult the *Norddeutsche Allgemeine Zeitung*, but the text of its declaration was widely reprinted; see, for instance, *Vossische Zeitung*, 23 April 1913; *Deutsche Warte*, 24 April 1913. A brief interview with a Berlin journalist, in which Werner corrected the official version, was followed by a letter giving further details; it was first published in the *Vossische Zeitung*, 23 April 1913, and reprinted in *Berliner Neueste Nachrichten*, 24 April 1913, and in other papers.

46. The Werner papers contain a newspaper report of the minister's declaration, marked by Werner's handwritten corrections and exclamations; ZStA Merseburg, Rep. 92, Nachlass Anton von Werner, VId, p. 189. Various handwritten and typed versions of Werner's memorandum, "Thatsachen und Berichtigungen," with the statement of his administrative assistant, who had been informed by the head of the 1913 salon that the Foreign Office would not permit the exhibition of Werner's pictures for "political reasons," and other relevant documents are contained in the Werner papers, ibid., pp. 164–203 verso.

or and the emperor's ideas was well known. Werner himself did not belabor the issue. After he had sent one letter to the newspapers and circulated his memoranda—without, however, permitting them to be published—he fell silent. A mass demonstration planned in his support by Munich artists was called off at his request.[47] It was enough for him to put the facts on record for the emperor, his friends, and officials in the relevant ministries. Until his death in January 1915 Werner continued to serve as director of the Royal Institute for the Fine Arts, equally unbending before the pressures of modern art and ministerial expectations of servile obedience.

What is significant in the muddle over Werner's historical paintings and in Jagow's exercise in public and private morality is not so much the behavior of the officials as the breadth and sharpness of the criticism leveled against them. The press comments on the police chief and on the Kultusminister and the Foreign Office are not merely antagonistic; rather, they convey the sense that once again, as so often before, those in authority had proved inadequate. The atmosphere in Berlin had changed since the late 1890s when the secession was founded. Fault finding had increased and had opened breaches in the official facade, which modernism exploited. Under those conditions, the great success of the secession's 1912 summer exhibition seemed to initiate an alliance of German impressionism and expressionism that could promote modern art throughout Germany more effectively than ever before. But almost as soon as the show had opened, the new cohesion broke down.

The thirteen members whose entries had been rejected by the jury would not accept the verdict quietly. They rented a shop a few doors from the secession gallery and exhibited their paintings—a protest that did their cause no good, one critic thought, because they revealed themselves to be nothing more than "decent, honest, and boring epigones of impressionism." The artists' inability to document their charges did not prevent them from claiming that they had been victims of a political struggle for control of the secession. According to one newspaper account, the methods they employed to attack Cassirer, Liebermann, and the three jurors who had rejected their works—Slevogt, Kollwitz, and Tuaillon—"were not always the cleanest," and a majority in the secession came to feel that it was impossible for both factions to continue under one roof.[48]

47. Werner to Eugen von Stieler, 25 April and 1 May 1913, ibid., pp. 173–175.

48. Julius Bab, "Berliner Kunst- und Theater-Brief," *Karlsruher Zeitung,* May 1913; see also his "Juryfrei?" *Pester Lloyd,* 3 October 1913. Curt Glaser, "Der Konflikt in der Berliner Secession," *Kunst für Alle,* 28 (1912–1913), p. 474. The quarrel led to several court cases. In one, the thirteen sued Cassirer for wrongfully accusing

At a special general meeting, Slevogt, as spokesman for the majority, demanded that the thirteen leave the secession. When they refused, Slevogt, Liebermann, Cassirer, and thirty-nine others resigned instead. Left behind were the weakest members of the secession—with the possible exception of Otto Modersohn and the engraver Hermann Struck, they are forgotten today—and Corinth, who surprisingly threw in his lot with them. A grotesque situation arose, Scheffler noted: "Those who remained, legally constituted an organization whose ideals they were not sufficiently talented to fulfill, while those who resigned could no longer call themselves members of the Berlin Secession, but truly represented its spirit."[49]

The artists who had resigned sponsored the autumn exhibition that Cassirer had already announced, which included Munchs and twenty-one Picassos, as well as works by the former Brücke painters and other expressionists. In the following spring they founded a new organization, the Free Secession, with Liebermann as honorary president. Cassirer, who, it was generally felt, had been a poor politician during his year a president—having "bent the bow too taughtly," as one man said—was not included on the executive committee but was elected an honorary member. He was unwilling to continue as business manager and played only a marginal role in the new group, though he remained on intimate terms with its leading members. The outbreak of war rendered continutiy of leadership impossible, and without the administrative backing of Cassirer's firm the Free Secession could not achieve financial strength. It held shows irregularly, never with much success, until at the height of the postwar inflation, in 1923, the group was disbanded. The rump Berlin Secession fared equally badly. Corinth was elected president, a position he occupied until his death in 1926; but his leadership was too sporadic, and the group itself was too weak to develop its own style and a rigorous exhibition policy. Increasingly, the Berlin Secession became merely an economic interest group, with little, if any, impact on German art. It was dissolved in 1932.[50]

The national and international significance of the Berlin Secession came to an end when the majority left in the fall of 1913. The new cohesion between earlier and later generations of the avant-

them of having insulted Liebermann, but the court found for Cassirer. See also Corinth, *Selbstbiographie*, pp. 154–156, and the objective report by Erich Vogeler, "Der Sezessionskonflikt," *Der Kunstwart*, 26, no. 17 (1912–1913), pp. 358–359.

49. Quoted in Rudolf Pfefferkorn, *Die Berliner Secession* (Berlin, 1972), p. 52.
50. Glaser, "Die Geschichte der Berliner Sezession," pp. 290–293.

garde, which Cassirer had created for the 1913 summer exhibition and which seemed to open a new stage in the fight for modernism in Germany, proved to be spurious. It was not only the divergence of styles that led to the breakup, since in the Free Secession impressionists, expressionists, and later exponents of the *Neue Sachlichkeit* could tolerate each other, but also personal animosity and — the constant dead weight of all such organizations — the envy felt by the less talented. As a movement that adhered to an international, nondidactic aesthetic and defended it effectively both against dissidents in its own ranks and against traditionalists and the art patriots, the secession had lasted for some fourteen years, from the first exhibition in May 1899 to the 1913 annual show.

Fourteen years was an unusually long life for such a group. The Munich Secession, never very innovative, became in a matter of years as conventional as the local chapter of the Allgemeine Deutsche Kunstgenossenschaft. The Vienna Secession, after eight years of existence, turned almost equally conservative with the departure of Gustav Klimt and his followers in 1905. Such more recent associations as the Sonderbund survived for barely five years. The much smaller groupings of artists in temporary intense sympathy with each other, such as the Brücke or the Blaue Reiter, never lasted more than a few years. Only one or two of the artists' colonies, notably the one at Worpswede, had a longer history, although their ideologies and policies changed along with their memberships. If the Berlin Secession retained vitality for longer than could have been expected, it was because of a conjunction of forces: the presence of an unusually large number of artists of considerable talent, some of whom consciously pursued cultural politics of an international rather than national cast; enerprising management that was serious about changing the German taste in art; the stimulating, if often hostile, Berlin environment, which underlined the differences between the secession and other institutions, and which posed greater obstacles to the secessionists' return to the compact majority than was the case, for instance, in Munich.

A change in attitudes at the turn of the century also played a role in what might be termed the timid readiness on the part of some Germans to accept impressionism, which coincided with the individual artistic development of such painters as Liebermann and Slevogt, and with the rebelliousness of Paul Cassirer. But as the secession captured a dominating position in German art, the cultural landscape was changing. In 1917, speculating on the reasons for the decline of the Berlin Secession and of the Free Secession that had fol-

lowed it, Scheffler suggested that a new age in art and in society had arrived:

It is time to be blunt—the secessions have outlived themselves. They achieved what they should and could achieve, they have fulfilled their historic mission; now their existence is no longer justified. German art owes an enormous debt to these organizations; especially to the Berlin Secession, which became a center of the best German art, and whose spirit survives in the Free Secession more than elsewhere. Impressionism —to use familiar shorthand—needed the tightly organized, combative group, and needed the opportunity to hold exhibitions for an artistic elite and for an elite of the public. The Berlin Secession stood for the ideal of quality at a time when that ideal was scarcely understood in Germany. In its best period, the secession was a nearly perfect working community, in which members learned from each other. And because it was like an extended family, defined and separate, the secession was more effective than any of the large artist organizations. But the type of art that is described as expressionism—again in shorthand—cannot really make use of this intimate group. The spirit that has captured our young artists and dominates them more every day rejects limits and boundaries, it seeks a direct link to the masses, it strives for breadth, universality, loudness—its essence is democratic, not patrician. Consequently the secessions do not suit it.[51]

The true successor of the old Berlin Secession was not one of the secession groups that continued to lead a stunted existence for some years, but—after the hiatus of the First World War—the new republican Prussian Academy of Arts. In a drastic reversal of roles, Liebermann became its president in 1920. He returned to Cassirer's policy of 1913, now backed by the authority and finances of the state and informed by the state's concern for bringing art to the people; in the academy's exhibitions, publications, and lecture programs, he combined the old guard of German impressionism with expressionists and representatives of still newer directions. In 1932, at the age of eighty-five, he retired and was named the academy's first honorary president. After the triumph of National Socialism the following year, he resigned from the academy with a brief explanation: "In the course of my long life I have tried to serve German art with all my strength. I am convinced that neither politics nor racial descent has anything to do with art. Since this point of view is no longer accepted, I cannot remain in the Prussian Academy of Arts, whose member I have been for more than thirty years, and as whose president I

51. Karl Scheffler, "Die Ausstellung der Freien Sezession," *Kunst und Künstler*, 16 (1917–1918), pp. 420–422.

served for twelve."[52] His resignation and its cause were early stations on a road that led in 1943 to his eighty-five-year-old widow's suicide to escape deportation to Poland.

52. Max Liebermann, "Erklärung," 8 May 1933, reprinted in *Die Phantasie in der Malerei*, p. 295.

7

DER BILDERMANN

In August 1914 the artists who had founded the Berlin Secession and those who were later associated with it supported Germany's entry into war as wholeheartedly as the rest of the German people. In an essay, "Vae Victis," Lovis Corinth lauded the *furor teutonicus,* which "showed the enemy that he could not disturb our peaceful existence with impunity." Elsewhere in the essay he wrote of a host of enemies, who "in the true sense of the word want to put an end to the young German empire," and called for a halt to "the aping of Gallic-Slav [models] that has characterized our most recent phase of painting!"[1] Max Liebermann signed the "Declaration of the Ninety-three," in which prominent scholars, scientists, and artists defended Germany against the charge of aggression; he at once set to work on graphics espousing the German cause, as did Ernst Barlach, August Gaul, and many others. Karl Scheffler went so far as to apostrophize war as a "cleansing storm," the disaster that would create a cultural rebirth, and declared that however it ended, the war would bring the German people "a new inwardness, more profound culture, and new strength to live." Through an extraordinary lapse of good sense and common decency, he even opened the pages of *Kunst und Künstler* to an article by the art historian Emil Schäffer, who demanded that Belgium deliver its most prized artworks to German museums as a "war indemnity," a proposal that was indignantly rejected by Wilhelm von Bode.[2]

Others took a more direct part in the war. Max Slevogt, now in his forty-sixth year, used his influence to gain an appointment as war artist, but was so sickened by the destruction that he returned home after little more than two weeks in Belgium.[3] Erich Heckel and Max

1. Reprinted in Corinth's *Selbstbiographie* (Leipzig, 1926), pp. 125, 127, 129.

2. Karl Scheffler, "Der Krieg," *Kunst und Künstler,* 13 (1914–1915), pp. 2, 4; Emil Schäffer, "Kriegsentschädigung in Kunstwerken," ibid., pp. 35–43. Bode's response was published in the *Berliner Lokal-Anzeiger,* a paper with close connections to the government, and reprinted in part in *Kunst und Künstler,* 13 (1914–1915), p. 94.

3. Hans-Jürgen Imiela, *Max Slevogt* (Karlsruhe, 1968), pp. 195–197.

Beckmann volunteered for the medical corps. Oskar Kokoschka joined the Austrian cavalry to avoid being drafted, was severely wounded and briefly captured by the Russians. Franz Marc and August Macke were killed on the Western Front; Martin Brandenburg and Waldemar Rösler died of wounds suffered in combat. Julius Meier-Graefe was taken prisoner by the Russians while serving as a Red Cross volunteer in Poland. Paul Cassirer, already in his forties and suffering from the early stages of the heart disease that would indirectly cause his death in 1926, volunteered as a dispatch rider in August 1914; the following month he was awarded the Iron Cross in Belgium.

While on active service, Cassirer continued to initiate a few projects for his firm, and soon brought out several books on the war — a volume of poems by members of the corps in which he served, illustrated with pen-and-ink sketches by Beckmann, and a collection of letters by a young officer, the son of the secession sculptor Fritz Klimsch. But his most important enterprise in the first year of the war was a new periodical, *Kriegszeit* — "Wartime."[4] The first issue of *Kriegszeit* appeared on 31 August 1914, and for a year it came out once a week. After the summer of 1915 publication became less regular; the last issue appeared in March 1916. The periodical, printed on cheap paper and sold at the low price of 15, later 20, pfennige for the benefit of destitute artists and their families, sought to bring modern artists' interpretations of the war to a broad public. Each issue typically consisted of four full-page original lithographs, accompanied by a poem, a brief comment, or excerpts from communiqués or official statements.

The first issue opened with a Liebermann lithograph of crowds before the imperial palace in Berlin, captioned with the emperor's words: "I no longer know parties, I know only Germans." It concluded with a statement by Meier-Graefe: "All political parties now march toward the same goal, and art must follow." The same patriotic note was sounded in the next issues, but soon intermingled with other themes: a Liebermann sketch of a pogrom in Russia; medics working among the dead and wounded, again by Liebermann; a woman waiting for news, captioned "Anxiety," by Käthe Kollwitz, in the same issue; a Beckmann portrait of a friend who had

4. See Wolfgang von Löhneysen, "Paul Cassirer — Beschreibung eines Phänomens," *Imprimatur*, new series, 7 (1972), pp. 167–168; Victor H. Miesel, "Paul Cassirer's *Kriegszeit* and *Bildermann* and some German Expressionist Reactions to World War I," *Michigan Germanic Studies*, 2, no. 2 (Fall 1976), pp. 149–168.

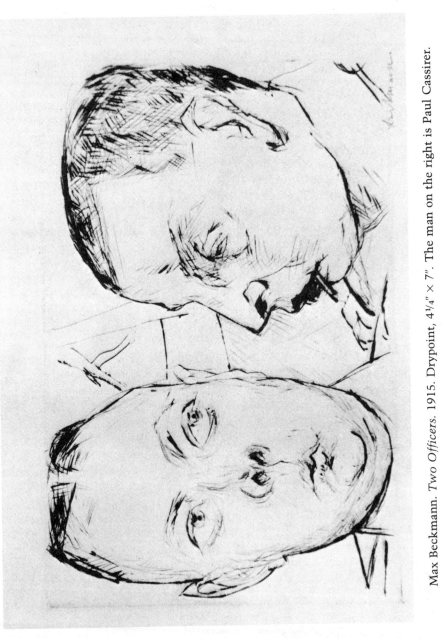

Max Beckmann. *Two Officers*. 1915. Drypoint, 4¼″ × 7″. The man on the right is Paul Cassirer.

been killed. For the remainder of its existence, *Kriegszeit* published a mixture of patriotic exhortations, objective reportage, symbolic depictions of human suffering, and caricatures of the enemy—among which a recent student has singled out as unforgettable Gaul's comment on Italy's entry into the war: captioned "Roman Eagle in May 1915," the lithograph shows a vulture perched on Michelangelo's *Moses*.[5]

Since Cassirer was on active duty, he could only outline general policy. Day-to-day editorial responsibility rested with the art critic Alfred Gold, who saw to it that enough patriotic themes were printed to induce the censor to pass more ambiguous work. Sometimes Gold refused a contribution as politically too dangerous; Barlach complained, for instance, that one of his lithographs, *Common Grave*, was held back out of fear of the authorities.[6] *Kriegszeit* thus does not perfectly reflect the political attitudes of the people who brought it out and who contributed to it. Nevertheless, the message of its illustrations accords closely with letters and other private statements made by their creators at the time. An attitude emerges that, with individual variations and differing emphases, was held in common by almost everyone who had been associated with the Berlin Secession. At least during the opening stage of the war, these people believed that Germany had been forced to take up arms; they trusted the army and its leaders and accepted the need for sacrifice; they were shocked by Allied propaganda that represented Germans as barbarians; they became aware of the horrors of war between industrialized mass societies and felt free to express their sense of the apparently unending tragedy, without regarding these reactions as tantamount to criticism of the government and the high command.

In the crisis of the First World War, their actions and their art provided a final refutation of the old charge that they were unpatriotic and even subversive. No government could have wished for more dedicated, energetic, and intelligent supporters than these artists, most of whom had shown little interest in politics before August 1914. The apolitical may, of course, have political implications. At a time of rabid nationalism the secession had managed, in one area of German life, to narrow the gap that had opened for a century between Western European and German culture. For the emperor to

5. *Kriegszeit*, no. 3 (16 September 1914); no. 10 (28 October 1914); no. 6 (4 October 1914); no 41 (27 May 1915). See also Miesel, "Paul Cassirer's *Kriegszeit*," p. 151.

6. Barlach to Arthur Moeller van den Bruck, 3 March 1915, *Die Briefe*, ed. Friedrich Dross (Munich, 1968–1969), I, p. 439.

equate the secession with socialism, for radical conservatives to see it as a tool of international Jewry, was to reject elements of German life for the sake of fantasies. But it may have been precisely the apolitical character of the art represented by the secession that enraged those Germans who were coming to depend increasingly on jingoism and patriotism to repress their anxieties.

The consequences of these fantasies are not difficult to trace. Not that German history would have been appreciably different if William II had shown himself less strident in rejecting impressionism and its successors. But his irresponsible encounters with the art of his day and the hatred populist groups felt toward this art were symptomatic of larger tendencies that undoubtedly did influence German attitudes and divide German society. To mention an obvious example, in 1914 German socialists, like the secession, did not behave as the enemies of the state they were supposed to be, but instead supported the war. A diminution of the fear of socialist subversion ten years earlier could only have increased the cohesiveness of German society and might even have improved the nation's military prospects.

In this sense the secession can be taken to exemplify both a social attitude and a missed opportunity. Few Germans wanted to destroy the imperial system, but many wanted to liberalize it and open it up, just as the secession wanted to take part in the Saint Louis Exposition. No consideration of national power and prestige warranted the resistance they encountered—on the contrary, it was self-defeating—just as no valid reasons, but only private fears, led the emperor to accuse the secession of existing in the gutter. Seen in this light, the secession appears as the aesthetic expression of doomed liberalism in Germany—doomed not only because the state, which needed all the help it could muster, rejected it, but also because Germany's defeat in the war and the consequences of the defeat fed the radicalism of the left and right that were to destroy it.

Opposition to modern art was indicative of the particular difficulties the empire experienced in integrating certain social and economic, as well as cultural, features of the twentieth century into its politics and institutions; beyond that, it is obvious that opposition to modernism also had implications for the years after 1918. It is true that modernism was resisted throughout Europe; its works were protested, misunderstood, or ignored everywhere, until the passage of time led to a new consensus that sacrificed parts of the old along with some of the less substantial or less appealing elements of the new. But German resistance was more intense. In

Germany, more than elsewhere, people were swayed by the fear that modernism threatened the substance of society and its political structure; behind this feeling lay a dread of the alien that many intellectuals and politicians, as well as some artists, elevated to the central part of their message.

When the war in the West reached a stalemate, the feelings of the contributors to *Kriegszeit* shifted, as did those of other Germans, from early euphoria and confidence in a quick victory to the realization that the war would be long and its outcome unpredictable. Some went further. Cassirer's letters from the front indicate that by the middle of the year he not only had become convinced that the war could not be won, but feared it was destroying Europe. In the beginning of 1916, at the age of forty-five, he was demobilized and returned to Berlin; there he decided to replace *Kriegzeit* with a new periodical, to appear twice monthly, which would reinforce people's awareness of the implications of the war and appeal to their yearnings for peace—feelings that he hoped might be associated with a new sensitivity to beauty. As editor he chose the pianist and music critic Leo Kestenberg, a well-known pacifist; nevertheless, he retained a strong voice in editorial policy, which is clearly heard in the programmatic announcement that appeared in the first issue:

Despite the horror of the times, our spirit has remained faithful to the old gods; in the midst of war we want to use our eyes as we used them before the war, even take pleasure as we once did. The strain of war has taught us to look horror calmly in the face, but it has also reawakened our longing for higher and purer things . . . Twice a month *Der Bildermann* will publish lithographs by masters . . . Lithographs are originals. In them the photographic process does not intervene between the artist's drawing and its reproduction; a lithographic line is as alive as the line of a sketch. The artist's unconscious, expressed in minute movements of his hand that can never be perfectly reproduced, is not lost in lithography. *Der Bildermann* hopes to bring a broad public directly in touch with art.[7]

The title of the new publication, "The Man Showing Pictures," was suggested by Slevogt, who also drew the title vignette of a sandwichman on a platform, with a barker explaining and commenting on the pictures he displayed on his boards.

7. Paul Cassirer and Leo Kestenberg, "Zur Einführung!" *Der Bildermann*, no. 1 (5 April 1916). On the founding and content of *Der Bildermann*, see Kestenberg's memoirs, *Bewegte Zeiten* (Wolffenbüttel and Zurich, 1961), pp. 35–36; Imiela, *Max Slevogt*, pp. 197–199; and Miesel, "Paul Cassirer's *Kriegszeit*," which contains several errors of detail—Liebermann contributed two lithographs, not one, for instance, and Kokoschka, eight rather than seven. That Miesel also exaggerates in asserting the

Like its predecessor, *Der Bildermann* consisted of four, and some-times five, full-page black-and-white lithographs, accompanied by a poem or a short story by classic authors or by such contemporaries as Max Brod, Else Lasker-Schüler, and Walter Hasenclever. The price continued to be kept low—30 pfennige—in order to reach the wide audience invoked by the subtitle carried on some of the issues: "Lithographs for the German People." But the artwork was general-ly more sophisticated and experimental than that of *Kriegszeit*, and the quality and complexity of the contents worked against the pub-lisher's hope for a strong impact, if not on the "German people," then at least on the general, educated public in Berlin. To a small group of readers, however, *Der Bildermann* offered reflective and powerful comments on the contemporary situation. Although its contributors, ranging from Gaul to Kirchner, Heckel, and Kokosch-ka, came from diverse stylistic camps, their work formed a remark-ably unified visual and emotional whole. The need to interpret the most tremendous experience of their generation brought the artists closer together, as did the anguish of cosmopolitans, now forced into a nationalist mold, who were witnessing the end of the European consensus they had stood for. Within the simple layout and typo-graphic design of the large pages, Barlach's apocalyptic visions do not jar with Liebermann's calm observation of guests at a lakeside restaurant; such conjunctions did, in fact, reflect the reality of a time when the routine of everyday life and mass destruction were closely joined.

A few of the illustrations—such as Gaul's magnificent variation on an ancient Assyrian frieze to mark the British surrender at Kut in Mesopotamia, or his sketch of a British sea lion befuddled by a Ger-man naval success—continued to celebrate German victories; but these are in the minority.[8] Far more space was given to interpreta-tions of civilian life in wartime Germany; some were romantic—such as the inevitable nude bathers by Otto Mueller, or an illustra-tion for Eichendorff's "Homesickness," a poem familiar to every Gymnasium student—but most showed no wish to evoke the past or prettify the present. Characteristic are the city scenes by Rudolf Grossmann, who had exhibited with the New Secession, in a style

publication "was indifferent not only to 'beauty' but also to patriotic war enthu-siasm" is demonstrated by several lithographs on lyric or idyllic themes and on Ger-man military and political successes.

8. *Der Bildermann*, no. 4 (20 May) and no. 6 (20 June). All issues were published in 1916.

Der Bildermann

Herausgegeben von Paul Cassirer

N⁰4

20. Mai, 1916
ERSTER JAHRGANG

STEINZEICHNUNGEN FÜRS DEUTSCHE VOLK

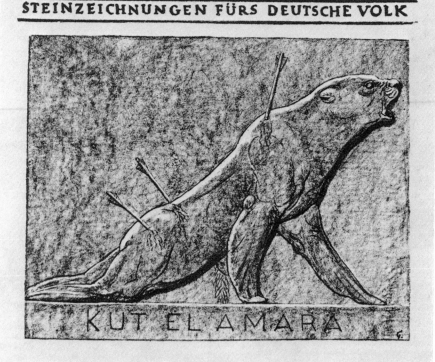

KUT EL AMARA

Title page of *Der Bildermann*, no. 4 (20 May 1916), with
August Gaul's lithograph on the British surrender at Kut. 12″ × 9⅞″.

of heavy contemporary realism; a harshly emotional landscape by Ernst Kirchner; Heckel's *Journey*, showing two women — one young, half smiling, the other battered by life — in a train compartment, passing through a city; and Heinrich Zille's affectionate or ironic vignettes of working-class life — children playing, a tavern keeper proud of his blood sausages.[9] Two of Zille's drawings approach social and political protest: a bar in which adults and children are getting drunk, and a mother and her children in a tenement room staring at the letter, containing an Iron Cross, that has informed them of the father's death in battle. An uninspired sketch by Käthe Kollwitz of a mother and her child smiling at each other is turned into an accusation by the caption, a verse bewailing the mother's poverty, which keeps her from feeding her child.[10]

Across this many-faceted image of life on the home front — difficult, but desirable — a series entitled *The New Society* slashed like a knife. With heavy lines and exaggerated gestures and expressions the artist, Ottomar Starke, revealed the brutal vulgarity of people for whom the war had turned into a good thing: a husband tells his wife she no longer needs to greet an acquaintance, since "we are richer than they are"; a well-dressed man avoids a bemedalled beggar.[11] Two series by stronger talents moved beyond social and economic differences to express horror at human suffering in general: eight illustrations of the life of Christ by Kokoschka, which interpreted the linked themes of betrayal and sacrifice with violent virtuosity; and ten drawings by Slevogt, *Symbols of Our Time*, in some of which he rose to heights of expressiveness he had never reached before. A few were brilliant cartoons, strongly reminiscent of Daumier: *Pax Vobiscum*, showing the Pope trying to calm the children of Europe quarreling on a hobby horse; an uncaptioned lithograph of soldiers thrusting with bayonets at a soap bubble that contains the dove of peace — a stormier version of Daumier's *L'Equilibre européen* of 1866. Others eschewed even the bitterest humor to confront war directly: an open mass grave, with thousands of mourners, stretching to the horizon, captioned "Across Frontiers, Across the Land, Endless Sorrow Spreads Its Wings," or an untitled sketch, later called *Paroxysm of Destruction*, that showed the ghosts of dead warriors continuing to fight with their own hacked-off limbs.[12]

9. Ibid., no. 6 (20 June); no. 3 (5 May); no. 4 (20 May) and no. 5 (5 June).
10. Ibid., no. 8 (20 July) and no. 16 (20 November); no. 2 (20 April).
11. Ibid., no. 11 (5 September) and no. 17 (5 December).
12. Ibid., no. 11 (5 September) and no. 17 (5 December).

Similar extremes of emotion were reached by Barlach. For the first issue he drew a male figure, his eyes cast down, striding forward on an inevitable journey. Another image of mankind in the grip of inexorable forces was a sketch, later given the title *The Tired One,* of an exhausted or suffering man being consoled by a spirit. In a September issue, war itself was depicted as a berserk giant, straddling a mountain of skeletons, smashing life with a sledgehammer. Several lithographs contain biblical references: one is entitled *Blessed Are the Merciful, for They Shall Obtain Mercy,* in another, *Anno Domini MCMXVI Post Christum Natum,* the devil shows an almost incredulous Christ a world that consists entirely of graves. Finally, in *Dona Nobis Pacem,* printed in the Christmas issue, a pleading female figure floats above the world; she is the source of an aureole of light that scatters, or holds back, a circle of swords.[13] The sense of tragedy, of the pointless but inexhaustible destruction of a war fought not for a significant moral objective but for finite political goals, that emanates from these pages is overwhelming.

The Christmas number of *Der Bildermann* was the last that appeared. It had failed to attract subscribers, the censors were becoming less tolerant, and serious difficulties in which Cassirer found himself prevented him from giving further time to the publication. Presumably as a means of silencing a publisher whose views were not liked, Cassirer was drafted in the summer of 1916, even though he was exempt on grounds of health and previous service. The medical discharge he eventually received was ignored or went unrecognized by another branch of the bureaucracy, which ordered him to be arrested and taken to a replacement battalion, from which he was finally discharged at the end of the year. A few months later he went to Switzerland on a mission for the Foreign Office, arranged by Count Harry Kessler; there he attempted to use his French contacts to explore the possibilities for a negotiated peace. He remained in Switzerland for the rest of the war.

If it was naive of Cassirer and his associates to hope that German society at war would welcome the ethical and aesthetic message of *Der Bildermann,* at least they did not passively submit to the deluge. They not only expressed their feelings but, in a medium that assured a minimum of distortion in the reproduction of art, sought to carry these expressions to a wider public. In their work for *Der*

13. Ibid., no. 1 (5 April); no. 4 (20 May); no. 11 (5 September); no. 13 (5 October) and no. 14 (20 October); no. 18 (20 December).

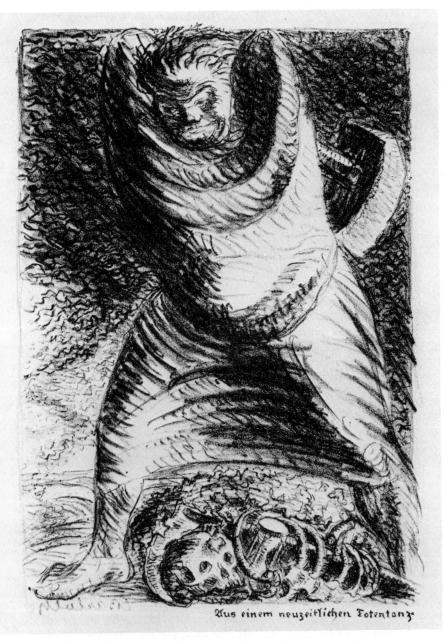

Ernst Barlach. *From a Modern Dance of Death.*
Der Bildermann, no. 11 (5 September 1916).
Lithograph, 11¾″ × 8″.

Bildermann they voiced once more the confidence of the secession's founders that good art would eventually have something to say to more than a few connoisseurs. When *Der Bildermann* ceased publication, several of its contributors searched for other outlets for their treatment of war. The most impressive result was a book by Slevogt, entitled *Gesichter*, or *Images*. In this expanded and revised version of his series *Symbols of Our Time*, he demonstrated that the best talents of German impressionism could break out of the framework of high bourgeois culture to meet the challenge of a world in crisis. *Images* opens with a female torchbearer staggering into the unknown. On another page, *Pegasus in the Service of War*, its wings tied, pulls a cannon while death whips it forward. The last pages show a fighter pilot shooting down the animals of the Zodiac, *The Man Responsible*, his face masked, carrying corpses through a sea of blood, and *The Forgotten Ones*.[14]

The values that *Der Bildermann* conveyed as the condition of Europe became desperate, and that Slevogt affirmed in *Images*, had found a home before the war in the Berlin Secession. Its leaders had made the secession an institutional expression of their personalities and convictions and had imposed their attitudes on the many members who were neither as good artists as they nor equally determined to fight against the established order. In the hands of the Liebermanns and Leistikows, the secession became a weapon with which to strike at Wilhelmine aesthetics and the government's cultural policies, and for a time the struggle engendered a sense of community that could stimulate and encourage others. But the decisive steps had been taken before the secession was founded, or had occurred apart from it, as soon as a few gifted painters and sculptors developed their own styles. Even if recognition and sales had not eventually come to such men as Slevogt and Barlach, they would not have stopped working in their own way and, in the long view, which is dominated by strong talents, the course of German art would not have seemed appreciably different.

The conflict between the secession and the forces of tradition in Berlin was not over the development of a new style, which is a matter for the individual alone, but over its acceptance. For that reason the fight for modern art and the forms that resistance to it took belong as much to the social and political history of Wilhelmine Germany as to the history of German art. Despite the arguments of its opponents, the values that the Berlin Secession represented were

14. Max Slevogt, *Gesichter* (Berlin, 1917).

German, but they pertained to a Germany that did not close itself off but sought its ideals in alien as well as in native soil. That for nearly fifteen years the secession maintained a forum for the German and foreign avant-garde, and won a small public for its works, constituted a victory in the war over modernism in Germany. At the time, both the supporters of the secession and its enemies regarded the victory as significant. They were right to do so, even if in the end, after the decline and collapse of the empire and the destruction of the Weimar Republic, the war itself was lost.

A Note on Sources

Manuscripts, Books, and Periodicals Cited

Acknowledgments

Index

A NOTE ON SOURCES

I have drawn on the following archival sources for information on the art policies of the Prussian government and on the emperor's attitudes toward the fine arts: Zentrales Staatsarchiv, Dienststelle Merseburg, Königliches Geheimes Civil-Cabinett, Rep. 2.2.1, and Kultusministerium, Rep. 76 Ve. Also valuable was the large, though incomplete, collection of the papers of the director of the Royal Institute for the Fine Arts in Berlin in the same archive, Rep. 92, Nachlass Anton von Werner. The diaries of the Kultusminister Robert Bosse, now in the Geheimes Staatsarchiv in Dahlem, contained interesting background information but nothing directly relevant to my study. The analysis of Germany's participation in the Saint Louis International Exposition is based in part on the extensive files of the Reich Foreign Office in the Zentrales Staatsarchiv, Potsdam, Auswärtiges Amt, Rep. 09.01.

For the early history of the secession I have used the minutes of its executive committee in the Cassirer Collection of the new Stanford Collection of German, Austrian, and Swiss Culture. Later volumes of the minutes appear to have been lost. Writings and correspondence of Paul Cassirer, Max Liebermann, Walter Leistikow, and other members and contemporaries of the secession, also in the Cassirer Collection, proved relevant to various aspects of this book, as did a few documents in the archives of the Akademie der Künste in West Berlin and the Leo Baeck Institute in New York.

Among printed documents that were especially useful are the catalogues of the Berlin Secession and the Cassirer Gallery, the speeches of the emperor, and the proceedings of the Reichstag and of the Prussian Landtag. My discussion of contemporary art criticism and of the public's reaction to the conflict between traditional and avant-garde art owes much to the newspapers and periodicals of the time, ranging in outlook from the monarchic conservatism of the *Kreuzzeitung* to the socialist *Vorwärts*. I have also relied on books, pamphlets, and articles by such diverse writers as Julius Meier-Graefe and Henry Thode. Equally enlightening was the published correspondence of members, supporters, and antagonists of the secession, and the sizeable autobiographical literature.

Two unusually problematical memoirs should be singled out even in this brief note: Emil Nolde's *Jahre der Kämpfe* (Flensburg, 1965), a highly suggestive account of the artist's progress, whose many errors and distortions

make it more impressive as a psychological portrait than as a factual record; and the autobiography of Paul Cassirer's second wife, the actress Tilla Durieux, *Eine Tür steht offen* (Berlin, 1954), or its expanded version, *Meine ersten neunzig Jahre* (Berlin, 1971). This work is more straightforward than Nolde's mystical evocation of the past, but it, too, contains obvious errors, confuses events, and fails to document some of its most interesting statements and quotations. I have, therefore, used it only sparingly.

The voluminous secondary literature is discussed in the footnotes, and a few references to it will suffice here. The most important analyses of the secession are Curt Glaser's article "Die Geschichte der Berliner Sezession," in *Kunst und Künstler*, 26 (1927–1928), pp. 14–20, 66–70; Rudolf Pfefferkorn's *Die Berliner Secession* (Berlin, 1972), a stimulating short book, based on secondary sources, which is less a consecutive history than a series of overlapping essays and biographical sketches; and, most recently, a work by the art historian Werner Doede, *Die Berliner Secession* (Berlin, 1977), whose 325 plates, constituting a useful pictorial record of the secession, are accompanied by a valuable but unduly condensed text of 62 pages. Nothing has been written on German impressionism that is the equivalent in its field of Peter Selz's informative synthesis, *German Expressionist Painting* (Berkeley, 1974). Most of the major artists I discuss have been the subjects of biographies, but so far only one has been treated in a modern, comprehensive interpretation that addresses itself both to the aesthetic issues and to the social, economic, and political aspects of the artist's life: Hans-Jürgen Imiela's *Max Slevogt* (Karlsruhe, 1968). Notable among older biographies are two books by painters who were contemporaries of their subjects: Erich Hancke's *Max Liebermann* (Berlin, 1914), a 550-page-long analysis that appeared when Liebermann still had more than twenty years to live, knowledgeable but not free of errors, such as those in its chronology of the secession's founding; and Lovis Corinth's *Das Leben Walter Leistikows* (Berlin, 1910), an intimate history of one of the driving spirits of the secession by a close friend, who himself played a major part in the secession's achievements and failures. Finally, the catalogue of the large Liebermann exhibition held in Berlin and Munich in the fall and winter of 1979, *Max Liebermann in seiner Zeit*, which contains interesting material on the artist's development and his aesthetic theories, appeared too late to be consulted for this study.

MANUSCRIPTS, BOOKS,
AND PERIODICALS CITED

Manuscripts

Akademie der Künste, West Berlin
 Friedensklasse des Ordens Pour le mérite, Abt. 3, Nr. 7
 Senat Akten, Abt. 2, Nr. 2, Bd. II
Leo Baeck Institute, New York
 Bodenheimer Collection
 Berthold Nothmann, "Meine Lebenserinnerungen"
Stanford Collection of German, Austrian, and Swiss Culture [GASC]
 Cassirer Collection
 I Paul Cassirer Correspondence and Manuscripts
 II Publications
 V Miscellaneous Papers
 VI Berlin Secession
Zentrales Staatsarchiv [ZStA], Dienststelle Merseburg
 Königliches Geheimes Civil-Cabinett, Rep. 2.2.1
 Nr. 19908
 Nr. 20002, Bd. 1
 Nr. 20564
 Kultusministerium, Rep. 76 Ve
 Sekt. 1, Abt. I, Teil I, Nr. 3
 Sekt. 1, Abt. IV, Teil IV, Nr. 9, III
 Sekt. 4, Abt. IV, Teil IV, Nr. 2, I
 Sekt. 17, Abt. IV, Teil IV, Nr. 21, XIV
 Nachlässe, Rep. 92
 Anton von Werner, VId
Zentrales Staatsarchiv [ZStA], Potsdam
 Auswärtiges Amt, Rep. 09.01
 Bd. 1, Nr. 51 (500)
 Bd. 2, Nr. 51 (501)
 Bd. 3, Nr. 51 (502)
 Bd. 4, Nr. 51 (503)
 Bd. 5, Nr. 51 (504)
 Bd. 6, Nr. 51 (505)
 Bd. 14, Nr. 51 (513)

Printed Documents, Catalogues, and Guidebooks

Ackermann Antiquariat. *Katalog 700*. Munich, 1979.

Bericht des Hauptvorstandes der Allgemeinen Deutschen Kunstgenossenschaft über die Betheiligung der Deutschen Künstlerschaft an der Weltausstellung in Paris 1900. Berlin, 1901.

Centre national Georges Pompidou. *Paris-Berlin: 1900–1933*. Paris, 1978.

Exhibition of Contemporary German Art. Chicago, 1909.

Great Britain. *Parliamentary Papers*, vol. I (*Reports*, 5, February–August 1904).

International Exposition St. Louis 1904: Official Catalogue of the Exhibition of the German Empire, ed. Theodor Lewald. Berlin, 1904.

Katalog der Deutschen Kunstausstellung der "Berliner Secession." Berlin, 1899.

Katalog der vierten Kunstausstellung der Berliner Secession. Berlin, 1901.

Katalog der siebenten Kunstausstellung der Berliner Secession. Berlin, 1903.

Katalog der zwölften Kunstausstellung der Berliner Secession: Zeichnende Künste. Berlin, 1906.

Katalog der sechsundzwanzigsten Ausstellung der Berliner Secession. Berlin, 1913.

Katalog: Grosse Berliner Kunst-Ausstellung. Berlin, 1897.

Mitglieder-Verzeichnis der Berliner Secession. Berlin, 1900, 1904, 1909.

Mitteilungen betreffend die Weltausstellung in St. Louis 1904, nos. 1 and 5. Berlin, 5 March and 2 April 1903.

Müller, Richard; Petersen, Hans von; and Schlichting, Max. "Bildende Kunst." *Amtlicher Bericht über die Weltausstellung in St. Louis 1904, Erstattet vom Reichskommissar*, vol. II. Berlin, 1906.

Official Catalogue of Exhibitors: Universal Exposition St. Louis, U.S.A. 1904; Department B Art. Saint Louis, 1904.

Official Guide to the Louisiana Purchase Exposition. Saint Louis, 1904.

Paul Cassirer Gallery. *X. Jahrgang: Ausstellung 1–10*. Berlin, 1907–1908.

Satzungen [der] Landes-Kunst-Ausstellungs-Gemeinschaft. [Berlin, 1892].

Satzungen für die grossen Berliner Kunstausstellungen. [Berlin, 1892].

Verein Berliner Künstler: Mitglieder Verzeichnis, Februar 1889. Berlin, 1889.

Verhandlungen des Preussischen Hauses der Abgeordneten: Stenographische Berichte, vol. CCCCLXX. Berlin, 1904.

Verhandlungen des Reichstags: Stenographische Berichte, vols. CVIIIC and CC. Berlin, 1904.

Verhandlungen des Reichstags: Stenographische Berichte, vol. CCXXXI. Berlin, 1908.

World's Fair Bulletin, vol. IV, no. 3. Saint Louis, January 1903.

Newspapers and Weeklies

Berliner Lokal-Anzeiger, 1899
Berliner Neueste Nachrichten, 1913
Berliner Tageblatt, 1884, 1899, 1904, 1913
Chicago Record-Herald, 1904
Deutsche Warte, 1913
Düsseldorfer Anzeiger, 1903
Frankfurter Nachrichten, 1913
Frankfurter Zeitung, 1904, 1905, 1913
Freisinnige Zeitung, 1899
Jugend, 1904, 1913
Karlsruher Zeitung, 1912, 1913
Kölnische Zeitung, 1903
Kreuzzeitung, 1892, 1899, 1904, 1913
Kriegszeit, 1914, 1915, 1916

London *Times*, 1904
Münchener Zeitung, 1913
Münchner Neueste Nachrichten, 1903, 1905
National-Zeitung, 1899, 1904
New York Times, 1904
Pester Lloyd, 1911, 1912
Die Post, 1904, 1911, 1913
Der Reichsbote, 1897, 1898, 1904
Rheinisch-Westfälische Zeitung, 1904
Simplicissimus, 1904
Der Tag, 1911
Vorwärts, 1904, 1911, 1913
Vossische Zeitung, 1892, 1899, 1903, 1904, 1913
Weser-Zeitung, 1903
Die Zeit, 1913

Books and Articles

Almanach 1920 des Verlags Bruno Cassirer Berlin. Berlin, 1919.

Alt, Thomas. *Die Herabwertung der deutschen Kunst durch die Parteigänger des Impressionismus*. Mannheim, 1911.

Aust, Günter. "Die Ausstellung des Sonderbundes 1912 in Köln." *Wallraf-Richartz-Jahrbuch*, 22 (1961).

Avenarius, Ferdinand. "Kaiserliche Äusserungen." *Der Kunstwart*, 20, no. 20 (1906–1907).

——— "Walter Leistikow." *Der Kunstwart*, 21, no. 22 (1907–1908).

——— "Was dünket euch um Liebermann?" *Der Kunstwart*, 20, no. 20 (1906–1907).

——— "Worauf kommt's an?" *Der Kunstwart*, 19, no. 1 (1905–1906).

——— "Zur Reichstagsverhandlung." *Der Kunstwart*, 17, no. 11 (1903–1904).

Barlach, Ernst. *Die Briefe*, ed. Friedrich Dross. 2 vols. Munich, 1968–1969.

——— *Ein selbsterzähltes Leben*. Berlin, 1928.

Becker, Benno. "Die Sezession." *Pan*, 2 (1896).

Berliner Maler, ed. Irmgard Wirth. Berlin, 1954.

Bie, Oscar. "Berliner Kunstausstellungen." *Neue Deutsche Rundschau*, 14 (1903).

——— "Berliner Sezession." *Neue Deutsche Rundschau*, 20 (1909).

——— "Bilder und Menschen." *Neue Deutsche Rundschau*, 21 (1910).

——— "Leistikow." *Neue Deutsche Rundschau*, 20 (1909).

Der Bildermann, ed. Paul Cassirer and Leo Kestenberg. Berlin, 1916.

Bode, Wilhelm [von]. "Die Berliner Akademie." *Pan*, 2 (1896).

―――― *Mein Leben*. 2 vols. in one. Berlin, 1930.

Bouret, Jean. *The Barbizon School*. London, 1973.

Buchheim, Lothar-Günther. *Der Blaue Reiter*. Feldafing, 1959.

―――― *Otto Mueller*. Feldafing, 1963.

Bülow, Bernhard von. *Denkwürdigkeiten*, vol. II. Berlin, 1931.

Bülow, Joachim von. *Künstler-Elend und -Proletariat*. Stettin, 1911.

Cassirer, Paul. "Erklärung." *Pan*, 1 (1911).

―――― *Fritz Reiner, der Maler*. Dresden and Leipzig, 1894.

―――― [Paul Cahrs]. *Josef Geiger*. Paris and Leipzig, 1895.

――――"Vorwort." *Katalog der sechsundzwanzigsten Ausstellung der Berliner Secession*. Berlin, 1913.

―――― "Kritiker?" *Pan*, 1 (1911).

―――― *Das Märchen vom Ewigen Weh*. n.p., n.d.

―――― "Nachtstück," *Blätter für die Kunst*, 3 (August 1894).

Cassirer, Paul, and Kestenberg, Leo, "Zur Einführung!" *Der Bildermann*, 1, no. 1 (1916).

Corinth, Lovis. *Das Leben Walter Leistikows*. Berlin, 1910.

―――― *Selbstbiographie*. Leipzig, 1926.

Creutz, Max. "Die 'Fine Arts' auf der Weltausstellung in St. Louis." *Kunst für Alle*, 19 (1903–1904).

Deiters, Heinrich. *Geschichte der Allgemeinen Deutschen Kunstgenossenschaft*. Düsseldorf, [1906].

"Die deutsche Kunstabteilung in St. Louis," *Kunst für Alle*, 19 (1903–1904).

Deutsche und französische Kunst, ed. Alfred Walter Heymel. Munich, 1911.

Dobsky, Arthur. "Kunst und Sozialpolitik." *Kunst für Alle*, 28 (1912–1913).

Doede, Werner. *Die Berliner Secession*. Berlin, 1977.

Dresdner, Albert. "Berliner Kunst." *Der Kunstwart*, 16, no. 3 (1902–1903).

―――― "Berliner Kunst–Die Ausstellung der Berliner Sezession." *Der Kunstwart*, 16, no. 18 (1902–1903).

―――― "Berliner Kunst–Die Grosse Berliner Kunstausstellung." *Der Kunstwart*, 16, no. 23 (1902–1903).

Drey, Paul. *Die wirtschaftlichen Grundlagen der Malkunst*. Stuttgart and Berlin, 1910.

Durieux, Tilla. *Meine ersten neunzig Jahre*, ed. Joachim Werner Preuss. Berlin, 1971.

Eichfeld, Hermann. "Münchner Malerei." *Süddeutsche Monatshefte*, 2 (1904).

Elias, Julius. "Der Berliner Glaspalast." *Kunst und Künstler*, 5 (1906–1907).

―――― "Chronik." *Kunst und Künstler*, 6 (1907–1908).

―――― "Die Grosse Berliner Kunstausstellung 1910." *Kunst und Künstler*, 8 (1909–1910).

—— "Walter Leistikow." *Kunst für Alle,* 18 (1902–1903).

—— Obituary of Franz Skarbina. *Kunst und Künstler,* 9 (1910–1911).

Fürstenberg, Carl. *Die Lebensgeschichte eines deutschen Bankiers,* ed. Hans Fürstenberg. Wiesbaden, 1961.

Gay, Peter. *Freud, Jews and Other Germans.* New York, 1978.

Geissler, Joachim. *Die Kunsttheorien von Adolf Hildebrandt, Wilhelm Trübner, und Max Liebermann.* Berlin, 1963.

Glaser, Curt. "August Gaul." *Kunst für Alle,* 27 (1912–1913).

—— *Edvard Munch.* Berlin, 1922.

—— "Die Geschichte der Berliner Sezession." *Kunst und Künstler,* 26 (1927–1928).

—— "Die XXVI. Ausstellung der Berliner Secession." *Kunst für Alle,* 28 (1912–1913).

—— "Der Konflikt in der Berliner Secession." *Kunst für Alle,* 28 (1912–1913).

Graul, Richard. "Die XI." *Pan,* 2 (1896).

Grossmann, Stefan. "Paul Cassirer." *Das Tagebuch,* 7 (1926).

Haftmann, Werner. *Emil Nolde: Unpainted Pictures.* New York, 1965.

Hamann, Richard, and Hermand, Jost. *Stilkunst um 1900.* Munich, 1973.

Hancke, Erich. "August Gaul." *Kunst und Künstler,* 21 (1922–1923).

—— *Max Liebermann.* Berlin, 1914.

—— "Der Nachwuchs der Berliner Sezession." *Kunst und Künstler,* 9 (1910–1911).

Hauptvorstand des Allgemeinen Deutschen Künstlerbundes. *St. Louis und die deutschen Künstler.* Berlin, 1904.

H[ennig], P[aul]. "Einfuhr von Kunstwerken in Amerika." *Kunst und Künstler,* 10 (1911–1912).

Herzog, Wilhelm. *Menschen denen ich begegnete.* Berne and Munich, 1959.

—— "Die unzüchtige No. 7." *Pan,* 1 (1911).

Hodin, J. P. *Edvard Munch.* New York, 1972.

Holstein, Friedrich von. *Lebensbekenntnis,* ed. Helmuth Rogge. Berlin, 1932.

Holtzbecher, Hans. *Die grosse Berliner Kunstausstellung; Eine Flucht der Künstler in die Öffentlichkeit.* Berlin, 1903.

Huder, Walther. *Theodor Fontane und die preussische Akademie der Künste.* Berlin, 1971.

Imiela, Hans-Jürgen. *Max Slevogt.* Karlsruhe, 1968.

Jordan, Max. *Koner.* Bielefeld and Leipzig, 1901.

Kalckreuth, Johannes. *Wesen und Werk meines Vaters: Lebensbild des Malers Grafen Leopold von Kalckreuth.* Hamburg, 1967.

Kerr, Alfred. "Jagow, Flaubert, Pan." *Pan,* 1 (1911).

—— "Die juristische Seite." *Pan,* 1 (1911).

—— "Nachlese." *Pan,* 1 (1911).

—— "Prozess-Ballade." *Pan,* 1 (1911).

—— "Vorletzter Brief an Jagow." *Pan,* 1 (1911).

Kessler, Harry. *Der Deutsche Künstlerbund.* Berlin, 1904.

Kestenberg, Leo. *Bewegte Zeiten.* Wolfenbüttel and Zurich, 1961.

Klimsch, Fritz. *Erinnerungen und Gedanken eines Bildhauers.* Stollhamm and Berlin, 1952.

Knauer, Hermann. *St. Louis und seine Welt-Ausstellung.* Berlin, 1904.

Kollwitz, Käthe. *Tagebuchblätter und Briefe,* ed. Hans Kollwitz. Berlin, 1948.

Kramer, Hilton. *The Age of the Avant-Garde.* London, 1974.

Die kranke deutsche Kunst; Nachträgliches zu "Rembrandt als Erzieher." Leipzig, 1911.

Kunst und Künstler: Aus 32 Jahrgängen einer deutschen Kunstzeitschrift, ed. Günter and Ursula Feist. Mainz and East Berlin, 1971.

Künstlerbriefe aus dem neunzehnten Jahrhundert, ed. Else Cassirer. Berlin, 1919.

Kunz-Lack, Ilse. *Die deutsch-Amerikanischen Beziehungen, 1890–1914.* Stuttgart, 1935.

Lange, Annemarie. *Das Wilhelminische Berlin.* East Berlin, 1976.

Lange, Konrad. "Über Bilderpreise." *Kunst für Alle,* 18 (1902–1903).

Langhammer, Carl. "Zum Deutschen Künstlerstreit." *Kunst für Alle,* 19 (1903–1904).

Leistikow, Walter [Walter Selber]. "Die Affaire Munch." *Freie Bühne,* 3 (1892).

——— "Über den Deutschen Künstlerbund und die Tage von Weimar." *Kunst für Alle,* 19 (1903–1904).

Lichtwark, Alfred. "Aus München." *Pan,* 2 (1896).

——— "Briefe an die Kommission für die Verwaltung der Kunsthalle." *Kunst und Künstler,* 21 (1922–1923).

——— *Briefe an die Kommission für die Verwaltung der Kunsthalle,* ed. Gustav Pauli. 2 vols. Hamburg, 1924.

——— *Briefe an Max Liebermann,* ed. Carl Schellenberg. Hamburg, 1947.

——— "Der Sammler." *Kunst und Künstler,* 10 (1911–1912).

Liebermann, Max. *Die Phantasie in der Malerei,* ed. Günter Busch. Frankfurt am Main, 1978.

——— *Siebzig Briefe,* ed. Franz Landsberger. Berlin, 1937.

Das Liebermann-Buch, ed. Hans Ostwald. Berlin, 1930.

Löhneysen, Wolfgang von. "Paul Cassirer—Beschreibung eines Phänomens." *Imprimatur,* new series, 7 (1972).

Louisiana and the Fair, ed. J. W. Buel, vols. IV and VII. Saint Louis, 1904 and 1905.

Lüdicke, Reinhard. *Die Preussischen Kultusminister und ihre Beamten.* Stuttgart and Berlin, 1918.

Malkowsky, Georg. *Die Kunst im Dienste der Staatsidee.* Berlin, 1912.

Mann, Golo. *Deutsche Geschichte des neunzehnten und zwanzigsten Jahrhunderts.* Frankfurt am Main, 1960.

Märten, Lu. *Die wirtschaftliche Lage der Künstler.* Munich, 1914.

Meier-Graefe, Julius. *Die Doppelte Kurve.* Berlin, 1924.

———— *Die Entwicklungsgeschichte der modernen Kunst: Ein Beitrag zur modernen Ästhetik.* 2 vols. Stuttgart, 1904.

———— *Der Fall Böcklin.* Stuttgart, 1905.

———— "Was wird aus der Kunst?" *Neue Rundschau,* 44, no. 7 (1933).

———— *Wohin treiben wir?* Berlin, 1913.

Miesel, Victor H. "Paul Cassirer's *Kriegszeit* and *Bildermann* and some German Expressionist Reactions to World War I." *Michigan Germanic Studies,* 2, no. 2 (1976).

Moeller van den Bruck, Arthur. *Nationalkunst für Deutschland.* Berlin, 1909.

———— "Die Überschätzung der französischen Kunst in Deutschland." *Der Kunstwart,* 18, no. 22 (1904–1905).

Moffett, Kenworth, *Meier-Graefe as Art Critic.* Munich, 1973.

[Müller, Hans]. *Zur Jubelfeier 1696–1896.* Berlin, 1896.

Nipperdey, Thomas. *Gesellschaft, Kultur, Theorie.* Göttingen, 1976.

Nolde, Emil. *Briefe aus den Jahren 1894–1926,* ed. Martin Urban. Hamburg, 1967.

———— *Jahre der Kämpfe.* Flensburg, 1965.

Norden, Julius, *Berliner Künstler-Silhouetten.* Leipzig, 1902.

Osborn, Max. "Von der Berliner Sezession." *Der Kunstwart,* 20, no. 16 (1906–1907).

Ostini, Fritz von. *Uhde.* Bielefeld and Leipzig, 1912.

Paas, Sigrun. *Kunst und Künstler.* Heidelberg, 1976.

Paret, Peter. "Art and the National Image: The Conflict over Germany's Participation in the St. Louis Exposition." *Central European History,* 11 (1978).

———— Review of *Kunst und Künstler,* ed. Günter and Ursula Feist. *American Historical Review,* 77 (1972).

Pastor, Willy. "Zwei deutsche Kunstausstellungen." *Der Kunstwart,* 19, no. 2 (1905–1906).

Paulus, Adolf. "Zwanzig Jahre Münchner Secession 1893–1913." *Kunst für Alle,* 28 (1912–1913).

Pevsner, Nikolaus. *Academies of Art, Past and Present.* New York, 1973.

Pfefferkorn, Rudolf. *Die Berliner Secession.* Berlin, 1972.

Piper, Reinhard. *Mein Leben als Verleger.* Munich, 1964.

Poggioli, Renato. *The Theory of the Avant-Garde.* Cambridge, Mass., 1968.

Purrmann, Hans. *Leben und Meinungen des Malers Hans Purrmann,* ed., Barbara and Erhard Göpel. Wiesbaden, 1961.

Rilke, Rainer Maria. *Sämtliche Werke,* vol. V. Frankfurt am Main, 1965.

Röhl, J. C. G. *Germany without Bismarck.* Berkely and Los Angeles, 1967.

Rosenberg, Adolf. "Die Ausstellung des Vereins der Elf in Berlin." *Kunst für Alle,* 3 (1892–1893).

Rosenberg, Alfred. *A. von Werner.* Bielefeld and Leipzig, 1895.

Rosenhagen, Hans. *Albert von Keller.* Bielefeld and Leipzig, 1912.

———— "Deutsche Kunstzustände," *Kunst für Alle,* 19 (1903–1904).

——— "Die Kunstausstellungen von 1902: Berlin." *Jahrbuch der bildenden Kunst.* Berlin, 1903.

——— "Von Ausstellungen und Sammlungen." *Kunst für Alle,* 19 (1903 – 1904).

[Rosenhagen, Hans?]. "Nachrichten von Berlin." *Kunst für Alle,* 18 (1902 – 1903).

Rossbacher, Karlheinz. *Heimatkunstbewegung und Heimatroman.* Stuttgart, 1975.

Sarkowski, Heinz. "Bruno Cassirer: Ein deutscher Verlag 1898 – 1938." *Imprimatur,* new series, 7 (1972).

Schäffer, Emil. "Kriegsentschädigung in Kunstwerken." *Kunst und Künst-ler,* 13 (1914 – 1915).

Scheffler, Karl. "Die Ausstellung der Freien Sezession." *Kunst und Künst-ler,* 16 (1917 – 1918).

——— "Berlin." *Kunst und Künstler,* 10 (1911 – 1912).

——— "Berliner Sezession." *Kunst und Künstler,* 5 (1906 – 1907).

——— "Berliner Sezession." *Kunst und Künstler,* 6 (1907 – 1908).

——— "Berliner Sezession." *Kunst und Künstler,* 8 (1909 – 1910).

——— "Berliner Sezession." *Kunst und Künstler,* 10 (1911 – 1912).

——— *Die fetten und die mageren Jahre.* Munich, 1948.

——— "Der Krieg." *Kunst und Künstler,* 13 (1914 – 1915).

——— "Kunstausstellungen," *Kunst und Künstler,* 6 (1907 – 1908).

——— "Kunstausstellungen." *Kunst und Künstler,* 9 (1910 – 1911).

——— "Kunstausstellungen." *Kunst und Künstler,* 10 (1911 – 1912).

——— "Kunstausstellungen." *Kunst und Künstler,* 12 (1913 – 1914).

——— *Max Liebermann.* 3rd ed. rev. n.p., 1953.

——— "Notizen über die 23. Ausstellung der Berliner Sezession." *Kunst und Künstler,* 10 (1911 – 1912).

——— "Ein Protest deutscher Künstler." *Kunst und Künstler,* 9 (1910 – 1911).

——— *Talente.* Berlin, 1921.

——— "Werdandi." *Kunst und Künstler,* 6 (1907 – 1908).

Schlichting, Max. *Staat und Kunst.* Berlin, 1904.

Schliepmann, Hans. "Die Ausstellung der XI." *Neue Deutsche Rundschau,* 3 (1892).

Schmidt-Ott, Friedrich. *Erlebtes und Erstrebtes, 1860 – 1950.* Wiesbaden, 1952.

Schott, Walter. *Ein Künstlerleben und gesellschaftliche Erinnerungen aus kaiserlicher Zeit.* Dresden, 1930.

Schuch, Werner. "Internationale Kunstausstellungen." *Die Zukunft,* 21 November 1896.

Schwarz, Georg. *Almost Forgotten Germany.* London, 1936.

Selz, Peter. *German Expressionist Painting.* Berkeley and Los Angeles, 1974.

Shapiro, Theda. *Painters and Politics.* New York, 1976.

Sievers, Johannes. "Die Ausstellung der Berliner Secession, 'Zeichnende Künste.'" *Kunst für Alle*, 25 (1911–1912).

Slevogt, Max. *Gesichter*. Berlin, 1917.

Spitzemberg, Hildegard von. *Das Tagebuch der Baronin Spitzemberg*, ed. Rudolf Vierhaus. Göttingen, 1960.

Stahl, Fritz. "August Gaul." *Kunst und Künstler*, 2 (1903–1904).

Storck, Karl. "Deutsche Kunst." *Deutsche Welt*, 8, no. 2 (1905).

Stuttmann, Ferdinand. *Max Liebermann*. Hanover, 1961.

Thode, Henry. *Arnold Böcklin*. Heidelberg, 1905.

——— *Böcklin und Thoma*. Heidelberg, 1905.

——— "Deutsche Weltanschauung und Kunst." *Süddeutsche Monatshefte*, 2, no. 10 (1905).

——— *Schauen und Glauben*. Heidelberg, 1905.

——— *Das Wesen der deutschen bildenden Kunst*. Leipzig and Berlin, 1918.

Thoma, Hans. *Briefwechsel mit Henry Thode*. Leipzig, 1928.

Tschudi, Hugo von. *Gesammelte Schriften zur neueren Kunst*, ed. E. Schwedeler-Meyer. Munich, 1912.

Uhde-Bernays, Hermann. *Im Lichte der Freiheit*. Wiesbaden, 1947.

Valentiner, W. R. "Die deutsche Ausstellung in New York." *Kunst und Künstler*, 7 (1908–1909).

Valentini, Rudolf von. *Kaiser und Kabinettschef*. Oldenburg, 1931.

Vinnen, Carl. *Ein Protest deutscher Künstler*. Jena, 1911.

Vogeler, Erich. "Berliner Sezession 1911." *Der Kunstwart*, 24, no. 20 (1910–1911).

——— "Berliner Sezession 1912." *Der Kunstwart*, 25, no. 19 (1911–1912).

——— "Berliner Sezession." *Der Kunstwart*, 26, no. 18 (1912–1913).

——— "Der Sezessionskonflikt." *Der Kunstwart*, 26, no. 17 (1912–1913).

Volker, Dr. "Die Berliner Kunstausstellungen." *Hochland*, 1 (1903).

Vom Beruf des Verlegers. Berlin, 1932.

Vorstand des Vereins Berliner Künstler. *Kunstgenossenschaft und Secession*. Berlin, 1904.

Wächter, Emil. *Der Prestigegedanke in der deutschen Politik von 1890 bis 1914*. Aarau, 1941.

Waldmann, Emil. *Sammler und ihrergleichen*. Berlin, 1920.

Wehler, Hans-Ulrich. *Krisenherde des Kaiserreichs 1871–1918*. Göttingen, 1970.

Weisbach, Werner. *Und alles ist zerstoben*. Vienna, 1937.

Wermuth, Adolf. *Ein Beamtenleben*. Berlin, 1922.

Werner, Anton von. *Ansprachen und Reden an die Studierenden der kgl. akadem. Hochschule f. d. bild. Künste zu Berlin*. Berlin, 1896.

——— *Erlebnisse und Eindrücke, 1870–1890*. Berlin, 1913.

——— *Die Kunstdebatte im Deutschen Reichstag am 16. Februar 1904*. Berlin, 1904.

——— Rede bei der Preisverteilung in der Königlichen akademischen Hochschule für die bildenden Künste, 22. Juli 1905. Berlin, 1905.

[Werner, Anton von]. "Die Weltausstellung in St. Louis und die deutsche Kunst." Weser-Zeitung, 31 December 1903.

William II. Das persönliche Regiment, ed. Wilhelm Schröder. Munich, 1907.

——— Die Reden Kaiser Wilhelms II., ed. Johannes Penzler, vol. III. Leipzig, [1907].

With, Christopher. "The Emperor, the National Gallery, and Max Slevogt." Zeitschrift des deutschen Vereins für Kunstwissenschaft, 30 (1976).

Wygodzinski, Wilhelm. "Die Kunst im preussischen Etat." Kunst für Alle, 19 (1903–1904).

Also cited are several unsigned and untitled reviews, communications, and other brief items, principally from the periodicals Kunst für Alle and Kunst und Künstler.

ACKNOWLEDGMENTS

I wish to thank the Historische Kommission zu Berlin, which supported research for this book with two fellowships, and the staffs of the Akademie der Künste in West Berlin, of the Leo Baeck Institute in New York, of the Zentrale Staatsarchiv of the German Democratic Republic in Potsdam and Merseburg, and of the Stanford Collection of German, Austrian, and Swiss Culture, for making their holdings available to me. The archive of Reinhard Piper Verlag in Munich generously gave me a copy of the now very rare book *Deutsche und französische Kunst,* edited by Alfred Walter Heymel, copyright © R. Piper Verlag, published in Munich in 1911. After I began writing, Agnes Peterson, curator of Central and West European holdings of the Hoover Institution, Peter Frank, curator of German materials in the Green Library, and Alexander Ross, head of the Cummings Art Library, all at Stanford, nearly made me forget that I was six thousand miles from German libraries. The editors of *Central European History* kindly permitted me to incorporate material that first appeared, in different form, in their journal. A grant from the Center for Research in International Studies, Stanford University, helped cover additional research and secretarial expenses.

I owe a debt of gratitude, which I fear I shall never be able to repay fully, to Felix Gilbert and to Beth Irwin Lewis, who were kind enough to read an early draft of the manuscript, and whose observations and suggestions helped resolve some major issues and many questions of detail. My colleague James Sheehan offered valuable comments on several aspects of the study. I am also grateful to Katharina Mommsen and James Shedel for calling my attention to material I might otherwise have missed, and to my student and colleague Daniel Moran, who helped me check the proofs. Finally, I must express my deep appreciation to Aida D. Donald and Barbara Gale of Harvard University Press for the interest they took in the manuscript and for the unusual care with which they saw it through the press.

INDEX

Academy, 20, 21n, 24, 54, 55, 56, 61, 63, 79, 96, 105, 108, 160, 222, 229; history and organization, 9-12; and Verein Berliner Künstler, 14-15, 37, 54; under Weimar, 233-234

Alberts, Jacob, 189n, 200

Allgemeine Deutsche Kunstgenossenschaft, 16, 31, 32, 107, 169, 232; history, 13-14; and Saint Louis Exposition, 115-116, 123-124, 127-134, 138, 140, 141, 146, 147, 148, 149, 152, 154, 169

Alt, Thomas, 189

Art proletariat, 12, 31, 89, 106-108, 168-170, 190, 196, 216

Art sales and prices, 31, 45, 82, 89, 95, 121-122, 161, 163-164, 169, 186, 191, 192, 194

August Wilhelm (prince of Prussia), 162

Avenarius, Ferdinand, 111, 162, 173n, 203

Bab, Julius, 81, 219, 221

Baluschek, Hans, 84, 182n, 200

Barlach, Ernst, 3, 98, 200, 201, 213, 216, 220, 246; career, 204-207; during First World War, 235, 238, 244

Baum, Paul, 200

Beckmann, Max, 159, 190, 191, 200, 207, 209, 210, 236

Begas, Reinhold, 46n, 84n, 96, 130

Berlin salon, 12, 14, 19-21, 37, 55, 56, 61-63, 81, 95, 105, 107-108, 222, 223, 227

Berlin Secession, exhibitions of: summer (1899), 79-85, 86-89, 101; summer (1900), 92-93; graphics (1901), 93; summer (1902), 93; summer (1903), 95, 111n;

graphics (1903), 93-94; (1904-1909), 158-159, 163, 167, 200, 202, 206, 207-208; graphics (1906), 163-164; summer (1910), 209-210; summer (1911), 217; summer (1912), 219, 223, 230; (1913), 220-221, 231, 232

Berlin Secession, public of, 80-82

Besnard, Albert, 11n

Bie, Oscar, 94, 202

Bismarck, Prince Otto von, 15, 84, 154

Blaue Reiter, 218, 232

Böcklin, Arnold, 27, 59n, 80, 83, 111, 171-177, 181-182

Bode, Wilhelm [von], 9n, 71, 160, 222, 235

Bondy, Walter, 191

Bosse, Robert, 20, 21, 64, 65, 66, 89, 116

Brandenburg, Martin, 82n, 189n, 236

Breyer, Robert, 216

Brücke, 3, 204, 207, 208, 210, 216, 219, 232

Buchheim, Lothar-Günther, 207

Bülow, Bernhard von, 115, 137, 160, 161

Cassirer, Bruno, 69-73, 76-78, 158

Cassirer, Ernst, 69, 72-73

Cassirer, Max, 79

Cassirer, Paul, 4, 86n, 87n, 96, 98, 101, 102, 158, 162, 164, 165, 189, 192, 201, 203, 206, 207, 209, 213, 216, 218, 222, 232; background and career, 69-70, 72, 73-75; negotiations with secession, 69, 76-78; exhibition policies, 71, 94, 109, 219-220, 233; response to Vinnen, 194-195, 196; as president of secession, 219-221, 230-231; and Jagow, 224-225;